Eighteenth-century ceramics

Numerous publications describe well the provenance of eighteenth-century ceramics. This book focuses instead on the producers and consumers of these new material goods. It explains the economic conditions, the new scientific knowledge and the social and cultural transformations which formed these products.

Eighteenth-century ceramics places British wares in a European context. The book makes clear that British delftwares, porcelains and creamwares were produced principally by middle-class entrepreneurs for middle-class consumers. Although influenced by the continental manufactories, British ceramics developed characteristics which reinforced the values and aspirations of a complex group of people who formed the commercial, professional and new industrial middle classes.

The author investigates the impact that refined ceramic wares made on the social practices and imaginative lives of eighteenth-century society. These new goods constituted part of a wider material culture which reinforced eighteenth-century concepts of a modern and civilised society in formation.

Sarah Richards is Research Fellow in the History of Design at Manchester Metropolitan University.

MANCHESTER
UNIVERSITY PRESS

STUDIES IN DESIGN AND MATERIAL CULTURE

general editor
Christopher Breward

Eighteenth-century ceramics

Products for a civilised society

Sarah Richards

distributed exclusively
in the USA by
St. Martin's Press

Manchester University Press

Manchester and New York

Copyright © Sarah Richards, 1999

The right of Sarah Richards to be identified as the author of this work has been asserted by her in accordance with the Copyright, Designs and Patents Act 1988

Published by Manchester University Press
Oxford Road, Manchester M13 9NR, UK
and Room 400, 175 Fifth Avenue, New York, NY10010, USA
http://www.man.ac.uk/mup

Distributed exclusively in the USA by
St. Martin's Press, Inc., 175 Fifth Avenue, New York,
NY10010, USA

Distributed exclusively in Canada by
UBC Press, University of British Columbia, 6344 Memorial Road,
Vancouver, BC, Canada V6T 1Z2

British Library Cataloguing-in-Publication Data
A catalogue record for this book is available from the British Library

Library of Congress Cataloging-in-Publication Data applied for

ISBN 0 7190 4464 2 *hardback*
 0 7190 4465 0 *paperback*

First published 1999

05 04 03 02 01 00 99 10 9 8 7 6 5 4 3 2 1

Typeset in Stone Serif with Sans display
by Carnegie Publishing, Lancaster
Printed in Great Britain
by Alden Press, Oxford

Contents

Figures

Acknowledgements

I would like to offer my wholehearted thanks to the following individuals: Julia Garratt, who read and commented on the manuscript at times in the academic year when she must have felt least like doing so; Diana Donald, who gave invaluable advice and encouragement in the last stages of completion; Oliver Fairclough, for his interest and generous support in allowing access to books and to the ceramic collections in the National Museum and Gallery, Cardiff; Glyn Downs, for keeping my foreign languages in intelligible order; Mr Edwin George and the late Stella George, for their painstaking work in transcribing the Bristol Diocesan Probate Inventories, and for Mr George's kindness and support; Professor Bryce-Smith, retired Professor of Chemistry at Reading University, for his comments on lead toxicity; The unidentified readers for Manchester University Press, for their constructive advice and criticism; Helen Long, Paul Greenhalgh, Katherine Reeve, Rebecca Crum, Stephanie Sloan, Matthew Frost, Jane Raistrick, Gemma Marren and other staff at MUP on whose work authors are dependent; Helen Hudson, Tom Piper, Catherine Meeus; and my mother, who at times of need provided refuge from inner-city noise at her cottage on the Welsh borders.

There are many individuals in museums, libraries and archives in Britain, Germany and France to whom I am also indebted for their assistance, especially the following: The Ashmolean Museum, Oxford; Bath Central Library; the British Library; the British Museum, Department of Prints and Drawings, Department of Medieval and Later Antiquities, Department of Oriental Antiquities; Bristol Record Office; Bristol Reference Library; Cardiff City Library; Liverpool Record Office; Manchester City Art Gallery; John Rylands University of Manchester Library; Musée Frédéric Blandin, de Nevers; Museum of London; National Art Library, Victoria and Albert Museum; Royal Pavilion Art Gallery and Museums Brighton; Royal Society of Arts Library and Archives; Sächsisches Haupstaatsarchiv Dresden; Staatliche Porzellan Manufaktur Meissen GmbH; University of Wales College of Cardiff Library, Arts and Social Studies; Wellcome Institute Library for the History of Medicine; Whitworth Gallery, University of Manchester. I would particularly like to thank those institutions who have granted permission to reproduce visual material at a reduced fee. My thanks to Bath Spa University College for financial assistance towards both travel, photographic and reproduction fees, and to the staff in the library at Sion Hill, Bath, especially Anne Jordan. I am also grateful to Manchester Metropolitan University for assistance with payment of reproduction fees.

Every attempt has been made to obtain permission to reproduce copyright material in this book. If any proper acknowledgement has not been made, copyright-holders are invited to inform the publisher of the oversight.

Introduction

The eighteenth century was a period in which the practices of everyday life as we now experience them were drawn into a more recognisable shape. Many of the social customs and rituals then absorbed into domestic and working contexts are still perceived to be the markers of a 'civilised' society. At the close of the twentieth century we may well have good reason to regard notions of what constitutes a civilised society with considerable circumspection. Although open to question, our material culture - the things of everyday life we make, use and invest meaning in - represents a tangible measure of what a civilised society is generally understood to be. In the eighteenth century men and women of means, but not necessarily of the elite landed classes, aspired to belong in a society where the practice of 'politeness' conferred social prestige.[1] The structures of refined and 'civilised' living had to be won by those who desired it, and constantly practised and renegotiated by those who had already acquired or inherited it. Refined consumer goods played a significant role in constructing and reinforcing this condition. As Douglas and Isherwood have argued, 'consumption is the very arena in which culture is fought over and licked into shape'.[2] Consumer goods were drawn into active use and made to signify in ways which were instrumental in forming a person's sense of self, affirming a sense of shared social and cultural belonging, and at the same time maintaining a distance from those unable to acquire the skills and material evidence of 'polite' conduct.

> 'Tis a just remark, that politeness, next to money, is the coin of most universal currency; in every situation we are fond of being treated with respect, and 'tis easily seen that the elegance of our dress has generally a material influence over our manners.[3]

Men and women of the eighteenth century were aware of the processes taking place, even if they could not see clearly where these processes would take them. By the end of the century the Industrial Revolution had thrown into sharper relief the fact that these profound social changes were part of the process of coming to terms with modernity.[4] The construction of a 'polite' society and the consolidation of a stable domestic base, expressed through a manufactured material culture supportive of the new civilising

social practices, were essential elements of this formative process of eighteenth-century commercial capitalism, transformed in England into industrial capitalism by the end of the century. The social status of those who appropriated and adapted the 'polite' practices of the people of 'Quality' was middle-class, but they constituted a complex and diverse middle class which had little homogeneity about it and was carving out 'social spaces' for itself.[5]

In the early eighteenth century Daniel Defoe was the spokesman for the entrepreneurial middle classes of Whig persuasion and how they should conduct themselves; in particular how they should steer a path through the contradictory nature of the times which encouraged a relish for commercial enterprise and a desire for moral restraint. A polite society emerged as a framework in which men and women found ways of adjusting to change under commercial and industrial capitalism, and in so doing relationships between the rulers and the ruled, between men, women and their children on a more personal level, were substantially remodelled.[6]

By the end of the eighteenth century fine ceramic products were available to many more people in Britain than had previously been possible. Attractive and relatively cheap tablewares substantially replaced the use of pewter and wooden vessels in the urban dwellings of people defined by Daniel Defoe as belonging to the 'middle Station of Life'.[7] Not all that long ago opinion was against the notion that a middle class existed in the eighteenth century. Controversy persists, and much depends on how a middle class is defined. Greater importance may be placed on occupational and economic divisions, on ownership of property, on the ability to read, or on social and cultural practices which marked a desired distinction from those above and those below, but ultimately all these factors are significant and interrelated.[8] The eighteenth-century British middle class was to a great extent that group of men and women engaged in commercial activities, supplying a new range of goods and services which formed a material culture of greater comfort and complexity, especially in middle- and upper-class life. It also included the professions, among whom writers in particular were active in persuading people of the merits – and demerits – of acquiring 'politeness'. This still left out a large proportion of the population who were not in a position to accumulate wealth or 'better' themselves, but whose lives were nevertheless affected by a society which became increasingly conscious of a link between a sense of individual worth, the ownership of goods, and the mechanisms by which things could be made to carry meanings beyond their ostensible function.

The intervention which sparked off increased north European

activity in the production of more highly refined ceramic wares was the trade in oriental porcelains and red stonewares principally through the Dutch East India Company in the very early seventeenth century. Inseparable from this trade was the importation of novel commodities in the form of coffee, tea, chocolate and sugar, commodities which were initially very expensive and confined to elite circles until the expansion of production overseas, and market forces at home, brought them within reach of a wider social band during the eighteenth century. It is difficult to be precise about the refined nature of the vessels manufactured to meet the requirements of these 'hot liquors'.[9] They were represented on the one hand by the finest wares China and Japan were prepared to export to the West, and by the best the European porcelain manufactories could produce. On the other hand it is important to take into account the inferior Jingdezhen wares and the less elegant and heavily potted European tin-glaze wares. The variable quality and diversity of eighteenth-century ceramic products tailored to serve more complex social and cultural developments at the table and for interior ornament make any attempt at a precise identification of 'fine' ceramics difficult. But such an attempt misses the point in this genus of ceramic manufactures. A plainly potted teapot sold by a pedlar in mid to late eighteenth-century rural England, with the addition of measures of tea, sugar and hot water, introduced greater degrees of comfort and refinement to the humbler domestic environment. When export porcelains, or delftwares in imitation of the oriental models, reached beyond the urban centres of manufacture and distribution, people experienced new material qualities and were exposed to new images. The invention of a hard-paste porcelain in Saxony in 1708 introduced a new material to the European ceramic tradition which gave fresh impetus to the development of ceramic manufactures, especially in the later development of animal and figure sculpture which was widely imitated and reinterpreted. In the latter half of the eighteenth century new material developments in English earthenware manufactures were augmented by the introduction of transfer-printed creamwares, which were capable of carrying more diverse and popular cultural references into people's lives across wider social bands. It is not helpful to assume that all fine ceramic wares fall into the category of luxury goods. The elite porcelains clamour for such recognition because of their predominant value as carriers of social and political meanings.[10] The wares used to brew and drink tea and coffee were luxury items at the beginning of the century, but by 1800 tea drinking was modestly life-enhancing rather than luxurious and had become a necessary part of everyday life. The status of these artefacts is complex and has to be assessed

in connection with the highly variable social and economic cir-
cumstances in which they were used.

These moderately or highly refined ceramic wares were pro-
duced in centralised manufactories, sometimes of several hundred
workers, or in much smaller workshops employing under fifty
personnel. Some of the production processes were contracted out,
and not infrequently the products were painted, gilded or printed
on another site. The system of division of labour was universally
practised and varied in complexity according to the nature of the
product and its market. The three principal groups of manufacture
were the tin-glaze wares generally known as faience or blue and
white delftwares, the soft and hard-paste porcelains, and the later
eighteenth-century creamwares, but all three types held consider-
able variations in character. In England an important and
distinctive group of white salt-glazed stonewares was manufac-
tured until superseded by the creamwares. The manufacture of
bone china was more widely significant in England than that of
porcelain, and has remained the preference of British consumer
demand into our own time. A word of caution is needed as docu-
ments of the period include all of these types under the flexible
terms of 'china', 'chaney' or 'cheney', 'purslane' or 'porcellan'. One
must refer where possible to documented prices and context to
sort out which type of product was in use. With the exception of
the relatively small output of red stonewares and finely potted
earthenwares, eighteenth-century 'china' refers to those products
made from white firing clays with the application of cobalt blue
underglaze painting or polychrome onglaze enamels or both, and
in contemporary documents 'china' most commonly refers to the
soft-paste porcelains or imported East India Company wares. The
'delftwares' were usually, but not exclusively, referred to as such,
and were made from buff-coloured clays obscured by a layer of
glaze opacified to a bluish white with tin oxide and a very small
quantity of finely ground cobalt oxide. Concerning eighteenth-
century prices of ceramic products, it is important to consider their
current value even if an approximation is all that can be expected.
To assess the expenditure required for even a modest artefact pur-
chased in the middle of the eighteenth century, some suggest that
the amount should be multiplied fifty times, others suggest one
hundred times. If a china teapot cost 3s and a pound of Bohea tea
4s, these sums represented a great deal of money if you earned only
£20 per annum. For most of the century these goods and com-
modities were only accessible to the middle class and upwards, and
for many middle-class households of modest income the cheaper
delftwares and creamwares, the lower quality teas, were all that
could be afforded. By 1800, however, these products were within

reach of the higher wage earners in the new manufacturing districts.

In continental Europe the development of refined faience and porcelains largely depended on the patronage of the ruling elites, aristocratic entrepreneurs, and the *haute bourgeoisie*. Interesting exceptions to this general rule can be found in the Thuringian porcelain manufactories which grew out of glass-making enterprises in the 1760s, and the later Bohemian creamwares, enterprises run by businessmen in Prague and members of the minor nobility on their country estates.[11] Long-established regional traditions in ceramic production were upheld by artisan potters in which refined stonewares and earthenwares served the requirements of urban citizens and the lesser nobility, but which did not necessarily attempt to imitate porcelain models. The breakthrough in the manufacture of a hard-paste porcelain in Dresden is significant in this book not for the high cultural and monetary value placed on the product, but for what Meissen represents in the application of new scientific knowledge and procedures which led to slow but incremental improvements in the manufacture of fine ceramics. In Britain the manufacture of fine ceramics was predominantly in the hands of the entrepreneurial middle class, some of whom are well known for their innovation and application of high cultural tastes to improve their product. But behind the limelight of a Josiah Wedgwood were numerous other entrepreneurs who produced wares tailored to cope with and meet regional limitations and differences.

From its legendary status in sixteenth-century Europe, 'china' imported to the West in the seventeenth and eighteenth centuries represented a novel series of products which worked on people's imaginations and were mobilised to carry cultural meanings; 'china' in its diverse forms functioned not simply as a social signifier, but as a visually expressive and emblematic category of desirable merchandise.[12] In order to catch sight of the meanings imposed on these artefacts, the social levels of ownership and how they were used, it is necessary to work across a wide range of sources. They include the objects themselves, as well as the prints and paintings of the period which depict their usage. In addition, contemporary novels, plays, poetry, memoirs and diaries extend our understanding of these products in people's practical experience and imaginative lives. Contemporary theoretical essays and legal documents of the period are also significant for the evidence they provide, and essential in corroborating or correcting less reliable personal accounts and imaginatively wrought works of literature.[13]

The visual and literary achievements of the eighteenth century

are still very much with us, and are still enjoyed by many people today. But it is not just the architectural spectacles and valued artworks that provide an occasional brush with this past. Some of us live with the inherited or collected products of the eighteenth century in our homes. But for many more people this historical period is represented in the form of reproduction furniture, upholstery, glassware, silverware, ceramic tableware and ornaments. It is also the case that these artefacts tend to be regarded with some disdain by those who feel that an attachment to the past through stylistic reproduction is misguided and inauthentic. There is justification for this point of view, but a refusal to acknowledge the continuing presence of the past in material artefacts runs the risk of losing sight of significant historical processes in which previous generations have reproduced patterns of behaviour, held on to certain stylistic preferences, and taken an active part in making cultural meanings out of things. Moreover, the people who do this are not only the social elites, but the unknown generations who preceded us and have left residual traces of their being in our contemporary lives. It would seem that in recent years the undervalued objects of material culture have become interesting to us, and it is now possible to turn our attention to those artefacts formerly considered unworthy of serious investigation and acknowledge their significance.[14]

This book considers fine ceramic wares and their consumers. It explains the artefacts as social products, as products of new forms of knowledge, as products with a contested economic and social value, and as products which reinforced other areas of cultural practice in a commercial context. It does not view fine ceramic wares as isolated fossils on the historical record of styles. The text approaches the subject thematically from several different points of view and by no means exhausts the field. It is intended to outline the potential which lies in the study of a category of material culture often evaluated only in terms of a singular object's capacity to hold value as a collectable item. The book does not attempt to achieve what has already been accomplished for curatorship, connoisseurship, and interested collectors. Principally it has been informed by the work of economic historians, cultural historians and ceramic history specialists in the museum sector who have investigated the nature and methods of production, distribution and consumption of fine ceramics. The history of ceramics generally stands in great need of more rigorous research of the calibre of David Barker's publication on William Greatbatch, and Rainer Rückert's work on Meissen, for example.[15] Students of the history of design and of ceramic practice are not well served by most of the publications available to them. No one should be surprised if

interest in the history of ceramics outside museum scholarship is chiefly maintained by enthusiastic collectors and connoisseurs, for many of the publications currently available are written by them, and for them.

In recent years, as David Barker's work on William Greatbatch demonstrates, the field of archaeology has contributed a great deal to a more accurate and fuller understanding of the production and consumption of fine ceramics.[16] Likewise the work of anthropologists has contributed much to ways of thinking about consumption and has resulted in some particularly fruitful studies which cross the boundaries of the social sciences.[17] This book is also indebted to the painstaking work of local historians who have done so much to make the documents of the past more accessible through their committed and unpaid interest in the history of their communities. The main objective in the pages that follow is to explain these products in relation to the wider commercial, social and cultural conditions of the time, and the illustrations have been selected to assist in this endeavour. They have been chosen to emphasise the contexts in which fine ceramic products were used and the cultural sources which influenced their appearance.

Notes

1 See L.E. Klein, 'Politeness for Plebes: Consumption and Social Identity in Early Eighteenth-Century England', in A. Bermingham and J. Brewer (eds), *The Consumption of Culture, 1600–1800: Image, Object, Text* (London, Routledge, 1995).

2 M. Douglas and B. Isherwood, *The World of Goods: Towards an Anthropology of Consumption* (London, Penguin Books, 1980), p. 57.

3 *The Oxford Magazine*, Vol. III, August 1769, p. 56.

4 See the essay by J.H. Plumb, Chapter 8, 'The Acceptance of Modernity', in N. McKendrick, J. Brewer and J.H. Plumb, *The Birth of a Consumer Society: The Commercialization of Eighteenth-Century England* (London, Europa Books, 1982).

5 Pierre Bourdieu's theoretical model of 'habitus' is useful here. See *Outline of a Theory of Practice* (Cambridge, Cambridge University Press, 1977), and *Distinction: A Social Critique of the Judgement of Taste*, trans. R. Nice (London and New York, Routledge, [1979] 1984), pp. 169–75.

6 An indispensable history of eighteenth-century Britain which considers these issues in the context of political and economic change is Paul Langford's *A Polite and Commercial People: England 1727–1783* (Oxford, Oxford University Press, [1989] 1992). An impressive synthesis of these changes in the lives of British men and women can be found in G.J. Barker-Benfield, *The Culture of Sensibility: Sex and Society in Eighteenth-Century Britain* (Chicago, University of Chicago Press, 1992).

7 D. Defoe, *Robinson Crusoe* (London, 1719), p. 3.

8 For further discussion and perspectives of the middle classes see J. Barry and C. Brooks (eds), *The Middling Sort of People: Culture, Society and Politics in England 1500–1800* (London, Macmillan, 1994). With specific reference to London see P. Earle, *The Making of the English Middle Class: Business, Society and Family Life in London, 1660–1730* (London, Methuen, 1989). For a subtle and deeper investi-

gation of the business elites appraised through publications of the period see J. Raven, *Judging New Wealth: Popular Publishing and Responses to Commerce in England, 1750-1800* (Oxford, Clarendon Press, 1992). Useful arguments can be found in two articles by D. Wahrman, 'National Society, Communal Culture: An Argument about the Recent Historiography of Eighteenth-Century Britain', *Social History*, 17, 1 (1992), pp. 43-72, and 'Virtual Representation: Parliamentary Reporting and Language of Class in the 1790s', *Past and Present*, 136 (1992), pp. 83-113.

9 See the interesting and well-illustrated publication by P. B. Brown to accompany the 1995 exhibition at Fairfax House, York, *In Praise of Hot Liquors: The Study of Chocolate, Coffee and Tea-Drinking 1600-1850* (York, York Civic Trust, 1995). It has to be said that most of the products illustrated chiefly represent the luxury market in tea and coffee 'equipage'.

10 In fact imported Chinese porcelains had long been perceived as useful and preferable vessels from which to eat because the taste of food was not tainted by metal plate. See M. Vickers (ed.), 'Puritanism and Positivism', in *Pots and Pans: A Colloquium on Precious Metals and Ceramics*, Oxford Studies in Islamic Art III (Oxford, Oxford University Press, 1986), with reference to Ulisse Aldrovandi's *Museum Metallicum* of 1648. It is beyond the scope of this book, but high-quality faience was an acceptable substitute for plate in continental Europe.

11 H. Scherf, *Thüringer Porzellan unter besonderes Berücksichtigung der Erzeugnisse des 18 und frühen 19 Jahrhunderts* (Leipzig, Seeman, 1980), and J. Kybalova, *European Creamware* (London, Hamlyn, 1989), with a useful bibliography for further reading about production in central Europe.

12 On the metaphoric uses of china with reference to the feminine in eighteenth-century literature see E. Kowaleski-Wallace, *Consuming Subjects: Women, Shopping, and Business in the Eighteenth Century* (New York, Columbia University Press, 1997), pp. 52-69.

13 One of the most significant contributions for a study of ownership patterns in material goods arises out of the work of economic historians who have analysed samples of seventeenth- and eighteenth-century probate inventories. The publication most relevant to this book is L. Weatherill's *Consumer Behaviour and Material Culture in Britain 1660-1760* (London, Routledge, 1988). Another very good study is that of C. Shammas, *The Pre-Industrial Consumer in England and America* (Oxford, Clarendon Press, 1990). For further information on probate inventories see M. Overton, *A Bibliography of British Probate Inventories* (Newcastle, University of Newcastle Upon Tyne, 1983). For a wider range of European sources see A. van der Woude and A. Schuurman (eds), 'Probate Inventories: A New Source for the Historical Study of Wealth, Material Culture and Agricultural Development', in papers presented at the Leeuwenborch Conference (Wageningen, 1980), and J. de Vries, 'Between Purchasing Power and the World of Goods: Understanding the Household Economy in Early Modern Europe', in J. Brewer and R. Porter (eds), *Consumption and the World of Goods* (London, Routledge, 1993).

14 For a very useful archaeological perspective on material culture as a signifying system see C. Tilley, 'Interpreting Material Culture', in I. Hodder (ed.), *The Meaning of Things: Material Culture and Symbolic Expression* (London, Unwin Hyman, 1989).

15 David Barker's *William Greatbatch, a Staffordshire Potter* (London, Jonathan Horne, 1991) demonstrates the indispensable part archaeological excavations play in bringing 'ceramic research down to earth a little', setting straight persistent inaccuracies (p. 277), and clarifying many questions concerning the nature and organisation of production. He also points out how research of this kind can bring to light the prolific output and significance of potters in Staffordshire other than Josiah Wedgwood. Rainer Rückert's *Biographische Daten der Meißner*

Manufakturisten des 18 Jahrhunderts (Munich, Bayerische Nationalmuseum, 1990) also achieves David Barker's objective in bringing ceramic research down to earth, and nowhere is this more needed than in the history of European porcelains. Meissen in particular has suffered from the tendency to turn the invention of a hard-paste porcelain into a good ripping yarn, one in which many inaccuracies have been recycled for decades. Rückert's meticulous publication is the first to give us an in-depth understanding of how a luxury porcelain manufactory might really have operated, and it brings to light previously un-known individuals whose lives were entirely, or only briefly, spent in working for Meissen. See also an earlier work of Lorna Weatherill's directly relevant to the Staffordshire pottery industry, *The Pottery Trade and North Staffordshire 1660-1760* (Manchester, Manchester University Press, 1971). With regard to the work of other historians of ceramics, the *Journal of Ceramic History*, published by the Stoke-on-Trent City Museum and Art Gallery, is an excellent source for focused and thorough research. Another excellent resource, although less consistently sound due to partisan loyalties and enthusiasms, is the *English Ceramic Circle Transactions*.

16 An indispensable periodical for the subject is *Post-Medieval Archaeology,* which is as thorough in its approach as the *Journal of Ceramic History* and sometimes shares contributors. The work of the archaeologist John Hurst has been invalu-able in encouraging the development of ceramic studies of the medieval and post-medieval periods. For an appreciation of his career and for very interesting contributions on a diverse range of pottery types see D. Gaimster and M. Redknap (eds), *Everyday and Exotic Pottery from Europe c. 650-1900* (Oxford, Oxbow Books, 1992).

17 For example, the very interesting approach of C. Mukerji in *From Graven Images: Patterns of Modern Materialism* (New York, Columbia University Press, 1983), and Bourdieu, *Outline of a Theory of Practice* and *Distinction.*

The European context

I

In sixteenth-century Italy the maiolica potter Cipriano Piccolpasso wanted to see progress in the breadth of achievement and in the quality of his ceramic art. He was convinced that progress was possible only under the patronage of the nobility, and that it was they who could remove the ambitious and imaginative potter from the fetters of conservative guild practices.[1] The social and economic elites desired novel and refined artefacts and they had the resources to support experiments towards the improvement of materials and techniques, as well as providing wider cultural references through which the maiolica potters and painters could extend imagination and skill. In the late fifteenth and sixteenth centuries there was a transition in mainstream European ceramic traditions towards 'modern' styles which represented the interests of a humanist Renaissance culture and replaced the forms and motifs of the medieval period. This transition was sparked off in cities where the level of luxury consumption was high, and where significant breakthroughs were made in the production of art, in print technology and in scientific knowledge. In many instances it was the wealthy merchant elites and not always the nobility who fostered ambitious production in ceramics, glass, metals and textiles. Ideas from other forms of production were appropriated by those pottery workshops supported by wealthy patrons who were also building collections of books, paintings and prints;[2] hence, for example, the emergence in the fifteenth century of highly sophisticated products like those made in Poitou where the decorative motifs have an affinity with bookbinding and jewellery, the so-called St Porchaire earthenwares. The production of Bernard Palissy's workshop was a direct expression of his interest in the natural world, and his developments in the chemistry of coloured glazes greatly enhanced wider forms of ceramic and glass production.[3] In sixteenth-century Italy the *istoriato* style developed in centres like Faenza and Urbino, in which the maiolica painters worked from engravings which had reached new levels of sophistication, therefore enabling them to push their own specialist technique further.[4] In the German Holy Roman Empire there was a demand from the patricians of the city states for fine but robust

salt-glazed stonewares, in which producers used sources from the copious output of the Nuremberg engravers, then the centre of German book production.[5] In London, however, it was the gold and silversmiths who produced prestige vessels, and for more utilitarian consumption it was the pewterers, and after 1570 the tin-glaze, or 'gallyware', potters, who supplied the everyday vessels for both the nobility and the affluent middle class; examples of the sophisticated 'modern' styles in European ceramic production were imported from the Continent, and Italian maiolica was especially favoured. Fine ceramic production did not get under way until the English economy had matured as a result of intense commercial activity in the last quarter of the seventeenth century. Even so, English potters could not expect the patronage Piccolpasso valued in the sixteenth century, or that of the eighteenth-century continental porcelain manufactories. On the other hand there was a growing 'middle class' in eighteenth-century Britain who desired to own artefacts of greater refinement, but not necessarily of opulence.

There were two major foreign interventions which transformed the character of European ceramic traditions. The first to transform Spanish, Italian and French earthenware pottery production in the Middle Ages was the Muslim conquest of Spain and southern France which began in AD 711. The second significant intervention, which was of a commercial nature rather than that of an occupying force, set in motion an entirely new point of reference for the production of refined ceramic artefacts in Europe. This was the introduction of Chinese, and later of Japanese, porcelains through the East India Trade. Faenza was one of the first centres of maiolica production to imitate closely the blue and white Ming porcelains, probably imported through nearby Venice in the late fifteenth and early sixteenth centuries. In the early seventeenth century the quantity of Chinese porcelains reaching Amsterdam through the Dutch Verenigde Oost-Indische Compagnie outstripped the earlier Portuguese and Italian imports, which had supplied a very small elite consumer group. The Dutch potters in Delft were swift to establish enterprises for the production of tin-glazed earthenwares in imitation of the Chinese prototypes – a form of pottery production which was very successful on the European market and which encouraged imitators across central and northern Europe.[6] However, for elite consumption in the context of the European courts the seventeenth-century demand was for authentic Chinese and Japanese porcelains. In order to produce a European equivalent of these products, resources of an uncommon kind were required, and patronage was one of the factors which contributed to the invention of a hard-paste porcelain in Dresden. But large sums of money

were in fact powerless to produce a porcelain of this quality with-
out tapping into significant human knowledge and resources of a
theoretical and practical nature.

The European courts

When tea and coffee bowls of the East India trade started to reach
English middle-class consumers in the early eighteenth century,
many members of the European ruling elites had already estab-
lished large collections of oriental porcelains and installed
porcelain 'cabinets' in their residences. In these rooms Chinese and
Japanese porcelains were displayed on specially constructed wall
mountings in European baroque, rococo or chinoiserie styles
(Fig. 1). Mirrors were often used to reflect the pieces from behind
and give these rooms an added sense of space and radiance. Some
cabinets were selectively furnished with porcelains, others
crammed with pieces, many of which were of inferior quality or
sometimes made of wood and painted to look like the real
thing.[7] There was an element of competitiveness in the court
porcelain cabinets, and they formed one of the spectacles to which
visitors were drawn in order to be impressed, but also to compare
and discuss the merits of a collection.[8] There is no doubt that fine
ceramics, and especially the porcelains, were significant items of
display in the context of court culture, but their function and
meaning were also more complex. These collections became a
focus for connoisseurship, especially in Dresden where the Elector
August II developed a particular interest in Japanese porcelains.
The ceramics displayed in the 'Japanese Palace' were not limited
to those from China and Japan, and included examples from the
European maiolica tradition, the Mexican terra-sigillatas of
Guadalajara, Dutch and Bohemian terra-sigillatas, and the Böttger
red stonewares in imitation of Chinese prototypes, but also

1] Longuelune, design for
the Meissen porcelain
gallery in the Japanese
Palace, Dresden, pen, pencil
and ink wash, 1735.

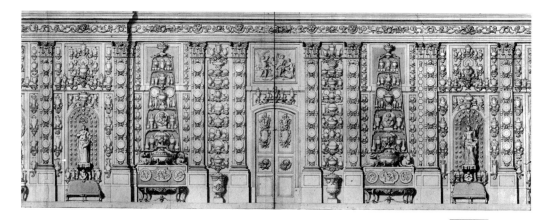

representing European cultural interests and copying prototypes made in other materials (Fig. 2).[9] The Japanese Palace had the characteristics of an early ethnographic collection and the rooms were furnished with further examples of curious artefacts and fine furniture bought through the East India trade, largely via Amsterdam.

The European courts evolved into complex social and political organisations which cannot be uniformly defined, and the function of the courts changed according to historical circumstances.[10] For example, the English court was radically transformed and its influence considerably weakened after the upheavals of the seventeenth century, which in comparison to the continental states had major implications for cultural patronage. In the German territorial states there were ecclesiastical courts, electoral courts of some considerable substance, and other much smaller establishments at the head of which were the petty princes. Unlike the French court there was no sovereign at the centre of things, and the imperial nexus of power in Vienna was remote in more ways than just geographical location; different religious beliefs and factions, cultural persuasions, political ambitions and alliances made for an extraordinarily complex and diverse network of states, in which the courts were by no means alike except for certain similarities in convention and protocol. Although many looked to Versailles to provide the model for court material culture, some departed from this example, and the Saxon court of Augustus II in Dresden referred to both its own heritage and to Italy rather than France during its early eighteenth-century development. The individuals who formed the court were diverse in status and in the

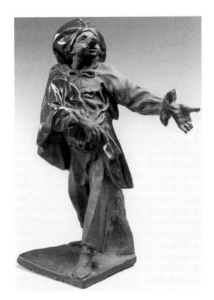

2] Balthasar Permoser, Arlecchino, from the 'Italian Comedy', Böttger red stoneware, partly polished, c. 1710–12, 18.4 cm high.

multifarious duties or roles they carried out. It was not generally the function of the eighteenth-century European courts to operate as centres of government; they had few, if any, constitutional or executive powers. At the same time, however, central figures of the executive were courtiers, and in the structure and operations of a privy council, for example, it is often difficult to consider court and council as clearly separate entities, especially with regard to patronage.[11] By the end of the eighteenth century most of the major European courts had devolved responsibilities to a complex network of administrators, many of whom were recruited from the educated middle class. Where a bureaucratic structure of this kind was earlier in place, the court became more significant as a focus for cultural activity which operated as a form of political representation and 'propaganda'.[12]

The collections, the rituals and spectacles of the court demonstrated the strength of the state in terms of its material, cultural and human resources. The products of the court workshops and manufactories had a symbolic function and the brilliance of their artistic production reinforced the right of the ruling house to maintain its position of power and also to compete in the commercial world. The so-called absolutist structure of the *ancien régime* was not as absolute as all that. There was a precarious balance of power to be managed between a court made up of a nobility not always guaranteed to support their monarch or

3] C. H. J. Fehling, *Die Königliche Tafel, mit denen von Zucker gemachten Gebürgen* (The royal table decorated with sugar sculptures representing the Saxon mining industry), pen and ink drawing, 1719.

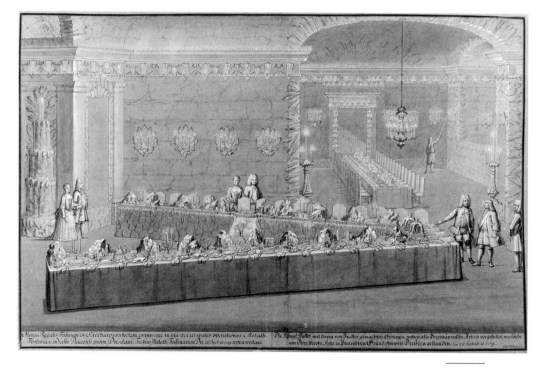

electoral prince, the executive body of the state, and the people who were the subjects of the state.[13] But what has become increasingly clear is the degree to which the courts influenced, and were influenced by, their wider communities. While they were orchestrated to be relatively enclosed societies, a filtering mechanism operated through which the knowledge, skills, energy and curiosity value of the wider world was absorbed and reinterpreted for court consumption, and the Italian Comedy represents an example of this process in which a popular theatre form was adapted for elite participants (see Fig. 2).[14] In the eighteenth century the ability of this culture to leak out into the wider world again became much greater, and it was increasingly, but selectively, imitated and reinterpreted by a growing middle class.

The court banqueting table was one site where spectacle was created in material displays of an extremely lavish but ephemeral nature. For centuries materials like ice, butter, marzipan and sugar had been used to decorate the banqueting tables of the ruling houses of Europe and the Middle East. An Egyptian feast which took place annually in the fifteenth century gives some idea of the elaborate nature of these displays. When the Nile waters were released into the irrigation canals it was the signal for one hundred cooks to use up twenty tons of sugar in gifts and festive table displays. The work entailed boiling fowls in syrup and sculpting figures of deer, elephants, giraffes and lions out of sugar.[15] Sugar paste was still used for this sculptural purpose at the European courts well into the eighteenth century, and other materials like biscuit dough, wax, cardboard and silk trimmings were employed.[16] These decorations could be taken to extreme expressions of fantasy, and were created partly to fill the cavernous spaces of state rooms.[17] In company with other field officers of the British regiments stationed in the Austrian Netherlands at the start of War of Austrian Succession in 1744, Lieutenant Colonel Charles Russell was invited to a dinner in the 'great Stat House' in Ghent. He described the dessert table in a letter to his wife Mrs Frankland Russell:

> we all went to dinner with the Prince ... about two hundred in number in one room, and about seven hundred dishes at two courses, but it took up near an hour to take off one and serve up the second course, besides as long for the dessert, which was magnificent beyond expression ... vast high structures with colonnades and figures composed of sugar paste and barley sugar with ensigns, trophies, and emblems of this country, and representing the past great acts and virtues, as well as the present, of the House of Austria, with innumerable Latin labels and mottoes ... being the principal part of the dessert, with music playing all the time, which lasted till near nine o'clock, when we parted.[18]

This not only gives some sense of the scale of a table decoration,

it also reveals something of the political state of Europe at a time
when the interests of a major European power, the Austrian branch
of the Habsburg dynasty, were given 'sculptural' form in a bid to
reinforce loyalty in their English allies. These displays also had an
aggressive function; they reminded the guests of the powerful po-
sition of their hosts, and during a century when power struggles
were rife this was one way among many of impressing your posi-
tion upon a potential ally or enemy. The table could be an
important political site, and materials like sugar, butter and ice,
wrought into elaborate forms by the court sculptors, were con-
sidered effective in underpinning state events with spectacle.

At the spectacular 'Saturnfest' held in Dresden in 1719 to
celebrate the marriage of the Crown Prince of Saxony-Poland to
the Archduchess of Austria Maria Josepha, the royal table was
decorated with tableaux representing the Saxon miners extracting
and processing valuable ores and gemstones from the Erzgebirge
mountains to the south-west of the city (Fig. 3). The table sculp-
tures at this date were made of sugar; Meissen porcelain was still
in its developmental stage and did not replace sugar sculpture
on the banqueting table until the 1730s. Although ostensibly a
marriage celebration, Augustus II used the 'Saturnfest' to remind
other powers in Europe of the economic and political significance

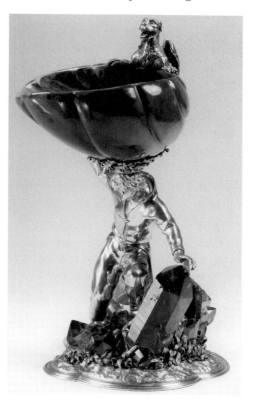

4] Onyx cup supported
by a silver gilt figure of
an officer of Mines,
Saxony, late seventeenth
century, 23 cm high.

of Saxony's natural resources, human skills and advanced knowl-
edge.[19] Mining and metallurgy formed a central theme to the entire
festival in a series of parades, firework displays and exhibitions of
Saxon products derived from the mining industry. This was not a
new theme in Saxon Electoral pageantry. The miners had been
represented in the court festivals since the sixteenth century, and
the particular character of the work of Dresden court goldsmiths
and sculptors was formed out of this highly lucrative and ad-
vanced mining region (Fig. 4).[20] It was the resources behind a
long-established and sophisticated mining and metallurgical in-
dustry which made the breakthrough in the development of a
hard-paste porcelain possible. This new type of refractory and very
pure clay had implications for future advances in science and tech-
nology as well as firmly establishing a European cultural tradition
in the manufacture of porcelain tablewares and figure sculpture.

Material progress in the production of porcelain

Underneath the extravagant material culture of the European
courts lay their less spectacular function as repositories of knowl-
edge. This could mean knowledge of a rather haphazard and
idiosyncratic nature, but from the early beginnings of the Dresden
collections in the sixteenth century, they had operated as a
resource where 'clear-headed practical men' could study, make and
experiment.[21] Under conditions where practical experience and ex-
periment were encouraged, the Dresden court developed a material
culture supported by its collections which certainly conveyed
splendour, but which since the sixteenth century had acknow-
ledged the need for an engagement between art and craft skills,
science and technology. High-fired porcelain was one highly sig-
nificant product of this engagement – a 'modern' innovation in a
German territorial state which was both seeking to establish its
modernity and hold on to its past, but increasingly outmoded,
certainties.[22]

The eighteenth-century development of European soft- and
hard-paste porcelains was generated by the desire and necessity
amongst the ruling elites to manufacture equivalents to the im-
ported wares from China and Japan. At the same time the interest
in the possibility of the alchemical transmutation of base metals
into gold was rekindled in its crudest form at a period in European
history when gold and silver were less likely to be valued for their
preciousness, as a mark of wealth in themselves, than for their
exchangeability for other things. These ores could be made to work
in new ways in this period of increasing commercial activity, when
'things take on value … in relation to one another', and 'precious

metals merely enable this value to be represented'.[23] The shortage of coin in circulation created problems for those European courts heavily reliant on imported luxury goods from the Middle and Far East, and silver was the principal currency used in exchange for East India goods. This crisis was largely caused by military conflict for control over the Baltic, from which region the wood to build the ships to trade with the Far East was produced. Reaching a peak on the cusp of the seventeenth and eighteenth centuries with the outbreak of the Northern Wars, the pragmatic solution was to encourage the manufacture of equivalents to oriental luxury goods within Europe itself. However, the financial crisis also fuelled what appear to be irrational and superstitious beliefs in the possibility of making alchemical gold. While rational Enlightenment persuasion in matters of material progress was trying to gain entry at one door, irrational schemes were allowed to enter at another. It is important to consider that these schemes did not necessarily appear irrational at the time, and some of the most scientifically advanced seventeenth-century minds remained partially open to the Hermetic arts.[24] Some of those who continued practice in alchemy were also keenly aware of the potential commercial applications of their skills in the context of mercantile economic policy.[25] In the case of Meissen porcelain, elements of both old alchemical and new scientific knowledge established the conditions for a breakthrough in ceramic technology. The Saxon Elector and King of Poland, Augustus II, settled for a Saxon equivalent to the oriental porcelains which at that time held almost as much credit for his reputation as the transmutation of base metals into gold would have done. The motivation to produce a European equivalent to the oriental porcelains was driven by commercial interests, but also by a long-established desire on the part of the ruling elites to know the world through its material wonders.

In the early seventeenth century the relationship between the natural world of materials and the making of 'art' was one of the concerns of thinkers like Francis Bacon. 'Art', the human activity of making wondrous things out of raw materials, or making things which extended human capabilities, was considered a logical progression or 'transition' in the processes of nature or of natural history as it was then understood. The deviations of nature were set straight and improved upon; nature was transformed into culture and control established in material progress.[26] In the European 'cabinets of curiosities', the 'Wunderkammer' or 'museums', a nautilus shell (Fig. 5) might be found in its unaltered state alongside an elaborately carved drinking vessel of the kind depicted in Wilhelm Kalf's painting (see Fig. 21), and displayed in most collections across Europe well into the eighteenth century. It was the

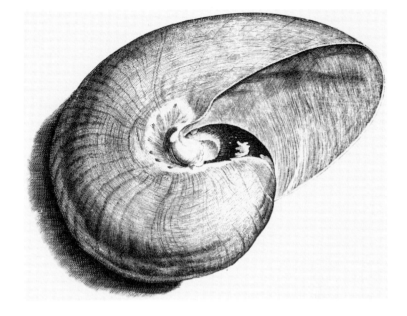

5] Shell of the octopus 'Nautilus Pompilus', Indian and Pacific oceans, in B. Ceruti and A. Chiocco, *Musaeum Calciolarianum Veronese*, engraving, 1622.

natural and 'worked' objects of this kind which represented nature transformed into culture, an expression of 'man's' knowledge and control over the natural world. The 'art' that Bacon had in mind was in part represented by work of outstanding virtuosity, and it was predominantly made in the European court workshops or in urban workshops under elite patronage. The objects were both informed by, and destined for, the collections of Europe's most powerful men and women.[27] The desire to exploit imaginatively the material qualities of natural objects, or to reproduce those of an exotic artefact like a piece of Chinese porcelain, led to further experiment and greater knowledge about the behaviour and potential of raw materials. Artists' and artisans' skills were extended in meeting the imaginative demands of their patrons.

Within the European intellectual elites the 'modern' thinkers were motivated to analyse artefacts in order to understand their origins and to assess their potential as functional and useful artefacts. It became necessary to approach a problem differently. A natural scientist or natural philosopher of the seventeenth- and eighteenth-century Enlightenment had an objective which was to solve a problem *in* the material world, a particular characteristic of modernity, whereas a mind attuned to the old medieval order of things (and many alchemists were so attuned) was more often concerned with seeking a material analogy to the spiritual world.[28] The revolutionary process under way during the European Enlightenment was a move away from the medieval account of the world in terms of analogies towards an emphasis on analysis: 'every resemblance must be subjected to proof by comparison'.[29] It

was through the collections in the cabinets of curiosities, the early museums, that this form of modern analysis started to emerge (Fig. 6).

In the sixteenth century Ulisse Aldrovandi collected natural objects which he used in his teaching at the University of Bologna. The catalogue, the *Musaeum Metallicum*, eventually published in Bonn in 1648, contained detailed explanations and illustrations of the samples of minerals, metals and organic substances he investigated. A collection and a catalogue of this nature had considerable significance in marking the transition from the old knowledge of the medieval world to the 'Enlightenment' of early modern Europe. Aldrovandi's search was for knowledge of the origins of the things of the world, their identity and their potential practical uses. He was interested in the cultural artefacts of remote lands, and he studied Chinese porcelains with a view to assessing their potential application in a European context, noting their advantage over plate because 'food tasted better' when eaten from porcelain vessels. A Ming porcelain dish (Fig. 7) was one of the few examples of manufactured artefacts rather than natural objects in Aldrovandi's collection of *artificialia*. It is characteristic of the more robust early sixteenth-century Ming wares which featured one of the

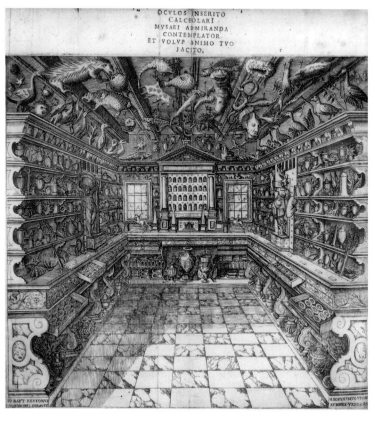

6] The Museum of Francesco Calzolari, in B. Ceruti and A. Chiocco, *Musaeum Calciolarianum Veronese*, engraving, 1622.

twelve ornaments, a phoenix painted in underglaze blue pigment, and which reached Europe chiefly through the Portuguese East Indies trade.[30]

The attempts to develop, or 'discover', an equivalent to oriental porcelains which began with the Venetian, Ferrarese and Florentine 'alchemical' experiments in the sixteenth century resulted in a rather unmanageable material, of which the Florentine Medici 'porcelain' remains in evidence (Fig. 8).[31] The accumulation of empirical knowledge and a better understanding of raw materials eventually led to the soft-paste porcelains of the late seventeenth and eighteenth centuries in Rouen and St Cloud. The only substantial guidelines available to the early experimenters in the making of a high-fired, so-called 'hard-paste' porcelain were its material qualities and the early eighteenth-century letters of the Jesuit Père d'Entrecolles, who worked in the city of Jingdezhen in the Chinese interior and observed the manufacture of porcelain. The exception was to be found in Saxony where scientific analysis revealed the principle constituents of Chinese porcelain. Since 1688 the Saxon scientist and mathematician Ehrenfried Walther von Tschirnhaus had experimented with the smelting of earths and clays in his laboratory on his estate in Kieslingswalde, from which he understood

7] 'Vas Porcellanicum', in Ulisse Aldrovandi, *Musaeum Metallicum Lib. ii*, woodcut, 1648.

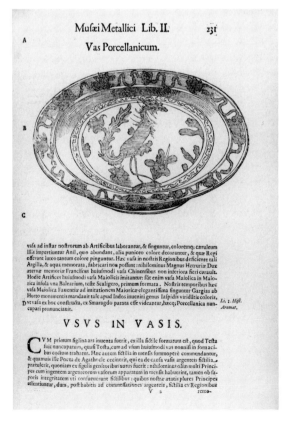

that porcelain was not a type of glass but a white earth mixed with a mineral flux. In a letter to Leibniz dated 27 February 1694 he wrote of an experiment in which he 'melted' a piece of Chinese porcelain under a burning-glass, identifying the principal constituents as alumina, silica and calcium (Fig. 9). A later development from these experiments led Tschirnhaus to solve the problem of making furnace bricks which would withstand the very high temperatures required to vitrify a high alumina porcelain.[32] His discovery enabled him to direct the trials towards the invention of a hard-paste porcelain in Dresden much more purposefully. It was also sufficient to ensure that the alchemist Johann Friedrich Böttger had a firm grasp of the problems to be solved for the successful completion of these trials after Tschirnhaus's death in 1708. The Saxon development was significant because of its wider applications. Hard-paste porcelain derivatives in the form of laboratory vessels and crucibles were especially useful in the developing chemical sciences because of hard-paste porcelain's resistance to corrosive materials and to thermal shock.

Material progress is not automatically associated with luxury goods or the 'decorative arts', but behind the highly refined and

8] Medici porcelain ewer, cobalt blue pigment painted on tin glaze with a clear lead glaze applied over the decoration c. 1575–87, 18.5 cm high.

9] Doppelbrennlinsen-apparat (double burning-lense apparatus), Ehrenfried Walther von Tschirnhaus, reconstructed in 1740.

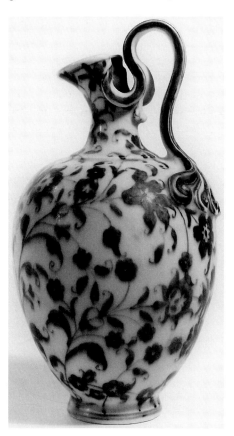

often iconographically loaded artefacts of the eighteenth century lie innumerable breakthroughs and innovations in the understanding and manipulation of raw materials. Many of these developments were possible because of the innovations made by scientists of Tschirnhaus's calibre, but also by the miners and metallurgists, chemists and alchemists at the raw material base of what was eventually to become a highly refined artefact in the context of a court workshop or a luxury manufacture. It is well known that alchemical skills played a part in the development of Meissen porcelain. The significant new knowledge for the development of this material was in great part found in the Saxon mining and metallurgical industries, and in the theoretical and practical fulfilment of ideas by projectors like Tschirnhaus.[33]

The processes of alchemical transmutation could be hard to disentangle from the refining of metal ores, and many less honourable alchemists made use of this, until sophisticated cupellation techniques made deception more difficult.[34] Even so, it appears that many powerful people were willing to be deceived, or to deceive others. The cult of hermetic knowledge still held ancient mystical resonance and at the same time could be used to assert international prestige, which was clearly evident in the Dresden 'Saturnfest' of 1719.[35] On the other hand it was generally accepted that even if gold-making was elusive, alchemical practice brought about many useful material developments which improved and refined important commodities like medicines and gunpowder. More significantly for luxury manufactures, alchemy contributed more widely to improvements in the processing and production of mineral pigments and enamel colours, of glass production and ceramics.[36]

In the first decade of the eighteenth century the Elector August II of Saxony placed the alchemist Johann Friedrich Böttger under the supervision, among others, of the physicist and entrepreneur, Ehrenfried Walther von Tschirnhaus, and the metallurgist Pabst von Ohain, who was responsible for the Saxon mining industry. Böttger was known to Tschirnhaus as a man of practical ability, if not a gold-maker. Alchemy represented one facet of the old knowledge, valuable in its accumulation of experience concerning the behaviour of a combination of minerals when subjected to heat, but unable to advance further without new knowledge in eutectics and furnace construction.[37] Augustus II was a patron of Tschirnhaus and respectful of his standing as a scientific innovator. He was prepared to accept a pragmatic alternative to gold-making in the projected development of a Saxon equivalent to the Chinese and Japanese porcelains, but he did not relinquish his interest in the possibility of alchemical transmutation.[38]

While the deposits of precious and semi-precious ores and stones were so much in demand at the Dresden court, the potential value of Saxon deposits of kaolin, or china-clay, were untapped by the mining industry. In a letter to the Elector in 1705 Böttger wrote: 'Because we still do not know whether or not there are deposits of white or red clay lying in other Sites in this Land, it is necessary that all Officials be ordered to send a few Pounds of Clay or Loam to be tested, so we can see which is the best'.[39] This systematic search for suitable clays to produce equivalents to both the Chinese porcelains and their red stonewares enhanced the knowledge of Saxon geology generally. Substantial deposits of kaolin were found at Colditz and later material of a better quality was mined at Aue and Schneeberg in the Erzgebirge hills.[40]

Further progress ultimately depended on a sounder understanding of eutectics, the point at which the combination of materials would vitrify, or 'freeze' their form and achieve translucency before collapse in the kiln or furnace. The construction of high temperature furnaces was the other key to success, and it was experienced metallurgists who helped to work through this problem. While at the University of Leiden, Tschirnhaus first developed his knowledge of reflective and magnifying technologies, in which metals and powerful magnifying lenses intensified the sun's rays to the point of melting mineral and metal substances (see Fig. 9).[41] It is difficult to ascertain whether or not the use of magnifying lenses to sinter refractory materials with solar power formed part of the early porcelain experiments beyond Tschirnhaus's early identification of the constituents of Chinese porcelain; ceramic materials behave very differently according to the environment under which they are subjected to heat, and it is certain that 'furnaces' were used in the significant breakthrough towards a hard-paste porcelain in 1708.[42] However, it is feasible that Tschirnhaus's work with burning lenses was formative in his understanding of the problems which needed to be solved in achieving an equivalent to the oriental porcelains. Solar lenses may have been used for early preliminary experiments in which two or more minerals were fused under the intense magnification of the sun's rays, but the Elector Augustus wanted to see vessels produced. For this purpose it was essential to mix a 'paste' with the correct proportions of minerals which would achieve three things: the clay body, or paste, had to be 'plastic' or malleable enough to be formed in a mould or on the potter's wheel, and once formed it had to retain its shape when subjected to fierce heat over a considerable length of time; in the firing the materials had to 'vitrify', or develop the characteristic translucency of porcelain, but without running into a molten glass; the combined minerals

also had to achieve a strength which would withstand sudden changes in temperature and immersion in liquids, and when struck a porcelain vessel should emit a clear 'ringing' tone. Kilns or furnaces had to be developed which could be fired to a temperature of 1400°C, which is a very fierce white heat. Little is known about the construction of the kilns, other than that they were wood-fired.[43] If anything was written down, or a plan drawn up, it was destroyed in order to preserve the 'arcanum', or the secret knowledge of porcelain production. Knowledge was kept in people's heads or in cryptic formulas using code and alchemical signs.

In Dresden, through the coalition of old and new practices, old and new knowledges, the understanding of refractory materials matured a stage further. A sheet of notepaper from the Dresden laboratory dated 15 January 1708 illustrates this transition (Fig. 10). Written partly in a debased form of Latin and in German, with the inclusion of some alchemical symbols, it is probably the most significant fragment left which records the experiments resulting in a hard-paste porcelain. The trials were carried out for about fourteen months before Böttger felt confident to declare success. Seven blends of kaolin and alabaster are noted and commented upon. The kaolin was probably mined in Colditz, and alabaster was the flux used before feldspar was introduced. The kaolin fired on its own in trial no. 1 was whitish but not at all translucent. With the addition of alabaster in one part to four the kaolin fluxed too far, i.e. melted to the extent it could not keep its form. In the fourth trial it retained its shape with the alabaster in a proportion of one to six. In trials five, six and seven with a proportion of alabaster in the range of one to seven, eight and nine, the paste was a very good white, and also translucent.[44] This fragment is indicative of the need to practice systematic experiments and maintain records in order to make progess, but at the same time secrecy was second sense to a man like Böttger; hence the mixing of Latin, German and alchemical ciphers. It is illustrative of the transition between the old order of early modern Europe and the Enlightenment, habitually arcane and yet methodical at the same time.

The Saxon metallurgical industry was also on the cusp of change, relying for the most part on the sound but eventually inadequate practices established in Agricola's sixteenth-century work *De Re Metallica* (1556). The practical work of the court goldsmiths and enamellers was significant in underpinning the subsequent development of pigments suitable for application to a high-fired porcelain, and the mining industry was able to provide many of the metals required for enamel colours. Like Böttger's experiments, early Meissen colour trials were couched in a form of shorthand, a mixture of written German and Latin and alchemical

signs (Fig. 11). The need for secrecy was of crucial significance, but was representative of the old habits associated with secret knowledge – obfuscatory practices which Agricola had criticised nearly two hundred years before. An extract from a 1728 recipe for purple began like this: 'Take fine filtered ⊙, do the same with AR in a Glass Alembic …'.[45] Later Meissen colour recipes were clear and detailed in their directions. In the 1775 Colour Book a recipe for a lead flux in which to carry enamel colour begins like this: 'I take 1 Part clean and clear powdered Quartz or Flint, and 4 Parts red lead …'.[46] The latter example, like Böttger's early experiments, allows for progress simply by giving an indication of proportions. It is more interesting to see this change in practice as evidence of transformations in the conduct of knowledge, rather than a means to preserve secrecy. But there is no doubt that the legacy of secret knowledge continued to maintain a hold on those engaged in the development of colours, glazes and clay bodies in porcelain production, and as the century advanced the human liking for the possession of knowledge inaccessible to others became a serious hindrance to further innovation and improvement of the product.

The breakthrough in the invention of a Saxon hard-paste porcelain was supported by sophisticated theoretical knowledge and practical skills, and not least by the local presence of raw materials. It would not have been achieved at this point in time, however, without the patronage of powerful individuals at the centre of the Saxon administration.[47] At the beginning of the century the production of porcelain emerged in a context of considerable complexity. Meissen porcelain was initially a luxury commodity required to contribute to a court culture which represented the Saxon state and Polish kingdom, and whose ruler had political and economic ambitions in commerce and international affairs. The successful production of porcelain signified more than a competitive drive to compete in the latest court fashion. It signified the ability to manufacture a modern product from the natural resources and human skills within a territorial boundary. The porcelains were prestige goods, but their production mobilised wider knowledge of the behaviour of raw materials, and this had consequences for the later development of technologies where the refractory properties of materials had important applications.

11] C. G. Bader, Specialia, pages from a notebook containing a lexicon of alchemical signs used in enamel colour formulas, 1728.

How different were the circumstances in England, where comparable resources in the form of advanced knowledge, institutional support and substantial patronage from the ruling elite were not directed towards the production of fine ceramics? The Quaker apothecary, William Cookworthy, began his investigations of Cornish kaolin and granite deposits in the 1740s. The fine, strong and very white Cornish stone and clay had been known about and exploited since the sixteenth century for building purposes. It was also used for the repair of fire-mouths and furnaces for tin smelting, where the white clay's heat resistant properties were turned to advantage, a use of which Cookworthy was aware. When closer to his goal in the 1760s he probably knew of the 'porcelain' crucibles manufactured near Truro for assaying tin and lead.[48] As in Saxony, the relationship between material progress in ceramics, the mining and metallurgical industries was close, but in England the attachment to alchemy was much weaker, although Cookworthy had a deep interest in the Christian mysticism of Swedenborg. The essential knowledge he possessed was that of a chemist who observed the transformation of minerals when subjected to fierce heat, and he used this experience in trials to assess the crucial proportions of kaolin to china stone needed for vitrification to take place. He was also capable of inventing a kiln (or furnace) designed to attain temperatures considerably higher than those used in the smelting of metals, and above the approximate 1200°C required for melting glass. The outcome of these trials, in which Cookworthy collaborated with others in Plymouth and Bristol, was a hard-paste porcelain, but of limited success. The short-lived enterprises in Plymouth and Bristol foundered for lack of technical expertise and lack of investment in the business. In addition to problems with the consistent supply of a successful product, the crucial determinant was lack of consumer demand. Unlike the continental manufactories, there was no substantial royal or noble patronage to keep afloat a form of luxury production for which there was never going to be a demand sufficient to ensure profitability.

While the product itself was inevitably confined to a small luxury market, the invention of hard-paste porcelain threw a stone into a pond which had greater consequences for the long-term development of the ceramic industry and applications in ceramic technology. It is the progress made in the understanding of raw materials and the ripples this caused in non-elite spheres of production which merits further consideration.[49] Not only that: the luxury manufactures patronised by the ruling elites in Europe provided a model for capitalist enterprises undertaken by British and continental entrepreneurs in the latter half of the eighteenth

century. These centralised luxury enterprises in the manufacture of ceramics and textiles pointed the way to the industrial factory system. The techniques of division of labour were copied and modified by entrepreneurs like Josiah Wedgwood, who was aware of continental models like Meissen when establishing his Etruria enterprise. A form of luxury production which originated in the mercantile world of early modern Europe, and in fact was rarely profitable, was eventually applied to a system of production which facilitated industrial capitalism.[50]

Notes

1 C. Piccolpasso, *Arte de Vasaio,* transcribed, translated and introduced by R. Lightbown and A. Caiger-Smith, 2 vols (Leicester, Scolar Press, 1980), p. xix.

2 In Italian maiolica wares, for example, the 'archaic' style refers to the predominance of medieval geometric patterns and heraldic devices painted in green and brown metal oxides. The influence of Hispano-Moresque wares introduced a wider range of colours and richer ornamentation before the adoption of innovatory or 'modern' forms of representation influenced by painting and printmaking during the Italian and north European Renaissance. It is also worth noting how much more significant the painted image became in maiolica production at this time, and how fundamental this was to achieving a higher status for ceramic artefacts. For an interesting discussion of this period, very useful in highlighting the significance of collections, the accumulation of a rich material culture, and the dependence of the ruling elites on the knowledge, skills and financial services of people outside their social and political circles, see L. Jardine, *Worldly Goods: A New History of the Renaissance* (London, Macmillan, 1996).

3 For an excellent and beautifully illustrated account of Palissy's work, in which there is a very interesting section on St Porchaire wares, see L. N. Amico, *Bernard Palissy: In Search of Earthly Paradise* (Paris, Flammarion, 1996).

4 On Italian maiolica see T. Wilson, *Ceramic Art of the Italian Renaissance* (London, British Museum Publications, 1987), and J. Poole, *Italian Maiolica and Incised Slipware in the Fitzwilliam Museum* (Cambridge, Cambridge University Press, 1995).

5 See D. R. M. Gaimster, *German Stoneware 1200–1900* (London, British Museum Publications,1997). For the connection between stoneware production and engravings see B. Lipperheide, *Das Rheinische Steinzeug und die Graphik der Renaissance* (Berlin, 1961).

6 On Dutch Delftwares see the excellent account by J. Montias in *Artists and Artisans in Delft: A Socio-Economic Study of the Seventeenth Century* (Princeton, Princeton University Press, 1982). On British delftware production see M. Archer, *Delftware: The Tin-Glazed Earthenware of the British Isles* (London, Victoria and Albert Museum, 1997).

7 P. Thornton, *Authentic Decor: The Domestic Interior 1620-1920* (London, Weidenfeld and Nicholson, 1993), p. 80, with a design for the cabinet at Schloss Charlottenburg in Berlin by Eosander von Göthe. Peter Thornton's book is a rich source for the display of fine ceramics in the domestic interiors of the European middle class and nobility. For cautious comparison, cautious because they are reconstructions, the porcelain cabinet in Schönbrunn, Vienna represents the former more selectively furnished cabinet, and Schloss Charlottenburg, Berlin, the latter crowded form of display.

8 See O. Impey and J. Ayers, exhibition catalogue, *Porcelain for Palaces: The Fashion for Japan in Europe 1650-1750* (London, Oriental Ceramic Society, 1990).

9 For a very interesting account of the collections in the Japanese Palace see M. Cassidy-Geiger, 'The Japanese Palace Collections and their Impact at Meissen', paper from the International Ceramics Fair and Seminar (London, 1995), pp. 10-19. On the Dresden Collections see also G. Heres, 'Der Zwinger als Museum', *Jahrbuch der Staatlichen Kunstsammlungen Dresden*, 12 (1983), pp. 119-33. For the practice of reproducing in Böttger red stoneware and in porcelain, sculptures and reliefs made in ivory see M. Baker, 'The Ivory Multiplied: Small-scale Sculpture and its Reproductions in the Eighteenth Century', in A. Hughes and E. Ranfft (eds), *Sculpture and its Reproductions* (London, Reaktion Books, 1997).

10 It is important to emphasise the complexity of the European courts, and the difficulties in defining their *modus operandi*. A very helpful discussion can be found in R. G. Asch, 'Introduction: Court and Household from the Fifteenth to the Seventeenth Centuries', in R. G. Asch and A. M. Birke (eds), *Princes, Patronage, and the Nobility: The Court at the Beginning of the Modern Age c. 1450-1650* (London and Oxford, The German Historical Institute/Oxford University Press, 1991). A review article by J. Larner also points out the difficulties in establishing priorities and methods in court studies, which although written fifteen years ago is still relevant; see 'Europe of the Courts', *Journal of Modern History*, 55 (1983), pp. 669-81. For an interesting interpretation of the function of material culture in the major European courts which is very much to the point see U. Pallach, *Materielle Kultur und Mentalität im 18 Jahrhundert: Wirtschaftliche Entwicklung und politisch-sozialer Funktionswandel des Luxus in Frankreich und im Alten Reich am Ende des Ancien Régime* (Munich, Universitäts Verlag,1987)

11 Asch and Birke (eds), *Princes, Patronage, and the Nobility*, p. 2.

12 *Ibid.*, p. 6

13 Pallach, *Materielle Kultur und Mentalität im 18 Jahrhundert*, p. 4.

14 For an excellent study of the influence of popular forms of entertainment like the Italian Comedy on the court and *haute monde* in France see T. Crow, *Painters and Public Life in Eighteenth-Century Paris* (New Haven and London, Yale University Press, 1985).

15 N. Deerr, *History of Sugar* (London, Chapman and Hall, 1949), p. 92. Sugar cane was cultivated on the Mediterranean coastal regions, and although it is difficult to establish how extensive it was, Egypt appears to have had a substantial sugar industry in the ninth century. See also S. W. Mintz, *Sweetness and Power: The Place of Sugar in Modern History* (Harmondsworth, Viking, 1985).

16 B. K. Wheaton, *Savouring the Past: The French Kitchen and Table from 1300-1789* (University Park Pa., University of Pennsylvania Press, 1983), p. 186.

17 See Thornton, *Authentic Decor*, pp. 74-5.

18 Russell-Astley Manuscripts. Lieut. -Col Charles Russell to his Wife, 20 April, 1744 (London, Historical Manuscripts Commission, HMSO, 1900), pp. 306-7.

19 For an interpretation of the 1719 'Saturnfest' see M. Schlechte, 'SATURNALIA SAXONIAE-Das Saturnfest 1719 eine ikonographische Untersuchung' in *Dresdner Hefte 21: Beiträge zur Kulturgeschichte*, 8, 1 (1990), pp. 39-52. For the relationship between Saxon mining and metallurgy and the production of art see the exhibition catalogue, M. Bachmann, H. Marx and E. Wächtler (eds), *Der Silberne Boden: Kunst und Bergbau in Sachsen* (Stuttgart and Leipzig, Deutsche Verlags-Anstalt, 1989).

20 For a history of the Saxon court festivals and an interpretation of their iconography with particular reference to appropriation from folk traditions see F. Sieber, *Volk und Volkstümliche Motivik im Festwerk des Barocks* (Berlin, Berlin Akademie Verlag, 1960).

21 J. Menzhausen, 'Elector Augustus's Kunstkammer: An Analysis of the Inventory of 1587', in O.R. Impey and A.G. Macgregor (eds), *The Origins of Museums: The Cabinet of Curiosities in Sixteenth and Seventeenth-Century Europe* (Oxford, Oxford University Press, 1985), p. 73.

22 Augustus II was highly conscious of making the most of a historical lineage which reinforced Saxony/Poland's political and cultural authority in the German Holy Roman Empire, and in so doing he maintained many of the court traditions and spectacles initiated by Augustus I in the latter half of the sixteenth century. Since the publication of Georg Agricola's *De Re Metallica* in 1556, the Saxon miners and metallurgists were perceived to be the European leaders in innovatory technology in these industries. In the early eighteenth century Augustus II's court goldsmiths and sculptors exploited their knowledge and skills in the production of cultural objects of outstanding virtuosity which were 'modern' in the innovatory techniques employed. While Augustus encouraged scientific experiment and material progress of a modern kind, he simultaneously, and probably more substantially, sustained the old practices and mysteries of alchemy. The Dresden court at this time was characterised by the will of a man striving to both modernise the state and yet hold on to the past.

23 M. Foucault, *The Order of Things: An Archaeology of the Human Sciences* (London, Routledge, [1966] 1992), p. 176. The transition described here was that of the Renaissance concept of money as commodity to the mercantile one of money as sign, or money as a pledge in the exchange of goods. See pp. 181-3.

24 See G. Scheel, 'Leibniz, die Alchimie und der absolute Staat', *Akten des Internationaler Leibnizkongresses: Studia Leibnitziana Supplementa* (1980), pp. 267-83. See also B. J. T. Dobbs, *The Foundations of Newton's Alchemy* (Cambridge, Cambridge University Press, 1975). In a note to his poem *The Botanic Garden* of 1791, Erasmus Darwin drew attention to the possibility of natural transmutations of metal ores taking place, and that nature could accomplish what the alchemists had failed to achieve; Vol. I, p. 94.

25 For a very interesting discussion of alchemy and commerce in relation to the Habsburg court see P. Smith, *The Business of Alchemy: Science and Culture in the Holy Roman Empire* (Princeton, Princeton University Press, 1994), pp. 209-17. With regard to the difficult relationship between the practice and patronage of alchemy and science in the context of the Dresden court see E. Winter, *Ehrenfried Walther von Tschirnhaus und die Frühaufklärung in Mittel-und Osteuropa*, Quellen und Studien zur Geschichte Osteuropas, Band VII (Berlin, Akademie Verlag Berlin, 1960), pp. 50-64.

26 For a fascinating study of early modern ideas concerning the relationship between nature, art and technology, and one which takes issue with Foucault on the construction of meaning in the Kunstkammer, see H. Bredekamp, *The Lure of Antiquity and the Cult of the Machine: The Kunstkammer and the Evolution of Nature, Art and Technology* (Princeton, Princeton University Press, 1995), pp. 109-10, and pp. 65-7 with reference to Francis Bacon. See Foucault, *The Order of Things*, pp. 50-8, on the transition from the 'old system of similitudes' to establishing 'identities and differences'.

27 For the history of these collections and their wider significance see Impey and McGregor (eds), *The Origins of Museums*. See also A. Grote (ed.), *Macrocosmos in Microcosmo. Die Welt in der Stube: Zur Geschichte des Sammelns 1450 bis 1800* (Opladen, Leske und Budrich, 1994). For a summary account see S. M. Pearce, *Museums Objects and Collections: A Cultural Study* (Leicester, Leicester University Press, 1992), Chapter 5, 'Museums: The Intellectual Rationale'.

28 See the Introduction in T. Burckhardt, *Alchemy* (Shaftesbury, Element Books, [1960] 1986), pp. 7-9.

29 Foucault, *The Order of Things*, pp. 54-6.

30 Concerning the use of porcelain tablewares in preference to metals see J. Raby and M. Vickers, 'Puritanism and Positivism', in M. Vickers (ed.), *Pots and Pans: A Colloquium on Precious Metals and Ceramics* (Oxford, Oxford University Press, 1986), p. 219, and U. Aldrovandi, 'Usus in Vasis', *Musaeum Metallicum in Libros ii Distributum* (Bologna, 1648), Libros ii, pp. 231-2. My thanks to Oliver Impey for confirmation of the approximate date of the Ming dish illustrated in Aldrovandi's *Musaeum Metallicum*, probably made in the reign of Zhengde or Xiaxing. See in addition L. Laurencich-Minelli, 'Museography and Ethnographical Collections in Bologna during the Sixteenth and Seventeenth Centuries', in Impey and McGregor (eds), *The Origin of Museums* pp. 19-20.

31 The significant constituents in the Medici porcelain body were predominantly silica, followed by alumina, potash, soda and calcium. See D. Kingery and P. Vandivar, 'Medici Porcelain', *Bollettino del Museo Internazionale delle Ceramiche di Faenza*, 70 (1984), N. 5-6. p. 444, Table 2. Soft-paste porcelains have a low ratio of alumina combined in white firing clays, whereas hard-paste porcelains have a high ratio of these heat resistant (refractory) and very pure white clays (kaolins). Consequently European hard-paste porcelains are fired at temperatures 1350-1400°C (contemporary studio practitioners accept 1300°C as the usual top temperature for porcelain, but there is debate as to whether or not this can be termed a hard-paste porcelain). The eighteenth-century European soft-paste porcelains, with proportionately much less alumina/clay content, were fired below this range. The difference in the material qualities of these porcelains is usually quite distinct. So-called 'frit' porcelains have little or no clay content at all and are closer relatives of glass.

32 R. Rückert, *Biographische Daten der Meißener Manufakturisten des 18 Jahrhunderts* (Munich, Bayerisches Nationalmuseum, 1990), p. 75.

33 Ehrenfried Walther von Tschirnhaus was one of many seventeenth-century scientific innovators, often described as 'projectors', who sought patronage for their theoretical propositions in order to put them into practice. For a full account and assessment of Tschirnhaus's career and contribution to the central and east European Enlightenment see Winter, *Ehrenfried Walther von Tschirnhaus und die Frühaufklärung in Mittel-und Osteuropa*. The history of the discovery of a hard-paste porcelain in Europe corresponds in many respects to Thomas Kuhn's argument concerning the nature of scientific discovery in 'The Essential Tension', first published in *Science*, 136 (1962), pp. 760-4.

34 'Cupellation' was a method introduced in the sixteenth century for refining silver and gold. The metals were melted in a 'cupel', a shallow vessel made of refractory, or heat resistant, materials which also absorbed impurities. In the case of silver it is often found combined with lead, and cupellation was a considerable advance in assaying which demystified attempts by alchemists to claim they could transpose the base metal of lead into gold or silver. For a 'modern' sixteenth-century account of remarkable clarity when compared to contemporary alchemical texts see *Lazarus Ercker's Treatise on Ores and Assaying*, translated from the German edition of 1580 by A. G. Sisco and C. S. Smith (Chicago, University of Chicago Press, 1951), and for the relationship between alchemy and assaying see R. Halleux, 'L'alchemiste et l'essayeur', in C. Meinel, *Die Alchemie in der europäischen Kultur und Wissenschaftsgeschichte* (Wolfenbüttel, Herzog August Bibliothek, 1986), pp. 277-91.

35 As has already been mentioned, an interpretation of the Dresden 'Saturnfest' of 1719 can be found in Schlecte, 'SATURNALIA SAXONIAE', pp. 39-52, and see also Sieber, *Volk und Volkstümliche Motivik im Festwerk des Barocks*.

36 For a case study of the changing role of alchemy in seventeenth-century Europe

through the career of Johann Joachim Becher see Smith, *The Business of Alchemy*, and with reference to both assaying and manufactures see pp. 182, 200.

37 'Eutectic' refers to a mixture - in the case of porcelain principally a mixture of alumina and silica- in which the minerals combined melt and solidify *together* at a temperature lower than if they were isolated from one another. The critical temperature at which this occurs is known as the 'eutectic point'. The alumina found in the white-firing china-clays or kaolins is highly refractory and requires aluminosilicates present in feldspathic minerals to melt it at a lower temperature; in this application the mineral or metal which is most active in reducing the melting point of combined materials is termed the 'flux', or 'fluxing agent'.

38 For a detailed biography of Böttger and the invention of hard-paste porcelain see C. A. Engelhardt, *J. F. Böttger Erfinder des Sächsischen Porzellans* (Leipzig, 1837). Although recent opinion places Tschirnhaus as the more significant contributor to the invention of Meissen porcelain, Engelhardt's biography is invaluable for the light it throws on early eighteenth-century attitudes towards alchemical practice. For an excellent account based on new research undertaken for the tercentenary of Böttger's birth, and which clearly establishes the team effort involved in the invention of hard-paste porcelain, see W. Goder *et al.*, *Johann Friedrich Böttger: Die Erfindung des Europäischen Porzellans* (Leipzig, Edition Leipzig, 1982). See also W. Goder, 'Zur Technikgeschichte des Meißner Porzellans', in *Meißner Porzellan von 1710 bis zur Gegenwart* (Cologne, Kunstgewerbemuseum der staat Köln, Exhibition Catalogue, 1983).

39 Cited in Goder *et al.*, *Böttger.*, p. 26, 'Dieweil wir noch nicht wissend sind, ob nicht noch an andern Orten in dero Landen Weißer oder roter Ton lieget, als wird nötig sein, das an alle Beamte deswegen Befehl ergehe, von allem Ton oder Letten etliche Pfund zur Probe einzuschicken, damit man sehe, welcher der beste'.

40 *Ibid.,* p. 26.

41 Goder, 'Zur Technikgeschichte', p. 30.

42 It seems that metallurgical smelting vessels, or crucibles, containing the porcelain in the form of flat discs or small bowls, were placed in furnaces for the early trials, but the exact nature of the firing techniques remains obscure. It took about five hours to fire these early porcelain trials, and they were drawn from the heat immediately, not left to cool in the furnace as in typical ceramic firing practice. See M. Mields, 'Eine Versuchsaufzeichnung von Johann Friedrich Böttger zur Porzellanerfindung aus dem Jahr 1708', *Berichte der Deutschen Keramischen Gesellschaft*, 44, 10 (1967), p. 516. See also W. Goder, 'Zur Technikgeschichte', with reference to the work of Samuel Stölzel, one of the Freiberg metallurgists whose knowledge of furnace construction and the behaviour of metal oxides in oxygen-starved and oxygen-rich firing atmospheres was essential for the development of the red stoneware as well as porcelain, p. 38.

43 Mields, 'Eine Versuchsaufzeichnung', p. 516

44 *Ibid.,* p. 515. The Colditz kaolin was soon replaced with the superior quality 'wig powder clay' from the St Andreas mine near Aue. Alabaster, calcium sulphate, was eventually replaced with a silicate of feldspar.

45 Staatliche Porzellan-Manufaktur Meissen GmbH. A. A. Pretiosa 48. Rezept für Fluß und Farbenherstellung. 1728. ⊙ = alchemical symbol for gold. 'Guht Purpur zu machen–Nim fein durchgoßen ⊙. Thun daßelben mit AR in einen Gläser Kolben ...'. In principle the gold was heated and 'dissolved' (solvire) in a solution of water with one or two other secret ingredients. The gold and water were allowed to settle out for 24 hours and then separated. The dry solids resulting from the process were then ground together to form a fine powder which yielded a purple. For a brief but interesting account of David Köhler's more

systematic colour experiments of this early Meissen period see W. Goder, *Meißner Porzellan von 1710 bis zur Gegenwart*, pp. 45-52.

46 Staatliche Porzellan-Manufaktur Meissen GmbH. AA. Pretiosa 55. Farbenbuch der KPM. um 1775. No. 1. A. 'ich nehme 1. Theil sauber und klar gestoßenen Quarz oder Kiesel, und 4 Theile Minium …'. The ingredients were mixed well together and placed in a crucible before smelting in a furnace. After cooling the glass was ground to a powder ready for mixing with prepared colours. The 'Farbenbuch' is written like an instruction manual.

47 Egon, Prince of Fürstenberg, Governor in Saxony when Augustus II was in Warsaw, the friend and patron of Tschirnhaus, was also responsible for holding Böttger a prisoner of the Saxon State. He was very interested in science and alchemy, and strongly represented the interests of both Tschirnhaus and Böttger to Augustus. Michael Nehmitz was another influential individual, a confidant of Fürstenberg and Augustus, who monitored Böttger's experiments in the Dresden 'Goldhaus' and 'Jungfernbastei'. He later became a director of the Meissen Manufactory. See Engelhardt, *J. F. Böttger Erfinder des Sächsischen Porzellans*, for a detailed account of Fürstenberg's and Nehmitz's involvement, see Rückert, *Biographische Daten der Meißner Manufakturisten*, for a summary account, pp. 75-6, p. 45.

48 M. Barton, *A History of the Cornish China-Clay Industry* (Truro, D. Bradford Barton Ltd, 1966), note 3, pp. 19-20. D. Selleck, *William Cookworthy (1705-80) and his Circle* (Plymouth, Baron Jay Ltd, 1978), pp. 56, 61.

49 A. Appadurai (ed.), *The Social Life of Things: Commodities in Cultural Perspective* (Cambridge, Cambridge University Press, [1986] 1992), pp. 37-9. In the 'Introduction: Commodities and the Politics of Value', Appadurai points to the work of Werner Sombart as having much to contribute to our understanding of the production and consumption of 'primary' luxury goods. Sombart elaborates on the cumulative repercussions this type of product had on related, but less potent signifiers in the range of commodities which carry meaning beyond their use value. In the case of 'primary' luxury goods, and the early porcelains are an example of this type of commodity, the value is solely that they embody a social or political sign; in the case of Meissen porcelain a sign which was intended to confer international prestige. See W. Sombart, *Luxury and Capitalism* (Ann Arbor, University of Michigan Press, 1967). However, although international prestige in the European political arena was part of the motivation behind the production of Meissen porcelain, the manufactory was intended to operate as a commercial enterprise in a mercantile economy. The reasons behind Meissen's production were complex, and subject to conflicting interests between the court and members of the commercial directorate.

50 For a case study of Meissen as a model for the centralised factory system, and for a history of Saxon manufactures, see R. Forberger, *Die Manufaktur in Sachsen vom Ende 16 bis zum Anfang des 19 Jahrhunderts* (Berlin, Berlin Akademie Verlag, 1958). For a discussion of Saxon manufactures derived from the mining industry, of which Meissen was one, see R. Forberger, 'Zur Rolle und Bedeutung der Bergfabriken in Sachsen', *Freiberger Forschungshefte*, 48 (1965), pp. 63-74. The Meissen Manufactory as a model for early modern capitalist enterprise was of particular interest in the former German Democratic Republic because of its centralised structure and the nature of its division of labour. For detailed discussion of a mineral-based economy and the transmission of skills see P. Mathias, *The Transformation of England: Essays in the Economic and Social History of England in the Eighteenth Century* (London, Methuen, 1979), Chapter 2. For a good summary account of mining and metallurgy in eighteenth-century England see M. J. Daunton, *Progress and Poverty: An Economic and Social History of Britain 1700-1850* (Oxford, Oxford University Press, 1995), Chapter 8, 'Furnaces, Forges and Mines'.

2 The economics of production and distribution in Britain

It was the political events of the middle decades of the seventeenth century which had the effect of greatly reducing the extent of patronage of the arts and the production of luxury goods in England. During the Civil War many of the art collections, libraries and furnishings of the great houses were broken up. The channels through which patrons upheld the practice of art and high quality artisanal skills could not be kept open. The religious ethos which pervaded the country during the English Commonwealth and Protectorate also discouraged the production of art and fine things. Charles II was restored to the throne in 1660, and in the last forty years of the century economic activity gained momentum, in large part because merchants as wealthy as landowners held seats in parliament. The Dutch had earlier succeeded in throwing out their Spanish rulers, and the English greatly modified the power of their monarchs, especially after the non-violent dispatch of James II in 1688. The two states were, in their different ways, modern in comparison to the rest of Europe; a significant expression of their modernity was commercial success.

The economics of production

On a visit to London in 1719 the French traveller, Maximilian Misson, made the following observation: 'it must be confess'd that neither Balls, nor any other Diversions of that Nature, are kept up in England with that Gayety & Show which always accompany them at the Court of France'.[1] George I preferred to avoid large and ostentatious court events, although like his Stuart predecessor Queen Anne, he was very fond of music. Only when under pressure from political instability and in difficulties with his son the Prince of Wales did he consent to preside at public dinners and balls in order to reinforce Whig support. In the same year that Misson visited London, Augustus II Elector of Saxony and King of Poland held what was claimed to be the most spectacular event on the court calendar in the whole of Europe, the 'Saturnfest' in celebration of his son's marriage to the Archduchess Maria Josepha of Austria (see Fig. 3) As we have seen, representations of Saxon

manufactures, with the mining industry a central thematic focus, formed the climax to the programme of festivities. The miners themselves took part in devising this spectacle in which the ores attributed to the seven planets then known – gold, silver, copper, mercury, lead, tin, iron – all of which were mined in the Erzgebirge to the south-west of Dresden, were marked out as the basis for Saxon material wealth and human ingenuity.[2] The geology of the British Isles did not contain the rich deposits of metal ores, precious and semi-precious stones which had supported Saxony's relatively strong economic and cultural position in the German Holy Roman Empire since the twelfth century. While some members of the British peerage were active in exploiting the mineral wealth on their lands, either through their own enterprise or more usually by leasing the mining rights to others, such activity was limited compared to their noble counterparts in continental Europe.[3] The important difference between Saxony and Britain in the first half of the eighteenth century was that in the former a feudal nobility remained in place, whereas in Britain their privileges had been curtailed radically in the upheavals of the seventeenth century. Relative to Saxony, Britain was an 'open' society which encouraged entrepreneurial growth in cheaper and standardised manufactures rather than highly exclusive luxury products.[4]

It would be misleading to suggest that the nobility of the British Isles were more restrained in display and luxurious pursuits than their continental counterparts. Some great families marked their position with enormous extravagance, often financed by successful commercial interests and investments overseas, but just as often from land mortgaged to luxury consumption, or from assets which were less prudently managed.[5] Wealth of this magnitude encouraged the manufacture of luxury goods, principally in London, where the nobility settled themselves in for the 'season', and where they placed commissions in the best artisan workshops. But in addition to high-quality luxury production there was the substantial middle-class entrepreneurial energy in centres like the West Midlands and North Staffordshire, where cheaper standardised goods were manufactured well before the 1760s.[6]

While the British nobility placed substantial orders with the new 'china' manufactories like Worcester, Chelsea and Bow in the 1740s and 1750s, there is no substantial evidence to confirm that they put capital into porcelain production on a scale comparable to the continental ruling elites and the *haute bourgeoisie*.[7] It is unlikely, but not out of the question, that the Dukes of Cumberland and Argyll placed capital in the Chelsea porcelain manufactory, but if so they seem to have had reason not to broadcast their support. A rumour that the Duke of Cumberland intended to

'purchase the Secret' of the Chelsea porcelain manufactory in 1763 was publicly denied.[8] Argyll's collection and knowledge of porcelain was well known and he was reputedly interested in porcelain manufacture. At a later date Charles Watson Wentworth, the second Marquis of Rockingham, who twice served somewhat briefly as Prime Minister during George III's reign, had concern for the pottery on his south Yorkshire estate at Swinton. However, neither of these men carried interest into substantial action, perhaps because, in an extremely lively political climate, affairs of state took priority. It was the Marquis of Rockingham's nephew, the Earl Fitzwilliam, who placed his interests locally, and after the Leeds Pottery partnership foundered in 1806, he supported the Swinton Pottery, which became the Rockingham Porcelain Manufactory in the nineteenth century. The powerful who desired porcelains were apparently content to buy from continental manufactories as much as from Chelsea, Worcester and Derby.

Taste and commerce

When members of the nobility took an interest in ceramic manufactures it was often of a detached nature, and more concerned with matters of 'Taste' than overtly those of commerce; but in fact the two were intimately related. No fine ceramic manufacturer could afford to neglect the forces of consumer tastes, because commercial success was dependent on meeting them. The recognition and practice of 'good taste' was accorded high value by those who wished to distance themselves from the acquisitive 'middling sort of people', many of whom were increasingly recognised as 'propertied' – properttied largely through commerce – and therefore franchised. For those who attempted it, establishing a definition or standard in matters of taste proved extremely difficult. Edmund Burke assessed the problem in his 'Introduction on Taste' prefixed to the second edition of his *Philosophical Enquiry*:

> It appears indeed to be generally acknowledged, that with regard to truth and falsehood there is something fixed. We find people in their disputes continually appealing to certain tests and standards which are allowed on all sides, and are supposed to be established in our common nature. But there is not the same obvious concurrence in any uniform or settled principles which relate to Taste. It is even commonly supposed that this delicate and aerial faculty, which seems too volatile to endure even the chains of a definition, cannot be properly tried by any test, nor regulated by any standard.[9]

Burke was interested in the senses, 'the great originals of all our ideas, and consequently of all our pleasures'.[10] 'Taste' in an eighteenth-century context could denote fashionalbe style: 'in the latest

taste'. It also referred to finely honed or inherited accomplishments and sensibilities which implied social superiority.[11] When applied to the class of consumer goods which particularly affected the visual and tactile senses, the use of the term 'Taste' was an attempt to bring these pleasurable artefacts into the sphere of politeness, and confer greater value by association with superior social and cultural interests. It was used in an attempt to push back the avaricious and undesirable characteristics associated with commerce. To have 'Taste' was evidence of fine feeling, of discrimination and refined judgement in material things. Given that commerce was by its very nature volatile and dynamic, manufacturers of consumer goods dependent on satisfying contemporary tastes faced challenges quite unlike the producers of nails or buckets.

To a certain extent the governing oligarchy in Britain took a particular, if suitably detached, interest in the production of luxury artefacts which were useful in maintaining a distinction between one social group and another, and which carried cultural references which were flattering to them and reinforced their interests and values, but direct patronage or intervention was not characteristic. However, entrepreneurs like the porcelain manufacturer Richard Champion in Bristol and Josiah Wedgwood in Staffordshire still had to win benevolent interest from the nobility for the success of their enterprises. Wedgwood was more successful in his methods of engaging aristocratic approval by introducing an element of flattering 'collaboration' and copying items from noble collections of antiquities in pursuit of innovatory techniques.[12] A letter from the Marquis of Rockingham to the less resourceful Richard Champion, of 10 February 1775, acknowledged a gift warmly: 'Lady Rockingham as well as myself exceedingly obliged to you for the very elegant China flowers which you have so politely sent her'.[13] The letter went on to wish Champion, who was also an active supporter of the Whig party, every success with his manufactory, and Rockingham assured him of his future interest in the venture, but remained detached from direct intervention in the events which followed.

Underlying this polite giving of gifts was the problem of reconciling disparate interests between taste and commerce. In 1775, soon after Champion made this gift to the Rockinghams, he petitioned Parliament to renew his patent right to continue the production of hard-paste porcelain in Bristol, which also meant holding a monopoly on access to the superior quality china-clay and china-stone on Thomas Pitt's estate in Cornwall.[14] In a letter to his friend Edmund Burke, the Member of Parliament for Bristol, Champion wrote of his anxiety concerning the petition for the extension of his patent, taken over from William Cookworthy

some years before. He feared the parliamentary committee was scheduled to sit too early for him to have fine examples of porcelain completed:

> and yet the things of the China house are now getting ready, and so curious as to be, I suppose, of consequence to be exhibited in the Committee. There are two sets of Beautiful Tea China; one from Ovid's metamorphosis, different subjects to each piece, an exact copy of a Dresden set – the other Herculanean antiquities each piece a different subject, also two pair of curious Vases with festoons of fine flowers; and tho! it is Treason to make a new King, we only have made his representation. The manager tells me it is impossible for these to be furnished in less than a fortnight, perhaps later, though not much.[15]

A decision to renew Champion's patent was in part dependent on his products meeting the 'taste' of the parliamentary committee. He was fairly confident of success at this point because he was not appealing for financial support. He felt sure the committee would approve extension of a patent right for a manufactory 'useful in this Kingdom' and where the raw materials were to be found in the country itself. Champion sought to strike the right balance between elite taste and mercantile principles, nudging his porcelains under the nose of the current Prime Minister through a gift to his wife. In a letter Edmund Burke noted: 'The idea of a present to Lady North is quick sight in every respect. I hope your Herculanean figures are on a Brown or sort of Pompadour Ground like the originals or they will not be quite so well.'[16] A gift was seen as strategically sound in Champion's efforts to rally support for his product, and in fact he went further and petitioned for an audience with Queen Charlotte. She did not have a strong attachment to luxury articles, however, and preferred the understated qualities of Wedgwood's cream(Queens)ware. The propriety of the King and Queen, their 'middle-class' respectability, favoured an entrepreneur like Josiah Wedgwood. His imitations of the antique appealed to the men of the nobility and substantial property who sat in the parliamentary committees and made decisions over patent rights. Few people, if any, were sufficiently well convinced that the manufacture of a Meissen equivalent was 'useful in this Kingdom'. In public interest, if not in private, members of the committee were not inclined in this particular case to model English ceramic manufactures on restrictive continental practices and encourage imitation of court porcelains, and Wedgwood's products were an impressive foil to such alternatives in superior ceramic manufactures.

In the same letter Edmund Burke warned Champion that 'the Wedgwood people think of giving you opposition', and this was the beginning of the protracted legal battle between Champion,

Wedgwood and the Staffordshire potters which was ruinous to the former in the long term.[17] But underlying this case were significant commercial issues which concerned open access to raw materials, and in this instance the fine, white-firing china-clay and cornish-stone deposits in Cornwall. Arguments against the patent claimed that it militated against the rights of landowners to sell useful raw materials on their land as they saw fit, the rights of entrepreneurs to have access to raw materials to improve their products, and the right of the public to expect an improved product as a result of manufacturers making use of superior materials. These were all convincing commercial reasons against renewal of the patent, especially in 1775 when Parliament was responding *ad hoc* to the legal conundrums thrown up by industrialisation. In support of the Staffordshire potters' petition against Champion, the following argument was made to the parliamentary committee:

> It would be injurious to the Manufacturers of Earthen-ware, because, notwithstanding the Mechanical Part of their Manufactory, their Execution, their Forms, their Painting, &c. are equal, if not superior to those of any other Country, yet the *Body* of their Ware stands in great Need of Improvement, both in Colour and Texture; because the Public begin to expect and require such Improvement; and because with no such Improvement the Sale of Manufactures will probably decline in favour of foreign Manufacturers, who may not be deprived of the Use of the Material that their Countries produce.[18]

The outcome was one of compromise, a common parliamentary solution at this time of industrial development. Champion was granted a patent to maintain a monopoly on the manufacture of high-fired porcelain, but the china-clay and cornish-stone deposits were made available to other manufacturers.[19] Ultimately Wedgwood had the edge on Champion in commercial acumen and in his manipulation, with the indispensable assistance of Thomas Bentley, of contemporary elite tastes.[20]

With John Turner of the Staffordshire Lane End pottery, Wedgwood travelled to Cornwall in 1775, prospecting for alternative china-clay and cornish-stone deposits to those on Thomas Pitt's land. Champion's difficulties were made worse because Wedgwood managed to strike a bargain with a Mr Trethawy of St Stephen's parish, who owned land adjacent to Pitt's and was willing to sell the materials at a cheaper rate, once the patent restriction was lifted. Before his business finally failed, Champion tried to persuade other Staffordshire potters to form a syndicate for the manufacture of hard-paste porcelain. Initially they declined because of the high cost of the raw materials extracted from Pitt's estate with the addition of transport costs. However, in late 1780 or early 1781 a consortium of Staffordshire potters eventually

bought the patent which led to the production of a modified hard-paste porcelain at New Hall.[21]

The significance of access to high-quality raw materials is not difficult to appreciate at a juncture in the production of fine ceramics when consumer demand and expectations sharpened considerably. Hence the urgency behind the Staffordshire potters' petition. The case of Champion's patent and the early years of the Cornish china-clay industry reveal some of the layers of complexity in the making of a commercial and industrial nation, of the efforts to pull legal and commercial rights into a coherent shape through a tangle of conflicting interests. Those with England's, and their own, commercial interests in mind wanted to represent the country as polite and civilised through its refined and tasteful products, yet retain a sharp competitive edge on the European and American markets.

This was not a battle confined to the elite end of fine ceramic production. Wedgwood spoke for the Staffordshire potters who were manufacturing for the provincial and rural communities of the English shires and the colonies, not for the wealthy urban middle classes, the nobility and gentry. The potwork clusters in Staffordshire, Liverpool, South Yorkshire and Sunderland manufactured for many people who led lives in which the elite discourses on taste reached no further than the libraries of the landed gentry and clergy. In the latter half of the century, however, more manufacturers differentiated their products in favour of the educated urban middle class, with a sense of 'good taste' derived from the increasing number of conduct books, newspapers and periodicals in circulation. These consumers were to be found in successful commercial ports like Newcastle and Liverpool, and in the 'genteel' households on the outskirts of expanding industrial centres like Leeds, Birmingham and Manchester.[22] It was for this consumer group that the New Hall partners decided to take the risk and commence hard-paste porcelain production – a risk which Wedgwood had earlier firmly renounced, although not without careful consideration and empirical investigation. Whereas Longton had failed in an attempt to manufacture and market their soft-paste porcelain in the mid-eighteenth century, it was possible for New Hall to succeed. Now that good quality tea was available at an accessible price, the new consumer demand for refined china teawares in particular was part of the equation. In addition to the availability of better materials from Cornwall, the completion of the Trent–Mersey canal in 1777 made an important difference to the Staffordshire potters. With a reliable and *smooth* passage to their markets it was realistically possible for a fine china works in Staffordshire to compete with the Liverpool enterprises and to

market an acceptably fine, but less costly product than Worcester or Derby. In addition, New Hall was significant in marketing a product which offered an attractive alternative to the Wedgwood creamwares and the more exclusive jasper and basalt wares. Among the urban middle class there was a taste for porcelains in imitation of the continental styles as opposed to - or as well as - the classicism of Wedgwood and his imitators. A propertied and increasingly confident industrial middle class could assert its consumer tastes.[23]

Politics and commerce

When fine ceramic producers gained access to the better quality materials in Cornwall this had an adverse effect on the production of fine wares in Ireland, and this occurred at a crucial point in the 1770s, when creamware production had just begun to get under way in Dublin. In 1772 Stacey and Co. established creamware production on the site of Henry Delamain's former delftware manufactory. Production lasted only two years at the most, failing largely because of competition from Wedgwood's saleroom established in the city in 1771, as well as insufficient internal capital investment.[24] In the middle of the century Dubliners experienced rapid urban development. The Protestant community within the Pale, many of whom were of the professional and commercial middle class, were filling their homes with the consumer goods widely available in London and the major provincial centres of England, and increasingly retailed in Dublin itself. But, even so, the obstacles faced by Stacey & Co. were too great for them to compete with Staffordshire. Straightforward competition from England may on the face of it appear to be a good enough reason why this and other Irish potteries failed to thrive, but a more complex political context has to be taken into account. Although supported by powerful figures in the English Parliament, some of whom had land in Ireland, the desire for political and commercial change came into conflict with the interests of English manufacturers in the late 1770s.[25]

Carrickfergus clay, excavated near Belfast Lough, had been exported to Liverpool, Glasgow and Bristol for delftware production certainly since the 1730s, and the development of Liverpool delftwares would probably not have been possible without this imported material. The quantity dropped markedly in 1771 and1776, finally ceasing in the 1790s. This decline has rightly been attributed to the increase in the production of and demand for English creamwares, for which the Carrickfergus clay was unsuitable. It could not compare with the greater strength and purity of

the Cornish kaolins.[26] Ireland had the potential to produce the new fine ceramics, supplying not only the home market but the colonies as well. This potential was curtailed because the country was subject to punitive restrictions on trade imposed by the English government, and because of insufficient capital investment and further legal impediments from within Ireland itself.[27] Financial aid in the form of premiums from the Dublin Society were meagre, and more substantial capital investment was required to support the necessary trials towards the improvement of production. Bound up with lack of capital for improvement of the product was the problem of gaining access to good quality materials. If Dublin and Belfast had later been able to import Cornish china-clay and stone as freely as Liverpool had imported Carrickfergus clay, there would have been stronger grounds for entrepreneurial optimism.[28]

It might cautiously be said that Ireland was relatively prosperous in the mid-eighteenth century, largely due to its agricultural base and increasingly to manufactures which were derived from it, but the country had nothing like the diversity of English trade and manufactures. Resentment about the lack of autonomy in constitutional affairs and continued economic disadvantage was intensifying. The American War of Independence which began in 1775 shifted consciousness towards a stronger mix of republican opinion and feeling in both Catholic and Protestant minds and hearts, and in the late 1770s increasing pressure was applied for the penal laws preventing Ireland from trading and legislating autonomously to be repealed. In 1778 Lord North proposed a bill for the removal of constraints on Irish trade, towards which both Westminster Whigs and Tories were well disposed. But the promise of these gains was short-lived, and the prospect of free trade for Ireland immediately came under attack from the English manufacturers. North retracted in the face of this opposition and the bill was thrown out. In a letter to the Bristol merchants in 1778, their Anglo-Irish MP, Edmund Burke, appealed to reason and better nature in turning hostility to 'approbation' that Ireland must enjoy free trade:

> I know that it is but too natural for us to see our own *certain* ruin in the *possible* prosperity of other people. It is hard to persuade us that everything which is *got* by another is not *taken* from ourselves. But it is fit that we should get the better of these suggestions, which come from what is not the best and soundest part of our nature, and that we should form to ourselves a way of thinking more rational, more just, and more religious. Trade is not a limited thing; as if the objects of mutual demand and consumption could not stretch beyond the bounds of our jealousies.[29]

Such words delivered to a proud and mature merchant com-
munity with a pioneering history in transtlantic trade did nothing
to help Burke regain his Bristol seat at the election of 1780. But he
had shown that the level of hostility towards Irish free trade was
out of proportion to the evidence that Ireland's manufactures
posed a threat to England's, which were at this stage considerably
in advance. This was especially the case with regard to fine ce-
ramics.

By the 1770s delftware production was clearly in decline in Eng-
land as well as in Ireland. Many well-established delftware
manufactories were turning to soft-paste porcelain production, es-
pecially in Liverpool, and also to creamware like the Delftfield
Pottery in Glasgow. In Dublin the transition had been unsuccessful
due to the collapse of Stacey & Co., but contemporary reports
indicate that creamware production was still under way, if fitfully.
In 1785, ten years after the débâcle over Champion's patent, Josiah
Wedgwood and the Staffordshire potters lobbied Westminster
again. Wedgwood spoke to a committee in the House of Lords to
whom fifty producers of the 'Finer Ware in Staffordshire' had
petitioned against the Irish commercial reforms proposed by the
Prime Minister William Pitt earlier in the year.[30] Wedgwood argued
that Irish potteries would undercut the Staffordshire businesses by
40–50 per cent because of cheap labour and a reduction in import
and export duties. There were corresponding fears of an exodus of
skilled labour and expertise from England to Ireland. Wedgwood's
argument was based on his knowledge of a creamware pottery
established in Dublin in 1784 where production in imitation of
'Queens ware' was in the hands of men brought in from Stafford-
shire, with designs taken from the Wedgwood warehouse in
Dublin.[31] If this was the case, then fine ceramic production still
hung by a very slender thread in Ireland, but Wedgwood and his
Staffordshire contemporaries were alarmed by the potential for
growth should the trade restrictions be lifted. Given the unstable
nature of fine ceramic production, and the importance of an un-
restricted 'plantation' trade to the West Indies and North America,
the reasons for the English potters' opposition to free trade in
Ireland may be understood. In 1775 the embargo on the import-
ation of continental porcelains and Dutch Delftwares was lifted.
While this was advantageous in certain respects, because it ren-
dered tit-for-tat prohibitions and the imposition of heavy duties
on English products less forceful, it did open up unknown com-
petitive territory. Nevertheless the fierceness of the opposition to
free trade in Ireland, as Edmund Burke argued, appears excessive.
Negative cultural attitudes towards the Irish people were clearly
in evidence, and Burke himself was lampooned for his Irish brogue.

The historical memory in England and Ireland had been darkened by the events of the previous century, and in the late eighteenth century the consequences of those times were about to emerge in serious unrest.

Josiah Wedgwood reinforced the principle of an embargo 'in the national interest' on the export of fine quality china-clay and stone from Cornwall. Ireland therefore had no access to the superior materials which were openly available to English manufacturers.[32] Pitt's proposed bill to liberalise trade in Ireland was withdrawn, but in 1782 the country had achieved independence in legislation with the repeal of Acts which had placed the Dublin Parliament under the control of London. This led to a rapid unravelling of the English legislative grip on Ireland, and even after the withdrawal of Pitt's 1785 reforms there was still optimism that free trade would eventually be granted. Because of this Thomas Greg and his partners felt confident in building the Downshire Pottery in Belfast in 1787, which was in production until Greg's death in 1796.[33] But the optimism that fine ceramic manufactures with an anticipated foreign market could be established in Ireland before the end of the century was set at nought by the turbulent events of the 1790s, ending in the Act of Union which passed into statute on 1 January 1801. This failure resulted from a combination of adverse political and commercial circumstances, and from Greg's own death, which meant it was well into the nineteenth century before fine ceramic production was again attempted in Ireland.

Business structures and money systems

Bankruptcies numbered high in the manufacture of fine ceramics, and very often an enterprise changed hands frequently as one syndicate or partnership failed and was bought out by another. The formation of a partnership or syndicate to establish a manufactory was not unusual, and with the exception of those manufactories where capital was injected by the royal house or a noble estate, it became the most common arrangement in attempts to balance out the risks of such an enterprise. Elite manufactories like Vincennes-Sèvres were formed on this basis, where the individuals involved were members of the *haute bourgeoisie* with close connections at court and direct control of state finance.[34] The later Paris porcelain manufactories were almost all founded by business consortiums, often with sleeping partners who put up initial funds or injected cash when the enterprise ran into difficulties.[35] Although England's legal structure was different from those on the Continent, this broad pattern was common in

English centres of fine ceramic manufacture like London and
Liverpool, South Yorkshire and Staffordshire. In England and on
the Continent partnerships and syndicates were often formed
from a membership diverse in interests and expertise. A good
example of this can be found in the Bow porcelain manufactory.
The founder members of the partnership were John Weatherby
and John Crowther, who were already running a wholesale pottery
business in London as well as being partners in a glassworks. They
were joined by a Master of the Saddlers' Company, Edward Heylyn,
who was in fact a merchant, a 'clothier', from Bristol, and by the
London Alderman George Arnold, who probably financed the
undertaking and operated as a 'sleeping partner'.[36] Lastly the group
of five partners was completed by the Irish artist Thomas Frye,
who was responsible for forming the substance and character of
Bow porcelains. The Bow partners set out to undercut an existing
product, that of the imported East India porcelains, and the site of
production was known at first as 'New Canton'. As an engraver for
the calico-printers of the Bow, Bromley and Stratford districts, and
with friends who were supercargoes in the East India trade, the
network of influences Frye used confirms the interdependence and
cross-fertilisation that went on between one form of business and
another.[37]

The greater degree of refinement which marked fine ceramic
manufactures was dependent on men and women who desired to
better their trade in a commercial climate of opportunity and ex-
pansion, but not without considerable risks. It was essential to have
more advanced empirical knowledge of the materials of their trade,
to grasp the need for higher levels of technical accomplishment,
and to keep abreast of market forces, often on an international basis.
Novelty was an important factor in the class of eighteenth-century
consumer goods which carried visual appeal, and while many fine
ceramic manufacturers imitated existing products, they were often
innovative in the way they reinterpreted them. For example, silver
sauceboats were not infrequently used as models for ceramic ver-
sions. The Staffordshire sauceboat shown in Figure 12 displays a
recurrent feature of virtuoso silverwares – a handle in the form of
a dragon – and additionally imitates an entirely different material
quality in the application of coloured, 'marbled' glazes (Figs 12 and
13). The Staffordshire reinterpretation may have an unresolved,
some might say 'naive', appearance in comparision to the silver
version, but they were relatively cheap to produce, and sauceboats
thus became available to a wider economic band of consumers who
could never aspire to own a silver one.

One of the main causes of bankruptcy was failure to balance
cash flow, and for this reason Wedgwood was reluctant to allow

credit on the purchase of his wares. Circulating or working capital was the life blood of an enterprise, where its primary requirement was the purchase of raw materials and the sale of finished goods. Fixed capital in buildings and equipment was of less significance than working capital in fine ceramic manufacture because it was heavily reliant on hand skills rather than machinery. In this

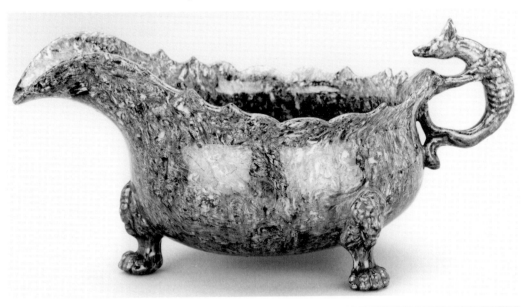

12] Staffordshire sauce-
boat, moulded
cream-coloured earthen-
ware, coloured marbled
glazes, 1760–70.

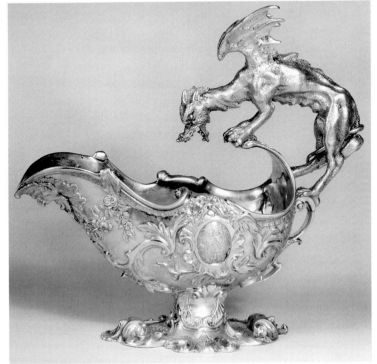

13] Unmarked silver
sauceboat, c. 1740.

———

respect it was quite different from the textile industry which operated on a much larger scale and during the eighteenth century became rapidly mechanised. Nevertheless, in comparison to the production of coarsewares, fine ceramics required more fixed capital given the greater complexity of production. However, at certain stages in production working and fixed capital were inextricably linked. Working capital invested in materials could not be productive unless processed by 'fixed' power-assisted devices, which were principally employed in the grinding and mixing of raw materials. Most manufacturers owned or shared the use of a watermill or windmill for grinding materials, and flint was of particular importance to the manufacturers of fine ceramics; it added to the durability of the wares, enhanced whiteness, and helped to prevent common problems like 'crazing' in the glazed surface. In Liverpool several of the potworks shared the facilities of a mill, and in 1770 there were reported to be '27 windmills, nine of which were used for grinding colours'.[38] Cross- contamination of materials was a problem which had to be carefully monitored in the manufacture of fine white wares, and on 8 December 1775 the *Liverpool General Advertiser* reported that 'some evil-minded person or persons have, at different times, secretly entered a Wind Mill ... belonging to John Pennington, China Manufacturer, and have made a practice of intermixing some hurtful ingredients with the materials grinding in the said mill, in such a manner as to render them unfit for use'.[39] The report, which offered a sixty guinea reward to anyone who could give information leading to a conviction, did not relate what was used as a contaminant, but it was a serious matter for a manufacturer whose costs for materials were also linked into the considerable time it took to prepare them. Such an attack affected the all-important 'working' rather than 'fixed' capital. A contaminated mill would have to be cleaned out thoroughly and the whole process started again from scratch.

Financial expedients which were generated through working capital were of central importance, and short- or medium-term credit enabled a manufacturer to obtain materials, produce the goods and sell them, in theory before cash had to be paid to creditors. However, it was common for ceramic manufacturers to allow dealers, retailers and individual buyers to purchase stock on credit. Financing this burden and balancing it with the purchase of raw materials and the production of stock was precarious. The debts a producer owed to the dealers who provided the minerals, metals and fuels for manufacture were often minimal in comparison to the debts owed to the producer from materials transformed into goods on the market. A drop in the market due to an outbreak of hostilities, the American War of Independence for example,

caused severe difficulties in Bristol, Liverpool, London, Glasgow and Whitehaven, all heavily dependent on the Atlantic trade, and resulted in a rise in bankruptcies.[40] A manufacturer could have a large number of debts outstanding from dealers and retailers, while manufactory or warehouse stock was at a standstill for want of a market lost because of war, yet there was insufficient cash to pay creditors who had called in debts for materials supplied several months earlier. The interdependency of the credit system was both its strength and its weakness; a system built on trust, mutual convenience and confidence that creditors would in time be recompensed, had the rug pulled from under it when crises emerged at international, national and local levels, and ceramic manufactures were, and still are, particularly sensitive to the volatile nature of the economy.[41]

Josiah Wedgwood's friend, John Turner, was reputedly 'dedicated to his trade' and tramped for miles over the Staffordshire countryside, returning with samples of clay on which to experiment; but this level of commitment did not prevent his eventual bankruptcy. Many of the Staffordshire potters were not in a position to engage with the world in the manner of Josiah Wedgwood, who benefited enormously from his partnership with the urbane Bentley, which in no small measure contributed to Wedgwood's success, and the latter readily admitted this was so.[42] Even a very able man like William Greatbatch eventually succumbed to bankruptcy after twenty years as a successful manufacturer.[43] Although portrayed as the worst possible condition of life, bankruptcy did not necessarily mean ruin and a future of destitution. Fine ceramic manufactures across Europe were sustained by close and often very mobile networks of entrepreneurs, skilled artisans and artists. While competition was fierce, there were strong elements of cooperation between manufacturers in private enterprise, as opposed to those under royal or noble patronage. Josiah Wedgwood, respectful of William Greatbatch's good practice over twenty years, employed him in a position of considerable responsibility after the latter was discharged from bankruptcy in 1788. In Liverpool, John Livesley's 'Black Ware Pot-house near the Doghouse' was destroyed by fire in 1758, but he seems to have continued in production until 1779 when declared a bankrupt, probably in company with John Wainwright. Four years later, in 1783, his name appears again in connection with Zachariah Barnes at the Haymarket Pottery, where delftware and china were sold and produced for the American market.[44] In Staffordshire, Liverpool and in many other centres of production there were opportunities for re-employment in the business. In a close-knit community where people understood the risks involved in the production and

marketing of fine ceramics, they were prepared to support 'honest bankrupts', those who had suffered misfortune from factors outside their control rather than from their own folly or dishonesty.[45] There were, of course, many who escaped their creditors, as possibly did William Greatbatch for several years, by offering their skills and experience elsewhere, but even this had a positive aspect in disseminating knowledge and new ideas more widely.

The manufacturers of fine ceramics at all levels in Britain struggled with the problem of costing their products, and the margins between success and failure, already made precarious by the credit system, were narrowed further because of this. Josiah Wedgwood admitted to Thomas Bentley that he was unable 'to find the proper data and methods of calculating the expense of Manufacturing', and in particular the production of vases which had caused cash-flow problems. The upshot of this was that Wedgwood undertook a meticulous costing excercise himself, but was greatly assisted by Bentley's stronger nerve in lifting market prices considerably higher in proportion to the costs of production.[46] There were no established measures of time, skill and money by which these factors could be matched to the prices the market would tolerate, and lack of experience in these crucial matters contributed to business failures generally in Britain and on the Continent.[47]

The organisation of labour

> Every undertaker in manufacture finds, that the more he can subdivide the tasks of his workmen, and the more hands he can employ on separate articles, the more are his expenses diminished, and his profits increased. The consumer too requires, in every kind of commodity, a workmanship more perfect than hands employed on a variety of subjects can produce; and the progress of commerce is but a continued subdivision of the mechanical arts.[48]

Division of labour in the production of ceramic artefacts has been practised since antiquity. The notion that an individual craftworker was ever solely responsible for the making of ceramic vessels, sculptures or ornament in West European culture would represent the exception rather than the rule.[49] It is the case, however, that the reorganisation of labour in an eighteenth-century porcelain or creamware manufactory tended to confine workers' skills into increasingly limited and repetitive modes of operation; greater complexity in the division of labour overall reduced the breadth of an individual worker's application of skill. Adam Ferguson identified a noticeable shift in the eighteenth-century practice of division of labour which he understood to be the refinement of manufacturing techniques satisfying the producer's

requirements to raise profits – or at least remain solvent – and the consumer's demand for more and better quality merchandise. What he observed was not new, but an extension and intensification in the application of division of labour as a mechanism for producing a greater volume of goods adapted to meet demands for greater refinement and standardisation.[50]

There were two principal branches of ceramic manufacture which were innovative in the application of materials and technical skill, and without which the products could not be considered 'fine'. These were the materials and skills associated on the one hand with the reproduction of wares through the use of plaster moulds, and on the other with the methods of finishing wares through glazing and hand-painting. In England the adaptation of print technology in the form of underglaze and on-glaze transfers, which occurred just as the creamwares were first manufactured in quantity, had enormous implications for the future development of fine ceramics.[51] The innovations and adaptations in these two branches of manufacture, the three-dimensional forming of the product and the application of a two-dimensional image, which were so effective in establishing the quality of fine ceramics, were at the same time dependent on innovations and adaptations in the processing of raw materials and in the techniques employed in firing the products.[52]

The use of plaster of Paris moulds both extended the volume and diversity of goods produced and ensured standardisation for the production of matching sets of refined tablewares.[53] The virtue of plaster of Paris in comparison to other materials used for press-moulding and a limited amount of slip-casting was its ability to draw moisture from the clay rapidly and evenly. Plaster of Paris allowed for a faster turnover of products with far fewer losses. Many of the English white salt-glazed stoneware vessels, latterly superseded by the creamwares, were based on silver or pewter prototypes which could not be reproduced successfully and economically by the conventional use of a potter's wheel. The adaptation of vertical and horizontal lathe-turning techniques overcame the formal limitations of throwing. It was possible to reproduce large quantities of negative plaster moulds, or 'working moulds', from a positive 'block' or 'master' mould, and when worn out the working moulds could be recast from the original block mould. These techniques made possible the relatively reliable reproduction of oval hollowwares and dishes, of octagonal plates, and sauceboats like the example in Figure 12.[54] Plaster of Paris was introduced to the Staffordshire potteries when creamwares were first starting to enter production. The conjunction of these materials eventually enabled fine ceramic manufacturers to produce

complete ceramic equivalents to table services normally made in silver, which would have been out of reach for the middle classes. Ownership of plate in middle-class households usually included only a few items like candlesticks, tea spoons and sugar tongs, a punch ladle, a tankard and a porringer or two.[55] The application of plaster of Paris also made possible the production of novelties like teapots in the form of a house, or a camel, and the popular but serviceable 'cauliflower' wares, many of which were exported through Liverpool to the American colonies. From Josiah Wedgwood the Liverpool dealer John Dunbibin ordered 'Mellons suitable for the West Indies, and an assortment of colliflower Teapots, ... send me some of your cups and saucers of Colliflower and Mellons'.[56]

While the introduction of a material like plaster of Paris contributed to the greater viability of fine ceramic production, it was more difficult to balance the application of the hand-painted image with the profits manufacturers sought. To begin with, some of the metals required for the preparation of enamel colours were expensive and labour-intensive to melt down, grind and mix before getting anywhere near a painter's brush – or 'pencil' as it was then termed. Generally, enamel painters were skilled miniaturists, sometimes of a very high order indeed in the context of luxury porcelain production, and if not well rewarded they could go elsewhere. Enamel painters applied their skills on glass, copper and gold as well as ceramics, and in England workshops were concentrated in London and Birmingham where luxury goods and their less costly imitations were produced. Painters tended to specialise in a particular branch of the trade and labelled themselves as 'box-makers' or 'box-painters' for example, usually in the finishing of snuffboxes or étui.[57] In the case of the German Thuringian glass-making communities it was possible to transfer this reservoir of skill from glass to porcelain when establishing the new manufactories in the middle of the century. The demand for underglaze blue painting, however, which was specific to fine ceramic manufactures, required training in hand-painting on a dry biscuit surface, or the use of pouncing techniques which required less skill.

It was common for fine ceramic producers to send their wares away from the manufactory to be enamel-painted, and some dealers bought in blank whitewares which were then painted in house or sent to another workshop.[58] In Bristol the 'sign painter' Michael Edkins frequently undertook to gild ceramics and blue Bristol glass for the dealers Vigor & Stevens. By the potter, Mr Taylor, he was paid 1s 9d 'To ornament 7 teapots with Gold' at 3d each, and the gold was probably of inferior quality.[59] This represented the most informal of the arrangements between dealers, a

small potworks and a local painter. Sending wares out could save the cost of establishing a specialist enamel-painting and gilding workshop in a manufactory, especially where premises were crampt and dust contamination was likely. In Staffordshire some pottery manufacturers sent their wares to local enamelling shops outside the works, others established decorating shops on their own premises.[60]

One central feature of this branch of manufacture, which producers in the luxury porcelain market especially could not ignore, was the importance of colour to eighteenth-century consumers. It was not just the painted subject which was of significance, but the vibrancy and 'truth' of the enamel colours. Developing novel colours in the 'latest taste' was one of the top priorities of manufactories like Sèvres, Meissen and Chelsea, and later of Josiah Wedgwood in the development of Jasper ware bodies after the interior colour schemes of Robert Adam. But it is evident Wedgwood was aware of cost. Good quality cobalt was expensive, and for his dark blue Jasper wares he developed a technique of coating or 'dipping' a white version of the Jasper into a dark blue liquid clay.[61] In porcelain production colour really became more important than the porcelain itself, which increasingly worked to provide a lustrous surface for the enhancement of rich colour grounds and to allow the subtler shades of enamel to reflect light.

In 1761, before Wedgwood struggled with the costs and technical difficulties of Jasper wares, he entered into an agreement with the Liverpool printers John Sadler and Guy Green, in which they were to undertake transfer printing on his creamwares.[62] The Liverpool delftware potters produced large quantities of tiles on which Sadler and Green experimented, and their venture in transfer printing was the first to make the technique commercially viable. Those party to the first successful batch of 1,200 tiles noted that the images could be applied by a few men rather than 'one hundred' hand painters, and therefore 'may be sold at half the price'. An additional quality noted about the printed tiles was 'that they are considerably neater than any that we have seen pencilled'.[63] In effect what this process did was to transfer the skills of an engraver to the surface of a tile or vessel at a point in the century when prints were becoming increasingly accessible and popular. With some exceptions like the early Worcester pieces from engraved plates by Robert Hancock, the quality of the prints was not high, and they were not representative of the best in the print market as a whole; popular genre themes dominated rather than elevated subjects which tended to attract the best engravers (Fig. 14). The original image taken from the etched and engraved plates also suffered degradation when transferred and fired in the enamel kiln. But to assess

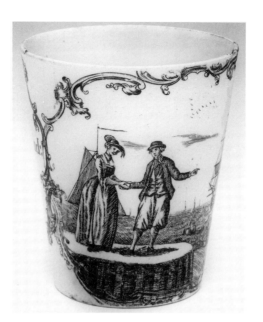

14] Mug, earthenware,
print of a sailor parting
from his sweetheart,
Staffordshire, c. 1770,
8.5 cm high, engraved
ceramic transfer-print with
the inscription on the
reverse side: 'When this
you see remember me /
and bear me in your mind /
Let all the World say what
they will / Speak of me as
you find'.

these wares in comparison to the work of the finest engravers misses the point: there was a highly receptive buying public for this novel technique with 'neat' and socially topical images reproduced on fine ceramic wares (Figs 15, 16).[64] Transfer printing developed initially as a separate enterprise, and ceramic producers dispatched wares to the printers when they required their services. The process reduced, and in some cases almost eliminated hand painting in earthenware production except for gilding. Because transfer printing is a difficult technique to apply to porcelain manufacture, high levels of hand painting skill were maintained, but so were high

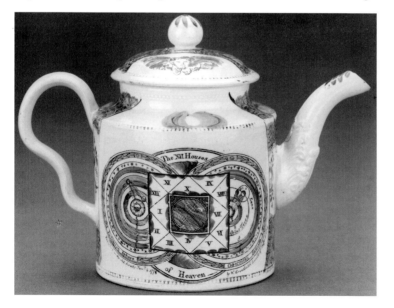

15] Teapot and cover, Staffordshire, probably William Greatbatch, 1778–82, ceramic transfer-print, painted with coloured enamels. *The XII Houses of Heaven.*

prices. In contrast the cost of manufacturing creamwares could be counted in pennies per piece for all but the most elaborate items. For the hand-painted images of British topographical subjects in the 'Frog Service' completed for the Empress Catherine of Russia in 1774, Wedgwood added at least £2 per piece for the enamel painting. The service included 950 items in total, amounting to a cost somewhere between £2,000 and £3,000, and this was a relatively modest commission compared to the major European porcelain manufactories. On the other hand Sadler and Green charged Wedgwood £8 6s 1½d to print a creamware service for David Garrick consisting of 250 pieces.[65] Transfer printing represented an enormous economic advantage to fine-ceramic manufacturers, especially when consumers responded to the market with their wilingness to purchase, and more significantly when a greater number of consumers found these wares affordable.

Adaptability was essential in all manufactures where the market responded to novelty and where 'tastes' changed in shorter cycles than had been the case at the beginning of the century. The successful fine ceramic manufacturers were adaptors and imitators, but aiso innovative and occasionally inventive. Wedgwood encountered resistance to adaptation; there was grumbling and recalcitrance among workers reluctant to change methods with which they had grown comfortable, and which did not tax them too severely. He realised that the only way to overcome this problem was by subdividing making processes further, to 'make machines of men that cannot err' and to train up the younger generation, who had no memory of the old ways.[66] It is not possible to mechanise fully many of the processes of ceramic production,

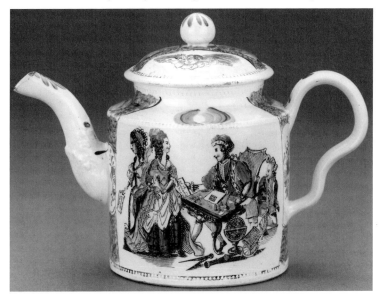

16] Teapot and cover, the reverse side of Figure 15. *The Fortune Teller.*

even in the late twentieth century. The pottery industry faced entirely different problems from those of textile production for example, and this was in large part because of the nature of the raw material. Wedgwood's priority was to achieve better quality and to standardise his products. His method of dividing labour in order to attain this goal can be understood as a form of mechanisation. Adam Ferguson did not condemn these new industrial practices, but he speculated about the effect division of labour might have on the skill of a nation:

> It may even be doubted, whether the measure of national capacity increases with the advancement of arts. Many mechanical arts, indeed, require no capacity; they succeed best under a total suppression of sentiment and reason; and ignorance is the mother of industry as well as of superstition. Reflection and fancy are subject to err; but a habit of moving the hand, or the foot, is independent of either. Manufacturers, accordingly, prosper most, where the mind is least consulted, and where the workshop may, without any great effort of imagination, be considered as an engine, the parts of which are men.[67]

Methods of distribution

It is difficult to overestimate the importance of an institution like the English East India Company. It was responsible for creating much of the wealth in the British economy during the eighteenth century, and its political and global influence was extensive. The directors and major shareholders sat in Parliament, and the Company, alongside the Bank of England, put up substantial public funding which financed the major military conflicts of the century.[68] The commodities imported through the East India Company permanently marked consumer tastes and social practices in Britain, and in the eighteenth century these life-enhancing products became widely accessible to the middle classes.

Although the cargoes were small compared to the Indian cottons and silks, the porcelains imported principally through the English East India Company and the Verenigde Oost-Indische Companie of the Netherlands introduced to the West a type of product which formed a model for the development of blue and white wares in Europe. The Chinese porcelains were absorbed into Western culture, imitated, adapted and transformed to become a widely accepted and lasting form of utilitarian tableware. Spode's 'Willow' type pattern emerged on English pearlwares before the end of the century, and the Meissen 'Zwiebelmuster' or 'Onion Pattern', which first appeared in the late 1720s, was revived to form an indispensable feature in the nineteenth-century German bourgeois home. It was David Hume's opinion that the presence of East

India goods encouraged manufacturers to 'emulate the foreign in their improvements …'.[69] There was a sense of urgency that English manufacturers should attempt to reproduce the quality of imported East India goods at a level which would satisfy consumer demand. The problem of the balance of trade occupied many economic thinkers of the period, and the East India Company was frequently targeted as an institution which maintained high imports to the detriment of English manufactures and exports. The affairs of the East India Company were controversial on both political and economic levels. At the beginning of the century Sir Charles Davenant acckowledged that the 'Company has been for a long time looked upon with an evil eye, by some people, because there has formerly been ill management in their affairs'.[70] While recognising the serious deficiencies in the East India trade, he was convinced that 'it can never be advisable for England to quit this trade, and leave it to any other nation'. Europeans were too long accustomed to 'their spices necessary to the constitutions of all degrees of people … their silks are pleasing everywhere to the better sort, … their callicoes are a useful wear at home, and in our own plantations …'.[71] Before the eighteenth century began, the East and West India trades were interdependent, and in the case of the textile trade this international dimension had serious and destructive forces within it, especially for the Indian producers.[72]

This was not the case with regard to the export from Canton of porcelains manufactured to European specifications. In this instance, the business was small in comparison to the trade in textiles, and a less troubled manufacturing and trading relationship was established. English porcelain manufacturers never produced an equivalent to match the Jingdezhen wares imported via Canton to London. The Bow manufactory made an attempt to do so, but the soft-paste body, like many others of its kind, did not have the robust qualities of the Chinese porcelains. The Liverpool porcelains were also fragile, and in the latter half of the eighteenth century the introduction of pearlwares ensured supply of an acceptably durable and much less costly product for the considerable market for tablewares in the 'Chinese style'. Although Richard Champion's hard-paste porcelain might have been expected to match the Chinese, it foundered for lack of capital investment and consumer demand. Only the continental manufactories could produce an equivalent, but their products were very expensive and made more so in England due to restrictions and heavy duties imposed on their import. The East India wares were cheaper and proven in their reliability. Their plates, which the English manufacturers found very difficult to produce successfully, were retailing at 10d per piece by the time Champion was in production.[73]

The East India Company officers and their agents, the supercargoes, sailed to Canton and conducted business directly with the Chinese merchants. The supercargo's main task was to purchase shiploads of tea and the utilitarian Chinese porcelains, but they also placed private orders for dealers and individuals at home. There were two branches of production in what has become known as Chinese 'export' porcelains, or porcelains tailored specifically to the European market. During the reign of the Qing Emperor Kangxi (1662–1722) Chinese manufactures and the country's trading relationship with the West were rejuvenated after a period of stagnation. Early in the eighteenth century the Chinese potters in the centre of porcelain production, Jingdezhen, started to produce blue and white wares based on Western models in the form of cylindrical beer mugs, plates, sauceboats and tureens, until by the 1740s the East India Company could import all that was required to furnish a full European dinner or tea set.[74] Imitation of foreign prototypes was nothing new in Jingdezhen, and had formed a substantial part of China's trade with Central Asia and the Middle East for centuries prior to the European East India trade.[75] These 'utilitarian' wares were usually painted with Chinese subjects, principally in cobalt blue underglaze pigment (see Fig. 40).

The other branch of the 'export' trade was much smaller. The supercargoes took orders from dealers or private individuals at home which were not part of the East India Company's business. They were permitted to make a profit on the orders, not just in ceramic wares, but also in lacquers, paintings, carvings, wallpaper and silks for example.[76] It may have taken two years, but a porcelain service ordered through a supercargo would eventually find its way to an English dinner table, and it was in this context that armorial wares were commissioned by the nobility, the gentry and those of the middle class who had become 'gentrified'. It was for these private orders that the Chinese copied Western ceramic prototypes, and numerous artefacts from the European manufactories formed the basis for this imitative trade. It involved both the Jingdezhen potters in reproducing the form, and the Canton painters who copied Western subjects on the surface of these vessels and some figure groups. For the reproduction of two-dimensional subjects, the supercargoes handed over designs on paper which were used to copy a coat of arms or a decorative motif for example, but paintings and particularly engravings formed much of the material from which the Chinese enamel painters worked.[77] The cross-cultural exchange could become convoluted, with Chinese potters reproducing the singular European form of a Dutch Delftware tulip vase, and a Chinese painter reproducing Dutch imitations of original Chinese motifs with Western additions.

The English East India Company discouraged the import of large quantities of Chinese ornamental pieces like jars, large bowls and small figure sculptures, and these items were brought to the West under a supercargo's private orders. The Company preferrered the bulk of imported porcelains to be made up of tea, coffee and chocolate wares, with dinner service items next in priority. Shipments of coffee cups, tea cups and saucers commonly ran into tens of thousands, and these cargoes of utilitarian wares represented the most secure market and lucrative profits for the Company's imported porcelains. For example, in 1719 the *Carnarvon* returned to London with 28,824 blue and white coffee cups advertised in the East India catalogue for sale in fourteen 'lots, 4 sorts in each Lot'. There were 85,409 blue and white cups and saucers to be sold in thirty-one lots, and 12,214 blue and white chocolate cups for sale in nine lots. The *Carnarvon* also carried 'painted' wares but in smaller quantities, for example 27,490 enamel painted cups and saucers to be auctioned in ten lots. Items like teapots, milk pots, slop 'basons' and plates were imported by the hundred or in numbers not exceeding 2,000–3,000, but the quantities varied considerably on different East Indiamen.[78] It was the cheaper blue and white porcelains which were accessible to the middle income groups and which had a broad influence on the style of fine earthenwares in British manufactories. Indian calicoes were also popular in middle-class households in the form of curtains, bed-hangings and chair covers, and printed in English workshops with the 'china-blue' and 'chaney' chinoiserie designs.[79]

The supercargo was a very interesting figure in the East India trade and had to be a man of considerable financial and linguistic ability, shrewdness and diplomacy, courage and trustworthiness.[80] Before a shipment of porcelain left Canton, he went to the porcelain warehouses which were 'very spacious, and contain large quantities of china, fit for the European market'. As with all East India goods, the supercargo kept a 'strict eye' on packing as 'they will sometimes put up china cracked, broken, or of inferior quality'.[81] The porcelains were usually packed in rice straw or husks and provided ballast for the ships carrying the much more valuable cargo of tea. In bulk Chinese porcelain was very heavy: crates stacked in the bottom and sides of an Indiaman's hold helped to prevent a vessel with an otherwise light cargo of tea from excessive pitching and rolling on the return voyage; they also helped to keep an inner core of tea chests and textiles dry and could not contaminate them through smell. East India goods were landed only in London, and from the wharf were carried to East India House in Leadenhall Street, or later to the new city warehouses, where they were auctioned. In the case of tea in particular this was a guarantee

of legal procurement, but it also meant that the Company kept the price artificially high, until William Pitt greatly reduced the duty on tea in the Commutation Act of 1784.[82] The East India sale catalogues stated that:

> *China-Ware* [had] to be taken with all faults, except visibly broke below the Rims, and none to be refus'd ... on pretence of not answering the Sample, difference of Figure, painting, or rub'd Edges ... and the Company will not allow of any Ringing; and for such *China-Ware* as appears to be crack'd, the Company will allow two for one thereupon, but that on all Lots shew'd open, they will give no allowance.[83]

The dealers who purchased the East India lots were known as 'chinamen', and not surprisingly they were principally London-based merchants. The East India Company had a monopoly on the sale of porcelains and until the 1770s sold only to the 'chinamen' who were in effect wholesalers to the smaller retailing sector. The chinamen were often retailers as well, with fashionable shops located in the city convenient for the East India warehouse. China selling was a 'genteel' occupation. Like the silk mercer, woollen draper and laceman, the china wholesalers and retailers needed capital to establish a business, and they had to be creditworthy, although bankruptcy was as much a hazard in china selling as it was in manufacturing. The dealers and retailers were most likely to come from moneyed families involved in the same or related luxury trades, in finance, or from the lower strata of the gentry. From the 1730s to the 1770s London trade directories and newspapers recorded about ten women in the business.[84] In their trade the china sellers mixed with people from the refined middle and upper classes, which required a 'genteel' education and the knowledge of how to behave in polite society.[85] The china selling trade operated on different levels, however, and only in London and the major provincial cities was specialist retailing of East India porcelains feasible in the early eighteenth century. Robert Campbell, in *The London Tradesman* of 1747, did not consider it necessary for the proprietor of an ordinary 'Earthen-Ware Shop' to have any special 'genius', and considered him or her to be on a level with the grocers. But by the mid-eighteenth century it was not uncommon for a china seller to stock tea, coffee and chocolate alongside East India porcelains, delftwares and 'Goods from several Houses in England'.[86] In the 1760s John Kendall at his warehouse 'The Golden Cannister' in Pierrepont St, Bath, sold 'all sorts of *useful* and *ornamental* China - Both Foreign and English. Also Fine Teas, Coffee and Chocolate of the highest Flavour' (Fig. 17). From the 1730s the term 'warehouse' was used to describe a large wholesale and retail establishment where it was possible to buy goods

JOHN KENDALL,

At his CHINA WARE-HOUSE,

The GOLDEN CANISTER in Pierpoint-Street, near the South-Parade, BATH,

Sells, on the most reasonable Terms,

All SORTS of

USEFUL CHINA,

Both FOREIGN and ENGLISH:

Also fine Teas, Coffee and Chocolate,

Of the highest Flavour.

He has just laid in a large Assortment of Bowls, Basons, Dishes, Plates, and Tureens: Foreign Cups and Saucers of all Prices; complete Sets of Teas from 44s. to 5l.

A large Assortment of Worcester China,

Which will be sold on the same Terms as by the Manufacturers in Worcester, and at their Ware-House in London.

All the above Goods will be warranted sound.

The *London, Bath,* and *Bristol*

MACHINES, in Two Days,

BATH.

BULL, JEWELLER,

GOLDSMITH, and TOY-MAN,

At the FLOWER-DE-LUCE, in the *GROVE,*

ACQUAINTS THE

Nobility, Gentry, & Public in general,

That he intends carrying on the above Trades

More extensively than they have ever been carried on in BATH:

He has for that Purpose provided himself with a large, rich, and elegant Assortment of Goods; where Ladies may be suited with Setts of Neck laces and Ear-Rings, from Eight Shillings to Thirty Guineas; a very large Variety of Fancy Rings, from Five Shillings to Forty Guineas; Snuff-Boxes from a Shilling to Fifty Guineas each; and so in Proportion for every other Article in the Goldsmith and Toy Way.

Also a very large and curious Variety of Useful and Ornamental China; amongst which is the most curious Tea-Sett of Dresden China now on Sale in England, painted with a beautiful Variety of Landscapes, &c.

The Bath Hair Mocho, Landscape and Cypher Rings, are continu'd making with that superior and improv'd Taste he has ever kept them up to, against all Opposers: He has had the Honour of making several for the English and many foreign Courts, who have all been pleased to distinguish him with the Preference: And tho' many of the Jewellers in the Kingdom are still following his Patterns, the Public may be assured that for Lowness of Price, Goodness of Work, Standard of Gold, or Beauty of Gems, none shall exceed him.

Tho' he does not profess himself a *Diamond Merchant,* yet he has always a prime Assortment of the various Sizes by him; and Ladies may be suited with Ear-Rings, &c. &c. from Fifty Pounds to almost any Price.

The plain Hair Rings, of which Numbers are made by him at 7s. each, will be found on Comparison to exceed by far those that are made in any other Part of the Kingdom.

☞ A very great Variety of Gown Buttons, which are now getting into universal Fashion amongst the Ladies.

❖❖❖❖❖❖❖❖❖ ❖❖❖❖❖❖❖❖

17] John Kendall, China Seller, advertisement in *Pope's Bath Chronicle*, 14 October, 1762.

18] Bull, Jeweller, Goldsmith and Toy-Man, advertisement in the *Bath Chronicle*, 5 September 1765.

relatively cheaply and in bulk if required. They were precursors to the store, and in a spa town like Bath Kendall and other 'warehouse' proprietors could hope for a quick turnover of fashionable stock during the 'season', but they were also vulnerable to failure if they took cheap bargains too far.[87]

The china shops were small specialist retail outlets in comparison to the warehouse, with considerable variations in character. In these establishments the proprietor frequently sold china with other novelty and luxury goods as well as glass. Alternatively, the costlier and more unusual porcelain items could be found in a goldsmith's or jeweller's shop, or at the 'Toy Man's' alongside a wide range of luxury and fancy articles (Fig. 18). By the middle of the century a china shop in a small market town in Dorset specialised in selling the finer wares. Ann Shergold, the widow of Thomas Shergold who died in 1756, continued in their Blandford business until her death three years later. In their shop they stocked glass, white salt-glazed stonewares, delftwares, imported porcelains

and Nottingham salt-glaze wares, which were certainly refined ar-
tefacts of their kind.[88] The Bath china seller, Sarah Wakelin, sold
'Useful & Ornamental China', cut and plain glass 'of the best and
newest Fashion', as well as 'Lace – Footings & Minionets'.[89] She also
took 'old Cloaths, Crape and Silk Hatbands, or Gold and Silver
Lace', in exchange for glass and china. She regularly advertised in
Pope's Bath Chronicle during the 1760s, and at this time advertising
was about selling a service; Sarah Wakelin was advertising herself
as a china seller and second-hand dealer. Her descriptions of the
products were vague, and no brand names were evident, although
she did itemise her prices on the china wares. The range of goods
she stocked might well excite curiosity at least to go and see what
she had to sell or exchange. In the tone of many advertisements
there is a strong impression of personal service and of a special
relationship between retailer and client.[90] In a spa town like Bath
clients would return regularly each year and patronise their fa-
vourite retailers, and Sarah Wakelin worked a season at Bath and
at her place of residence in Castle Street, Bristol.

At different levels of society it was a long-established practice to
exchange second-hand clothes for other goods, and china sellers
quite frequently followed this pattern. It was also a common prac-
tice among itinerant traders, the hawkers and pedlars, who sold
goods in the busiest urban centres and the remote rural regions.
The need and desire to keep up appearances had long sustained a
second-hand market in clothes, and a printed or plain well-tailored
waistcoat could have another life on the body of an artisan after it
was discarded by a wealthy merchant or local squire. 'Crockery'
weighing up to 75 lb, or 34 kg, was carried by the traders and
exchanged for cast-off clothes. When all the crockery had gone the
pedlar would continue to meet the original weight by purchasing
more items of clothing.[91] 'Crockery' is a non-specific term, but
suggests the carriage of cheap wares rather than fine ceramics. How-
ever, by the last quarter of the century many types of earthenware
were 'fine' relative to coarse wares. A travelling salesman with one
or more horses or asses could carry a substantial quantity of cheaper
versions of the more refined and costly wares on the market. It was
the ability of the cruder imitations to *represent* greater refinement
which was significant and effective in enhancing material life. The
travelling salesmen usually went directly to the manufacturers to
purchase their loads, and some of them distributed products over
a wide area. In the latter half of the century fine earthenwares,
including creamwares, were sold alongside coarsewares at the mar-
kets and fairs, and in Bunbury's print the precariously placed tables
display the finer fashionable vessels with the utilitarian jugs,
storage jars and flower pots underneath (Fig. 19). In the late 1770s

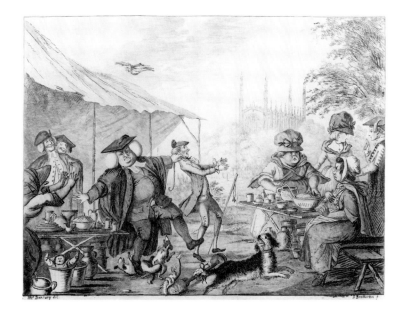

19] Bunbury, *Pot Fair at Cambridge*, etching, drypoint, 1737.

most of the major towns and cities in England had a dealer in Staffordshire creamwares, and some were finding it worth their while to buy in Staffordshire rather than London. By 1800 fine ceramic wares had reached into most regions of Britain, even the aceramic communities of mid-Wales, which had no vernaclar tradition of ceramic production and consumption.[92]

One-off sales and auctions were popular methods for marketing fine ceramics, and a sale was as much a social event as an opportunity to buy and possibly catch a bargain. There were several contexts in which sales or auctions might occur. An advertisement in *Pope's Bath Chronicle* of 29 November 1764 gives notice of a sale at the Wheat-Sheaf in Stall-Street of a 'Large, Curious and Capital Collection of China' which is sure to meet with the approbation of the 'Nobility and Gentry'. Included were Chelsea porcelains,[93] 'Some pieces of old Japan; variety of compleat Tea-sets; India Dressing-Boxes and glasses; very curious fans; compleat Services of fine oblong Dishes and Plates; and abundance of Curiosities too tedious to infer'. The advertisement stated that the wares were for sale at 15 per cent less than in London. This collection was seized in Exeter *en route* for export after unsatisfied creditors in London had issued a bill of sale. It is likely that the sale in Bath was the end result of a dealer failing to meet debts when they were called in. Forestalling goods in this type of circumstance, and when bankruptcy had been declared, required a sale so that creditors could recover losses at least in part. Sales or auctions were also commonly held after the death of a retailer with no partners or heirs willing or able to continue in business.

Another sale, this time an auction to take place in Bristol and principally of interest to West Country and South Wales dealers, was advertised in *Pope's Bath Chronicle* on 1 May 1766. In this case cargoes seized from 'several Indiamen' contained 'a very large and elegant Assortment of several Thousand Pieces of curious Useful and Ornamental FOREIGN CHINA; consisting of Bowls, Basons, Plates, Dishes, Mugs, Cups and Saucers, Setts &c ... are to be peremptorily sold to the best Bidder'. The lots to be auctioned included Indian cottons and muslins and the ships may have been French East India vessels which had fallen foul of the British navy, possibly in the Bay of Bengal following the Seven Years War. These seizures were privateering ventures intended to damage an enemy's merchant fleet and commerce. But in more ordinary circumstances dealers in East India porcelains organised sales or auctions in the provinces for the smaller wholesale and retail trade.

For the English and continental porcelain manufactories auctions proved to be a useful sales technique, if not always considered desirable. It was just one of the ways in which stock was disposed of, and it had a major advantage in that no credit was allowed and therefore an immediate injection of cash was received. An auction could quickly discharge outmoded stock and make way for new orders, and it also proved to be an effective method of selling 'seconds'. With imperfect kiln technology and firing techniques, many manufactories had a large quantity of these faulty products, and it made sense to gain some sort of return on them. It was relatively cheap and quick to organise a sale of seconds, especially if they were held locally and therefore cost less to transport the wares.[94] Sales took place at all levels of wholesaling and retailing. They were also common on a more informal and opportunistic basis among hawkers selling wares in local inns. When a substantial property changed hands, a town or country sale was again an opportunity for goods to be exchanged and find a place lower down the social scale.

Unfortunately, in the case of fine ceramics there is very little documentary evidence to throw light on the relationship between dealers, manufacturers and consumers, particularly in the early part of the century. In 1695 a stoneware potter, Moses Johnson, declared he made his wares 'according to his own fancy', but he also took notice of 'directions as his customers and acquaintance would bespeake'.[95] However, as this statement was given in evidence during one of John Dwight's legal actions against infringement of his patent, one might question how accurately it represented Johnson's mode of working, at a time when production generally was heavily imitative of other ceramic or metal prototypes. In the later 1700s there is more substantial evidence

that dealers and consumers played an important part in influenc-
ing the nature of a manufacturer's products, and evidence like the
Leeds Pottery order book of the late eighteenth century is one of
the few surviving examples of this type of dialogue.[96]

Pattern books and manufactory drawing books survive from the
late eighteenth century, when they were used to ensure stand-
ardisation in shape, enamel-painted image or decorative motif. The
use of these reference works was substantially formalised in manu-
factory practice by Josiah Wedgwood and Messrs Hartley, Greens
& Co. of the Leeds Pottery, and they were also used as a guide for
dealers or private individuals who purchased from the manufac-
tory itself or from the firm's showrooms.[97] Trade catalogues issued
by fine ceramic manufacturers in England also started to appear in
the latter half of the century, again most notably those of Josiah
Wedgwood and Messrs Hartley, Greens & Co.[98] While particularly
effective for the overseas markets, illustrated trade catalogues also
functioned as pattern books and the designs were imitated. Wedg-
wood was not inclined to be put off by this, and in 1779 wrote to
his Dresden client, Madame Conradi, concerning his 'imitators':

> I observe that you have had offers of Pottery at lower prices than mine…
> I am sensible there are imitations of my goods at less prices, and I have
> no objection to your making a trial, as several of those who are now my
> best customers have done, and come to me again, and I flatter myself
> that upon your making a comparison of my goods with others in
> quality and prices, they will be found cheaper that is better worth their
> price than any imitation of them brought to your market …'[99]

It was essential to eliminate as far as possible any technical dif-
ficulties in the production of wares before they were marketed
through trade catalogues. This also meant that other producers
used trade catalogues as pattern books, secure in the knowledge
that the wares illustrated were sound in their design, although
variations were introduced. But products were also subject to ad-
justment and improvement in response to suggestions or criticism
from dealers. For example, Basil Paul Schilling, Wedgwood's dealer
in Frankfurt am Main, reported on the perfectionism of his clients
who would have nothing to do with the 'six imperfect vases with
serpents broken':

> the wary German buys nothing without examining it before, behind,
> on all sides, with the greatest attention, and as soon as he perceives the
> least defect in it, it is in his eyes refuse, and the most perfect beauty in
> other parts has no longer any attraction or value for him; for which
> reason I cannot sell such imperfect pieces, not even for 10/- a piece. The
> garden vases with foliage are reckoned, in form and pattern, heavy and
> disagreeable, which will retard their sale.[100]

Josiah Wedgwood took note of these criticisms, amended his wares and adjusted to the differences in taste across his foreign markets as far as was practicable, and his success on the Continent was considerable in spite of Schilling's criticisms. The Leeds Pottery was similarly successful in its response to, and management of, its overseas market.[101] The advantage of an illustrated catalogue was that it enabled a dealer to place orders with greater confidence. Wedgwood's new Dresden client in 1776, Madame Conradi, wrote to report that a 'box' of patterns had mistakenly been taken back to London, and requested that it be returned so that she could see the 'Assortment of Colours' before placing an order.[102] These services were increasingly seen to be good trading practice, especially when products were carried or imported over long distances. Dealers could discuss the design options and prices with their buyers. In the late eighteenth century affluent consumers were more conscious of making an individual choice in their purchases, and aware that they were buying 'quality' associated with a name like Wedgwood, whose products were widely promoted in the German States.

The market as spectacle

The business of selling introduced to the urban environment a strong element of visual interest and appeal, but it would be a mistake to assume that until the eighteenth century the retail trade was comatose. Most of the routes of supply for luxury fabrics and utilitarian textiles, small luxury items of haberdashery, trinkets, spices and fine foreign foodstuffs like almonds and dried fruits, were in place in the early seventeenth century and before, even if they were limited in their distribution and consumption. In the latter half of the 1600s there was a marked increase in activity as the economy grew and new overseas commodities were introduced to the market. The business of retailing and purchasing was always complex, but became more so after 1660 and through the eighteenth century. This especially applied to the development of retailing; the shop was the site where goods were made visible, consumer desires and imaginations were animated, and acted upon or not according to circumstances.[103] In urban centres, where the sale of luxury items and the less extravagant but novel articles could be sustained, shopkeepers drew attention to their premises with window displays and well-appointed or sometimes luxurious interiors.[104]

In addition to the substantial amount of enamelling and gilding on glass and fine ceramics wares, the Bristol sign painter Michael Edkins was frequently engaged to paint and letter cannisters for

tea and coffee merchants; for example, in August 1767 he charged Mr Parry 1s to paint a 'Round Cannister Yellow Scroll and Wrote Coffee'. For Mr Cadell he painted ten tea cannisters, green with yellow scrolls. In 1775, again for Mr Parry, he painted '2 Cannisters Green and wrote Black Letters for Turkey Coffee'. Obviously certain conventions were upheld in using the colour green with yellow scrolls, but his work testifies to the efforts of shopkeepers to present their wares with a reliable consistency, and also attractively. In addition Edkins painted apothecary pots and sugar loaves, as well as completing work on the entire interior decoration of retailers' premises.[105]

The colour and diversity of the urban environment and its commodities evidently formed a spectacle. In London the Royal Exchange had been the centre for exotic merchandise since the seventeenth century and housed about two hundred shops which sold commodities imported from overseas through the East India Company, including silks, china and lacquer furniture. There the bored and disappointed 'Lydia', the subject of John Gay's poem 'The Toilette: A Town Eclogue', took to the upstairs walks:

> Through every Indian shop through all the Change;
> Where the tall jar erects his courtly pride,
> With antick shapes in China's azure dy'd;
> There careless lies the rich brocade unrolled;
> Here shines a cabinet with burnished gold:[106]

The image of the china jar in Gay's poem clearly makes use of commodities to suggest erotic interest. The development of urban retailing in which display was used to create desires, informs Gay's choice of the Exchange as the setting for his poem. Spaces in the city were increasingly organised as specialist retail centres (Fig. 20). It was possible to derive visual and tactile pleasures from artefacts which were a novel experience in the everyday lives of urban dwellers. Their exotic and seductive material qualities were easily appropriated into metaphor, or given emblematic meaning.

In centres like Bath the boundary between display for the purposes of selling and display as spectacle could easily be crossed. In a letter to his daughter Margaret, the Reverend John Penrose described a visit to Mrs Smith's shop 'where artificial flowers are made and sold'. Here the family saw 'a made Auricula' which had deceived the judges of the 'Florist's Prize', a competition for growers of this popular plant species:

> The Judges were set, the Flowers produced by their several Rearers, and this Flower by the Maker as the Production of Nature. So much in this Instance Art exceeded Nature, the Judges gave the Preference to this artificial Auricula, imagining it to be a true one. The Maker obtained the

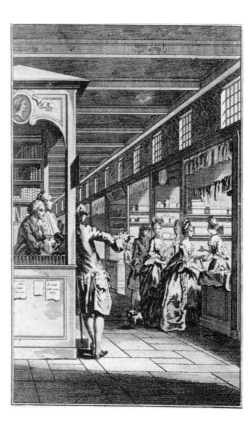

20] Hubert François
(Bourguignon) Gravelot,
The Unlucky Glance, etching
and engraving,
mid-eighteenth century,
book illustration of
unknown origin.

Prize, and was afterwards threatened with a Prosecution of the Imposture, unless the Prize was returned: but the Thing dropt, and Ingenuity had its Reward.[107]

John Penrose did not elaborate on the materials employed in this deception, but he referred his daughter to Ainsworth's *Dictionary* or Collier's *Historical Dictionary*, so that she might read of the 'antient story' in which, according to Penrose, the painters 'Zeuxes and Apelles' competed in their ability to imitate nature.[108] Penrose took the opportunity, like so many of the educated middle class, to make a point of learning from the novel and spectacular.[109]

The late eighteenth-century introduction of the showroom also marks the stage at which manufacturers developed products of distinctive quality and style, with Josiah Wedgwood and Messrs Hartley, Greens & Co. of Leeds the most eminent in fine ceramic production. The showroom increased public awareness of the products, and did so in a context which was more akin to an art exhibition or curio collection than a shop. They were predominant in centres like Bath and London where spectacles and exhibitions of all kinds were keenly sought and expected by a middle-class public.[110] When a young man, Silas Neville spent time in London frequently attending theatre performances and dropping in on

every kind of show available. In June 1767 he 'Went to James St, Golden Square to see some white Dresden china with hawks, herons etc. engraved by the Baron Burt, Canon of Hildersheim, who is the only person that possesses the art ...'.[111] Visits to manufactories were also taken in on Neville's travels and during a stay in Birmingham he toured both a button-making enterprise and 'a very singular manufactory of Baked paper ... which when varnished & polished in a particular manner has all the appearance of the fine Wood Japan with the addition of figures after the antique particularly the Etruscan'.[112] In the latter half of the century manufactories were considered 'sights' of production well worth including in a tour, and the middle classes became more inclined to travel in search of experiences which were both educational and curious in their urban modernity, as well as seeking the romantic and sublime in the picturesque landscape.[113] Neville's journey from the north to the south of England meandered in and out of the urban and the rural; the former he found disagreeable and the latter greatly to his liking. Derby he found a 'strange stragling place in a medow' where he saw the 'famous silk mills' turned by the river Daran and then saw 'the *fabricia di porcellano*'. Both forms of manufacture were in Neville's opinion 'improper to be attempted in this country'.[114]

Important though the expansion and increasing sophistication of the retail trade was, there were other contexts already outlined which formed a spectacle for the curious. In the event of death or financial ruin, the sale of a person's 'effects' was quick to follow. In fact a death could often mean financial ruin for a family when the creditors, often quite justifiably, took their opportunity to claim what was owed them and had been denied them during a person's lifetime. In Fanny Burney's novel *Cecilia*, which comments sharply on excessive consumption and social ambition, the heroine is put under pressure by a new London acquaintance, Miss Larolles, to attend the sale of Lord Belgrade's house and possessions: 'All the world will be there; and we shall go in with tickets, and you have no notion how it will be crowded'. Cecilia asks what is to be sold, and Miss Larolles informs her, 'O every thing you can conceive; house, stables, china, laces, horses, caps, every thing in the world'. Cecilia then discovers that Miss Larolles has no intention of buying anything, it is purely for the spectacle that she will attend: 'one likes to see people's things'.[115] These events became diverting amusements amongst a leisured, and often bored, urban middle and upper class.

Although the auction was a very useful method for the disposal of luxury goods, it was also perceived by some as morally reprehensible. In his poem *The Auction: A Town Eclogue*, William Combe,

the writer and pamphleteer, satirised the sale as a symptom of 'modern extravagance'. In the preamble he directed his invective against the auctioneers, whom he perceived as vultures waiting to swoop on the ailing fortunes of the genteel and honourable: 'The Gentlemen of the Wooden Hammer seem to thrive most by modern dissipation. Indeed, I have not a doubt, but the Heirs of Mr Christie and Mr Tattersall will look down upon many an impoverished Lord, &c. whose Father's extravagance, or perhaps his own, has helped towards the increase of their ample possessions.'[116]

Combe's poem traces the fate of a young woman, Vainetta, who wakes to the realisation that she is to lose the rich material possessions surrounding her. From austere and humble origins her desire to escape an arid existence led her to the 'pleasures of the Ton', a childless marriage to a 'scare-brain' and escape into 'a gilded mask'. What pains Combe's victim most is not simply the loss of her fine possessions, but the loss of them to 'Some purse-proud Cit' who seeks the better air of St James Square and who:

> May press this downy Couch, and loll in yonder Chair.
> Ye splendid forms, the gay and costly boast
> of *Seve* and *Dresden*, where will you be lost!
> No more from you will sav'vy incense rise,
> To wake the sense to evening sacrifice;
> O'er some old-fashion'd gaudy chimney plac'd,
> Your Owner, bless'd with pride, but void of taste,
> May leave your beauties to the dust a prey,
> And let your orient colours fade away.[117]

There was some accuracy in the fate Vainetta imagined for her Sèvres and Meissen, and William Combe may have written from his own bitter experience of bankruptcy. The sale was an effective means of redistribution of goods based on the misfortunes of others, and Combe's image of the fading beauty of commodities is suggestive of the destructive forces of consumption for those caught in financial ruin.

The notion of consumption as a destructive force which burned up the resources of a nation or an individual was persistent, and parallels were drawn with the progressive wasting of a pulmonary tuberculosis sufferer. At a later stage of crises in the narrative of Fanny Burney's *Cecilia*, the heroine tries to persuade her childhood friend to adopt a more moderate level of expenditure and give up what is obviously a ruinous pursuit of 'luxury'. Mrs Harrel is bemused by Cecilia's warnings of danger:

> 'What danger? cried Mrs. Harrel, much alarmed, 'do you think me ill? do I look consumptive?'
> 'Yes, consumptive indeed!' said Cecilia, 'but not, I hope, in your constitution.'[118]

The pursuit of hedonism in the Harrel household became a frantic bid to ignore approaching financial ruin rather than confront it. In fiction and in commentaries of the time there was an accurate perception that through excessive consumption values could become distorted, and that old values had certainly been challenged. On another level luxury consumption was also perceived as shifting the values associated with wealth. For example, the French middle-class observer of his times, Louis Sebastien Mercier, noted the degree of expense incurred in the purchase of luxury goods like the finest French or German porcelains: 'What a wretched luxury porcelains are! One tap of a cat's paw can do more damage than the loss of twenty arpents of land.'[119] The amount of money a luxury good represented skewed older notions of wealth held in bullion or land, which were safe and durable commodities rather than ephemeral and trivial.

On the other hand many claims were made to support the argument that trade and manufactures reached into people's imagination and added to their knowledge of the world. A late eighteenth-century German commentator expressed the importance of the market in the following terms:

> it enhances our pleasure through the multiplication of objects available; greater diversity creates an attraction to novelty; through this encounter with a wider and better selection of goods our taste is refined and our judgment focused. The range of our ideas is extended through the propagation of objects which represent them, and that has the effect of giving further incentive for thought, thereby enriching our knowledge.[120]

David Hume and Adam Smith were convinced that manufactures played a key role in the 'civilising process', particularly those manufactures allied to the 'liberal arts'. Apart from the few who left copious records like Josiah Wedgwood and Matthew Boulton, evidence of this connection having been made by entrepreneurs is elusive. At the beginning of the century what the market could provide in materials and finished goods for clothing the person was of paramount importance for the middle classes, and indeed for anyone who had reason to dissemble as to their true social status in order to live. The spectacle made of oneself was of prime significance at a time when non-elite dwellings were not yet developed as social spaces in which a complex material culture had something to say. But by the end of the century the middle-class home was rich in material goods which signified much about the social and cultural values of its occupiers, and there can be little doubt that the quality of life for those who could afford the new material goods was greatly enhanced. Furthermore, the absorption

of these goods into everyday life had a role to play in moulding and transforming the ways in which people thought and behaved.

Contested property

The corollary of increased production and consumption, and the ability of commodities to represent a higher value than their actual worth in material terms, was an increase in theft. In spite of draconian punishment awaiting those who were caught, thousands of men, women and children, and mainly those who were not of the propertied classes in Britain, resorted to thieving. In a world where people increasingly defined themselves through the ownership of goods, refined ceramic artefacts were not in fact a common target for the 'sneaks' and 'sharpers', 'dining-room jumps' and 'fidlum bens'.[121] Greater value could be gained for less trouble in the theft of fine textiles, jewels, watches and money. Stealing fragile and bulky items presented practical problems when swiftness in action and inconspicuousness were vital. Daniel Defoe did not give an account of Moll Flanders stealing seventeenth-century 'china'. Her targets were jewels, pocket watches, plate, money, lace and bales of cloth. Eighteenth-century newspapers reported a similar list of items stolen from the person, from shops or from private dwellings, but even though records of stolen goods which included fine ceramics were rare, such thefts did occur. On 11 February 1766 *Pope's Bath Chronicle* published an advertisement offering a reward of ten guineas to anyone who could give information leading to the prevention of 'divers Felonies which have lately been committed in the Parish of Bathwicke', or assist further in 'bringing the Person or Persons who committed the said Felonies to Justice'. Several summer-houses in the village close to the city of Bath had been robbed of 'Plate, Linen, China and other Effects', and a Mr John Hay was prepared to put up the reward should a successful conviction be obtained.[122]

The majority of thefts were committed 'against men and women of small property', often by people who were known to one another, and in many cases the value of the stolen goods may not appear great.[123] In 1784 the Bristol Gaol Delivery Fiats record a 'Margaret Lewis, wife of John Lewis' who was committed for trial on 10 February 'charged on the oath of John Meredith, & Mary his wife, with having feloniously stolen five earthen-ware cups, value two shillings, two earthen-ware jugs, value six pence, three tea-pots, value two shillings, & several other things …'.[124] It is possible that Margaret Lewis was employed by John and Mary Meredith; she may well have resented her employers for some reason and chosen theft as a means to extract some satisfaction, or she may have quite

simply desired to own artefacts which she found attractive and useful, but could not or would not purchase for herself. Motives for theft of this kind were seldom recorded.

Manufacturers of fine ceramics were a target for theft, on occasion for a considerable quantity of goods which required planning and organisation on the part of the thieves. In April 1776 John Antrobus, a Bristol clog maker, gave evidence against Joseph Townsend for the theft of a box of porcelain from Richard Champion's works at Castle Green. Townsend worked in the warehouse and seems to have planned to send or smuggle the box of china from its supposedly safe hiding place in the clog maker's house across the Severn estuary to Chepstow. Antrobus must have become suspicious, or curiosity got the better of him, because he opened the box and discovered it to contain one dozen cups and saucers, twelve cups, seven basons, one coffee pot, seven tea pots and 'sundry other pieces of china ware' which amounted to a value on the higher side of £1 12s. They were confirmed as belonging to the porcelain manufactory by one of Richard Champion's employees, John Britton, who was in fact a man with major responsibilities for the management of the site. Citizens in a relatively small city like Bristol kept a close eye on one another, and unusual goings on were conspicuous to people living at close quarters. It was not that easy to dispose of stolen goods without a fair chance that someone would recognise the artefacts and become suspicious.[125] The 1784–85 quarter sessions in Bristol recorded the theft of six cups and saucers to the estimated value of 20s, and if the estimate is correct these must have been fine porcelain pieces, and represented the same value as 8 lb of snuff, or 14 lb of tobacco listed as stolen in the same year. They were taken from John Wale's and John Chapman's china shop in Wine Street, where Elizabeth Chapman worked as a saleswoman. She testified to the fact that the cups and saucers produced in court were the same as those stolen from the shop, recognisable by their pattern. They were found in the house of one Nicholas Roach at Tower Lane in Bristol.[126]

In Liverpool the export trade in fine ceramics from the city manufactories and from Staffordshire was prolific by the last quarter of the eighteenth century, with much of the trade intended for America. Theft from the Livesley and Wainwright 'pot-house' in which 'Black Ware' was produced was reported in *Williams' Liverpool Advertiser* on 18 June 1777. A reward of two guineas was offered to anyone who could give information leading to the perpetrators of the crime being brought to justice. A ten guineas reward was offered by James Maury and Thomas Wolfe for information leading to the conviction of thieves who stole 'Five Crates of

Earthenware, containing Black Glazed Teapots, Cream Colour Dishes, Green Edged Ditto, One Crate of Cream Colour Cups and Saucers' from the Duke of Bridgewater's Quay on 12 May 1800.[127]

In the case of theft from shops and manufacturers, the watchful eyes of a Bristol artisan were early indications of the wage labour system driving a wedge between the petty bourgeois - the artisan clog maker - and the factory worker. But thefts of this kind were often strategies employed by men and women trying to gain something in what for many was a precarious and often wretched existence, made all the more bitter by witnessing the increasing affluence expressed through the ownership of commodities all around them. The East India House employee who left the warehouse with china hidden in the skirts of his coat, or the coffee warehouse worker who scooped up the grains spilled on the floor, might have employed the 'tactics of the weak' from one point of view, or practised sharp opportunism from another.[128] In the most extensive and diverse branches of skilled artisan trades and manufactures many workers developed systems of misappropriation, like the journeyman hatters who substituted an inferior material for one of higher value, a strategem known as 'bugging'.[129]

Smuggling was another favoured method of gain, the proportions of which are extremely difficult to determine, but likely to have been high. In August 1764 *Pope's Bath Chronicle* reported a 'Seizure of Foreign Laces, Cambrics, &c amounting to a considerable Value'. The goods, which were probably smuggled, were found 'near Eltham in Kent, from two antient Women, who travelled with a Jack Ass under cover of selling Earthen Ware: The Goods were concealed in large Earthen Jars, covered with Hay and Straw'. In the same year, and at the other end of the social scale, a 'Right Hon Personage', while travelling over Westminster bridge in a 'single horse Chaise', was found to be in possession of a 'considerable Quantity of China'. Custom-House officers seized '60 of the finest Dishes ever seen, besides silks, and many other Things to a considerable Value'.[130] It was permitted to bring small quantities of continental 'china' into the country, although it appears a considerable amount more than a small quantity was available on the market, some of it smuggled and some to which customs officers seemed to be blind.

The perception that crime rose in proportion to excessive luxury consumption cannot be easily verified; theft in all its various forms was as complex as the patterns of consumption attached to the legitimate ownership of goods. Other factors intervened to increase anxieties among property owners that crime was out of control, and the demobilisation of troops after the War of Austrian Succession was one such event, which brought large numbers of

men without the means to support themselves into a society which offered more opportunities to commit crime.[131] Each time a person was hanged for theft in England it was a lesson imparted by the ruling class – the monarch, judiciary, Church, Parliament and City – that respect for private property was 'at the heart' of the 'social contract'. According to the lawyer William Blackstone, 'Whatever ... hath a *Value* is the Subject of Property'.[132] Most people who were sentenced to hang had been convicted for stealing. The implementation of the law could depend on 'relatively humble people', and circumstances in Bristol would certainly seem to agree with this view. The 'small tradesmen, craftsmen, and artisans' who frequently apprehended law breakers may then have sat on the jury when an accused person came to trial.[133] In a century when the material conditions of people's lives underwent enormous change, and when the financial and legal structures associated with property were fundamentally revised, the conflict between labour and capital, between the propertied and the poor intensified.[134] The judicial system was one route through which the ruling class could assert control and authority, especially as the disempowered sought to counteract their weakness through attacks on property in a country which derived so much of its energy and a sense of self-worth from commerce and ownership.

A double standard was alive and vigorous. On 30 August 1764 *Pope's Bath Chronicle* updated its readers on the cargo of a Manila ship, the *Sante Trinidad*. En route for Acapulco it was seized and brought to England by some Ships of War belonging to Admiral Cote's Squadron: 'We are informed that there is no Plate nor Money in the cargo of the Manilla Ship ... as hath been asserted; there are 85,112 Pair of Silk Stocking, 20,000 Pieces of India Handkerchief, Silk thrown and raw, China Ware a large Quantity, India Piece goods of all Sorts, Silk and White cloth, a great Quantity of Muslins of all Sorts, Drugs, Spices &c'.[135]

Privateering was a strategy characteristic of the hostilities which rumbled on between rival colonial interests, and which was in part trade warfare. The seized cargoes represented a fraction of 'misappropriated things', animals and people on a mighty scale.[136] A barbarous trade of highly uncivilised proportions, colonial commerce was at the same time a trade which advanced 'civilised' practices in the West. Through the import of exotic and refined artefacts, and by adapting the social customs associated with commodities like coffee and tea from the Middle and Far East, middle- and upper-class Europeans discovered new ways to make themselves polite.

Notes

1 M. Misson, translated by Mr Ozell, *Memoirs and Observations in his Travels over England* (London, 1719), p. 11. See J. Brewer, '"The Most Polite Age and the Most Vicious": Attitudes Towards Culture as a Commodity 1660-1800', in A. Bermingham and J. Brewer (eds), *The Consumption of Culture, 1600-1800: Image, Object, Text* (London, Routledge, 1995), in which he argues that the 'weakness of court culture' left lacunae which made way for the development of a 'public sphere' of polite cultural interests, pp. 342-5. See also R. O. Bucholz, *The Augustan Court: Queen Anne and the Decline of Court Culture* (Stanford Calif., Stanford University Press, 1993).

2 As mentioned earlier for literature on Saxon court festivities and the Dresden 'Saturnfest' in particular see F. Sieber, *Volk und Volkstümliche Motivik im Festwerk des Barocks* (Berlin, Berlin Akademie Verlag, 1960), and M. Schlecte, 'SATURNALIA SAXONIAE – Das Saturnfest 1719 eine itonographische Untersuchung', *Dresdner Hefte 21: Beiträge zur Kulturgeschichte*, 8, 1 (1990), pp. 39-52.

3 R. Porter, *The Making of Geology* (Cambridge, Cambridge University Press, 1977), p. 54. High-quality glass was desired by the English nobility and its manufacture after the Restoration in 1660 was monopolised by the Duke of Buckingham, until George Ravenscroft invented lead glass while employed by the Glass Sellers' Company in the early 1670s.

4 P. Mathias, *The Transformation of England: Essays in the Economic and Social History of England in the Eighteenth Century* (London, Methuen, 1979), p. 27. For an interesting discussion in explanation of Britain's industrial growth in the context of Europe as a whole see D. Landes, *The Unbound Prometheus: Technological Change and Industrial Development in Western Europe from 1750 to the Present* (Cambridge, Cambridge University Press, 1969). Some British landowners were drawn more extensively into the industrial exploitation of their assets in the latter half of the century, especially those who had lead and coal seams on their land. P. Langford, *Public Life and the Propertied Englishman 1689-1798* (Oxford, Clarendon Press, 1991), pp. 62-3. After the Seven Years War of 1756-63, Saxony underwent a period of state reform in which manufactures were further encouraged and the infrastructure improved. This is perceived as a pre-industrial phase before the Saxon Industrial Revolution of 1800-60. See R. Forberger, *Die Manufaktur in Sachsen vom Ende des 16. bis zum anfang des 19 Jahrhunderts* (Berlin, Berlin Akademie Verlag, 1958), and *Industrielle Revolution in Sachsen: Die Revolution der Produktivkräfte in Sachsen 1800-61*, 2 vols (Berlin, Berlin Akademie Verlag, 1982).

5 Langford, *Public Life and the Propertied Englishman*, see pp. 558-9, and p. 64 with reference to Lord Verney's bankruptcy in the 1780s, but also the 'spectacular' expenditure of the Duke of Devonshire, p. 559. Capital investment in an estate like Chatsworth is estimated to have exceeded that of the largest factory in eighteenth-century terms. See M. J. Daunton, *Progress and Poverty: An Economic and Social History of Britain 1700-1850* (Oxford, Oxford University Press, 1995), p. 236.

6 For arguments concerning industrial growth before 1760 see P. Langford, *A Polite and Commercial People: England 1727-1783* (Oxford, Oxford University Press, [1989] 1992), pp. 650-51, and especially M. Berg, *The Age of Manufactures 1700-1820* (London, Fontana Press, 1985). L. Weatherill, *The Pottery Trade and North Staffordshire 1660-1760* (Manchester, Manchester University Press, 1971). It is also important to note that the capital investment, let alone the costs incurred in maintaining the British navy, far exceeded that of the large cotton manufactories and iron foundries. See J. Brewer, *The Sinews of Power: War, Money and the English State 1688-1783* (London, Unwin Hyman, 1989), pp. 34-5, and Daunton, *Progress and Poverty*, p. 236.

7 The full list of such instances would be too long but for some examples of those still in production today: Meissen (1710) subsidised until the 1830s by the Saxon House of Wettin; Doccia (1737) founded by the Marquis Carlo Ginori; Vincennes-Sèvres (1738) established by the *haute bourgeois* Orry de Fulvy and taken over by the royal house in 1759; Kloster-Veilsdorf (1760) established by Prince Friedrich Wilhelm Eugen von Hildburghausen, which was taken over by the Thuringian porcelain manufacturers, the Greiner brothers, in 1797.

8 See E. Adams, *Chelsea Porcelain* (London, Barrie & Jenkins, 1987), p. 65. E. Adams and D. Redstone, *Bow Porcelain* (London, Faber & Faber, 1981), p. 20.

9 E. Burke, 'Introduction on Taste', in *A Philosophical Enquiry into the Origin of our Ideas of the Sublime and the Beautiful* ed. A. Phillips (Oxford, Oxford University Press, [1759] 1990), p. 11.

10 *Ibid.*, p. 22.

11 For a very good discussion which teases out the complexities of eighteenth-century middle-class society and the perception of 'gentility debased' in the pursuit of fashion, see P. Langford, Chapter 3, 'The Progress of Politeness', in *A Polite and Commercial People*.

12 For example, Sir Watkin Williams Wynn lent cameos and gemstones for Wedgwood to copy in the 1770s, and in 1790 the copy of the Portland Vase was the subject of considerable public interest. See H. Young (ed.), *The Genius of Wedgwood* (London, Victoria and Albert Museum, 1995), pp. 62, 132. One of the problems facing Champion was that his products in imitation of continental porcelains were perceived as outmoded by many influential antiquarian collectors in British society in the 1770s.

13 Bristol Record Office. Richard Champion Letterbooks, Vol. IV, 1760-75, MS. 38083 (1-4) (7)S, 10 February 1775, fo. 22.

14 Thomas Pitt was reputed to be a collector of porcelains and interested in their manufacture. He was also the nephew of William Pitt the Elder, Earl of Chatham, and with influence and wealth behind him he encouraged William Cookworthy's enterprises in Plymouth and Bristol, agreeing to sell his china-clay and stone solely to Cookworthy. See R. M. Barton, *A History of the Cornish China-Clay Industry* (Truro, D. Bradford Barton Ltd, 1966), p. 20, and n. 4, p. 20. See also D. Holgate, *New Hall* (London, Chapman and Hall, rev. edn 1987), p. 6.

15 Bristol Record Office, Richard Champion Letterbooks, Richard Champion to Edmund Burke, 22 March 1775, fo. 150.

16 *Ibid.*, Edmund Burke to Richard Champion, 24 March 1775, fo. 169. Lord North had gained a high reputation during his office as Lord of the Treasury and as Chancellor of the Exchequer. He had tried, somewhat unsuccessfully and without sufficient nerve, to levy taxes on luxury consumption at a time when it was considered desirable to reduce the burden of taxation on essential goods and therefore on the poor. See Brewer, *The Sinews of Power*, pp. 216-17. Burke's interest in Champion's product was not entirely related to the support the latter gave him in the Bristol election of 1774. The formal and material qualities of ceramic artefacts interested him in the light of his *Philosophical Enquiry into the Origin of our Ideas of the Sublime and the Beautiful*; his search to explain those qualities inherent in the beautiful object, the 'smoothness ... in several sorts of ornamental furniture, smooth and polished surfaces'. See the *Philosophical Enquiry*, ed. A. Phillips, pp. 103-4.

17 Bristol Record Office, Richard Champion Letterbooks, Edmund Burke to Richard Champion, 24 March 1775, fo. 169.

18 *Papers Relative to Mr Champions Application to Parliament for the Extension of the Term of a Patent* (1775), p. 15.

19 For a concise summary of the advantages and disadvantages of patent rights see Daunton, *Progress and Poverty*, pp. 189–90.

20 For a more detailed account of the complex legal conditions affecting the Cornish china-clay and stone deposits see Barton, *A History of the Cornish China-Clay Industry*, Chapter 1, 'The Potters in Cornwall 1750–1820'. Wedgwood drove a hard case to win these rights and his methods were subject to sharp criticism. Richard Champion was primarily a merchant and heavily involved in Whig politics. Originating from a Quaker family, his relationship with a luxury product like porcelain was ambivalent, and his conduct in business perturbed the Bristol Society of Friends. In the exacting and complex production of hard-paste porcelain, without the injection of suffcient capital or expertise to drive further experiment, success was bound to elude Champion in the absence of single-minded application to the business. After the failure of the porcelain manufactory in Bristol, and subsequent difficulties in establishing his family in Staffordshire, the Marquis of Rockingham appointed Champion Paymaster General of His Majesty's Forces, a move justified on the grounds of his services to the Whig party, especially during Edmund Burke's successful 1774 election campaign in Bristol. Champion eventually retired to live in America where he died in 1791, but not before writing his *Comparative Reflections on the Past and Present Political, Commercial, and Civil State of Great Britain*, published in London in 1787, in which he railed against luxury consumption and the East India trade, but with no hint whatsoever of his past involvement with porcelain manufacture or any direct reference to the product beyond a reference to the 'luxurious elegance of our tables', p. 239.

21 On New Hall see Holgate, *New Hall*.

22 In continental Europe porcelains for a middle-class market emerged in the 1760s. For example, the community of potters and glassmakers in Thuringia began the manufacture of porcelains based on Meissen models, but more modest in form and painted decoration, and which were accessible to the rural and urban middle classes in the relatively liberal Duchy of Saxe-Weimar and beyond. Workers from these enterprises were also instrumental in establishing porcelain manufactories in Bohemia, the two regions benefiting from a geography which ensured local supplies of timber at a low cost, as well as access to water power. For histories of the Thuringian and Bohemian enterprises see H. Scherf, *Thüringer porzellan unter besonderes Berücksichtigung der Erzeugnisse des 18 und frühen 19 Jahrhunderts* (Leipzig, Seeman Verlag, 1980); W. Stieda, *Die Anfänge der Porzellanfabrikation auf dem Thüringerwalde* (Jena, 1902); E. Poche, *Bohemian Porcelain* (Prague, Artia, 1954).

23 English soft-paste porcelains were not suitable for the manufacture of plates, which is one reason why tewares formed a major part of production at New Hall. Creamware was still the best clay body for dinner plates and large serving dishes. It was followed by the development of pearlware, which with its blue-tinted glaze was more suitable for the application of blue transfers and marked the beginning of the 'Willow Pattern' series. See R. Copeland, 'Josiah Spode and the China Trade', *English Ceramic Circle Transactions*, 10, 2 (1977), p. 99.

24 See M. Reynolds, 'Irish Fine-Ceramic Potteries, 1769–96', *Post-Medieval Archaeology*, 18 (1984), pp. 251–2. The work of Mairead Reynolds, and more recently Peter Francis, has made a long overdue contribution to the history of fine ceramic production in Ireland. The account which follows is indebted to their work, which merits wider reading.

25 The difficult relationship between England and Ireland in matters of trade reached a peak of tension at this time, but it was of long standing, particularly with regard to the production of wool. For a substantial contemporary analysis of Irish trade in the mid-eighteenth century see M. Postlethwayt, *Britain's Commercial Interest Explained and Improved*, Vol. I (London, 1757). For a later analysis

and passionate plea for free trade in Ireland see E. Burke *Irish Affairs* ed. M. Arnold (London, Century Hutchinson, [1881] 1988), pp. 97–115. In 1772 a former employee at the Chelsea Manufactory approached James Caulfield, Earl of Charlemont and Lord Lieutenant of Ireland, requesting his consideration of a plan to establish a porcelain manufactory in Dublin. One of the arguments put forward in favour of the project was the easier access to timber and coal than in an urban area like London. Obviously nothing came of the plan, and one of the main obstructions may have been the difficulty in obtaining suitable minerals. See B. Denvir, *The Eighteenth Century: Art, Design and Society 1689–1789* (London, Longman, 1983), pp. 216–18.

26 Geologically rare, Carrickfergus clay was like the deposits found in East Anglia and Kent, chiefly exploited in London and Norwich delftware production from the late sixteenth and early seventeenth centuries. P. Francis, 'The Belfast Pott-house, Carrickfergus Clay and the Spread of the Delftware Industry', *English Ceramic Circle Transactions*, 15, 2 (1994), p. 270.

27 Reynolds, 'Irish Fine-Ceramic Potteries', p. 257. Mairead Reynolds argues that one of the most damaging factors militating against the growth of fine ceramic production was the inability to obtain raw materials on credit. The Irish pottery entrepreneurs could only buy small quantities of materials in cash all the year round, instead of purchasing large quantities on credit at less cost and in the cheaper off-peak seasons.

28 Francis, 'The Belfast Potthouse', p. 270.

29 Burke, *Irish Affairs*, pp. 110–11.

30 P. Francis, 'Irish Creamware: The Downshire Pottery in Belfast', *English Ceramic Circle Transactions*, 15, 3 (1995), p. 402.

31 Reynolds, 'Irish Fine-Ceramic Potteries', pp. 252–3. Wedgwood was already active as founder of the General Chamber of Manufactures, which opposed Pitt's re-forms in lifting at least some of the restrictions on Irish trade which North had earlier failed to secure. See Francis, 'Irish Creamware', pp. 402–3. The fear that Ireland was capable of undercutting English goods on foreign markets was of long standing. See Postlethwayt's *Britain's Commercial Interest Explained and Improved* for a mid-eighteenth-century analysis of trading relations between England and Ireland, and arguments for the desirability of Ireland's union with England.

32 Francis, 'Irish Creamware', p. 403.

33 For further discussion of Thomas Greg's Downshire Pottery see Francis, 'Irish Creamware' and Reynolds, 'Irish Fine-Ceramic Potteries'.

34 The exact circumstances of the establishment of Vincennes-Sèvres are not clear, but it is known that the King's Commissioner for the French East India Company, Orry de Fulvy, was responsible for forming a company of sorts comprising seven shareholders in 1745. See S. Erikson and G. de Bellaigue, *Sèvres Porcelain: Vincennes and Sèvres 1740-1800* (London, Faber & Faber, 1987), p. 29.

35 Like Orry de Fulvy's enterprise, the later Paris porcelains were largely established with a board of sleeping partners. These hard-paste porcelain manufactories were private enterprises, but whenever possible members of the nobility were per-suaded to put capital into the business and to publicise their support in opposition to Sèvres. For a history of these manufactories see R. de Plinval de Guillebon, *Paris Porcelains 1770-1850* trans. R. Charleston (London, Barrie & Jenkins, 1972).

36 For a history of this interesting enterprise see Adams and Redstone, *Bow Porcelain*. Chapter 2 explains the formation of the partnership outlined here.

37 *Ibid.*, p. 38.

38 Liverpool Record Office, Liverpool Libraries and Information Serives, Entwistle Collection, 942 Ent/1 (1922), fo.13, Underhill MSS, Vol. 16. Where water and wind power were not realistic options, manufacturers used horse power to drive grinding mechanisms until replaced by steam.

39 *Ibid.,* fo.100.

40 J.Hoppit, *Risk and Failure in English Business 1700-1800* (Cambridge, Cambridge University Press, 1987), p.126.

41 For a comprehensive account directly relevant to ceramic manufactures see L. Weatherill, 'Capital and Credit in the Pottery Industry Before 1770', *Business History,* 24 (1982), and *The Pottery Trade and North Staffordshire 1660-1760.* See also the very interesting chapter by J.Brewer, 'Commercialization and Politics', in N. McKendrick, J.Brewer and J.H. Plumb, *The Birth of a Consumer Society: The Commercialization of Eighteenth-Century England* (London, Europa Books, 1982). For a clear explanation of the merits and demerits of credit see Daunton, *Progress and Poverty,* pp.247-52. On the complexities of bankruptcy and credit see Hoppit, *Risk and Failure in English Business.*

42 B.Hillier, 'The Turners of Lane End', *English Ceramic Circle Transactions,* 6, 1 (1965), p.5.

43 For an excellent account of William Greatbatch see D. Barker, *William Greatbatch a Staffordshire Potter* (London, Jonathan Horne, 1991).

44 Liverpool Record Office, Liverpool Libraries and Information Services, Entwhistle Collection, fos 50-1, fo.135. The 'Dog-house' was a kennel where a pack of hounds were kept on subscription. Livesley was involved in several pottery businesses over several decades.

45 Hoppit, *Risk and Failure in English Business,* p.28.

46 Letter to Thomas Bentley, 23 August 1772, cited in N.McKendrick, 'Josiah Wedgwood and Cost Accounting in the Industrial Revolution', *Economic History Review,* 23 (1970), p.49, and Young (ed.), *The Genius of Wedgwood,* p.103. Wedgwood compiled his 'Price Book of Workmanship' when the over-production of vases drained capital in costs for materials and extra expenses. See also N.McKendrick, 'Josiah Wedgwood and Thomas Bentley: An Inventor-Entrepreneur Partnership in the Industrial Revolution', *Transactions of the Royal Historical Society,* 14 (1964), pp.30-1.

47 Hoppit, *Risk and Failure in English Business,* p.14.

48 A. Ferguson, *An Essay on the History of Civil Society* ed. F. A. Oz-Salzburger (Cambridge, Cambridge University Press, 1995), pp.172-3.

49 The emergence of the individual ceramic practitioner is a twentieth-century phenomenon which has arisen out of particular changes in economic and institutional structures. The desirability of small-scale craft operations practising with traditional materials and techniques has its roots in the Arts and Crafts Movement. These principles were influential in forming the inter-war studio pottery movement among a small group of moneyed individuals who also absorbed the aesthetic of the Japanese ceramic tradition. Post-war transformations in art education, and the supply of materials and kilns through the educational and 'hobby' trade in the ceramic industry, has allowed for an expansion in individual studio practice.

50 For further discussion of these transformations in manufacturing practice see Berg, *The Age of Manufactures,* and with reference to the textile industries see J.Styles, 'Manufacturing Consumption and Design in Eighteenth-Century England', in J.Brewer and R.Porter (eds), *Consumption and the World of Goods* (London, Routledge, 1993).

51 See C. Williams-Wood, *English Transfer-Printed Pottery and Porcelain: A History of*

Over-Glaze Printing (London, Faber & Faber, 1981). The *English Ceramic Circle Transactions* include many meticulously researched contributions to the history and techniques of transfer printing too numerous to mention here.

52 For detailed accounts of these processes and techniques in Staffordshire see Barker, *William Greatbatch a Staffordshire Potter*. The best publication to throw light on the structure and organisation of luxury porcelain manufacture is R. Rückert's, *Biographische Daten der Meißener Manufakturisten des 18 Jahrhunderts* (Munich, Bayerisches Nationalmuseum, 1990). For a good chapter on 'Materials and Technique' at Sèvres see Erikson and de Bellaigue, *Sèvres Porcelain*.

53 In Staffordshire plaster of Paris was probably introduced *c.* 1740. See Barker, *William Greatbatch*, p. 18. In Meissen records indicate that plaster moulds were in use from the beginning. This would not be surprising as the early Meissen modellers were trained initially as sculptors and had experience of working in several different materials and techniques which required mould-making skills.

54 Unfortunately little is known in detail about this fundamental branch of ceramic manufacture. The exhaustive biographical survey of the Meissen Manufactory in the eighteenth century undertaken by Rainer Rückert leaves no doubt that these workers formed a substantial and highly skilled force, known as the 'Weißes Corps' or 'White Company', which also included the throwers. See Rückert, *Biographische Daten der Meißner Manufakturisten*, pp. 97-133. For an excellent and clear account of Staffordshire production see Barker, *William Greatbatch*, pp. 18-19, 112-18. In addition to the potter's wheel, the mechanically assisted techniques applied in fine ceramic production were those of lathe-turning, and, in the 1760s, engine-turning. The application of lathe-turning was important for the production of precisely formed and lightweight hollowwares. See Barker, *ibid.*, pp. 119-120, and on engine-turning see also J. Adeney, 'Incised and Impressed Decoration on Wedgwood', *Thirty-Fourth Annual Wedgwood International Seminar* (1989), pp. 103-24.

55 This pattern of middle-class ownership of silver in a trading port like Bristol is commonly confirmed by probate inventories. For a wide survey see L. Weatherill, *Consumer Behaviour and Material Culture in Britain 1660-1760* (London, Routledge, 1988). On the Continent faience manufactories provided an alternative to plate until gradually superseded by cheaper porcelains and creamwares in the mid to late eighteenth century, largely because the latter two were very much more serviceable and durable.

56 Liverpool Record Office, Liverpool Libraries and Information Service, Entwhistle Collection, fo. 75, 17 January 1764. Dunbibin was also a manufacturer of delftware and tiles. He and his partner John Lathom went bankrupt in 1768. 'Mellons' were conventional in shape but characterised by green and yellow glazes, sprigged and rouletted decoration. Cauliflower ware was commonly referred to in the trade as coloured 'moulded ware'. See Barker, *William Greatbatch*, pp. 254-8.

57 E. Benton, 'The London Enamellers', *English Ceramic Circle Transactions*, 8, 2 (1972), p. 141.

58 For example the well-documented business run by James Giles in London. See A. M. George, *James Giles, China and Enamel Painter 1718-1780*, Exhibition Catalogue (Albert Amor Ltd. 1977), and several articles in the *English Ceramic Circle Transactions*: A. Toppin, 1933; W. B. Honey, 1951; R. J. Charleston, 1967.

59 By kind permission of Bristol Reference Library, Michael Edkins, Ledger Book 1761-1786, MS 20196. This is an exceptionally interesting document, giving insight into the range of work undertaken by a versatile 'sign painter'. Edkins originally trained as an enamel painter in Birmingham and then worked at the Redcliffe Back delftware pottery in Bristol. When delftware production declined he turned to coach painting and interior work for a Mr Simmons, eventually

establishing his own business in Bridge Street. He was considered the best enameller in Bristol at the time, especially on pottery and the fashionable opaque white and blue Bristol glass. He also undertook interior work in private houses, churches and shops, as well as a considerable amount of work for the King's Theatre. He was apparently a good musician and had a fine counter-tenor voice which brought him frequent engagements at the theatre in Bristol, and for a short time at Covent Garden in London. See H. Owen, *Two Centuries of Ceramic Art in Bristol* (Gloucester, 1873), p. 329. For Edkins's activity as a glass enameller see M. Archer and R. J. Charleston, 'Michael Edkins and English Enamelled Glass', *Transactions of the Society of Glass Technology*, 38 (1954), pp. 3-16.

60 David Barker points out that little is known about creamware decorators and the organisation of their work in Staffordshire. Archaeological excavations which reveal the existence of enamel-painted 'wasters', or flawed items, in a manufactory tip, confirm that an enamel-painting shop was established in house, as was the case in William Greatbatch's enterprise.

61 Young (ed.), *The Genius of Wedgwood*, p. 53.

62 It was possibly the engraver, John Brooks of Birmingham, who was responsible for hitting on the principle of transfer printing on japanned wares in 1753. Brooks moved to London, probably in the same year, and with the Irish delftware potter Henry Delamain from Dublin he joined in partnership with Stephen Janssen at the Battersea Enamel Works, but the enterprise failed within a short time of opening. The Delamain connection may be significant in that he had contacts with the Liverpool potters, and might have informed them about the potential for transfer printing on ceramics which was achieved by Sadler and Green in collaboration with the delftware potters Thomas Shaw and Samuel Gilbody in 1756, but this remains conjecture. Transfer printing was possibly begun at Bow by the engraver Robert Hancock who moved to the Worcester porcelain manu-factory when Bow's future became uncertain, and where the technique was greatly improved. See Williams-Wood, *English Transfer-Printed Pottery and Porce-lain*, pp. 40-1 and 52-5.

63 Declaration of Thomas Shaw and Samuel Gilbody, the delftware potters who 'burnt' the tiles. Williams-Wood, *English Transfer-Printed Pottery and Porcelain*, p. 103.

64 There were two principal methods of transfer printing. The image was usually etched and engraved into a copper plate, 'inked' with prepared pigment and printed onto tissue paper made from textile waste – which is much stronger than the wood pulp variety. The image was then applied directly onto the surface of a ceramic tile or vessel previously coated with a size for adhesion if glazed. Wrinkles were eliminated with the use of a boss, and with application to three-dimensional forms the print had to be cut to fit the contour of the vessel. The abrasive powdered glass included in the pigment wore the copper plates out very rapidly and Sadler and Green developed a pouncing technique to avoid this problem. See Williams-Wood, *ibid.*, pp. 48-9. The other technique employed was so-called 'bat-printing', in which a gelatine based 'bat' was used to pick up the image from the 'inked' copper plate, then placed directly onto the prepared surface of the vessel. The advantage of this technique was that it eliminated some of the problems in a tissue transfer, because the 'bat' had an elastic property which shaped itself to the convex surface of hollowwares. The pieces were then fired to fuse the printed image to the glaze, or in the case of underglaze printing to harden the image onto the dry 'biscuit' surface before glazing. The technique of underglaze transfer printing took longer to perfect than on-glaze and was im-proved at the Caughley porcelain manufactory in Shropshire by Robert Hancock.

65 Williams-Wood, *ibid.*, p. 24.

66 N. McKendrick, 'Josiah Wedgwood and Factory Discipline', *Historical Journal*, 4 (1961), p. 35.

67 Ferguson, *An Essay on the History of Civil Society*, p. 174. Ferguson's work was informed by the methods of natural history as they were then understood and debated by his fellow men of letters in the Scottish Enlightenment, among them Adam Smith. The *Essay on the History of Civil Society* is particularly apposite because his main concern was to account for the 'progress of human society from the "rude" to the "polished" state'. See T. Benton, 'Adam Ferguson and the Enterprise Culture', in P. Hulme and L. Jordanova (eds), *The Enlightenment and its Shadows* (London, Routledge, 1990), p. 104.

68 The existence of the East India Company long preceded that of the Bank of England, which was established in 1694. It was a joint-stock company with affiliations to both Tory and Whig interests – the 'Old' and 'New' East India Companies – which merged in 1709 to become the United East India Company. For a history and analysis of trade and operations see K. N. Chaudhuri, *The Trading World of Asia and the English East India Company 1660-1760* (Cambridge, Cambridge University Press, 1978). For an analysis of English financial institutions and economic structures 1660-1720 see B. C. Curruthers, *City of Capital: Politics and Markets in the English Financial Revolution* (Princeton, Princeton University Press, 1996). Louis Dermigny's *La Chine at L'Occident: Le Commerce à Canton au XVIII siècle* (Paris, S. E. V. P. E. N., 1964) is an exhaustive and rewarding study of the East India trade in Europe as a whole.

69 D. Hume, 'Of Commerce', in *David Hume: Selected Essays*, ed. S. Copley and A. Edgar (Oxford, Oxford University Press, World's Classics Series, 1993), p. 163.

70 C. Davenant, *Sir Charles Davenant: The Political and Commerical Works of that Celebrated Writer*, collected and revised by Sir Charles Whitworth (London, 1771), p. 96. The original works were published between 1695 and 1712. See also Sir Josiah Child, *A New Discourse of Trade* (London 1693).

71 Davenant, *The Political and Commercial Works*, p. 91.

72 For an account of the 'Calico Campaign' see B. Lemire, *Fashion's Favourite: The Cotton Trade and the Consumer in Britain 1660-1800* (Oxford, Oxford University Press, 1991), pp. 21-42.

73 C. Sheaf and R. Kilburn, *The Hatcher Porcelain Cargoes: The Complete Record* (Oxford, Phaidon/Christies, 1988) is a very good account of the trade in general with a description of the salvaged cargo of the 'Geldermalsen', a Dutch East India vessel which hit a coral reef in 1752.

74 D. Howard and J. Ayers, *China for the West: Chinese Porcelain and other Decorative Arts for Export* (London and New York, Sotheby Parke Bernet, 1978), p. 21. This is a well-catalogued and beautifully illustrated survey of the Chinese export porcelains in the Mottahedeh Collection.

75 *Ibid.*, p. 14.

76 For a comprehensive study of all the major branches of Chinese exports for the West see C. Clunas (ed.), *Chinese Export Art and Design* (London, Victoria and Albert Museum, 1987).

77 While some copies are gauche, others are highly skilled and in the case of engraved subjects have led to controversy as to whether or not the Chinese used transfer printing techniques. They did not, however; instead they painstakingly reproduced the Western printed image *en grisaille*, and a well-known example is that of Hogarth's satirical portrait of John Wilkes. See Howard and Ayers, *China for the West*, Vol. 1, p. 244. It is thought that Chinese artists learnt enamel-painting skills from the Jesuit missionaries who were very active in the country during the seventeenth century.

78 *The East India Sale* (London, September the First, 1719), pp. 227-39. The *Carnarvon* also carried teas and Indian textiles.

79 See L. Weatherill, 'The Growth of the Pottery Industry in England, 1660-1815', unpublished PhD thesis, University of London (1983), pp. 102-4. For a wider analysis of goods see her book *Consumer Behaviour and Material Culture in Britain 1660-1760*, and on calicoes see Lemire, *Fashion's Favourite*. Lorna Weatherill's work on probate inventories supports the view that East India porcelains were accessible to middle income groups in the early eighteenth century to a limited extent. The cost of a blue and white East India teabowl, and later in the century a teapot, was likely to be less than the tea served in it. A complete dinner service, however, was too expensive other than for the nobility, the wealthy landed gentry and top economic layer of the middle class.

80 For a history of the East India trade which fleshes out the role of the supercargo see H. B. Morse, *The Chronicles of the East India Company Trading to China, 1635-1834* (Oxford, 1926).

81 *A Voyage to the East Indies in 1747 and 1748* (London, 1762), p. 310.

82 For an interesting discussion of the Commutation Act and tea dealing in general see H. C. and L. H. Mui, *Shops and Shopkeeping in Eighteenth-Century England* (London, Routledge, 1989), pp. 250-72, and also Chaudhuri, *The Trading World of Asia and the English East India Company*, pp. 385-406. The corollary of high duties on tea and other luxury goods, including continental porcelains on occasion, was a great deal of smuggling activity. There was a prohibition, imposed in 1672, on the importation of continental porcelains and Delftwares, except for private use. The embargo was not lifted until 1775. See p. 44.

83 *The East India Sale*. 'Ringing' refers to the practice of striking a porcelain vessel to test whether or not it had a hairline crack. If so the vessel would transmit a flat or 'dead' tone as opposed to a 'live' ringing tone.

84 See A. Topping 'The China Trade and Some London Chinamen', *English Ceramic Circle Transactions* (1934), pp. 37-57. This article contains good examples of trade cards issued by London china sellers.

85 P. Earle, 'The Middling Sort in London', in J. Barry and C. Brooks (eds), *The Middling Sort of People: Culture, Society and Politics in England, 1500-1800* (London, Macmillan, 1994), p. 146.

86 R. Campbell, *The London Tradesman* (London, 1747), p. 188. The purpose of Campbell's book was to describe the personal aptitudes and requirements of the trades for parents seeking to place a child in apprenticeship.

87 For an interesting account of this system of retailing in clothes and accessories see T. Fawcett, 'Bath's Georgian Warehouses', *Costume*, 26 (1992), pp. 32-9.

88 See J. Draper, 'Inventory of Ann Shergold, Ceramic Dealer in Blandford, Dorset', *Post-Medieval Archaeology*, 16 (1982), pp. 85-91. The few extant household inventories from Blandford which correspond closely in date confirm that fine ceramic and glass wares were in use. For a late seventeenth-century inventory which gives an excellent breakdown of stock held in a small market town before the East India Company porcelains entered London in significant quantities, see D. G. Vaisey and F. S. C. Celoria, 'Inventory of George Ecton, "Potter", of Abingdon, Berks, 1696', *Journal of Ceramic History*, 7 (1974), pp. 13-42. For an account of the fine Nottingham salt-glazed stonewares see Chapter 3 of A. Oswald's book *English Brown Stoneware* (London, Faber & Faber, 1982).

89 *Bath Chronicle and Weekly Gazette*, 21 May 1761 (Bath Central Library).

90 On advertising see J. Styles, 'Manufacturing, Consumption and Design', in Brewer and Porter (eds), *Consumption and the World of Goods*, pp. 541-42.

91 B. Lemire, 'Consumerism in Preindustrial and Early Industrial England: The Trade

in Secondhand Clothes', *Journal of British Studies*, 27 (1988), p. 8, and n. 17, pp. 8-9. The peddling described was observed by Henry Mayhew in the mid-nineteenth century, although the practice had been common for centuries before, and certainly in the 1700s.

92 William Beloe, china dealer in Norwich, claimed to trade directly with Staffordshire in 1783, because the manufacture had 'improved' there. See S. Smith, 'Norwich China Dealers of the Mid-Eighteenth Century', *English Ceramic Circle Transactions*, 9 (1974), p. 128. He supplied Parson James Woodforde's Norfolk vicarage with creamwares; see Chapter 4, p. 157. For an interesting anecdotal account of itinerant ceramic traders see B. Hillier, 'Two Centuries of China Selling', *English Ceramic Circle Transactions*, 7 (1968), pp. 2-15. For a useful account of pottery production and consumption in Wales see E. Campbell, 'Post-Medieval Pottery in Wales: An Archaeological Survey', *Post-Medieval Archaeology*, 27 (1993), pp. 1-13. For a very fine illustrated catalogue of the English pottery products available on the market see L. B. Grigsby, *English Pottery 1650-1800: The Henry H. Weldon Collection* (London, Sotheby's Publications, 1990).

93 At Chelsea Nicholas Sprimont was in difficulties due to ill health and had been forced to cancel his annual sale in London, but Chelsea porcelains were still reaching the market through dealers.

94 The Meissen Manufactory produced a substantial quantity of 'Mittelgut' wares, or 'seconds'. These were ordered by dealers who supplied a middle-class demand for fluted, but relatively plain blue and white ('Blau geript') and straw coloured (Paille geript) tea and coffee wares. A smaller quantity of 'Mittelgut' pieces for dinner services – and chamber pots – was ordered, for example in 1775 by C. D. Hertwig in Marienberg, C. H. Loh and Frau Wittib in Schleswig, and the brothers Gastel in Warsaw. Staatliche Porzellan-Manufaktur Meissen GmbH, A. A. IV g 22 Handelswesen, 1775. Meissen products which were proving difficult to shift on the market because they were perceived as outmoded, or because they were not of the best standard, were sold quite frequently at auction in the last quarter of the eighteenth century. Auctions continued to take place in the nineteenth century after the wars with France were over.

95 L. Weatherill, 'The Growth of the Pottery Industry in England 1660-1815', p. 129. See also L. Weatherill *The Pottery Trade and North Staffordshire 1660-1760*.

96 Messrs Hartley, Greens & Co., order book in the Victoria and Albert Museum, see S. Lambert (ed.), *Pattern and Design: Designs for the Decorative Arts 1480-1980* (London, Victoria and Albert Museum, 1983), p. 72.

97 The first Leeds drawing book to survive is dated 1786. See D. Towney, *The Leeds Pottery* (London, Cory, Adams & Mackay, 1963), p. 49. For further discussion of pattern books and their uses see Chapter 5, pp. 194-5.

98 Josiah Wedgwood's first catalogue of creamwares was issued in 1774, Hartley and Green's in 1783.

99 University of Keele, Wedgwood Archive, L. 79-13652, Josiah Wedgwood to Madame Conradi, 27 August 1779.

100 University of Keele, Wedgwood Archive, W/M 1513, Basil Paul Schilling to Josiah Wedgwood, 24 September 1790. Letter transcribed by A. Chisholm.

101 See N. McKendrick, 'Josiah Wedgwood: An Eighteenth-Century Entrepreneur in Salesmanship and Marketing Techniques', *Economic History Review*, 2nd Series, 12 (1960), pp. 408-25. Towney, *The Leeds Pottery*, pp. 56-8. The pattern books, drawing books and catalogues were distinct from those order books which recorded the specifications and cost of individually commissioned items and table services. Many of these orders were intended as gifts and were exchanged between members of the European nobility and *haute bourgeoisie*. These represented the European manufacturers equivalent to the private orders placed in

Canton by the supercargoes, but the latter were less costly than many of the elite porcelain manufactories at home.

102 University of Keele, Wedgwood Archive, 79-13649 Madame Conradi to Josiah Wedgwood, 16 January 1776.

103 See Mui and Mui, *Shops and Shopkeeping*. The authors have brought to light the pivotal role of the shopkeepers in the distribution of the new consumer goods. R. M. Berger's *The Most Necessary Luxuries: The Mercer's Company of Coventry, 1550-1680* (Pennsylvania, The University of Pennsylvania Press, 1993) reveals the complex nature of trade at all levels in the realignment of the urban economy in England before the eighteenth century.

104 For an interesting and detailed study see C. Walsh, 'Shop Design and the Display of Goods in Eighteenth-Century London', *Journal of Design History*, 8, 3 (1995), pp. 157-76. For the luxury market in Paris, which is particularly interesting for its discussion of trade between France and England, see C. Sargentson, *Merchants and Luxury Markets: The Marchands Merciers of Eighteenth-Century Paris* (London, Victoria and Albert Museum, 1996), Chapter 6.

105 By kind permission of Bristol Reference Library, Michael Edkins Ledger Book 1761-86, MS 20196.

106 J. Gay, 'The Toilette: A Town Eclogue', in *The Works of the English Poets*, Vol. 41, John Gay Vol. 1 (London, 1779), pp. 225-26. In William Wycherley's *The Country Wife* (1675), the 'New Exchange', as it was then known, was the site chosen for the scene in which Horner attempts to seduce Margery Pinchwife, who is disguised as a boy. The Exchange was close by Covent Garden, the centre for the trade in pornography and sexual aids, and from where prostitutes worked in the numerous 'bawdy houses'. Women worked in, and in some cases owned or managed, many of the 'India' shops in the Exchange, and men would cruise the 'walks' to gaze and confuse these women with the Covent Garden prostitutes and female traders in sexual material. See J. G. Turner, '"News from the New Exchange": Commodity, Erotic Fantasy, and the Female Entrepreneur', in Bermingham and Brewer (eds), *The Consumption of Culture, 1600-1800*.

107 B. Mitchell and H. Penrose, *Letters from Bath 1766-1767 by the Reverend John Penrose* (Gloucester, Alan Sutton 1983), p. 123.

108 For a discussion of this competition see N. Bryson, 'Xenia', in *Looking at the Overlooked: Four Essays on Still Life Painting* (London, Reaktion Books, 1990), pp. 30-1. It was the contest recorded by Pliny in his *Natural History, XXXV*, 65, in which Zeuxis's depiction of grapes on the 'walls of the stage' fooled the birds into thinking they were real and edible fruits. Parrhasios painted a curtain which deceived Zeuxis that it was a drape concealing an image behind it, whereupon having fooled *only* the birds Zeuxes surrendered the prize to Parrhasios for having deceived a *painter's* eye.

109 On this subject see B. M. Stafford, *Artful Science: Enlightenment and Entertainment and the Eclipse of Visual Education* (Cambridge, Mass., MIT Press, 1994). With reference to the print as a source of instruction and entertainment see chapter 4 of Timothy Clayton's excellent study, *The English Print 1688-1802* (New Haven and London, Yale University Press, 1997).

110 For an essay very much to the point see M. Baker, 'A Rage for Exhibitions', in Young (ed.), *The Genius of Wedgwood* pp. 118-27, with particular reference to Josiah Wedgwood's display of the Frog Service. For an extensive study of London entertainment see R. D. Altick, *The Shows of London* (Cambridge, Mass., Belknap Press at Harvard University Press, 1978) which also emphasises the interplay of the market with spectacle.

111 B. Cozens-Hardy (ed.), *The Diary of Silas Neville 1767-1788* (London, New York and Toronto, Oxford University Press, 1950), p. 9. By permission of Oxford University

Press. There are a few extant examples of these 'intaglios' on undecorated Meissen porcelain which represent a unique form of 'Hausmaler' work, i.e. applied decoration, normally gilding and enamelling, undertaken outside the manufactory which was commissioned or sanctioned by the directorate. Some Hausmaler pieces were executed without such authority, which was an illegal practice.

112 *Ibid.*, p. 280. 'Baked paper' referred to papier mâché.

113 There are several publications which investigate the difficulty people experienced in late eighteenth-century England of accommodating changing patterns in labour, changes which had an impact on the rural and urban environment and how they should be represented in the production of art and literature. For an interesting discussion on this theme see J. Barrell, 'Visualizing the Division of Labour: William Pyne's *Microcosm*', in *The Birth of Pandora and the Division of Knowledge* (London, Macmillan, 1992). For a very important and rich contribution see R. Williams, *The Country and the City* (London, Hogarth Press, 1985), especially Chapters 8, 12 and 13. See also D. E. Cosgrove, 'Sublime Nature: Landscape and Industrial Capitalism', in *Social Formation and Symbolic Landscape* (London and Sydney, Croom Helm, 1984).

114 Cozens-Hardy, *The Diary of Silas Neville*, p. 277. James Raven has some interesting observations to make on the 'mysteries of industrial operations' and the frustration of visitors in the 1780s, who were refused entry to industrial sites like Arkwright's mills and the chemical works at Prestonpans. The reasons for this were partly due to concerns regarding the safety of visitors, and partly to protect trade secrets. See *Judging New Wealth: Popular Publishing and Responses to Commerce in England, 1750-1800* (Oxford, Clarendon Press, 1992), pp. 233-4.

115 F. Burney, *Cecilia, or Memoirs of an Heiress*, ed. P. Sabor and M. A. Doody (Oxford, Oxford University Press, World's Classics Series, [1782] 1992), p. 31.

116 W. Combe, *The Auction: A Town Eclogue* (London, 1778), p. iv.

117 *Ibid.*, p. 10. Combe was the author of *The Tour of Dr Syntax in Search of the Picturesque* (1809), a successful work which poked fun at the self-conscious and affected sensibilities of middle- and upper-class tourism. In spite of its success, the work did not alleviate Combe's financial difficulties. Rowlandson's illustrations from the poem were reproduced in transfer prints on creamwares.

118 Burney, *Cecilia*, p. 193. See R. Porter, 'Consumption: Disease of the Consumer Society?', in Brewer and Porter (eds), *Consumption and the World of Goods*.

119 L. S. Mercier (1771), cit. in F. Braudel, *Capitalism and Material Life 1400–1800* (London, Fontana, 1973), p. 123.

120 L. C. C. Veillodter, *Journal für Fabrik, Manufaktur und Handlung* (Leipzig, July 1794), p. 133.

121 G. Parker, *A View of Society and Manners in High and Low Life* (London, 1781), pp. 77, 139. 'Sneaks' and 'sharpers' were terms applied to various specialists in theft and felony. As the name implies, 'dining-room Jumps' specialised in artefacts normally found in this room, and mounted an elaborate team effort to carry out the theft. 'Fidlum bens' were opportunistic thieves who lifted anything from 'a diamond ring on a Lady's toilet down to a dish clout in the sink-hole'.

122 *Pope's Bath Chronicle*, 13 February 1766 (Bath Central Library).

123 Langford, *A Polite and Commercial People*, p. 157

124 G. Lamoine (ed.), *Bristol Gaol Delivery Fiats 1741-1749*, 10 February 1784 (Bristol, Bristol Record Society, 1989).

125 E. George (ed.), 'Bristol Gaol Delivery Fiats, Quarter Sessions Bundle, 1776', Vol. 7, *Notes on Bristol History*, compiled under E. Ralph and P. McGrath (Bristol University, Department of Continuing Education, 1971), p. 72.

126 M. Burdsell (ed.), 'Bristol Gaol Delivery Fiats, Quarter Sessions Bundle 1784-1785', Vol. 11, *Notes on Bristol History*, pp. 137, 143-4.

127 Liverpool Record Office, Entwhistle Collection, 942/ENT1 (1922), fos 51 and 93.

128 For interesting ideas on the employee stealing time, materials and profit from their employers, see M. de Certeau, *The Practice of Everyday Life* (Berkeley, University of California Press, [1984] 1988), p. 37.

129 P. Linebaugh, *The London Hanged: Crime and Civil Society in the Eighteenth Century* (London, Penguin Books, [1991] 1993, pp. 237-8. 'Wearing apparel' was the most conspicuous and powerful signifier of social status which could be carried on the person out into the street, even if the domestic environment was impoverished. For the theft of clothes, which was very common, see Lemire, *Fashion's Favourite*, Appendix 2.

130 *Pope's Bath Chronicle*, 16 August, 1764 and 20 September, 1764 (Bath Central Library).

131 Langford, *A Polite and Commercial People*, p. 158.

132 Cited in Langford, *Public Life and the Propertied Englishman*, p. 3.

133 Langford, *A Polite and Commercial People*, p. 158. The severity of the punishment appears to have had some correlation with the monetary value of the articles stolen. Metal objects and commodities amounting to £10 or more seem to have incurred the death penalty. Lesser monetary values led to punishments like 'burnt in hand' or whipping. This sort of punishment was often inflicted for a first offence. See Linebaugh, *The London Hanged*, pp. 80-1.

134 For a detailed study of eighteenth-century English concerns with authority and property see Langford, *Public Life and the Propertied Englishman*.

135 *Pope's Bath Chronicle and Weekly Gazette*, 30 August 1764 (Bath Central Library).

136 Linebaugh, *The London Hanged*, p. xv.

3

The middle-class consumer: values and attitudes

There is no doubt that the desire to emulate their social superiors was a middle-class motivation to consume the novel and attractive products increasingly available on the market, but it should not be assumed that this was the only reason. Patterns of consumption were complex and informed by different values and opinions. The British middle class included people from rural and urban communities, from professional, entrepreneurial, and artisanal backgrounds, across which there existed different religious and political affliations as well as greater or lesser degrees of wealth. The development of fine ceramics during the eighteenth century differentiated between these diverse levels of income, values and attitudes. At the same time fine ceramic products represented interests, experiences and consumer desires which were broadly shared and recognised by many people of the middle class.

Material values

A Dutch still life painting of the seventeenth century, one of the 'pronkstilleven' by Wilhelm Kalf, testifies to the shifting material values and social mobility of artefacts and their users (Fig. 21). The material qualities of these objects are described through sheer virtuosity, and part of Kalf's intention appears to be that of communicating the experience of being in the presence of things. These objects represented economic value through their material origins, and through the achievements of highly focused skills manifested in the working of such materials, Kalf's own painting skills as well as the makers of the artefacts depicted.[1] The lemon placed nearest the viewer reminds us that someone was in the process of preparing a drink of some kind, and that these objects were activated by human use. The fragile things only just have a hold on their position, placed on the edge of a polished marble table, partly resting on a heavy Persian rug which might be pulled by its own weight to the floor. It is both a rich and a troubling image, opulent and yet insecure. The acquisition of luxury goods in seventeenth- and eighteenth-century Europe troubled the minds of those who felt responsible for the moral health of their

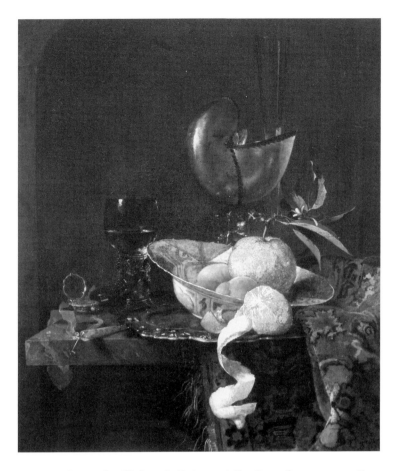

21] Wilhelm Kalf, *Still Life with Nautilus Cup*, oil on canvas, *c*. 1660.

community and still feared divine retribution; the consumption of goods was fraught with problems as well as pleasures.[2] During the seventeenth and eighteenth centuries many people belonging to the middle classes experienced pleasure, but also moral unease, as a richer and more complex material culture entered their lives. The late seventeenth-century entrepreneur, Nicholas Barbon, recognised that 'Wares, that have their Value from supplying the Wants of the Mind, are all such things that can satisfie Desire', which he considered to be 'the appetite of the Soul', as natural as the need to eat. But the parallel was drawn uncomfortably close to an instinctive and undisciplined 'Desire' which was troubling to those who feared it to be a force for instability and disobedience in society. Barbon's 'Artificial Wares … those which by Art are Changed into another Form than Nature gave them', were perceived by those of a puritanical cast of mind as meeting sensual and superfluous desires.[3]

Kalf's painting represents a further stage in the migration of objects through the various strata of European society. In the sixteenth century a nautilus shell and a porcelain vessel would have

been found only in the cabinets of curiosities among the scholars and ruling elites of Europe. In this painting they have reached the households of wealthy Dutch merchants.[4] In just over one hundred years from the approximate date Kalf painted this still life, cream-ware dessert services would be masquerading as nautilus shells on the tables of the English middle and upper classes (Fig. 22). Blue and white china would be in use in the homes of the English yeomanry.

Fine ceramic vessels did not make a substantial and widespread impact on English middle-class domestic interiors until the eighteenth century. Spanish lustrewares from Malaga and Valencia were imported in the late medieval period and used for conspicuous display in the households of the nobility and the wealthy merchant class.[5] In the sixteenth century examples of imported Italian maiolicas and German stonewares with English silver mounts certainly suggest these vessels acquired a value that made them worthy of convivial use and display in affluent merchant and aristocratic households. The so-called 'coarse' earthenwares were made in quantity for the purposes of cooking and dairying, for preserving and storage, and they were found under the bed in the form of chamber pots. The term 'coarse' is inappropriate to describe what were often very skilfully and finely potted wares in the form of dairy creamers and jugs for example. Seventeenth-century ceremonial slipwares and tin-glazed earthenwares were used and displayed in the social spaces of the house, and in their context

22] Wedgwood dessert service, centrepiece, *Nautilus* shape in Queens-ware, No. 384 in the 1770 pattern book.

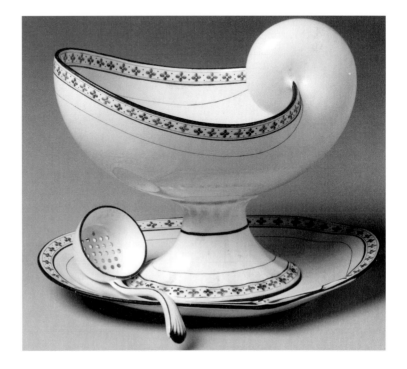

may appropriately be regarded as a form of fine or superior ceramic artefact, even if the potter's skills were relatively unsophisticated. But pewter was the principal material used for tablewares in urban and rural homes of moderate affluence.[6] The labouring classes on the lower income levels used some pewter, but mainly wooden and coarse earthenware vessels. On Lord Mayor's Day, 29 October 1663, Samuel Pepys felt justified in recording his distaste at the lack of refinement when at table: 'I set near Proby, Baron and Creed at the Merchant Strangers table – where ten good dishes to a messe, with plenty of wine of all sorts, of which I drunk none; but it was very unpleasing that we had no napkins nor change of trenchers, and drunk out of earthen pitchers and wooden dishes'.[7] Pepys's discomfort at the table was caused by the absence of city plate which had been melted down during the Civil War and not yet replaced after the Restoration of the monarchy in 1660. Behind the material changes in domestic vessels lay issues concerning investment in the value of the materials themselves and what they signified in relation to social status; the more highly valued metals were therefore relinquished only slowly.

In the late seventeenth, and well into the eighteenth century, the English East India Company imported substantial quantities of Chinese blue and white porcelain tablewares of fine and inferior quality. However, the porcelain trade represented a very small percentage of the Company's imports in comparison to tea, and was only 2 per cent of the total cargoes landed at London which included numerous shipments of textiles.[8] Nevertheless, these imported porcelains and their European tin-glazed imitations had an impact on consumers sufficient to make them an acceptable alternative to metalwares. In 1734, shortly before the Prince of Orange's marriage to the Princess Royal, the Bristol Corporation, 'in regard of his illustrious descent and firm attachment to the Protestant religion', invited the Prince to a dinner at the Merchant's Hall, followed by a tour of the Hot Well and Quays and a 'sumptuous supper and ball'. The total cost of the entertainment was £297 1s 3d and it appears that in preference to pewter 'cheny' was hired at the cost of 26s. The 'cheny' may well have been imported porcelain or Delftware, but in Bristol the City Corporation could have hired local delftware made especially for civic entertainments in one of the city potteries.[9] There is nothing to suggest that theft of plate was a concern among the Bristol merchants, but evidently it was a problem at public events; although inferior to the precious metals, pewter still held value by weight, and small items were liable to find concealment in a cloak, a generous sleeve or coat pocket. Linen also held investment value and was frequently hired out for banquets and entertainments, but with a similar risk of theft. In

1702 the *London Gazette* reported that plate, pewter and table-linen used at the Coronation Feast of Queen Anne had been stolen, and that nowhere was secure against the sneaks and sharpers. In Daniel Defoe's *Roxana* the substitution of '*China*' for plate was a feature in Roxana's preparations for an 'Entertainment' at her London lodging in Pall-Mall. She found a 'deficiency' of linen and purchased 'twelve Dozen of fine Damask Napkins, with Table-cloths of the same'. In addition she also bought:

> a handsome Quantity of Plate, necessary to have serv'd all the Side-boards, but the Gentlemen would not suffer any of it to be us'd; telling me, they had bought fine *China* Dishes and Plates for the whole Service; and that in such publick Places they cou'd not be answerable for the Plate; so it was all set up in a large Glass-Cupboard in the Room I sat in, where it made a very good Show indeed.[10]

The ownership of gold and silver plate by the European social elites was linked to the state economies, and was a reserve called upon when gold and silver bullion was in short supply. Plate in the form of table services, candelabra, ewers and drinking vessels could be melted down without serious loss of value and put into circulation, usually towards the support of military campaigns. In the seventeenth century a pan-European debate emerged between theorists who supported the notion that wealth should continue to be represented by bullion, a commodity, and those who argued for a more abstract system of paper money; in increasing favour was the concept of accepting the function of bullion as a sign, as an equivalent in value to commodities, or representative of them. It was one of the projects of Enlightenment thinkers to engage in an analysis of wealth, and the development of economic theory was coterminous with increased activity in trade and manufactures.[11] In the 1740s David Hume noted an example of the divergence of opinion concerning the advantages and disadvantages of bullion as against paper money in his essay *Of the Balance of Trade*. He wrote of the fashion 'which still has place in England and Holland, of using services of CHINA-ware instead of plate', and how this same fashion had until a few years ago 'prevailed in Genoa … but the senate, foreseeing the consequence, prohibited the use of that brittle commodity beyond a certain extent; while the use of silver plate was left unlimited'.[12] A new commodity like china could have an impact on old economic practices which relied on value represented by material gold and silver reserves, rather than an intangible value represented on paper. Conversely, shortage of bullion and the melting down of household plate opened up opportunities for faience and porcelain manufactures to become better established, especially in continental Europe.

In the seventeenth century porcelain was not in serious compe-
tition with pewter or plate because it fulfilled a specific function
in support of new social practices like tea and coffee drinking, or
as desirable exotic ornament which signified disposable income in
a household with aspirations to gentility.[13] China afforded novel
and genuine aesthetic pleasure, both in the handling of such
refined artefacts and in purely visual terms.[14] Ownership of both
pewter and 'china' vessels in many English middle-class eight-
eenth-century households confirms their compatibility alongside
one another, and this continued into the nineteenth century, es-
pecially in rural areas. It was the fine earthenwares, and principally
the creamwares, which ousted pewter from a significant propor-
tion of urban homes in the latter half of the eighteenth
century.[15] Porcelains and fine earthenwares were not in competi-
tion with refined vessels made in glass for the consumption of
wines, or the brown and cobalt-blue salt-glazed stonewares which
fulfilled functions associated with the European dependence on
beer as a staple 'food'.[16] Glass, stoneware and the cruder delftwares
took care of the serving and drinking of ales, wines and spirits, and
stonewares were well matched to the more robust manner of living
across rural and urban Europe. They were also expressive of that
way of life, and many people would have preferred them as repre-
senting a social and cultural identity they valued, in opposition to
the refined practices of tea, chocolate and coffee drinking, which
for as long as they remained costly commodities were associated
with the 'superior' behaviour of social elites, or observed as risible;
they typified the 'foppish' and 'effeminate' mannerisms of the
small but visible leisured class heavily criticised by moralists. The
refined social practice of drinking the new hot liquors in novel and
exotic containers also brought to mind their foreign origins. In his
journey to Paris in 1698 the physician Martin Lister was vexed at
the 'Wanton Luxury' of the French who had taken to drinking tea,
coffee and chocolate in a country abundant in 'Excellent Wines,
the most cordial and generous of all Drinks'. Why, he wondered,
should they 'ape the necessity of others', and by 'others' Lister
meant the customs of the Persians, Indians and Turks.[17] To a great
extent 'politeness' was achieved through commerce, and achieved
by men and women of property directly and indirectly involved
with the expansion in foreign trade. Simultaneously there was a
marked development towards refinement in the making of stone-
wares alongside the introduction of fine earthenwares and
porcelains to the market. However, it was not until the 1750s and
1760s that increased prosperity became more widely visible
through these refined, but relatively cheap manufactured pro-
ducts. Facilitated by the new manufacturing techniques, it was the

combination of novelty, greater refinement and accessible prices which marked the success of the Staffordshire potteries as well as other forms of English production like printed textiles and the metal trades.[18]

The material refinement of artefacts was inseparable from the refinement of manners and the value placed on civil and polite social conduct, most sharply visible in the centres of commerce and urban living in the first half of the century. Here in the dense concentration of people, goods and services the tone of moral unease at all this getting and spending on material luxuries and leisured pursuits intensified, especially when the country was drawn into major international conflicts after 1739. In 1757, the year following the outbreak of the Seven Years War, the Newcastle cleric John Brown directed his ire against wasteful and extravagant consumption, particularly if it was modelled on French practices. His perception was that it led to vanity and 'effeminacy':

> Vanity lends her Aid to this unmanly Delicacy: Splendid Furniture, a sumptuous Side-board, a long Train of Attendants, an elegant and costly Entertainment, for which Earth, Air and Seas, are ransacked, the most expensive Wines of the Continent, and Childish vagaries of a Whimsical Desert, these are the supreme Pride of the Master, the Admiration and Envy of his Guests.[19]

The 'vagaries of a Whimsical Dessert' were represented by the French fashion of serving fruits and sweetmeats 'en Pyramide', often in glass vessels or imported blue and white porcelain dishes (Fig. 23).[20] François Massiolot's *Le Confiturier Royal* and his better known *Le Nouveau cuisinier royal et bourgeois* were among many publications which appeared during the course of the eighteenth century which made modified forms of French court cuisine

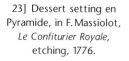

23] Dessert setting en Pyramide, in F. Massiolot, *Le Confiturier Royale*, etching, 1776.

accessible to the socially ambitious outside aristocratic circles. It
was the imitation of court practices and luxury consumption
which moralists were convinced rendered the eighteenth-century
man of means an 'effeminate'; luxurious living was thought to
enervate masculine strength and lead to men becoming more like
women. While deploring the effeminacy Brown observed in some
men of his time, he noted a shift in the conduct of women too:

> The Manners of Women – are essentially the same as those of the Men,
> and are therefore included in this Estimate. The Sexes have now little
> other apparent Distinction, beyond that of Person and Dress: Their
> peculiar and characteristic Manners are confounded and lost: The
> one Sex having advanced into Boldness, as the other have sunk into
> Effeminacy.[21]

There were women who gleefully and publicly, or much more
secretively, flouted gender conventions, and such behaviour was
frequently remarked upon and caricatured in the press. Most of the
women who were able to challenge conventional female roles
were highly educated, often affluent and independent, and there-
fore did not represent the majority. Moral invective such as
Brown's did not represent eighteenth-century England in total.
Although aristocratic and newly moneyed urban women quickly
became associated with the 'vanities' of exotic consumer goods in
the early decades of the century, a significant proportion of
middle-class women experienced a steady improvement in the ma-
terial comforts and pleasures of everyday life without the
sensational element featuring beyond an interest in the scandals
of high society. Brown's anxieties were not to be relieved however.
The twenty years following the publication of his *Estimate* wit-
nessed even greater excesses in 'luxury', 'vanity' and 'effeminacy'
in urban centres. But there was more than one tune being played
in the latter half of the century, and while an affected and ex-
cessive *materialistic* culture was condemned, another emerged in
middle-class England which placed high value on the ability to
'feel'. Refined manners were transposed into a 'heightened sensi-
bility' which tended to favour candour, openness and the 'natural'
expression of individual emotion. It was to this group that the less
ostentatious and serviceable products of the new manufactured
material culture appealed.[22]

Consumers made circumspect decisions whether or not to own
or refuse these new goods and to practise the social refinements
associated with them. Their decisions were based on a complex
range of economic and symbolic values. At the beginning of the
century most people had no choice to make because the new com-
modities lay beyond their financial means. By the end of the

century tea, sugar and attractive if modest ceramic tablewares were accessible even to the labouring classes in many parts of Britain. In refusing these goods and commodities there was quite likely to be a denial of pleasures, not just in the spirit of evangelical revival, but also in the spirit of patriotic and conservative resistance to change. Many of the new pleasures were 'foreign'. To be polite meant that you readily accepted the pleasures and practices of 'others', whether of a geographically distant people or a superior social class within your own country. It meant possessing a degree of flexibility and openess to new experiences which were the result of invention and innovation in working life or in leisure pursuits. Polite society had to reconcile the deep-seated anxieties of an age in which many of the familiar material and moral values were disturbed and had to be redefined through the experience of modernity.[23]

Social and cultural refinements

Acquiring refined artefacts represented the material substance of polite and civilised living, but this was not convincing unless accompanied by personal refinement. Among those who aspired to politeness, work had to be done on the body as well, and gesture had to be brought under control with careful precision; a polite body technique demanded practice until it became habitual. It was not enough to display refinement in clothes and consumer goods, the body was on display and was required to conduct itself with seamless grace and delicacy, whether female or male. The new ceramic goods and the practices associated with them encouraged controlled and delicate management of the body. The new hot drinks and china vessels were also expensive, and had to be handled with care. It was important for people who wished to gain entry to polite society to learn how to handle these goods and consume their contents with elegance. An illustrated instruction book published in 1737, *The Rudiments of Genteel Behaviour*, indicates just how much work could be involved in acquiring the appropriate movements in order to give or receive an object in polite society (Fig. 24).

> Observe well the easy Disposition of this Figure, and in that Manner approach with becoming Modesty and gentle Motion, not too near, nor Stop at too great a Distance … then make a Courtsie … and, as about to Deliver or Receive, present the Right Hand, and withdraw it a little, then presenting it again, GIVE or RECEIVE the Thing intended, and easily withdrawing the Hand, till it comes to a circular Action, place it on the other … and Courtsie as before …[24]

Instructions for men were equally complex, in fact at times so confusing that many an over-conscientious young man must have experienced some embarrassing moments in society, quite the reverse of the effect to which they aspired. Control extended to the composure of the 'manly Boldness in the Face' in which 'the Lips must be just join'd to keep the Features Regular' (Fig. 25).[25]

The control of the body and the language of gesture in the court culture of medieval and Renaissance Europe established the distance between the gross and the refined person.[26] Treatises on refined manners, or 'civility', had been in circulation since the Middle Ages, and were based on the codes of behaviour practised at court. Although one of the purposes of civility was to ensure predictable and non-intrusive behaviour between members of a social group, it also had the power to intimidate. Refinement of the mind and body could be potent techniques for reinforcing class distinctions. In Dr Johnson's *Dictionary* of 1756, 'refine' (citing Dryden) meant 'to improve in point of accuracy or delicacy'. Johnson included Swift's definition of 'refinement' as 'Improvement in elegance or purity', and with reference to Addison refinement was an 'Affectation of elegant improvement'.[27] The sense of refinement as a process of purification, getting rid of dross and superfluity, was contrasted by the sense that it had to do with 'artificial practice' and the acquisition of superfluous niceties.

In his much satirised *Analysis of Beauty* published in 1753,

William Hogarth ascribed an ornamental purpose to those gestures which consisted of 'graceful movements in serpentine lines'. Such gesture was appropriate for occasional use in leisured moments: 'The whole business of life may be carried on without them, they being properly speaking, only the ornamental part of gesture; and therefore not being naturally familiarised by necessity, must be acquired by precept or imitation, and reduced to habit by frequent repetitions'.[28] The generally domestic social practice of tea drinking was not part of the 'business of life'; it was regarded as a leisure pursuit largely under the control of women even though tea was popular in the coffee-house. Often negatively ascribed to women's supposed predilection for scandal and slander which brought 'relish' to the 'Conversation', the 'pretty prattling Mouths in Great Britain' and even the 'Ladies of better breeding' made the 'Tea-Table their Mart' to ruin reputations with 'Elegance and soft Language'.[29] In this writer's mind the tea-table was equated with a market for scandal and for dealing in reputations. In a society where 'reputation' counted for much, and increasingly so among the middle classes, this may have been hyperbole but not wildly inaccurate. In a letter to her friend, the porcelain entrepreneur Richard Champion, a Miss Wright wrote from Bengal in 1765: 'It is a long time before a letter can reach us, therefore pray send me all the News you can, All the Chit Chat, and even the Tea table Scandal you can pick up, it will be some Amusement to an absent friend'.[30] The coffee-house was an unlikely site for 'ornamental gesture', unless frequented by the leisured male, and had more to do with easing the conduct of business. The gestures of the coffee-house and the tea-table, and the nature of the conversation, were very different, but they were linked together in contemporary middle-class commentaries intended to place at a distance the ribaldry and foul habits of the ale-house.[31] The refined consumer goods were a material support which reinforced polite behaviour, and were increasingly available to wider strata in society. By the late eighteenth century with tea and coffee no longer expensive and likely to be found on the tables of 'the lower orders', and when transfer-printed creamwares entered the market in substantial quantities in the last two decades of the century, this finer form of earthenware was among the most visible of the new domestic goods available to many more people in the middle and lower-middle classes. Polite behaviour was still potent social currency, but with the added distinction among the educated middle classes of the capacity to express sensibilities. Refined *sensibility* was another inflection of polite behaviour which attempted to reconcile gentility with commercial life and industrial development, and to maintain a distance from the artisan and labouring classes.[32]

In the middle of the century, just before 'sensibility' became all
the rage, John Brown's focus for attack was the privileged male in
a society dedicated to refinement and delicacy. It was his percep-
tion that the classical 'heroic' virtues of the male sex supposedly
buckled under the onslaught of 'polite' social practices, the increase
in luxury goods, and the (relatively) greater self-confidence which
emerged among women.[33] In the early eighteenth century the
'china jar' was established as an emblem, or in poetic uses as a
metaphor, for femininity and female desire:

> What ecstasies her bosom fire!
> How her eyes languish with desire!
> How blest, how happy should I be,
> Were that fond glance bestow'd on me!
>
> New doubts and fears within me war:
> What rival's near? a *China* Jar.
> *China's* the passion of her soul;
> A cup, a plate, a dish, a bowl
> Can kindle wishes in her breast,
> Inflame with joy, or break her rest.[34]

In John Gay's satirical verse these desirable goods presented the
affluent urban woman with material distractions of such seductive
power that they replaced her affections for the male sex. His poem
goes further in contemplating the new values men placed in things
and in knowledge: those who collect antique gems and who 'view
the rust' on medals 'with lover's eyes'; those 'who court the stars
at midnight hours' or 'doat on Nature's Charms in flowers!'. Gay
suggests that these cultural interests change the nature of human
relationships, and that too much value placed in objects of beauty
or the lessons of science displaces the all too fleeting value of
loving a beautiful woman. The poet finds a metaphor in the 'an-
tique Jar' for both female virtue and frailty, and whether:

> ... white, or blue, or speck'd with gold
> Vessels so pure, and so refin'd
> Appear the types of woman-kind:
> Are they not value'd for their beauty,
> Too fair, too fine for household duty?
> With flowers and gold and azure dy'd,
> Of ev'ry house the grace and pride?
> How white, how polish'd is their skin,
> And valu'd most when only seen!
> She who before was highest priz'd
> Is for a crack or flaw despis'd; ...[35]

Gay's metaphor is tightly woven to confuse the china object with
the human subject. The male ideal of transitory female beauty,

which unlike the increasing value of old china 'cheaper grows in growing old', he contrasts with the 'coarser stuff', the 'strong earthen vessel' of which men are made, 'For drudging, labour, toil and trade'. Although husbands may 'Condemn this *China*-buying rage', and decry their women for setting their hearts 'on things so brittle',[36] can men themselves be so certain that their taken-for-granted wisdom, their ambitions and promises are less frail; how sure can they be of their pleasures in their ownership of women and of land? The themes of Gay's poem are old ones, but they are inflected by the profound cultural changes brought about by commerce, by social and political change, and by the new knowledge of the Enlightenment.

There were two sides to the construction of a 'polite' society which were central to the problematic relationship eighteenth-century consumers had with their new world of goods. Gender roles were inextricably bound up with the processes of redefining and reconciling the social and economic changes under way. On the one hand women presiding at tea in the context of the family represented the agent 'formed to temper Mankind, and sooth them into Tenderness and Compassion, not to set an edge upon their Minds, and blow up in them those Passions which are too apt to rise of their own Accord'.[37] A growing number of men of Whig persuasion, who were concerned to place in people's minds the notion that commerce and virtue were not incompatible, were convinced that the home as a site of material refinement and reform in manners would bring the age to its senses, steering it away from vice and foolishness.[38] On the other hand the tea-table could represent something entirely different, as satirised by a 'husband of the merchant class' in Eliza Haywood's *The Female Spectator*:

> the Tea-Table, as manag'd in some Families, costs more to support than would maintain two children at Nurse – it is the utter destruction of all Oeconomy, – the Bane of good Housewifry – and the Source of Idleness, by engrossing those Hours which ought to be employed in an honest and prudent Endeavour to add to, or preserve what Fortune, or former Industry has bestowed … all degrees of women are infected with it, and a Wife now looks upon her Tea-Chest, Table, and its implements, to be as much her Right by Marriage as her Wedding-Ring.[39]

Objections to the perceived waste of time and money were part of the lament, and what comes across clearly in this satire is the 'ritual' of tea drinking: 'The first Thing the too genteel Wife does after opening her Eyes in the Morning, is to ring the Bell for her Maid, and ask if the Tea-Kettle boils'. Breakfast takes an hour, after which the Maid returns to the kitchen 'and sits down to the

Remains of the Tea ... with the same State as her Mistress'. Husbands are lucky to 'get a bit of Dinner ... by two or three o'clock', after which the 'Tea-Table must be again set forth', followed by a succession of 'Mrs Such-a-ones' who add to the 'friendly Neighbour' who 'comes to Chat away an Hour'.[40] Essentially the complaint is against the power women appropriated for themselves through the ritual created around the tea-table and the mysteries of the equipage.[41]

The negative and often misogynistic assessment of these new female rituals had begun much earlier when the East India goods were a novelty accessible principally to the nobility and wealthy urban middle class; a man who drank tea with women could be accused of effeminacy and become an object of ridicule. Sir Jasper Fidget, in William Wycherley's late seventeenth-century play *The Country Wife*, is taken in by the rake Horner's pretence of impotency, and advises him on his future:

> Sir Jasper Fidget ... Come, come, man, you must e'en fall to visiting our wives, eating at our tables, drinking tea with our virtuous relations after dinner, dealing cards to 'em, reading plays and gazettes to 'em, picking fleas out of their shocks for 'em, collecting receipts, new songs, women, pages, and footmen for 'em.
>
> Horner I hope they'll afford me better employment, sir.[42]

Wycherley's *The Country Wife* was performed at the height of the seventeenth-century 'china craze' in 1675, when the East India Company was importing wares from Japan. In Act IV of the play, Wycherley's notorious metaphorical reference to china allows Horner and Lady Fidget to get what they want, a new and illicit sexual experience; Wycherley conflates desires for china with the erotic and with notions of insatiable female desire.[43] Lady Fidget's desire for Horner is expressed through her appetite for china. She returns from her encounter, a piece of china in her hand which immediately sparks off the desires of Mrs Squeamish: 'O Lord, I'll have some china too. Good Mr Horner, don't think to give other people china, and me none; come in with me too.' In a fastidious pretence, Horner declines, and Lady Fidget assures her he has none left, 'What, d'ye think if he had any left, I would not have had it too? For we women of quality never think we have china enough.'[44]

In *The Plain Dealer*, first performed in 1676, Wycherley throws china into the plot again, picking up the thread of popular public interest in *The Country Wife*. One of the principal characters, Olivia, decries the action of an acquaintance who was seen to attend a performance of 'the hideous *Country Wife*. In the dialogue between Olivia and her cousin Eliza, Wycherley makes it clear that

to interpret the 'china scene' in *The Country Wife* in such a way as to damage the 'Reputation of poor *China*' and sully 'the most innocent and pretty Furniture of a Ladies Chamber' is a matter of choice. The double standard revealed is Olivia's questionable virtue. She is Manly's – the 'Plain Dealer's' – mistress, and her objection to Wycherley's 'filthy Play' and 'nasty debauched China' is sharpened against Eliza's virtue and refusal to be 'put out of conceit with *China*,' or 'the Play'.[45]

'China' could be made to mean very different things. Wycherley's comedies explore the late seventeenth-century audience's enjoyment of that tension in which the refined and the gross, vice and virtue, were constantly in coexistence and in conflict. People were confronted with this duality in everyday life as refined goods and social practices became more visible against the grosser realities of living and the double standards of sexual mores. In the seventeenth century it was a more robust and potent tension, a closely run contest in which people took great delight in seeing the gross shove the refined off its pedestal. This duality continued to find expression in eighteenth-century popular texts and in the English satirical cartoon, where the world was turned upside down and inside out. Conversely, the effect of rational, abstract and mechanistic Enlightenment thought and the demands of a successful commercial economy meant that refined social practices gained a much stronger foothold in cultural life; politeness gained inevitably led to laughter tamed, and the division between vice and virtue became more sharply focused.[46] In 1766 David Garrick produced an adaptation of *The Country Wife* with the title *The Country Girl*. In the 1760s Wycherley's undiluted emphasis on libertinism, wit and aristocratic amorality was discordant and Garrick virtually expunged Horner from the plot, reducing his part to that of a 'walking Gentleman'.[47] At a time when Garrick was trying to make the theatrical profession respectable and persuade audiences to be more self-disciplined, the boisterous and titillating form of Restoration comedy had to be restrained in the interests of an 'improved taste'.[48] Politeness attempted to push raw and uncontrolled nature into the elevated form of refined culture, a process evident in the works of John Dryden, Alexander Pope and John Gay – and constantly subverted by Jonathan Swift. In the material and formal qualities of china, and specifically the exotic and tumescent forms of the imported Japanese and Chinese products, Wycherley established an emblem which conflated sexual and consumer desires. Dryden, Pope and Gay also incorporated these artefacts as poetic devices but at the same time set out to refine and limit their effects.[49] In the latter half of the century when Garrick staged *The Country Girl*, the earnest form of the antique

ceramic vase, and especially the urn, became the emblematic focus of consumers' sentiments and sensibilities. It was not a coincidence that this occurred at a period of rapid transition from a commercial to an industrial economic framework, and the notion of ancient and steadfast values seemed particularly appealing.

Middle-class ownership of fine ceramics

To return to the *Still Life with Nautilus Cup* (see Fig. 21). It has already been noted that these exotic objects had left the exclusivity of the princely cabinets of curiosities and come under the ownership of the Dutch merchant class. But the objects Kalf selected do not refer inwards to the quiet domestic space of the seventeenth-century Dutch household, they refer the viewer outwards 'onto the great masculine world of trade and navigation'.[50] It is a male vision, in which these costly artefacts have occupied the domestic space and brought it into the frame of the commercial empire.[51] Conditions in the mid-seventeenth-century Dutch Republic were not replicated in other parts of Europe, but the new goods introduced by the East India Companies were starting to make an impact in regions of northern Europe not affected by civil strife and war. At the beginning of the eighteenth century their influence on Western material culture and social practice was making a difference to the lives of a growing number of people.

For most women in early modern Europe the home was not a comfortable place; often it was cold and dark, and the location for arduous domestic tasks. Living quarters were frequently in close proximity to a workshop or a business, especially in crowded urban areas like Bristol, where much of the fabric of the city was of medieval origin. The interiors of many middle-class homes were sparsely furnished and unadorned; the beds were often the only items of upholstered furniture in rooms where families also lived and ate. One of the most noticeable consequences of the increased availability of new and pleasing consumer goods was an improvement in domestic comfort; for many, domestic space was 'softened', and quite startlingly so in the transition from the seventeenth to the eighteenth century.[52] In town and city households especially there was a marked increase in ownership of mirrors, window curtains and upholstery, often in 'china blue' or yellow printed cottons. Prints or 'pictures' of an undefined character were frequently recorded in inventories of the century's middle decades.[53] These incremental improvements in the material culture of the home were of particular significance to women, and enhanced their ability to influence the quality of family life on a daily basis. But the changes in the material well-being of the

household were not achieved without tensions arising between the sexes, and this was ultimately due to the impossibility of separating out the new consumer goods from social practices which by their very nature gave rise to conflicting interests. Male social gatherings continued in the taverns and coffee-houses, but as the home became increasingly comfortable it was used more widely as a place to entertain friends and associates. How did the middle-class family make allowances for the social activities surrounding the punch-bowl, the pipe, and the tea-table? There were gender divisions implicit in the uses of these artefacts which allowed leisured middle-class women to drink tea or coffee during working hours, but vacate the room for another part of the house when the punch-bowl came out. In early eighteenth-century Lancashire Nicholas Blundell's wife, Frances, appears to have put pressure on her husband to convert the buttery into a second parlour, and this may well have been requested so that she could rely on having a place to entertain her many lady visitors who enjoyed 'a dish of coffy'. Her husband also had frequent visits from 'men of all sorts' who enjoyed much stronger drink.[54] In the late seventeenth and early eighteenth centuries old medieval housing was evidently subject to adaptation and renovation which afforded greater importance to food preparation with an increase in 'kitchens' solely for this purpose.[55] Questions concerning the adaptation of old housing cannot be answered precisely or with certainty, but within the varied social groupings which made up the 'middling sort' there were considerable differences in the way people used domestic spaces, and how they chose to use the new 'convivial' commodities, if at all. Practices were very different in urban and rural contexts and across the regions.

New housing developments in urban areas started to take account of the middle-class desire to entertain visitors at home, and recognised that the nature of these social encounters might not always be compatible. There was an increase in the number of parlours set aside for special social gatherings in many middle-class homes. The inclusion of dining-rooms in genteel middle-class housing was an indication both of greater affluence and the changes in social practices within the home. In Bristol a member of the wealthy merchant elite was quite likely to own a house with a 'Dining-Room and Withdrawing-Room, each neatly Wainscotted and Painted, with a marble Chimney-Piece in each', and in the same sale advertisement of 1746 this particular house in Guinea Street boasted 'three parlours', two of which had marble 'Chimney-Pieces'.[56] A more modest 'Dwelling House' in the Brunswick Square development was advertised for letting in 1785, and in these premises there was no dining-room specified. There were two

parlours and a 'China and Servant's Pantry, a genteel Drawing-Room, and convenient Lodging-Rooms with Garretts'. In this house, as in many others, there were 'two kitchens', one of which probably operated as a scullery, or was set aside for the use of lodgers.[57] In this type of urban dwelling a degree of flexibility is evident in that a 'parlour' could be used as a dining-room, and some of the rooms could be sub-let. In cities like Bristol and Bath new developments were built with tenants in mind who would lodge temporarily for the 'season'.

Artefacts have 'socially strategic' purposes, and they can function in very different ways.[58] Incidents around the table recorded by John Ramsey of Ochtertyre illustrate how objects were used to speak one language in the late seventeenth century, and quite another in the eighteenth. He recalled a Mrs Robertson of Myreton who remembered her life in Kincardine before the Revolution of 1688, when James II was forced to renounce the crown in favour of William of Orange. She lived with her grandfather who was a minister of Kincardine, obliged to leave his post in 1689 for 'refusing to pray for William and Mary'. Mrs Robertson recalled entering a room in her grandfather's house where 'he and a number of men were drinking. All of them had dirks stuck into the table, except one, Graham of the Gartur family, who had a pistol before him.'[59] In his own memoirs of about one hundred years later Ramsey wrote of the movement of wealth from old families to the new lowland 'speculators'. He was troubled by the rapid accumulation of wealth and noted that 'it requires both strength and soberness of mind in men of old family and moderate fortune to avoid the example of these new men, some of whom aim at distinction by the elegance of their table and the splendour of their equipage'.[60] Dirks were 'socially strategic' in Scotland one hundred years earlier, but the Presbyterian Ramsey commented on a startling visible transition when the table became a site for the expression of economic superiority through the ownership of china, glass, plate and well-polished rosewood or mahogany dining tables, especially among the Glasgow merchant class.[61]

Until the production of creamwares got under way in the latter half of the century, middle-class British households owned a range of lead and tin-glazed earthenwares, salt-glazed stonewares, pewter and wooden wares. Less commonly probate inventories record the ownership of the imported East India Company porcelains, usually in the form of tea and coffee sets, but porcelain or tin-glaze bowls, punch-bowls and fruit dishes were also desirable items. In his memoirs Thomas Somerville, who lived and worked as a tutor and minister on the Scottish borders in the late eighteenth and early nineteenth centuries, noted that wooden platters were in use in

most households, particularly among the farmers and 'many of the clergy'. Pewter vessels were in use among the 'country gentlemen … with a set of delft, or china, for the second course at table, in the case of such of them as could afford pretentious three o'clock dinners'. Unlike Ramsey commenting on the lowland merchants and new landowners, Somerville noted few mahogany dining-tables, but observed that even oak tables 'by constant rubbing, shone like a mirror'. However, 'a punch-bowl and teacups and saucers of china were … considered indispensable, and were ostentatiously arranged in what was called *the cupboard*, a small press with an open or glazed door placed in a conspicuous part of the dining room'.[62]

Among the delftwares, which represented the type of 'blue and white' ceramics most likely to be found at various levels of middle-class ownership, there are indications of the opportunities potters took to articulate the social nature of these artefacts. A well-known example is the *Merrymen* plates, of which there were six, with the following rhyme painted in the centre: 1. What is a Merry Man / 2. Let him do what he can / 3. To entertain his Guest / 4. With Wine and Merry Jest / 5. But if his Wife does frown / 6. All Merriment goes down. Sufficient numbers of these sets still exist to suggest they were generally used for display rather than on the table. The implications of the text hardly need pointing out, and refer to earlier versions of the rhyme found on wooden trenchers. It has a link with carnival practices, 'the world turned upside down', when traditional roles were reversed and women took authority or scolded men for their pleasures. There were still other residual attachments to these older cultural forms in punch-bowl inscriptions like, 'Drink, Drink whilst ye have breath / For there's no drinking after death'. These practices did not by any means disappear in the 1700s, but the refinements of 'polite' society muted the raw vitality of popular social customs, and many of these versions were found in the less polite surroundings of taverns and inns.

Although the sense of novelty derived from the new products was in large measure accompanied by an increasingly secular outlook, communities in eighteenth-century England, Scotland and Wales were still God-fearing,[63] and many examples of the following text survive: 1. When thou sit down to meat / 2. Give thanks before thou eat / 3. Unto him that doth give / 4. The mercies thou receive / 5. That such favours may be / 6. Repeated unto thee. This version may well have been intended for a Quaker family, or made by a Quaker pottery, of which there were several, especially in the Bristol area. 'Thou', the correct form of address among Quakers, was not common, 'you' or 'ye' being the most likely version to be

found on these vessels. The blue and white wares, or in many cases simply white tin-glaze wares with no decoration except perhaps an inscription, could be socially instructive. The inscription told the users how these wares should be handled, and how to adjust habitual, but gross or 'impolite', table manners: for example the remaining two plates of a set of six dated 1712 – 4: 'Who often Breaks me with a Fall' / 5. 'On me to Eat both Sauce and Meat' (Fig. 26). Similarly the punch-bowl inscription 'Drink Fair, Don't Swear' suggests the minding of manners and moderation in eating and drinking, all in order to encourage a convivial but controlled social encounter.

The city of Bristol, one of the major centres for the production of 'blue and white' wares, was, according to Daniel Defoe, the wealthiest and most successful trading port apart from London.[64] Bristol's social elite was that of a wealthy merchant class rather than the nobility. New housing developments and public assembly rooms were built in the 1720s, including the Hotwells spa. At the same time a noticeable increase in the accumulation of fine ceramics and other household durables starts to become evident in the probate inventories of the Bristol Diocese. But even in the 1680s it was evident that glass and earthenwares were owned for display, not just by the wealthy merchant families, but by the

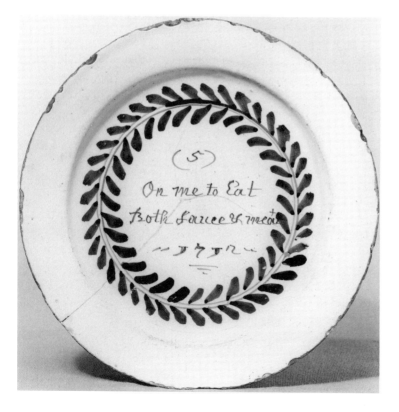

26] Tin-glaze plate, *On me to Eat both Sauce and Meat*, Brislington, Bristol ?, 1712, 22.6 cm diameter.

skilled artisans and retailers.[65] Bristol is interesting in this respect because, unlike London, there really was no significant aristocratic elite to emulate; if anything, Bristol people were contemptuous of the leisured class who did not engage in hard work and enterprise. Nevertheless, there were individuals who purchased and selected artefacts which broke away from the overall pattern of ownership of goods. Because Bristol was a major port, all manner of foreign goods were brought in legally and illegally. Inventories often record that it was the mariners who owned pottery like the Dutch Delftwares, and the Barnstaple wares which were traded to North America from Bideford via Bristol. The Brislington delftware pottery was established in the mid-seventeenth century with Temple Backs following in the 1680s. There was therefore an opportunity for people to purchase new types of wares which could perform both functional and ornamental purposes. A punch-bowl may have been used on occasion, but when not in use it was an attractive and often humorous article to keep on display in the 'fore st room' or the parlour, with a set of glasses 'on the clavy'.[66]

Compared to Londoners, and in the absence of a significant leisured class, Bristol people may have been relatively conservative in their tastes and in their degree of willingness to introduce new artefacts into the home. In the late seventeenth and first half of the eighteenth century probate inventories testify that pewter wares remained the predominant type of domestic tableware held in ownership, and the Bristol pewterers were known for their fine products. However, after about 1710 there was a marked increase in the ownership of 'china' alongside items like tea-tables. Earthenwares were also more likely to be specified in inventories as 'fine', 'Dutch' or 'Delph', and at the same time sets of knives and forks start to appear frequently. Where inventories specify the position of artefacts in the house, pewter wares were increasingly relegated to the kitchen in urban households, and listed less frequently in prestigious positions of display. China started to take its place in the 'Bofett', which was usually placed in the dining-room, the parlour or 'fore st room'. From the 1760s onwards it is clear that the Bristolians owned a greater range of fine ceramic tablewares; a Queensware service was itemised in the 1766 inventory of Phillip Cadell, tea-man, soon after this type of product became widely available.[67] Edward Pye Chamberlyn of Wine St, Bristol, who failed in the grocery business inherited from his father, owned Dresden china. He also possessed a considerable quantity of good furniture, linen, glass, kitchen equipment and other types of fine ceramics, but in his case there were links by marriage to the local landed gentry, the Astry/Smyths of Ashton Court, which may account for such ownership through family gift giving, marriage acquisitions

or inheritance.[68] Yet even these assumptions are not entirely reliable, because the gentry could also be unadventurous in their choice of material goods, particularly on the country estates.

The gradual ousting of pewter in favour of fine ceramic wares did not necessarily indicate an increase in wealth across the broad range of middle-class consumers. During the latter half of the eighteenth century there was if anything a relative decline in wealth, and certainly a downturn in Bristol's fortunes. Although probate inventories indicate the accumulation of more material goods, this was not necessarily substantial enough to suggest a consumer boom, or even a fashion-led increase in consumption.[69] It was more a question of fine ceramic manufactures representing affordable, easily replaceable, and socially useful artefacts sufficient to maintain a middle-class household's sense of propriety. Householders in Bristol, as elsewhere, responded to the merchandise available to them in a variety of different ways, and made specific decisions which were a blend of pragmatism and desires. These desires did not necessarily conform to leading fashions or to the social emulation decried in contemporary commentaries which ridiculed imitation of luxurious living predominant in, and largely confined to, London.[70] Emulation of elite material culture and an acute awareness of social status expressed through snobbery certainly existed, but it was not universal, and it was not always of the same kind. As the century progressed the middle class expressed a greater concern not to emulate their social superiors in all things, but to establish their own rules of propriety which distinguished them from both their 'superiors' and 'inferiors'.[71]

Household and business account books give another perspective on material goods in a living context; inventories record what was in the possession of a deceased person at a particular point in time, but household accounts reveal what was purchased over longer periods. Again the vagaries of individual circumstances do not allow for any certainties, only indications of the priorities in consumption and the levels of importance attached to the ownership of refined artefacts when they were affordable. For example, a Bristol tradesman, Joshua Wharton, kept a detailed accounts and memoranda book. On 2 April 1734 he paid 5d for earthenware, purchasing more to the value of 2s 3d later in the month. The more costly durables like china, or 'cheney', were only occasional entries compared to the more regular purchase of earthenwares, and appear at a later stage in his life, suggesting growth in prosperity as his business developed.[72]

Moving to London and up the social scale, the account book of Sir Charles Stanley kept between 1772 and 1782 records the purchase of ceramic wares in great detail. Stanley was a customer of

Wedgwood and Twining, but he also took care to itemise the less prestigious and more numerous goods acquired from Chamberlayne the ironmonger, Storer and William Greenhalgh, who supplied 'earthen' goods, including glass as well as ceramic tablewares, chamber pots and garden pots. According to Stanley's accounts, over a period of ten years, purchases from Wedgwood's London showroom amounted to a couple of teapots, two mugs and two double handled cups. He appears to have bought china at auctions; for example a table service for £2 18s 6d was purchased in 1773 at the same time as a breakfast set for £1 8s 0d. Coarse kitchen wares and cheaper tablewares most likely to be subject to the vagaries of everyday breakages appear frequently, and also indicate the presence of a substantial number of household servants. In September 1773 a teapot, cups and saucers were bought for 9d, and were probably for the use of domestic staff. Frequent purchases of gally pots and sweetmeat pots from Greenhalgh suggest a considerable amount of household activity in making preserves, and Chamberlayne supplied less expensive china wares, wine and water glasses, decanters and blue salt linings.[73]

Stanley's household accounts are of additional interest because he included the humblest everyday items usually associated with, and recorded by, the female members of an upper-class household. In 1696 Mary Astell wrote of the contempt men had 'about things trivial and of no moment in themselves'.[74] While not going so far as to claim a woman's right to enter the public world, she was very clear that men 'understood not the value' of women's skills in the home:

> Thus when they hear us talking to, and advising one another about the Order, Distribution and Contrivance of *Household Affairs*, about the *Regulation* of the *Family*, and *Government* of *Children* and *Servants*, the provident management of a *Kitchen*, and convenient disposition of *Furniture* and the like, they presently condemn us for impertinence.[75] Yet they may be pleased to consider, that as the affairs of the World are now divided betwixt us, the *Domestick* are our share, and out of which we are rarely suffer'd to interpose our Sense.[76]

In 1696 Mary Astell clearly perceived her world to be divided into a realm of public affairs in which men predominated and a domestic one of 'household affairs'. She was insistent that the quality of men's lives within the home was dependent on the skills of women: 'as light and inconsiderable' as domestic concerns may seem, men 'are capable of no Pleasure of Sense higher or more refin'd than those of *Brutes* without our care of 'em'.[77] Articulated here was one of the most contentious and problematic of eighteenth-century issues which emerged between the sexes.

Civility, refinement and polite conduct were essential to the suc-
cessful outcome of business and commerce, and to the increasingly
desired notion of the home and family as a proper foundation for
the health of the nation. But if taken too far by the eighteenth-
century man he was deemed to be in danger of becoming
'effeminate', and too much time spent in the society of women,
with their 'impertinent' concerns, was liable to weaken those
manly qualities which John Brown, writing in the 1750s, believed
had beginnings in the 'unwholesome Warmth of a Nursery' and
where 'Every circumstance of modern Use conspires to sooth him
into an Excess of Effeminacy: Warm Carpets are spread under his
Feet; Warm Hangings surround him; door and Windows nicely
jointed prevent the least rude Encroachment of the external
Air'.[78] Such was the problem surrounding the greater refinement
and comfort achieved in domestic life, about which there was a
strong sense of ambivalence. Men trod a fine line between 'effemi-
nacy' and 'politeness', and yet polite social practices required the
presence and organisation of women. Men looked to women to
keep them civilised, and yet resented them for doing so.

Mary Astell's sharp commentary emphasised the social useful-
ness, skill and practicality of women's work.[79] At the close of the
seventeenth century women with responsibility for households of
property, whether in business or in farming the land among the
lesser gentry, had much work to do. It was the female head of the
household who had a wide range of skills and knowledge in the
maintainance of nutrition and health. She was likely to be in
charge of baking and brewing, the preserving of meats, fruits and
vegetables, of collecting ingredients for the preparation of various
medications, the making and mending of clothing, and certainly
these skills were learned and practiced by the young Mary Astell
in her Newcastle family home.[80] Beyond the essential duties of
maintaining the health and welfare of the family, commonplace
books and household accounts testify that women took pains to
embellish their work with imaginative skills in the presentation
of food, in ensuring that attractive and socially commanding
clothing was available for the family, in increasing the comfort of
the home environment - her civilising 'impertinences'.[81] While
these responsibilities did not disappear from middle-class women's
lives, and many women in rural areas and on the fringes of towns
in particular upheld them, their nature was substantially redrawn
as the eighteenth century progressed, becoming less significant in
directly maintaining the family economy and more important as
signifiers of accomplishments and duties appropriate to a 'polite'
and 'enlightened' society; for instance many women of the middle
class became involved in charitable organisations and undertook

work as teachers or instructors; they involved themselves in Sunday Schools, and some took part in local organisations supporting philanthropic campaigns like the abolition of slavery. Although at present it is hard to verify, an increase in the availability of consumer goods probably brought more women into the retail trade, individually or with other family members.[82] Married middle-class women at home who employed domestic servants spent more time with their children and supervised social events for their husbands. In addition both women and men spent more time in reading and discussion; with a greatly increased output from writers and publishers there was much more material to read and people were aware of newsworthy events and novel developments in their world. If, as many historians have assumed, middle-class women were increasingly marginalised as partners in family businesses and in the economics of the family as a whole, it is hardly surprising that relative inactivity in the *production* of things, and an increase in the volume and diversity of manufactured goods, meant that middle-class women became much more active as consumers rather than producers. Inactive they were not, but the nature and economic value of their work changed.[83]

Taste and sensibility

Samuel Fawconer compared luxury, the consequence of 'extensive commerce and exorbitant wealth', to a contagious disease of an 'assimilating insinuating nature' which ran through a people from the highest to the lowest in the land. The threat to the old established social order lay in the visible manner in which people remade themselves through the use of consumer goods, especially through the clothes they wore. Fawconer interpreted the fashionable clothes he saw on the city streets as evidence of 'inborn pride', and in consequence asserted that 'every impertinent inferiour treads on the heels of his betters …'.[84] It is not difficult to see how the notion of social emulation appeared obvious to many observers, but conspicuous consumption and emulation were highly visible chiefly in urban centres, and particularly so with regard to clothing. It would be an oversimplification to assume that there were no other motivations at work to consume the new material goods, motivations which were driven by pleasures and interests in themselves, and which generated new sensibilities.

In 1719 Thomas Toms, a London barber-surgeon, died at the age of thirty. Toms accumulated possessions which were fashionable and sufficient to crowd his living space of four rooms. He owned forty-one pieces of china as well as a tea-table, eleven pictures and two prints, nine cane chairs with cushions, two pier glasses, a

chimney glass and a pair of glass sconces.[85] A Bristol surgeon, Robert
Edwards, who died in 1715, owned 'china ware in the Bofett' and
more which was kept in the first floor 'fore st. room'. He also owned
cane chairs, an easy chair and a considerable quantity of pictures
hung on the stairs, in the first floor rooms and the kitchen, in
which there were likenesses of twelve Roman emperors. In fact he
owned more pictures than Toms did pieces of china, fifty in total.[86]
People of Defoe's 'middle Station in Life' were evidently enhancing
visual interest in their domestic environments and creating greater
comfort.

One of the consequences of trade and manufactures was greater
cultural integration. Thomas Toms and Robert Edwards owned
pieces of china, pictures, prints and cane chairs which were to be
found in the households of their own 'middling sort', as well as the
households of the upper classes in more refined and grandiose
versions and with variations in style. These artefacts were repro-
ducible, if not mechanically then certainly in batches of
considerable quantities following certain specifications which
could be replicated over lengthy periods of time, but subject to
adaptation when technical or stylistic interventions demanded it.[87]
As the century progressed it was increasingly possible to exercise
choice in the purchase of goods within individual or collective
constraints. This had the effect of extending a sense of belonging
to social and cultural groups across wider geographical areas, and
at the same time allowed for a degree of individual expression.[88] In
the case of the florist's trade there was a direct link with geographi-
cal exploration which had a major impact on rural and urban
sensibilities in response to the visual and olfactory pleasures of
flowers. The production of ceramic vessels in which to grow and
display flowers formed a significant branch of both rural and
urban manufactures.[89]

The enthusiasm for cultivating flowers occurred at a time when
refined sensibilities expressed changes in taste, notably that floral
perfumes were now preferred to those of animal origin. The degree
to which floral imagery and flowers themselves were absorbed into
material culture indicates the growth of an aesthetic appreciation
of nature which suppressed the grosser associations. In the eight-
eenth century people started to 'clean up' the seventeenth-century
anthropomorphic and zoomorphic names for plants; 'mare's pistle'
became 'mare's tail' for example, and these names with their re-
gional variations often had their origins in the imaginations of
shepherds and farmers. In his *Critica Botanica* of 1737, Carl Linnaeus
gave plants two Latin names which made no reference to their
characteristics, only identifying the genus and the species to which
they belonged.[90] Human responses to smells are not static, and are

subject to changes in taste which indicate more deep-rooted social movement. As middle-class society became more polite and refined, delicate and decent, it became more difficult to refer to those 'number of actions on which 'tis proper to draw a veil'.[91] The scatological rites and odours of excretion formerly taken in people's stride and tackled in carnivalesque popular culture with humour and frankness became increasingly intolerable to contemplate and experience in polite middle- and upper-class society. In male company Welsh women of the gentry retired behind their fans or looked down upon the floor when language became too coarse, and excrement could only be referred to as 'nastiness'.[92] Perfumes extracted from the sex glands and excreta of animals, like musk, ambergris and civet, which were close to odours of decomposition, were rejected in favour of the floral scents. From their earlier use as a means of protection against infection or foul air, a miasma which was strongly associated with the source of disease, the animal scents were gradually discredited as carrying the essence of putrefaction. Aromatic perfumes were also considered to be the cause of psychic disturbance; they were too powerful and likely to cause anxiety, or the complete opposite, stupor.[93]

In Tobias Smollett's *Humphrey Clinker* smell has a recurring and potent presence in the narrative. There are references to evil-smelling substances in close proximity to, or issuing from, 'polite society' – an indication of Smollett's own ambivalent feelings about the social and cultural changes he witnessed. At the Bristol Hotwells Matthew Bramble complains of the stink 'occasioned by the vast quantity of mud and slime which the river leaves at a low ebb under the windows of the Pump Room'.[94] The effect of the smell of the crowd at an Assembly in Bath has a violent effect on his constitution when the 'multitude' rises to begin the 'country dances'. He described the experience to his doctor at home in Wales.

> Imagine to yourself a high exalted essence of mingled odours, arising from putrid gums, imposthumated lungs, sour flatulencies, rank armpits, sweating feet, running sores and issues, plasters, ointments and embrocations, hungary-water, spirit of lavender, assafoetida drops, musk, hartshorn, and sal volatile; besides a thousand frowzy steams, which I could not analyse. Such, O Dick! is the fragrant aether we breathe in the polite assemblies of Bath.[95]

'Tastes' were transformed and developed in the sensory experiences of life as well as the intellectual ability to discriminate and form correct judgements about things. In an advertisement in the *Bath Chronicle* of 2 November 1774, Richard Warren promised readers that his 'Vegetable System of Perfumery from roots, woods,

barks, leaves, and flowers' was entirely 'without musk, civet, or any of those fetid drugs commonly made use of in the trade'.[96] The taste for floral imagery on ceramic vessels, and for cultivating sweet-smelling pot plants, reinforced the olfactory pleasure and suppressed the distasteful. In *The Female Spectator* of 1745:

> The Jonquil, the Rose, the Jessamin, the Orange-Flower, the Auricula and a thousand others, ravish two of our senses with their Beauty, and the Fragrancy of their Odeur ... They are, I think, the Universal Taste; – and we not only see them in Gardens, but preserved in Pots and *China* Basons in Ladies chambers; and, when deprived of the originals by the cold Blasts of Winter, we have them copied in Painting, Japanning, and in Embroidery.[97]

The exuberance with which fine ceramic tablewares, ornaments, textiles and wallpapers were covered in floral imagery was indicative of both new cultural interests, the pleasure of new scents and particularly of colours, and of the expansion of commerce. As the century progressed there was a vigorous development in the cultivation and sale of seeds and plants and the making of gardens: 'For these, the Alps and the Andes have been successfully scaled, and the remotest regions of the earth adventurously traversed'.[98] The commercial judgement that floral imagery would therefore find a market less susceptible to sudden changes in fashion, that it met a 'Universal Taste', was a sound one, and gardening tends to be a long-term project. Even if a garden was not accessible to urban people, flowers were cultivated in whatever space was available; inhabitants would crowd a 'board before their chamber-windows' with flower pots 'filled with Angelica, Southernwood, Pinks, Roses'.[99]

Writing in 1722, Thomas Fairchild stated his belief that:

> our judicious Traders in the City have as much reason to hope for the Enjoyment of the Pleasures of this Life, as the Persons of Quality, which are in the highest Stations; for the Pleasures of Gardening, or Country Air, which I speak of, are equally the Right of one and the other ...[100]

Fairchild had in mind the wealthy men of business who were thinking of retiring to the country. His recommendations for gardening in London were of a more expensive and sophisticated nature than a few pots of southernwood and pinks on the window sill, but he took care to select species which grew well in the smoke and grime of the city streets. Fairchild's ideas were derived from the nobility, although his intention was to make the potential for growing plants in a city environment more widely known, as well as to advertise his own gardens and nursery at Hoxton, where gardeners could view the plants and make an informed choice. For an interior display he suggested:

a Pyramid of Shelves to be cover'd with Pots of blossoming orange-Trees, with Fruit upon them, intertwixt with Mirtles, Aloes &c. for Variety-sake, it would be extremely beautiful for the Summer; and the Pots, to add the greater Beauty, might be of Delph Ware, or well painted, to stand in Dishes, which are now in Use; so that when we water the Plants, the Water will not run upon the Floor.[101]

For most people their aspirations had to be more modest, but the eighteenth-century enthusiasm for growing plants was marked by its urban character and was a part of the modern process of becoming polite and civilised.[102] Floral societies and gardener's clubs were established with annual or biannual flower shows for the growers of popular species like carnations or auriculas, further increasing a sense of shared community interests.

It was for interiors that the forcing of bulbs for the winter months became a popular practice, and special bulb pots were designed in which hyacinths in particular were grown in water with space for cut flowers around them (Fig. 27). 'Winter', according to John Hudson, was a season:

> not without its advantages: it may be considered a time of social tranquillity, in which we may taste a thousand pleasures of domestic retirement. Nay, the skill and industry of man may put a force upon Nature, and, in spite of the rigours of the Winter, produce in that season all the beauty and fragrance of Spring. By persevering industry we may be enabled to exhibit a pleasant *garden* in a *chamber*, and that at a season when Nature, bound in Winter's icy fetters, lies torpid and incapable of acting.[103]

Hudson was full of confidence in man's ingenuity in bending nature to his will, and in this sense horticulture was related to the wider modern confidence in scientific discovery and technological change, especially in the last decade of the century when Hudson's

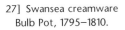

27] Swansea creamware
Bulb Pot, 1795–1810.

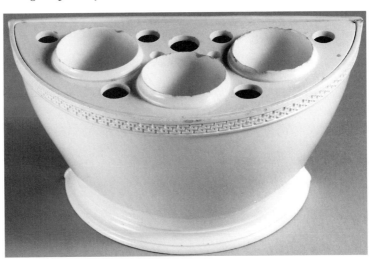

book was published.[104] In the domestic environment floral arrangements were becoming an increasingly significant and elaborate form of display for those who could afford the costs, anticipating the even greater exploitation of floral spectacle in the nineteenth-century middle-class home, with its plethora of ceramic vessels. Hudson's meticulous instructions for success in the forcing of bulbs either in water or in earth is followed by directions for a winter display of hyacinths, jonquils, iris or narcissus following the same pyramid structure advocated by Fairchild in the early eighteenth century: 'to make a show, the flowers should be disposed in a pyramidal form, upon semicircular shelves, rising one above another, and gradually diminishing. This arrangement forms a grand mountain of flowers, which will strike the eye most agreeably.'[105]

In the latter half of the century the seed and bulb market had expanded enormously, and most local potters had access to clays suitable for the making of strictly functional coarse flowerpots at a few pence each. There was a heavy demand for standardised flowerpots from both the retailers of plants and seeds and their customers. In *The Florists Companion* of 1794 John Hudson took care to advise on the correct size of the pot for the 'replantry' of auriculas: 'A good blooming Auricula may have a pot of three-half pence in value, and for the largest one of not more than two-pence; for it has been proved by experience, that in pots of large dimensions, the Auricula never does well'.[106] According to Hudson the 'graceful display' of an Auricula was dependent on 'covering the top of the flower-pot with fresh verdure or foliage of luxurious growth and an agreeable green colour, such as are expressive of the most perfect health and vigour'.[107] The Bristol Counterslip Potteries were producing stoneware bottles, pickling jars and mugs in 1764, and had added garden pots, chimney pots and water pipes to the production by the end of the century – an indication of the urban growth which required the provision and replacement of such items. In Westbury-on-Trym George Hart also produced 'useful and ornamental chimney pots ... likewise all kinds of useful and ornamental garden pots', which he claimed were made of a 'peculiar sort of clay' which was able to withstand frost and adverse weather conditions. Hart supplied the garden pots to a Bristol earthenware dealer, William Plant, who also exported ceramic goods to Dublin.[108]

The inventory of a Bristol weaver, Jonas Bates, who died in 1736, recorded ownership of 'a parcel of garden pots and some Exotic Plants' valued at £4 16s. The type of plant was not recorded, but alpines were commercially available and sought after by growers (Fig. 28). A 'parcel' of garden pots indicates a considerable number, which suggests that Jonas Bates took the cultivation of plants

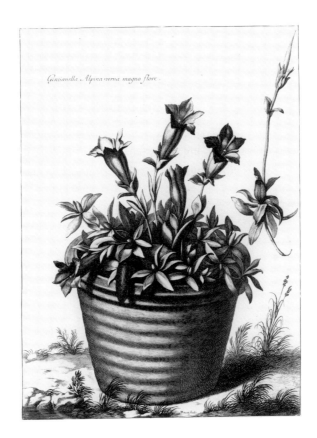

Gentianella Alpina verna magno flore.

28] Nicolas Robert,
'Gentianella Alpina', *Recueil
des Plantes*, Vol. I,
engraving, 1700.

seriously. The value of these plants represented a considerable sum;
it amounted to more than his silver, which was just over £4. Like
Robert Edwards, the Bristol barber-surgeon, Bates also owned many
pictures and prints. At his death Bates's estate was valued at just
over £116, and Edwards, the barber-surgeon, was worth £154.[109] A
skilled artisan and a barber-surgeon supposedly on the lower mar-
gins of the middle class obviously had shared sensibilities for
artefacts of visual interest; or, at least, someone in their families
did. Flowerpots provided the artisan and manufacturing classes
with portable gardens. Where no deep soil was available, the
flowerpot, if a relatively coarse object in itself, allowed those in
urban areas to find pleasure in the cultivation of auriculas, carna-
tions, anenomes, hyacinths, polyanthus, tulips and ranunculus, all
defined as florist's flowers according to the rules of floral societies.[110]

Among people in the lower income levels of the 'middle Station
of Life', and those who were likely to be classed in the 'mechanic
Part of Mankind', there was evidently a growing tendency to em-
bellish the home with material goods and cultivated flowers which
appealed to the senses of sight, smell and touch. Jonas Bates's
ownership of exotic plants indicates the existence of more expens-
ive enthusiasms even in the 'mechanic' artisan class. This is a

further reminder of the complexity of material culture in the past, and the difficulty of ascribing particular consumer choices to people in specific social and economic categories. The creamware bulb pot in Figure 27 represents an inexpensive version of this type of vessel, which was a new addition to the range of fine ceramic products reaching the market during the century. Such specialised artefacts would not have been manufactured had the development of market gardening not taken place and made bulbs, seeds and cuttings commercially available . But inseparable from commerce was the change which took place in people's sensibilities; these examples underline the interdependence of product development and shifts in tastes, and the importance of a commercial enterprise acute enough to tune into them.

Notes

1 S. Alpers, *The Art of Describing: Dutch Art in the Seventeenth Century* (London, Pelican Books, [1983] 1989), p. 114. See also N. Bryson, *Looking at the Overlooked: Four Essays on Still Life Painting* (London, Reaktion Books, 1990), pp. 124–6, for a discussion of the competitive element between painting and craft practice.

2 S. Schama, *The Embarrassment of Riches: An Interpretation of Dutch Culture in the Golden Age* (London, Fontana Press, 1988), p. 326. C. Mukerji, *From Graven Images: Patterns of Modern Materialism* (New York, Columbia University Press, 1983), p. 13.

3 N. Barbon, *A Discourse of Trade* (London, 1690), pp. 1., 14.

4 Alpers, *The Art of Describing*, p. 111.

5 See J. Hurst, 'Post-Medieval Pottery from Seville Imported into North-West Europe', in D. R. Hook and D. R. M. Gaimster (eds), *Trade and Discovery: The Scientific Study of Artefacts from Post-Medieval Europe and Beyond*, British Museum Occasional Paper 109 (London, British Musuem, 1995), pp. 45–54.

6 See J. Hatcher, and T. C. Barker, *A History of British Pewter* (London, Longman, 1974). Pewter was quite rapidly taken up by the urban and rural middle income groups in the sixteenth and seventeenth centuries, and evidence exists to confirm its accessibility to the better-off within the artisan and peasant classes.

7 *The Diary of Samuel Pepys*, ed. H. B. Wheatley, Vol. III (London, G. Bell, 1928), p. 321.

8 K. N. Chaudhuri, *The Trading World of Asia and the English East India Company 1660-1760* (Cambridge, Cambridge University Press, 1978), p. 407.

9 J. Latimer, *Annals of Bristol*, Vol. 2 (1893), p. 187.

10 D. Defoe, *Roxana* (London, Penguin Classics, [1724] 1987), p. 218.

11 M. Foucault, *The Order of Things* (London, Routledge, [1966] 1992), pp. 167–8.

12 D. Hume, 'Of the Balance of Trade', in *David Hume: Selected Essays*, ed. S. Copley and A. Edgar (Oxford, Oxford University Press, World Classics Series, [1741–42] 1993), p. 196.

13 P. Langford, *A Polite and Commercial People: England 1727-1783* (Oxford, Oxford University Press, [1989] 1992), pp. 70–1.

14 L. Weatherill, *Consumer Behaviour and Material Culture in Britain 1660-1760* (London, Routledge, 1988), p. 8. According to Lorna Weatherill's survey of 3,000 inventories, ownership of 'decorative' china was limited to 4 per cent, and 41 per cent of this ownership was represented by wealthy London merchants. After

1760 there was a greater range of cheaper decorative wares in production, and these were accessible to a larger group of middle-class consumers.

15 Lorna Weatherill's extensive survey of probate inventories confirms the initially slow but increasingly faster pace of change in the ownership of fine ceramics in preference to pewter, *ibid.*, pp. 110–11. The author's survey of 2,252 of the Diocese of Bristol probate inventories from 1680 to 1749 agrees with this trend. However, other surveys, as Weatherill takes care to point out in Chapter 3 of *Consumer Behaviour and Material Culture*, are indicative of an uneven tempo of change in localised contexts. For example, see J. S. Roper, *Sedgley Probate Inventories, 1614-1787* (Sedgley, 1960). In the Staffordshire manor of Sedgley fine ceramics are rarely recorded until well into the eighteenth century; for example, see the inventory of Joshua Bissell, Victualler, 1786, who owned a substantial quantity and variety of wares.

16 W. Schivelbusch, *Das Paradies, der Geschmack und die Vernunft: Eine Geschichte der Genußmittel* (Munich and Vienna, Hanser Verlag, 1980), p. 32.

17 M. Lister, *A Journey to Paris in the Year 1698* (London, 1699), p. 166.

18 Langford, *A Polite and Commercial People*, pp. 68–9.

19 J. Brown, *An Estimate of the Manners and Principles of the Time* (London, 1757), p. 37.

20 B. K. Wheaton, *Savouring the Past: The French Kitchen and Table from 1300-1789* (University Park Pa., University of Pennsylvania Press, 1983), pp. 186–93. Somewhat perilously constructed, the pyramid of fruit often interspersed with layers of flowers was formed in a conical tin mould, which when full was inverted onto tin, pewter, or silver 'porcelaines'. Glass or porcelain dishes were too heavy for large constructions, and the losses usually total if the edifice collapsed.

21 Brown, *An Estimate ...*, p. 51. On *An Estimate ...* see J. Brewer, *The Pleasures of the Imagination: English Culture in the Eighteenth Century* (London, Harper Collins, 1997), pp. 80–3.

22 On the cultivation of sensibility in its diverse forms see Langford, *A Polite and Commercial People*, Chapter 10.

23 J. H. Plumb, 'The Acceptance of Modernity', in N. McKendrick, J. Brewer and J. H. Plumb, *The Birth of a Consumer Society: The Commercialization of Eighteenth-Century England* (London, Europa Books, 1982), p. 316.

24 F. Nivelon, *The Rudiments of Genteel Behaviour* (London, 1737), Plate 2, 'To Give or Receive', no page numbers.

25 *Ibid.*, Plate 5, 'Standing'.

26 R. Muchembled, 'The Order of Gestures: A Social History of Sensibilities Under the Ancien Régime in France', in J. Bremmer and H. Roodenburg (eds), *A Cultural History of Gesture* (Cambridge, Polity Press, 1991), pp. 141–2. For an extensive study of manners see N. Elias, *The Civilising Process: Vol. 1 The History of Manners*, trans. E. Jephcott (Oxford, Basil Blackwell, 1978).

27 S. Johnson, *A Dictionary of the English Language*, Vol. II (London, 1756).

28 W. Hogarth, *The Analysis of Beauty* (London, 1753), p. 142.

29 *The Gentleman's Magazine*, March 1735, p. 133.

30 Bristol Record Office, Richard Champion Letterbooks, MS 38083, 1760-1775, fo. 137, letter dated 12 March 1765.

31 For extended discussion on the transformation of behaviour and reform in manners see P. Stallybrass and A. White, *The Politics and Poetics of Transgression* (London, Methuen, 1986), p. 94, and also G. J. Barker-Benfield, *The Culture of Sensibility: Sex and Society in Eighteenth-Century Britain* (Chicago, University of

Chicago Press, 1992). For further discussion on the coffee-house see Chapter 4, pp. 133–8.

32 For a wider discussions of 'politeness' and 'sensibility' see Langford, *A Polite and Commercial People*, Chapters 3 and 10. See also C. Campbell, Chapter 2, 'The Ethic of Feeling', in *The Romantic Ethic and the Spirit of Modern Consumerism* (Oxford, Basil Blackwell, [1987] 1989).

33 For a fuller account of the effeminacy question and the significance of consumer goods in women's lives, see Chapters 3 and 4, 'The Question of Effeminacy' and 'Women and Eighteenth-Century Consumerism', in Barker-Benfield, *The Culture of Sensibility*.

34 J. Gay, *To a Lady on her Passion for Old China* (London, 1725). Probably written for the Duchess of Queensbury. The Duke was John Gay's patron.

35 *Ibid.*

36 *Ibid.*

37 *The Spectator*, Saturday 5 May 1711.

38 The role of *The Spectator* and *The Tatler* in the reformation of manners is treated at some length in Barker-Benfield, *The Culture of Sensibility*, Chapter 2, 'The Reformation of Male Manners'. For a discussion of these two periodicals in relation to commerce and politeness see D. H. Solkin, Chapter 1, 'Kit-Cats, Commerce and Conversation', in *Painting for Money: The Visual Arts and the Public Sphere in Eighteenth-Century England* (New Haven and London, Yale University Press, 1992), especially p. 30.

39 E. Haywood, *The Female Spectator*, Vol. II, Book VIII (London, 1745), p. 96. For a history and illustrated survey of tewares and social practices see R. Emmerson, *British Teapots and Tea Drinking 1700-1850* (London and Norwich, HMSO, 1992).

40 Haywood, *The Female Spectator*, p. 97, but numbered 79.

41 Barker-Benfield, *The Culture of Sensibility*, p. 159.

42 W. Wycherley, *The Country Wife* licensed in 1675, in *The Works of the Ingenious Mr. William Wycherley* (London, 1713), Act II, Scene I, p. 162. 'Shocks' were lap dogs.

43 B. Kowaleski-Wallace, 'Women, China, and Consumer Culture in Eighteenth-Century England', *Eighteenth-Century Studies*, 29, 2 (1995-96), p. 155.

44 W. Wycherley, *The Country Wife* (1713), Act IV, Scene III, p. 204.

45 W. Wycherley, *The Plain Dealer* licensed in 1676, Act II, Scene I, in *The Works of the Ingenious Mr. William Wycherley* p. 33.

46 M. Bakhtin, *Rabelais and His World* (Bloomington, Indiana University Press, [1965] 1984), pp. 116–18.

47 D. Cook and J. Swannell (eds), *The Revels Plays: The Country Wife: William Wycherley* (London, Methuen, 1975), p. lxvii.

48 *Ibid.*, p. lxvii.

49 Stallybrass and White, *The Politics and Poetics of Transgression*, p. 108, with reference to the Augustan poets Dryden and Pope in particular.

50 N. Bryson, 'Still Life and Feminine Space', in *Looking at the Overlooked*, p. 160. See also E. Kowaleski-Wallace, *Consuming Subjects: Women, Shopping, and Business in the Eighteenth Century* (New York, Columbia University Press, 1997), p. 60.

51 Bryson, *Looking at the Overlooked*, p. 161.

52 For an interesting and much fuller discussion of these transitions see C. Shammas, *The Pre-Industrial Consumer in England and America* (Oxford, Clarendon Press, 1990), especially Chapter 6, 'Housing, Consumer Durables, and the Domestic Environment'. See also Barker-Benfield, *The Culture of Sensibility*. On housework

see B. Hill, *Women, Work and Sexual Politics in Eighteenth-Century Britain* (Oxford, Basil Blackwell, 1989). For a rewarding and extensive study of women's lives in early modern Europe see O. Hufton, *The Prospect Before Her: A History of Women in Western Europe 1500–1800*, Vol. 1 (London, Fontana Press, [1995] 1997).

53 For a comprehensive analysis of the ownership of goods in English middle-class households see Weatherill, *Consumer Behaviour and Material Culture*.

54 M. Blundell (ed.), *Blundell's Diary and Letterbook 1702–1728* (Liverpool, Liverpool University Press, 1952), p. 53. The Blundells were minor landed gentry rather than middle class. However, Nicholas Blundell's papers provide a rich insight into early eighteenth-century rural life in Lancashire at a social level which was frequently not far removed from that of the affluent merchant class. In fact many of the latter were often wealthier than the lesser landed gentry with intermarriage of mutual advantage to the these social groups.

55 U. Priestley and P. J. Corfield, 'Rooms and Room Use in Norwich Housing 1580–1730', *Post-Medieval Archaeology*, 16 (1982), pp. 93–123. See also Shammas, *The Pre-Industrial Consumer*, pp. 163–4.

56 W. Ison, *The Georgian Buildings of Bristol* (Bath, Kingsmead Press, 1978), p. 157. Many of the new housing developments in Bristol had sewerage systems installed and water was plumbed in.

57 *Ibid.*, pp. 208–9. John Penrose gave a good insight into the experience of 'lodgings' in Bath in his letters home to his daughter, see B. Mitchell and H. Penrose, *Letters from Bath 1766–1767 by the Reverend John Penrose* (Gloucester, Alan Sutton, 1983).

58 For a fuller discussion of artefacts as socially strategic see J. de Vries, 'Purchasing Power and the World of Goods', in J. Brewer and R. Porter (eds), *Consumption and the World of Goods* (London, Routledge, 1993).

59 A. Allardyce (ed.), *Scotland and Scotsmen in the Eighteenth Century: From the MSS of John Ramsey Esq. of Ochtertyre*, Vol. II (Edinburgh and London, Blackwood and Sons, 1888), p. 48.

60 J. G. Fyfe (ed.), *Scottish Diaries and Memoirs 1746–1843* (Stirling, Eneas Mackay, 1942), p. 180.

61 S. Nenadic, 'Middle-Rank Consumers and Domestic Culture in Edinburgh and Glasgow 1720–1840', *Past and Present*, 145 (1995), pp. 142–3.

62 Fyfe, *Scottish Diaries and Memoirs*, pp. 228–9.

63 On the Evangelical revival see Langford, *A Polite and Commercial People*, Chapter 6.

64 D. Defoe, *A Tour Through the Whole Island of Great Britain* (London, Penguin Classics, [1724–26] 1971), p. 361. Bristol lost this place to Liverpool later in the century, and the latter also took over prominence in the manufacture of Delf-twares and blue and white soft-paste porcelains.

65 Bristol Record Office, Diocese of Bristol, probate inventories, on the evidence of the author's survey.

66 A 'clavy' was a West Country term for a shelf used for the display of ornaments, glass and ceramic wares. The sample of probate inventories investigated corresponds generally with the findings established in other parts of the country, most notably in Lorna Weatherill's *Consumer Behaviour and Material Culture in Britain 1660–1760*. As Weatherill is careful to stress, there are always local factors to take into account which can reveal marked regional differences, although she argues that discrepencies are not necessarily marked by urban and rural oppositions. See Chapter 4, 'The Influence of Towns'.

67 Bristol Record Office, Diocese of Bristol Probate Inventories, inventory of Phillip Cadell, Teaman, 1776.

68 Bristol Record Office, Inventory of the Household Goods of Edward Pye Chamberlayne, Smyth MSS. AC/WH18, 1756.

69 See de Vries, 'Purchasing Power', p. 101. It is important to establish that between different classes of goods there were variable consumer patterns, some of which were more active than others. Fashion-led consumption was not surprisingly most active in clothing, but the rate at which it moved varied according to social position and regional location.

70 For an interesting and thoughtful case study of consumer motivation and constraints which questions the assumption that social emulation explains growth in production and consumer demand see A. Vickery, 'Women and the World of Goods: a Lancashire Consumer and her Possessions, 1751-81', in Brewer and Porter (eds), *Consumption and the World of Goods*. In the same volume see L. Weatherill, 'The Meaning of Consumer Behaviour in Late Seventeenth- and Early Eighteenth-Century England', and also her book *Consumer Behaviour and Material Culture in Britain 1660-1760*, which broadly agrees with Jan de Vries's assessment. For a discussion of consumption in the American colonies see T. H. Breen, 'The Meaning of Things: Interpreting the Consumer Economy in the Eighteenth Century', in Brewer and Porter (eds), *Consumption and the World of Goods*.

71 The literature which made these distinctions is largely to be found in the conduct books, for example Hester Chapone, *Mrs Chapone's Letter to a New-Married Lady* (London, 1777); Rev. John Harris, *An Essay on Politeness by a Young Gentleman* (1775); Thomas Gisborne, *An Enquiry into the Duties of Men ...* (1794) and *An Enquiry into the Duties of the Female Sex* (1797).

72 Bristol Record Office, Joshua Wharton, Household accounts and memoranda book 1733-42, MS. 6783.

73 National Art Library, Victoria and Albert Museum, Household account book probably belonging to Sir J. P. Stanley Bart 1769-1810. Eng. MSL 996-1960. Sir Charles Stanley's greatest expense was in the maintenance of the stables, with considerable sums paid for care of the horses, the purchase of saddlery and the repair of coaches. After a trip to Italy he returned with paintings to the value of £129 12s, among which were listed two by Domenichino and Guido (Reni?).

74 M. Astell, *An Essay in Defence of the Female Sex* (London, 1696), p. 84.

75 Impertinence in this context refers to the now defunct meaning 'That which is of no present weight; that which has no relation to the matter in hand ... Trifle; thing of no value'. It also meant 'Troublesomeness; intrusion' and 'Sauciness; rudeness'. Johnson, *Dictionary of the English Language*.

76 Astell, *An Essay in Defence of the Female Sex*, p. 85.

77 *Ibid.*, p. 86.

78 Brown, *An Estimate of the Manners and Principles of the Times* pp. 29, 36. Brown's admonishments were directed at men of the affluent middle class, the gentry and nobility who held positions of responsibility in civic and military life. His perception was that material wealth eroded the qualities of leadership and fortitude required for government and the conduct of war. The *Estimate* was written and published at a time of international military conflict, the beginning of the Seven Years War, in which contrary to Brown's fears many Britons emerged in 1763 well pleased with their heroic performance.

79 For an interesting biography of Mary Astell see R. Perry, *The Celebrated Mary Astell: An Early English Feminist* (Chicago and London, University of Chicago Press, 1986).

80 *Ibid.*, p. 45.

81 The household account book of Anne Brockman of Beachborough in Kent, married to William Brockman, JP and Deputy Lieutenant for Co. Kent 1689-1690,

and MP for Hythe 1690-1695, is interesting for the evidence of her work and expenditure to ensure the family were very well clothed. British Library Add. MS. 45208, Anne Brockman, Household Accompts. See also Vickery, 'Women and the World of Goods'.

82 M. Hunt, *The Middling Sort: Commerce, Gender, and the Family in England, 1680-1780* (Berkeley, Los Angeles and London, University of California Press, 1996), p. 132.

83 For further discussion which questions the model of clearly defined public (male) and private (female) spheres, and the notion of an increasingly inactive role for middle-class women see M. Hunt, Chapter 5 'Eighteenth-Century Middling Women and Trade', and Chapter 6, 'The Bonds of Matrimony and the Spirit of Capitalism', in her book *The Middling Sort* and A. Vickery, *The Gentleman's Daughter: Women's Lives in Georgian England* (London and New Haven, Yale University Press, 1998). For an excellent study which moves into the nineteenth century and considers these issues see L. Davidoff and C. Hall, *Family Fortunes: Men and Women of the English Middle Class 1780-1850* (London, Routledge, [1987] 1992), N. Armstrong and Leonard Tennenhouse, in *The Ideology of Conduct* (London, Methuen, 1987) argue more strongly for a sharp division between public and private life and the role of the conduct book in defining the ideal, and by definition virtuous, middle-class woman.

84 S. Fawconer, *An Essay on Modern Luxury* (London, 1765), p. 4.

85 P. Earle, *The Making of the English Middle Class: Business, Society and Family Life in London 1660-1730* (London, Methuen, 1989), p. 300.

86 Bristol Record Office, Diocese of Bristol Probate Inventory, Robert Edwards, Surgeon, 1715.

87 For a discussion of these production techniques see J. Styles, 'Manufacturing, Consumption and Design in Eighteenth-Century England', in Brewer and Porter (eds), *Consumption and the World of Goods*, pp. 527-35.

88 For an important contribution which argues the case for not establishing rigid boundaries between elite and non-elite forms of material culture in early modern Europe see C. Mukerji, *From Graven Images: Patterns of Modern Materialism* (New York, Columbia University Press, 1983), p. 66.

89 It has to be said that evidence is scanty. When no longer useful, flowerpots were tipped or crushed and used as infill on building sites, roads and paths. For a short but interesting contribution see C. K. Currie, 'Horticultural Wares from Ham House, Surrey', *Post-Medieval Archaeology*, 29 (1995), pp. 107-11, especially p. 110. Many of the garden pots still in use today have not changed their form or dimensions significantly since the seventeenth century. Gardeners and potters of the past knew what they were doing.

90 K. Thomas, *Man and the Natural World: Changing Attitudes in England 1500-1800* (London, Allen Lane, 1983), pp. 85-6.

91 F. V. Toussaint, *Manners*, translated from the French (London, 1751), p. 89.

92 P. Jenkins, *The Making of a Ruling Class: The Glamorgan Gentry 1640-1790* (Cambridge, Cambridge University Press, 1983), p. 258.

93 A. Corbin, *The Foul and the Fragrant: Odour and the Social Imagination* (London, Picador, [1982] 1994), p. 67.

94 T. Smollett, *The Expedition of Humphrey Clinker* (London, [1771] 1985), p. 26.

95 *Ibid.*, pp. 95-6.

96 *Bath Chronicle and Weekly Gazette*, 2 November 1774 (Bath Central Library).

97 E. Haywood, *The Female Spectator*, Vol. V, Book XIX (London, 1745), p. 57.

98 J. Hudson, *The Florists Companion* (Newcastle, 1794), p. vi. For a discussion of the

practice of horticulture as indicative of modern pursuits see J. H. Plumb, 'The Acceptance of Modernity', in McKendrick, Brewer and Plumb, *The Birth of a Consumer Society*.

99 *Low-Life: or One Half of the World Knows not how the Other Half Lives* (London, 1764), p. 27.

100 T. Fairchild, *The City Gardener, containing the most Experienced Method of Cultivating and Ordering such Evergreens, Fruit-Trees, flowering Shrubs, Flowers, Exotick Plants, &c as will be Ornamental, and thrive best in the London Gardens* (London, 1722), p. 8.

101 *Ibid.*, p. 64.

102 J. Goody, *The Culture of Flowers* (Cambridge, Cambridge University Press, 1993), p. 206. See also Plumb, 'The Acceptance of Modernity', pp. 323-7.

103 Hudson, *The Florists Companion*, p. 77.

104 Plumb, 'The Acceptance of Modernity, p. 327.

105 Hudson, *The Florists Companion*, p. 81.

106 *Ibid.*, p. 5.

107 *Ibid.*, p. 15.

108 R. and P. Jackson and R. Price, 'Bristol Potters and Potteries 1600–1800', *Journal of Ceramic History*, City Art Gallery and Museum, Stoke-on-Trent, 12 (1982), pp. 31, 49.

109 Bristol Record Office, Diocese of Bristol Probate Inventories, Robert Edwards, Surgeon, 1715, and Jonas Bates, Weaver, 1736.

110 M. Hadfield, *A History of British Gardening* (London, Penguin Books, 1985), p. 262.

4 Fine ceramics in social use

In the following pages fine ceramics are considered in the light of what they may have signified to eighteenth-century consumers, and more specifically the contexts in which they were actively used. Not surprisingly the consumption of food and drink is of immediate significance, and the table one of the most important sites on which our concepts of civilised behaviour depend. It would be misplaced to assume that people were 'uncivilised' in their conduct before the introduction of fine ceramic wares. Even with a few basic and perhaps crude tablewares, people of the past conducted themselves with civility when such behaviour was valued for the maintenance of social cohesion, and not in elite circles only. The introduction of fine ceramics lent a polite tone to social encounters, whether in the home, the assembly room or the coffee-house. In the middle-class home such products brought comfort acquired through a measure of refinement, taking into account one's station in life and not always wanting to rise above it. If there were desires and wants, the motivation could be to enhance individual and social experience through finer material circumstances, and emulation might well have been instructive and character-forming rather than merely status-seeking.[1] It is also the case that at times of social discord the artefacts which support polite and civilised structures can be utilised when such structures start to unravel, and the artefacts themselves turned to destructive purposes.

Comforting refinements

Tea, which now figures among the necessities of life, was at first regarded as an expensive, unpleasant drug. But having taken deep root in England, it made its way northwards by degrees. Though the precise time of its introduction among us cannot now be ascertained, yet all our old people agree that it made rapid progress after the year 1715; and before the Rebellion of 1745, it was the common breakfast in most gentleman's families in this country.[2]

In the latter half of the eighteenth century John Ramsey of Ochtertyre noted that tea was not always well received by the

'old-fashioned people, who either rejected it altogether, or required a little brandy to qualify it'.³ After the 'Forty-Five Rebellion which marked a watershed in eighteenth-century Scottish history, the lowland regions settled into a calmer period in which the variety and quality of the new material goods and commodities made a considerable impact on social interaction among the urban and rural middle classes. Ramsey also noted the astonishment caused to the 'common people' at first sight of a tea-table, when a Highlander inquiring 'after the health of Mr. Graham of Braco's family, brought back word that he fancied they were not well, as he found them drinking *hot water* out of *flecked* pigs'.⁴ Ramsey intended no mockery. Although a Presbyterian of Whig persuasion, he was deeply concerned about the fate of the Highlanders and the break-up of the clans after the 'Forty-Five Rebellion, and he was a man who observed with great interest the impact of modernity on the Scottish people.⁵ A practice which astonished a Highlander had already been well absorbed by the Lowlanders, and Ramsey commented on the importance of tea drinking for 'female manners'. Tea 'afforded a cheap and elegant repart to ceremonious company who came rather to pay their compliments than with a view to eating and drinking', and he considered the tea-table effective 'to soften and polish manners'.⁶ 'Improvement' in late eighteenth-century Scotland tended to be most visible in the urban areas and was represented largely by cultural transformations. In England there was cultural transformation accompanied by more marked economic growth and technological innovation, but the latter did not really get under way in Scotland until the very end of the century. The Highlands were generally considered an 'economic backwater', and the people, many of whom spoke Gaelic and no English, were resistant to urban lowland culture and new ideas.⁷

Yet the polite practices of tea and coffee drinking were not absent from the Highlands. Bishop Robert Forbes of Ross and Caithness only visited his diocese twice, in 1762 and 1770, preferring to live in milder Leith. He appreciated good food and before embarking on one of his diocesan tours had been advised to take a loaf of good bread with him, Caithness 'being so poor and despicable a Country that I could have no good thing to eat in it'. It was an 'agreeable Disappointment' to Bishop Forbes and his companion Mr Innes to discover that on requesting breakfast from a landlady on the Caithness border she was able to offer a choice of Green-Tea, Bohea-Tea or Coffee, with fresh milk, butter and oatcakes: ' "Upon my Word, that is good sense truly," said Mr. Innes. "Come, let us alight, and get a good Breakfast, even in the Wilds of Caithness" '. Although Forbes found the region 'bleak, heathy and mossy', his surprise at finding such civilised standards led to hyperbole in

judging Caithness 'one of the most plentiful and hospitable Countries in the whole World'.[8]

In Bath such standards were expected and taken for granted by regular visitors in the 1760s, but for those less familiar with the Spa and its social practices the novelty of what the city had to offer was worth comment. While taking the waters to ease the gout, the Reverend John Penrose was 'most elegantly regaled with a Breakfast at Spring Gardens, with all the other Cornish Gentlemen and Ladies now in Town'. It was possible to purchase a subscription for walking in Spring Gardens, and the 'Breakfasts', which took place in a large pavilion, were advertised in *Pope's Bath Chronicle*. John Penrose described his elegant Breakfast in a letter to his daughter Margaret, who remained at the vicarage in Penryn to look after the younger children of the family:

> the Tables were spread with singular Neatness. Upon a Cloth white as Snow were ranged Coffee Cups, Tea Dishes of different sizes, Chocolate Cups, Tea Pots, and everything belonging to the Equipage of the Tea Table, with French Rolls, Pots of Butter, all in decent order, and interspersed with sweet Briar, which had a pretty Effect both on the Sight and Smell. At the Word of Command were set upon the Table Chocolate, Coffee, Tea, Hot Rolls buttered, buttered hot cakes. What should hinder one from making a good Breakfast?[9]

Bath entrepreneurs could muster considerable organisational skills to provide a service of this standard, offering a pleasurable social occasion followed by a walk in the Gardens which Penrose found an 'enchanting scene'.[10] All the senses of sight, smell, taste and sound were engaged at Spring Gardens, where music was also played by arrangement with the proprietors. In the course of his 'Breakfast' Penrose drank a cup of chocolate, two cups of tea and two of coffee, which he considered very moderate.

It is well known that the East Anglian parson James Woodforde was very fond of food and drink, and it was a parson's obligation to entertain the local gentry, church visitors and at certain times of the year to provide a meal for the poor. Woodforde entered into this way of life with abundant generosity and good humour, living for many years in a parsonage which was large and difficult to maintain at any level of comfort during the several very cold winters he experienced; the degree of cold was several times gauged by the freezing of urine in the chamber pots during the night. The social requirements of his work were smoothed with much drinking of tea and coffee, and many long evenings were spent at cards with his social equals, lubricated with more tea, coffee, wines and spirits. It was in such a context that Woodforde felt most at ease, and not in the company of the gentry or church dignitaries. After

dining with Sir William and Lady Jernegan and the Bishop of Norwich, and in spite of Sir William being a 'very fine Man, very easy, affable and good natured', he wrote in his diary of 7 November 1783: 'Upon the Whole we spent an agreeable Day, but must confess that being with our equals is much more agreeable'.[11]

Given the considerable quantities of tea consumed, it is perhaps not surprising that Parson Woodforde resorted to the services of local smugglers to maintain these comforts at an affordable cost. On 29 March 1777 he wrote, 'Andrews the Smuggler brought me this night about 11 o'clock a bagg of Hyson Tea 6 Pd. weight. He frightened us a little by whistling under the Parlour Window just as we were going to bed. I gave him some Geneva & paid him for the tea at 10/6 per Pd. £3.3.0.'[12] Woodforde bought the better quality teas: Hyson was twice as expensive as Bohea, although he seems to have restricted himself to the 'Good Hyson' rather than the 'Super-fine' which could amount to 18s per pound wholesale. The consumption of fine tea was a considerable expense, a luxury, especially when compared to a labourer's outgoings on tea and sugar for a whole year, which in the 1790s could amount to less than £1. In his *State of the Poor*, Frederick Eden detailed the earnings and expenses of Samuel Price, a labourer of Monmouth, among which bread was by far the heaviest outgoing on food for his wife and nine children, costing on average 9s per week. Price worked for a 'gentleman', earning 8s per week plus beer, with an extra 1s 6d during harvest. Bread appears to have taken up more than his usual wage each week. His eldest son added a small amount to the annual income, as did his wife by actually baking bread. It was she who drank the tea, with milk provided by the employer, and two-thirds of what she earned covered the annual cost of tea and sugar. In deeply rural Presteigne to the north of Monmouth an agricultural worker's wage was not sufficient to include tea and sugar.[13]

It would be reasonable to assume that even in the late eighteenth century fine ceramics were not a visible feature in the rural regions of Wales, except in the homes of the gentry and churchmen.[14] Elizabeth Morgan, wife of Henry Morgan of Henblas, Langristiolus, in Anglesey, went on a shopping expedition in 1736 visiting London, Bath, Bristol and Leominster. She returned with 'twelve china cups and saucers of porcelain, two "slope" bowls a china milkpot and seven teapots'.[15] Not until the end of the century was tea found in the homes of working people on the island, and then it was most likely to be purchased by the 'copar ladis', the women who worked in the Anglesey copper mines and augmented their income to fill their houses with 'tea and the best fine flour, strong coffee and eggs'.[16] By this time Staffordshire pottery was carried into those Welsh areas which had no tradition of

ceramic production. In the middle-class homes of the market towns, and in the resorts like Aberystwyth and Swansea where tea drinking was readily adopted, fine ceramics were a necessary adjunct. However, when tourists came in search of the 'picturesque' and romantic scenery in the last decades of the century, travel accounts suggest that tea and sugar had to be carried into Wales from England because its supply could not be relied upon in roadside inns.[17] The gentry and middle classes of Glamorgan purchased from Bristol material goods that were unavailable in South Wales, and the city was easily accessible for people of leisure to visit the theatre, the Hotwell and to travel on to Bath. But south-east Wales was by no means typical of the country as a whole. Cardiff inventories confirm the ownership of teapots and coffee-sets after 1710, yet in Cardiganshire 'gentlemen' still ate with cups and spoons of wood.[18]

In the eighteenth century there were changes in the diet of most European peoples which represented a break with older patterns and supplies across all social classes. In the German States coffee drinking among the labouring classes moved across those regions most developed in mining and manufacturing, a similar pattern to that represented by the copper-mining region of Anglesey. In 1800 tea, coffee and sugar were accessible to many of the working people in England. In the German States coffee had reached the villages by the middle of the century, but in a less flexible class structure it was then forbidden to the lower social orders, somewhat ineffectively, by landowners from the Rhineland across to Prussia and Saxony.[19] In 1780 an Episcopal decree in Hildesheim ordered all coffee-drinking equipment, cups, bowls, mills and bean roasters, to be destroyed.[20] A prohibition of this nature indicates how unsettling new commodities and their associated social practices could be, especially in a society which observed even sharper divisions between the classes than was the case in Britain.

However, an example serves as a reminder of the real economic divisions which existed in the British class structure. In the mid to late eighteenth century Sir Watkin Williams Wynn was among the wealthiest landowners in the country, with estates in North Wales and Shropshire and a very good address in London. Sir Watkin had a preference for continental porcelain and Wedgwood wares rather than the products of English porcelain manufactories. With his antiquarian interests and predilection for fine quality ceramics, Sir Watkin became a patron of Josiah Wedgwood, and presented him with a copy of the first volume of Sir William Hamilton's *Collection of Etruscan, Greek and Roman Antiquities* in 1769. In the 1770s he bought a considerable quantity of continental porcelain, amongst which was a Dresden dessert service which cost

£94 10s, a small fortune in the eighteenth century. Porcelain at this sort of price was accessible only to the very wealthiest, but another purchase reveals that even the much cheaper blue and white Chinese export wares were well out of reach for the majority. In 1771 Sir Watkin purchased 'a compleat table service of "Nankeen" china, 141 pieces, costing £26.5s'.[21] Accessible to the more affluent levels of the middle classes, this export table service represented more than the sum of one year's earnings for a family in the new manufacturing centres of British society.

Tea and coffee drinking enhanced and formed the focus for social interaction among the leisured classes at home and in the new spas and resorts, and supported the conduct of commerce in the coffee-house. But these commodities also assisted mediation to repair a breakdown in relationships. Before James Woodforde moved to East Anglia he had a living in his home town of Castle Cary in Somerset. An entry in the diary on 12 February 1770 records his intervention to try and resolve disputes between members of the community, and it reveals his use of social rituals, in this case coffee drinking, to help ease the path of reconciliation:

> I went to Mr Will[m] Melliar's and Mr Creed's and Mr Clarke's to desire all three of them to drink a dish of coffee with me this afternoon at Lower House and if possible to reconcile all animosities in Cary and to stop and put an end to all Law Suits now subsisting ... I dined and spent part of the afternoon at Mr Creed's with him and his Father, and after the Justice took a walk with me to my house and drank a dish of coffee with me. Mr. Will[m] Melliar and Dr Clarke also drank a dish of coffee with me and after coffee we talked over the Parish Affairs. After much altercation it was settled for Peace.[22]

It was in situations of tension or a burdensome daily life that commodities like tea and coffee were valued. Woodforde could try and sort out a difficult set of problems in his parish over dishes of coffee, rather than offering wine or beer which might inflame tempers already warm. The use of tea and coffee as a focus for hospitality was not inconsequential. In Parson Woodforde's bid to help resolve a dispute it provided a space and time for people to prepare themselves for a difficult encounter in the neutral context offered through social ritual.

The presence of finer, but not ostentatious, types of ceramic tableware added to the comfort of upholstered furniture and curtains, and to the visual and tactile pleasures these artefacts introduced to the middle-class home. Printed cottons, hand-painted and transfer-printed ceramics made for a brighter and varied visual experience alongside glasswares, mirrors, paintings, prints and ornaments. Edmund Burke recognised the difficulty in tolerating an excess of, or long exposure to, intense aesthetic and

emotional experience. His notion of 'Beauty' held associations with the amiable, the 'softer virtues':

> Those persons who creep into the hearts of most people, who are chosen as companions for their softer hours, and their reliefs from care and anxiety, are never persons of shining qualities, nor strong virtues. It is rather the soft green of the soul on which we rest our eyes, that are fatigued with beholding more glaring objects.[23]

In his *Philosophical Enquiry* Edmund Burke conflated the beautiful with the sensual, and the two with the 'feminine'. The conflation of feminine 'qualities' with the soft, mild and reticent was problematic for contemporary feminist critics like Mary Wollstonecraft.[24] The gendered association implicit between the feminine, domestic space and the objects inhabiting that space was moving into sharper focus. Burke considered the soft, the sweet, the small, the smooth, to be qualities of beauty which relaxed the soul; the idea of 'home' as a place of refuge from the 'masculine' cares of the world, an association which became firmly established in nineteenth-century bourgeois society, was already evident in the mid-eighteenth century. Such values did not necessarily indicate a drive to emulate social superiors however; they had more to do with comforting refinements which underpinned a social and moral ideal than with conspicuous consumption.

Convivial spaces

> In the Coffee-Room – Quin (who you know very well)
> Calls, *Give me some Coffee, as hot, Sir, as Hell.*
> Sir Garrick, cries *Tom* (as the Boy held the Pot)
> *Let me have a Dish, but not* quite *so hot.*[25]

The social institution in which ceramic products served a public purpose was the coffee-house, and in Figure 29 the vessels of this important institution are evident: the tin or copper coffee-pot in the boy's left hand, of which John Dwight made stoneware versions; the blue and white porcelain coffee-dish imported from China, or alternatively a tin-glaze imitation; the mug for beer drinking; the wine flask; the clay tobacco-pipes; and a copy of what is probably meant to represent the *London Gazette*. The introduction of coffee, a non-alcoholic stimulant, to seventeenth-century Europe was a significant civilising influence. The form of the coffee-house varied across Europe, but as a general pattern most houses were furnished with long tables and benches at which the clientele would sit, drink, smoke, converse or read papers and correspondence. Food of a basic or more varied nature was usually available. The character of a coffee-house was shaped by the men

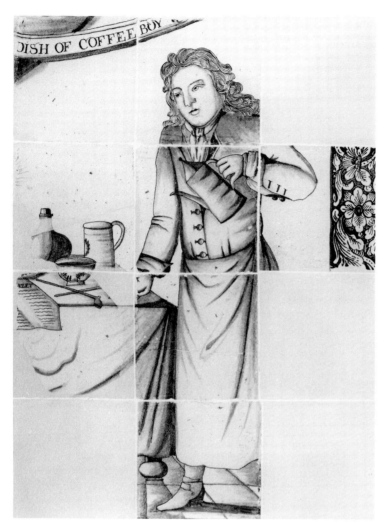

29] *Dish of Coffee Boy*, Coffee-house sign, 'Delft' tiles, late seventeenth century.

30] Unknown German artist, *Saal eines öffentlichen Kaffee-hauses* (Room of a public coffee-house), Dresden, pen and ink, eighteenth century.

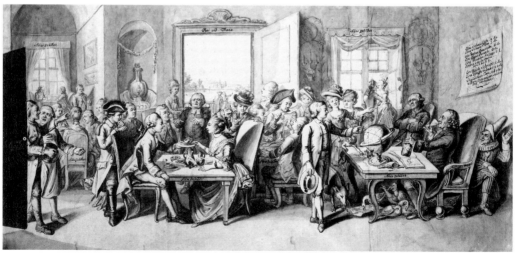

who made it their meeting place for social and business purposes –
the communities of artists, architects, musicians and writers, scientists, physicians and lawyers, émigrés and minorities, but also more
clandestine groups like the numerous secret societies of a political
and esoteric persuasion, and the quacks, rakes, spies and thieves.
Coffee-houses in England were not usually open to women, and
certainly not ladies of the middle or upper class, but working
women were present as managers, or in some cases as entertainers
or prostitutes.[26] Exceptions were to be found in the tea gardens at
Ranelagh and Vauxhall, and in provincial centres and spa towns,
where the leisured social routine permitted men and women to
mix more freely. In a court city like Dresden the interior of the
coffee-house illustrated here is elegant, but represented as a chaotic
throng of diverse people and animals (Fig. 30). The tariff on the
right-hand wall lists the availability of a bowl of coffee or tea, a
cup or mug of chocolate, a glass of punch, a bottle of Malaga, as
well as other foreign wines, schnapps and the ubiquitous pipe of
tobacco.

Coffee-houses flourished in contexts where crowds gathered
purposefully and with common interests. The focus was frequently
a theatre, a business institution like the Royal Exchange in London,
or sporting facilities like the bowling greens and tennis courts in
Paris. These establishments required 'china' dishes, which were supplied by the East India fleets, or the less expensive but less refined
delft and whiteware imitations supplied by European manufacturers. In spite of their codes of conduct coffee-houses were not
immune from violence, and even in the most respectable establishments fights broke out and pranks or wagers were set up which
could result in damage to men and drinking vessels, quite apart
from the breakages which would be expected in everyday use in
crowded rooms.

In Bristol the first coffee-house appears to have been *The Elephant*
which opened in 1677 under the tenure of John Kimber. At his death
in 1681 the probate inventory gives some idea of the layout and
furnishing of the establishment which corresponds more or less to
the London type. 'In the Great Lower Coffy rooms' there were three
long tables with benches, and in addition 'Three Chayres' and 'one
joyned Stool'. There was a clock, indispensable to the industrious
Bristolian; a counter with drawers where money was taken; iron
and brass equipment for the fire which included an 'iron plate to
stand', and provided a surface on which to keep the copper and tin
coffee pots warm. Glasses and coffee dishes to the value of 6s were
listed, and the value would suggest the use of local deltwares and
glass. There was another coffee room on the first floor which was
equipped with two tables, eleven chairs, a looking glass, fire irons

and curtains. The rather more comfortable furnishings would sug-
gest this room was used by a different clientele, and was perhaps a
meeting place for Bristol organisations, a gaming room, and a place
were women may have been admitted. Downstairs the kitchen
equipment was not elaborate, but suggests Kimber may well have
provided food. He also sold beer as the cellar contained beer barrels,
glass bottles and '7 dozen earthen muggs'. The presence of a tea
chest indicates he may have sold tea, but more substantial were the
stocks of coffee berries and tobacco, although surprisingly no
tobacco pipes were listed. Furnishings in one other room and the
inclusion of two 'lodging rooms' suggest he had accommodation
to offer.[27] John Kimber's estate was valued at £85 on his death. His
wife Ann died two years later, but the coffee-house seems to have
remained in the family into the 1730s, perhaps longer.[28] Nearly a
century after Kimber's death the coffee-house was still a lively in-
stitution in Bristol. Henry Dawes snatched a moment to write to
his friend the porcelain entrepreneur Richard Champion: 'methinks
I often see you ... slipping into Forster's, so Dick, so Tom how do
ye do Joe? What news anything strange? a dish of Coffee Waiter,
This Wilkes is an uncommon sort of a fellow. Somebody calls hurry
out, no time to be lost, Uncle calls and away you go ...'.[29]

Bristol was a small city where local people were known to each
other. Paris and London were the largest cities in Europe, and in
their streets a great number of people mingled who were strangers
to one another. It was very difficult to maintain a sense of focus
in a city which had no 'centre'; there was no civic or market square
which could be identified as the 'heart' of the city. Leipzig, for
example, had the Rathaus at its centre with an open space before
it where the fairs were held, and where the much smaller resident
population could meet and become familiar to one another. Lon-
don and Paris, both seriously damaged by fire in the seventeenth
century, regrew and regrouped their population, institutions,
manufactures and commercial enterprises in scattered 'specialist'
complexes.[30] It was in these large cities that civil exchanges
between strangers became so essential; the greater variety in the
'material conditions of life made people question marks to each
other'.[31] Although the guild trades, servant's liveries, professional
habits of dress and markers of social rank were 'readable' on the
street, they were not necessarily accurate all the time. On a Sunday
morning the '*French* Mechanics and wou'd-be Gentlemen naked in
Back-Garrets' boiled water in their pipkins and chamber pots 'to
wash their sham Necks, ruffled Sleeves, and worn-out roll-up Stock-
ings, that they may make a genteel Appearance in the public
Streets and Walks at Noon'.[32] This 'masquerade' had a more serious
side to it in situations where appearances had a direct impact on

social and material prospects. There were good reasons to dissemble through refinement and civil conversation, and at higher social levels this was crucial to those owners of property who wished to consolidate political and economic power.[33]

The coffee-houses established rules of conduct which were designed to enable men of different social ranks to converse freely and without embarrassment. Obviously the clientele were adept at picking up information about a person from their clothes, manner of speech, gestures and facial expression, but as has just been mentioned appearances were not always reliable. In theory anyone was free to take part in conversation at the table, no matter what their social rank, religious or political persuasion. In practice the London coffee-houses were more partisan, which inevitably gave each establishment a particular character. John Macky described some of them in his *Journey Through England* of 1714:

> I must not forget to tell you, that the Parties have their different Places, where however a Stranger is always well received; but a *Whig* will no more go to the *Cocoa-Tree* or *Osinda's*, than a *Tory* will be seen at the Coffee-House of *St. James.* The Scots go generally to the *British*, and a mixture of all Sorts to the *Smyrna*. There are other little *Coffee-Houses* much frequented in this Neighbourhood, *Young-Man's* for *Officers*, *Old-Man's* for *Stock Jobbers*, Pay-Masters and *Courtiers*, and *Little-Man's* for *Sharpers*.[34]

In travelling from Bath to Bristol Macky noted the change in character with the 'manners' of the two cities: 'In three Hours one arrives from *Bath* at *Bristol,* a large, opulent, and fine City: But notwithstanding its Nearness, by the different Manners of the People, seems to be another Country. Instead of that Politeness & Gaiety which you see at *Bath,* here is nothing but Hurry, Carts driving along with Merchandises, and People running about with cloudy Looks and busy Faces'.[35] 'Politeness and gaiety' required leisure to cultivate such qualities. The frank, if often civil, communication required in business and commerce was a harsh language compared to polite and leisured conversation, although many successful merchants and financiers were capable of straddling both the commercial and the polite worlds.[36]

Leipzig's coffee-houses were well known and the city was one of the most important centres for European trade and commerce, but political sensitivity and state surveillance curbed the freedom of speech enjoyed by the English. Of course there were spies in England, and security was an especially sensitive issue until the Jacobite rising of 1745–46, and again during and after the French Revolution. John Macky's powers of observation were reputedly linked to his spying activities, and, in a century of far-reaching and

turbulent political transformation, the services of government spies and *agents provocateurs* were in demand. In the German territorial States, Saxony in particular was repeatedly engaged in the major international conflicts of the eighteenth century, partly due to its geographical position, but also because of the ambition of Augustus II in the first three decades of the century and his taking the Polish crown in 1696. A frontispiece in Figure 31 illustrates an establishment situated in woodland outside Leipzig's city walls which served as a discreet meeting place where conversation could take place and information be exchanged more freely or in greater privacy.[37] The book describing the character of this inn, in which this engraving can be found, was published in 1755, the year before the outbreak of the Seven Years War and during a period of relative calm after the conflicts of the 1740s. Leipzig citizens valued their relative independence from the Saxon State, but the city's function as an international trading centre also made it susceptible to the suspicions of the administration.

In contrast to the city coffee-houses, John Macky found the

31] Frontispiece, *Angenehmer Zeitvertreib*, Leipzig, engraving, 1755.

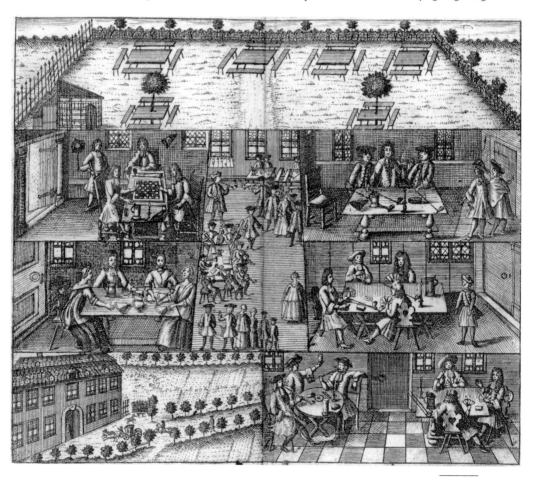

routine and the society in the English spa towns wearisome, especially at Tunbridge Wells. As the eighteenth century progressed England witnessed the creation of public leisure sites where people put themselves on display: the spas, assembly rooms, walks and public gardens where tea could be taken and entertainments enjoyed (Fig. 32). Public leisure sites were not only limited to the main urban centres and spas, but extended to small provincial towns usually in the form of assembly rooms.[38] In the 1730s the antiquarian John Loveday of Caversham travelled through parts of Wales and wrote that in Carmarthen 'There are several Coffee-houses and Taverns in the Town; in the Winter is a large Assembly, the Gentry (all the Summer at their Country-Seats) then residing here'.[39] An important market town, Carmarthen hosted an influx of leisured people who entertained one another through the winter months when Welsh roads were often impassable. In spite of himself John Macky noted how provincial 'Assemblies are very convenient for young people; for formerly the Country Ladies were stewed up in their Fathers' old Mansion Houses, and seldom saw Company, but at an Assize, a Horse-Race, or a Fair. But by means of these Assemblies, Matches are struck up, and the Officers of the Army have pretty good Success, where Ladies are at their own Disposal.'[40] It was in these public spaces that men and women could mix with the necessary social propriety, drink tea and coffee, play cards and join in country-dances. But John Macky was not unique in finding these social pursuits wearisome. Many novels of the period allude to the problem of 'Time' and how it should be

32] Fan Leaf, *Pump Room at Bath*, engraving, 1737.

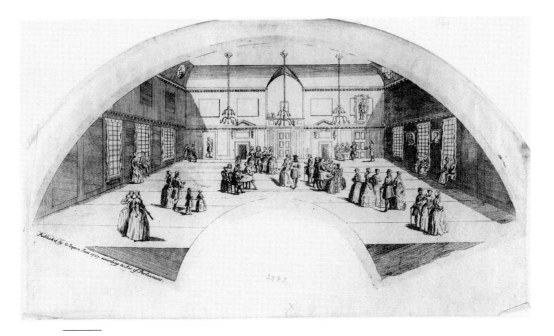

spent. In trying to persuade her high-minded cousin Arabella, *The Female Quixote*, to enjoy the company at Bath, Miss Glanville insists:

> there is no place in *England*, except *London*, where there is so much good Company to be met with, as here. The Assembly was very numerous and brilliant, and one can be at no Loss for Amusements: The Pump-Room in the Morning, the Parade, and the Rooms, in the Evening, with little occasional Parties of Pleasure, will find one sufficient Employment, and leave none of one's Time to lye useless upon one's Hand.
>
> I am of the Opinion, replied *Arabella,* that one's Time is far from being well employ'd in the Manner you portion it out: And People who spend theirs in such trifling Amusements, must certainly live to very little Purpose.[41]

Charlotte Lennox's heroine, Arabella, is a character immersed in seventeenth-century romantic fiction, and she represents a dual problem for women. Romances provided Arabella with her only access to knowledge of another world and other possibilities; that she enters into society totally inexperienced, with only this spurious lexicon to support her aspirations and her 'conversation', inevitably leads her into difficulties. The greater comfort, leisure and distractions in social and material life which confront her, seem to represent a mental vacuity. In reality, this supposed vacuity was the target for much male hostility towards women.

It is hardly surprising that states of boredom were frequently described in the eighteenth-century novel, and usually in narratives about middle- and upper-class people of leisure. Boredom does not necessarily refer to inaction, and people were engaged in activities in the eighteenth century in which they discovered it was possible to be bored when perhaps they did not expect to be, and they got bored with each other.[42] It would be inaccurate to assume that boredom was a new experience, even though the word 'bore' was only just entering common usage, but evidently it was possible to describe this experience in ways not abundantly clear beforehand. The punctuations in the day provided by eating and drinking assumed an importance not unrelated to this expanse of time which had to be filled; it was 'boredom created by comfort'.[43] It accounts for the popularity of card games in many middle- and upper-class households, often accompanied by tea in Britain and coffee in France and the German States. Quadrille filled many empty hours and provided a reason for people to get together. The engraving of a game of *Quadrille*, after one of Francis Hayman's Vauxhall supper-box paintings, was one of the many themes out of a total of fifty subjects with which the affluent Vauxhall visitors could identify with some wry humour. The subject of cards, with close

associations to low life and immoral practices, is made polite, but evidently the expressions on the faces of the black servant boy and the maid placing a tea tray on the table presage discord in the company before the game is over (Fig. 33).[44]

Conversation and the drinking of tea and coffee in public and private return us to those social activities in which the display of refinement in self-conduct and in 'equipage' was of 'strategic' importance for the affluent middle class and gentry. It is not difficult to appreciate how tedious tea-table conversation could be in certain social contexts. But the notion of 'polite' conversation was not consistent, and evolved a particular character based on context and the gender of those taking part. Broadly speaking two kinds of 'polite' conversation were advised, one of which required an ability to speak civilly and in an informed manner on a variety of subjects, and which in England was usually confined to the male institutions of coffee-house, club and academy. The other form was that of mixed company at home, at the spa, the tea-rooms and assemblies. Joseph Addison dismissed this as the 'Talk' which 'generally runs upon the Weather, Fashions, News and the like publick Topics'.[45] It was advised that in company it was important to avoid silences, conversation had to be maintained so that all might feel at ease, but it was also this type of conversation which was associated with the feminine, tea-table talk. The separation of conversational spheres through institutional, educational and social structures reinforced the divide in which men held ownership

33] Etching and engraving after Gravelot's design and Francis Hayman's painting, *Quadrille*, 1743.

of learning and authority in knowledge. In England the distinction between masculine and feminine forms of conversation became more precisely defined, and all the more differentiated, as the 'natural' roles and characteristics of the genders were reconstructed during the century.[46] At the same time there were many men and women who paid little heed to any attempt on the part of the moralisers, the authors of conduct books and newspaper homilies, to prescribe the boundaries of intellectual exchange in male and female company. The pleasure of a reading circle, or the viewing of new editions of prints, could be augmented by tea and coffee drinking and enjoyed by both sexes. This was particularly so in the last quarter of the century when a greater number of middle-class people experienced a rise in their standard of living. While holding on to wealth and social position was still a precarious business, there was also an increased sense of confidence which encouraged less formality in social relations between people of diverse social and economic backgrounds. One facet of the cultivation of sensibility was greater ease and openness in social encounters which made allowances for this.[47]

In eighteenth-century satire a 'polite' social gathering around the punch-bowl was an irresistible theme illustrating the descent into male drunken aggression and stupor, and representations of

34] Punch-bowl, Bristol delftware, after William Hogarth, *A Midnight Modern Conversation*, cobalt blue pigment painted on tin glaze, *c.* 1750.

Hogarth's *Midnight Modern Conversation* found their place in turn
on, or in, delftware punch-bowls (Fig. 34). The punch-bowl was
often the focal point of male conviviality and was used in many
different types of gathering in a century when there was a consid-
erable increase in the formation of clubs and societies. Many of
these organisations were established to support various amateur
enthusiasms, for civic and philanthropic purposes, and others were
formed in response to political events; whatever drew men
together it was customary to promote their general sense of unity
and well-being through the drinking of toasts. The bowl of punch
was often an indispensable part of official functions related to local
government and the law. James Brockman Esq. of Beachborough,
Newington-next-Hythe in Kent, held a dinner after a court baron
in his manor on 21 October 1740 in which the Bill of Expenses
included:

For 29 Pound of Beef at 3d. a Pound	00 – 07 – 03
For Bread Greens and Dressing the Dinner	00 – 05 – 06
For One Bowl of Punch for the Jury	00 – 05 – 00
For Beer and Tobacco	00 – 03 – 09 [48]

A gathering of this kind was most likely to be held in a local tavern
or inn, but the presence of punch bowls in probate inventories of
the late seventeenth and eighteenth centuries supports their in-
creasing use at home among friends and family, at meetings
between business or professional associates when the tavern or
coffee-house was perhaps considered uncongenial.[49] In the first half
of the eighteenth century the practice of inviting guests to dine
at home in middle-class households was not common, but
evidence suggests it became much more so after 1760, especially in
prosperous urban communities. Not only was the 'dining-room'
more frequently recorded as a specific space in urban households,
a greater variety of furniture and manufactured goods were
available to fill it. The dining-room also became a domestic space
appropriated by the male members of the household and their
guests as a place for drinking and smoking, while the ladies
retired to the 'drawing room'. The late eighteenth century estab-
lished patterns of domestic social practice which became firmly
entrenched in nineteenth-century middle-class life.[50]

One of the reasons for the success of coffee over tea and choco-
late in the male institutions of the coffee-house, tavern and
ale-house was the good company it formed with tobacco, although
women smoked and took snuff more widely than is usually rec-
ognised. An indication of the importance of smoking is evident
in a 1736 Leipzig directory which listed two pipemakers under
'artists', and eight potters under 'craft workers'. The highly skilled

pipemakers produced the elaborately carved wooden, ivory or horn section pipes, and perhaps cases in which to hold the fragile, disposable and ubiquitous white clay pipe itself.[51] In Leipzig the consumption of beer, coffee and tobacco was the most important social and solitary enjoyment and often eulogised in verse, song or prose. The song from J. S. Bach's second *Klavierbüchlein* for Anna Magdalena Bach, 'Erbauliche Gedanken eines Tabakrauchers' or 'Edifying Thoughts of a Tobacco Smoker', draws a somewhat darker metaphor between the clay tobacco pipe, the act of smoking and reflections on human mortality in which 'The Pipe comes from Clay and Earth / From this am I also made' and to earth the corpse will be returned.[52] The whiteness of a clay pipe prompts the smoker to think about his pale corpse; when broken in two in his hand it reminds him of the arbitrariness of fate; a burn from its ashes makes him consider the pains of hell fire, and no matter how much contentment he derives from smoking, the presence of his pipe is a constant reminder of human frailty. In contrast, the smoker's erotic ardour expressed through the metaphors employed in this poem from the *Gentleman's Magazine* hardly needs to be pointed out:

> Pretty tube of mighty power,
> Charmer of an idle hour;
>
> Object of my hot desire,
> Lip of wax and eye of fire:
>
> And thy snowy taper waste,
> With my finger gently brac'd:
>
> And thy lovely swelling crest:
> With my bended stopper prest:
>
> And the sweetest bliss of blisses,
> Breathing from thy balmy kisses;
>
> Happy thrice and thrice again,
> Happiest he of happy men.[53]

In these two examples the same simple but pleasurable activity has been invested with imagined potency of very different kinds. They are an indication that these social and often solitary practices, built up around a commodity and its material support in the form of a clay pipe, were drawn into the imaginative lives of users, often with humour and wry commentary on the condition of life.

Like a dish of coffee, the pipe could also be used to ease or prevent social tension. In his diary for 1 June, 1764, Thomas Turner recorded an evening in which 'Mr Banister and myself smoked a pipe or two with Tho. Durant, purely to keep Mr Banister from

quarelling; his wife, big with child, lame of one hand, and very much in liqour, being out in the middle of the street, amongst a parcil of girls, boys etc., Oh, an odious sight, and that more to an husband'.[54] At Whitsun of the same year he wrote of a Sunday in which church took up most of the earlier part of the day, followed by a social afternoon drinking tea with 'Sam Jenner and Tho. Durant' after which they walked to the village of Chiddingly to look at a house under repair. From there they walked to Mr Robert Turner's 'where we staid and smoked two serious pipes, and came home about nine. As pleasant an even as ever walked in my life.'[55] Thus on a daily basis these East India and New World commodities became an indispensable part of people's lives, but in highly varied social contexts their uses, and the vessels associated with them, carried very different meanings and inflections.

Intimate spaces

An eighteenth-century middle-class household was not always very large, on average between four and seven people at any one time. The nuclear family was not unknown, but it was not necessarily perceived as such by people at the time; the concept of 'family' was quite different from that of the twentieth century.[56] In urban areas where housing development was under construction, a newly married middle-class couple could establish a modest home of their own. They might also experience all the tensions and difficulties of marriage, for which many young people were not well prepared. *Pope's Bath Chronicle* of 27 January 1763 contained a fictitious moral tale about those 'Matrimonial Quarrels (which) generally proceed from such *very very* Trifles', but it reflects the changing nature of middle-class society in which greater material affluence was perceived by some to be the cause of marital disorder. The author described the trials of a 'young Fellow' of twenty-three who had recently married a 'deserving girl for love ... Before the first Week was over we quarrelled who should fill the Tea-Pot – and in less than a Month lay asunder a whole week about cutting last at Table'. A crisis was reached in a quarrel over the merits of bread pudding over suet, and 'pudding' of a sweet or savoury kind was a very important dish on the eighteenth-century English table:

> My Wife's manner of eying me, Mr Printer ... was by no means agreeable – I bit my Lip – She frown'd – and I look'd steadfast – she cry'd hum – I redden'd – she color'd – I rose from the Table – and she burst into Tears ... Retiring immediately to the Coffee-House, and not coming Home to Tea or Supper, my Wife, who thought herself grossly insulted, locked herself up in her Room, and left a

Letter with the Maid, intimating that since we could not agree together, it was much better to part.[57]

On one level the text is an amusing homily against allowing 'trivial' matters to disrupt a young marriage. On another level it criticises a society which places high value in material things and polite protocol, pointing out that it was precisely in the enactment of refined social practices that relationships could come to grief, and particularly so in the private space of the home. The young man rushed out to the coffee-house for convivial solace, the young woman was not able to do the same, and in her isolation was driven to more extreme measures in contemplating a parting. With no jest intended, Hester Chapone advised on the 'important duty' of a 'New-Married Lady' to avoid the 'dreadful consequences' of childish matrimonial quarrels 'which at first perhaps quickly end in the renewal and increase of tenderness, but, if often repeated, they lose their agreeable effects, and soon produce those of a contrary nature'.[58] Many young middle-class women were schooled in the advice of Mrs Chapone and others who sought to 'direct' their 'conduct', and 'fix' their characters for 'an *useful* and *agreeable* member of society',[59] and many texts similar to the example from *Pope's Bath Chronicle* resonated with these new ideas for a domestic harmony which was in great part underscored by the softer and more comfortable nature of the new consumer goods and commodities.

In Georgian England, lowland Scotland and Ireland the urban architecture accessible to middle-class households evolved to include corridors, stairwells and landings which allowed separate access to rooms; it was therefore easier to 'retire' from the view of others. Total privacy was compromised by the presence of servants, although in many less affluent middle-class households there may have been only one or two. The attempt to maintain a fiction of normality in the presence of servants, on whom one depended to provide the refinements and comforts of everyday life, could be easily overturned. However, it is also necessary to consider that eighteenth-century people were not concerned about maintaining so-called 'normal' appearances in the sense we might expect in the late twentieth century. Demands upon ladies' maids and manservants unthinkable to later generations were taken for granted: the administering of colonic irrigation in order that a mistress (or a master) might maintain a flawless complexion for example; the meticulous cosmetic intimacies of the daily 'toilette'.[60]

Even in a modest household, with possibly only one and not more than three servants, privacy was compromised. At times a person's conduct seemed to run extraordinary risks, in the face of

consequences likely to ruin their lives. In 1795 Mary Easterbrook, the wife of Joseph Easterbrook, a Bristol tobacconist, took advantage of her husband's absence on a business trip to pursue an affair with a gentleman, Thomas Gaisford. During the divorce case which was brought before the Episcopal Consistory Court of Bristol in 1797, Sarah Norton, a maid in the Easterbrook household, gave evidence against her mistress, supported by business acquaintances of Joseph Easterbrook who put up the money to cover the enormous costs of divorce proceedings. According to Sarah Norton's testimony, at about nine o'clock one morning she carried Mary Easterbrook's breakfast of some chocolate and toast into the drawing room, which happened to adjoin her mistress's bedroom. Although she saw her mistress enter the drawing room alone, 'the Drawing Room bell presently rang' and Sarah Norton returned to find her mistress 'the said Mary Easterbrook, and the said Mr. Gaisford sitting by the fire with the Breakfast Table between them'. Her mistress ordered the maid to bring up another 'Dish of Chocolate and some more Toast for the said Mr. Gaisford', after which the couple continued in the room for the rest of the day, 'and dined and supped together, and were all on the greatest part of the Time together and alone, except when the servant was waiting on them'. On leaving the room after waiting upon the couple Sarah Norton reported having seen Mr Gaisford put his arm around Mrs Easterbrook's neck and kiss her.[61]

Servants were themselves contained within a hierarchy of service which encouraged intrigue and competitiveness in gaining favours and increasing their prospects for perks or betterment of their position. The intimate nature of a personal servant's duties could lead to fierce loyalties in certain divorce cases and to treachery in others. In the fairly clear-cut case of *Easterbrook* v. *Easterbrook* the deponents unequivocally supported the husband, who was eventually granted a divorce with custody of the children. The protagonists caught up in this and in other divorce proceedings may appear to have been extraordinarily inept in managing infidelity or concealing cruelties from their servants. However, this judgement would overlook the complexity of household arrangements and 'politics', which were finely balanced when life ran relatively smoothly, but pernicious when this balance was disturbed.[62] In such circumstances, no matter how 'civilised' the outer appearance, the tensions of maintaining propriety under stress often broke down to the extent that the material equipment normally used to support polite behaviour became the means to express violent emotion. In the late eighteenth-century Yorkshire case of *Middleton* v. *Middleton*, violence erupted between the French cook, Jean Bouvier, and Clara Louisa

Middleton's maid, Hester Swinburne. In this highly complex case Bouvier's suggestion to Swinburne that she was having an affair with the man suspected of being Clara Louisa's lover sparked off such anger in the already overwrought Swinburne that she picked up two or three cups and saucers and hurled them at Bouvier, whereupon more serious physical violence was halted only by the intervention of other servants.[63] Outbursts of this kind were, and of course still are, ubiquitous across the social classes, and were often the occasion for turning a familiar domestic artefact into a weapon which could have fatal consequences. *The Ladies Magazine* of 18 November 1749 reported the sorry tale of 'Elizabeth Brooks, Servant Maid to the Blue Maid Inn', who was 'committed to the New Jail, Southwark … for the Murder of a young Man, her Fellow Servant, by striking him upon the Head with a Pint Pot'.

The pleasure of eating and drinking as part of an intimate encounter, or simply in a private and informal gathering, became increasingly accessible to the moneyed middle classes during the course of the century. New developments in the organisation of space within the domestic interior were met by new items of furniture less massive in size. This change was facilitated in the second quarter of the century by the introduction of mahogany, a wood with a strength that enabled furniture design to develop the characteristic slenderness fully exploited in the latter half of the eighteenth century. Developments in furniture design were largely inspired by the innovations of Thomas Chippendale, and later in the century by the Adam brothers and Thomas Sheraton. Sheraton's designs in particular responded to demographic change as the pressure on domestic spaces increased with the rise in population, leading to new desires for privacy on the part of those who could afford it. Items like 'dumb waiters', side-tables and wine coolers allowed for social gatherings which were less dependent on servants, and the wider range of fine ceramic tablewares in which to serve foods also supported an elegant table at more modest prices than plate. Inventories taken in the latter half of the eighteenth century are far fewer in number, but the Cause Papers that remain extant in Bristol testify to a significant increase in middle-class ownership of furniture generally, much of it probably old in date but with the addition of dumb waiters, small dining-tables and tea-tables.[64]

Fine ceramic wares reached further into the more intimate spaces and experiences of people's lives and were concerned with the maintenance of the body in terms of appearance and cleanliness. While shaving bowls and wash bowls, warming pans, close-stool pans and chamber pots had long been found in bedchambers and dressing rooms, they were frequently made of

pewter, tin, coarse earthenware or white tin-glazed ware. Only the wealthy could afford the finer tin-glaze or porcelain vessels. But from roughly the middle of the eighteenth century much larger quantities of fine lead-glazed earthenwares were available, and these became more decorative, especially after the introduction of transfer printing on creamwares in the 1750s. By the end of the century the Staffordshire potteries, and many other regional enterprises, were producing cheap and attractive vessels for maintaining bodily hygiene as well as supplying more diverse and decorative tableware.[65]

In the course of the eighteenth century personal hygiene and its relationship to physical health and a person's moral condition were revised and debated over and over again. Samuel Rolleston in his *Dialogue Concerning Decency* found the earthen vessel a suitable reminder of the futility of human pride or vanitas:

> it would be a good effect upon men to reflect that the very vessels which they make use of for the most dishonourable and base purposes, the receiving their dung and excrements, are made of as good, nay the same material as their own bodies – the finest and most beautiful bodies are but earthen vessels as well as chamber-pots; they are but statues made of clay, and are therefore as brittle and as liable to be broke as their chamber-pots and closestool pans, and will certainly be reduc'd and crumbled into as many pieces.[66]

And with a rather more acerbic observation reserved for the 'ladies', Rolleston concludes: 'If a lady was extremely proud and insolent on account of the beauty and form of her body, or the exquisite fineness of her flesh and skin, she could not but see the absurdity of being so, if a philosopher should say to her, Madam, what you are so proud of is made of no better materials than my chamber-pot or closestool pan: and has the same kind of nastiness in it'.[67]

The ancient emblematic resonances of clay, faeces and the corruption of the body were underscored by the practical problems of disposal, which all too frequently led to the meeting of 'nastiness' with humanity in the street below, when the contents of a chamber pot landed on passers-by. The *Privilegia Londini* of 1723 required that inhabitants of the city adhere to the following rules:

> No Man shall cast any Urine-Boles, or Ordure-Boles, into the Streets by Day or Night, afore the Hour of Nine in the Night: And also he shall not cast it out, but bring it down, and lay it in the Channel, under the pain of Three Shillings and Four pence. And if he do Cast it upon any Person's Head, the Party to have a lawful recompense, if he have hurt thereby.[68]

Chamber pots and close-stool pans were kept in the bedrooms, but

in those dwellings where a privy or 'house of office' was available they had to be emptied there rather than in the street 'kennels'. In London the privy was usually situated in the yard at the back of the house. The job of cleaning the city of excrement was carried out by the 'night men' who started work after nine o'clock in the evening and continued until early the following morning.[69] The stench which inevitably issued from the 'channels' or 'kennels' in the streets of a densely populated urban area was overwhelming, and in Paris an 'anxiety-laden discourse' emerged concerning the vapours which arose, and the mud that oozed from the rubbish dumps, cesspools, latrines and urine-soaked walls of the city.[70]

Ceramic vessels have evolved a close relationship with the alimentary tract from the point of ingestion to excretion. A deep-rooted sense of the need to maintain boundaries between these biological processes may have something to do with the difficulty in acknowledging this relationship. Although not perfectly understood, there may also have been a degree of apprehension that contamination through human waste products was a cause of disease, and it was thought that infection issued from the foul smells which increasingly gave rise to anxiety. Parson Woodforde and his household made use of a latrine in the garden, euphemistically referred to as going down to 'Jericho'. In his diary for 26 April 1780 he wrote, 'Busy in painting some boarding in my Wall Garden which was put up to prevent people in the Kitchen seeing those who had occasion to go to Jericho'.[71] A society which placed value in politeness, propriety and decency increasingly disciplined and suppressed acknowledgement of the 'baser' functions of the human body and its maintenance.

Radical improvements in sanitary conditions were possible only among the aristocracy, the gentry and the wealthy top layer of the middle class. Until the widespread availability of running water, sanitary ware could not develop much further than the chamber pot and the close-stool. Londoners at least had piped running water as a result of urban improvements undertaken in the latter half of the century, and this had the effect of sluicing drains and sewers, which generally reduced the stench. Provincial towns had also taken steps to improve water supplies as far back as the late seventeenth century, and the affluent paid to have pipes laid to their properties from a central system.[72] The concern amongst elite social groups to introduce more facilities to maintain privacy and cleanliness in the home appears to have coincided with a desire to connect technical developments, like a water closet or installation of a bathroom, with a more highly developed sensibility; luxury was linked to advances in the 'techniques' of hygiene.[73] Personal cleanliness had largely cared only for what was visible - the hands

and the face, clean clothes and especially clean linen. Water was therefore used to wash only the hands and face, the rest of the body was dealt with by rubbing and wiping with cloths, and by the liberal application of perfumes.[74] The expansion in publishing released more treatises into the hands of an educated middle class, and presented new medical theories to a lay public. Often addressing themselves to the male head of a household, physicians advised on the prevention and management of illness and how to maintain a healthy family.[75] Advice was given about when and when not to use water for cleansing the body, and ideas concerning the value of water for good health changed considerably from advocating total avoidance to full immersion in sea water. The characteristically euphemistic language of eighteenth-century treatises on hygiene stressed the necessity to maintain cleanliness in those 'secret regions of the body', and such a practice was declared a 'rule of a refined civilisation as well as sound health'.[76] Slowly the increase in production of 'china' wash -stand bowls and jugs, bidets, shaving bowls and attractive sets of toilet wares, encouraged people to take more care of personal hygiene in those intimate spaces of the home. As the volume of fine earthenwares on the market increased, at prices affordable to people farther down the social scale, '*French* mechanics and wou'd-be Gentlemen' had less cause to rely on chamber pots in which to 'to wash their sham Necks, ruffled Sleeves, and worn-out roll-up Stockings'.[77] Again, the development of new items of furniture was inseparable from intimate and polite social practices in maintaining bodily hygiene and 'conveniences'. Wash-stands and dressing-tables were introduced with numerous devices specially designed for the 'toilet', all of which included metal or ceramic bowls, boxes, jars and phials for holding cosmetic preparations and perfumes. For decency's sake pedestal cupboards, bedside steps, bidets, and close-stools concealed the metal or china chamber pots or pans, and designers commonly included sham drawers to further disguise the real purpose of these items. For the upper classes furniture of this period was luxurious, elegant and ingenious, but cabinet makers were adept at producing less expensive versions, especially towards the end of the century, when many designs allowed for portability, and could be adapted from a toilet or dressing table to a writing desk or needlework table in confined dwellings.[78]

The problem with personal hygiene was the sheer difficulty and expense of maintaining it without adequate water supplies, and good quality soap was expensive. Furthermore, moralists had strong objections to any activity which might be the cause of sensual arousal, and bathing was certainly considered dangerous in this respect. For centuries the smells emitted by the body had

formed an important part of medical diagnosis, and not only by the physicians: everyone was attuned to smells and what they might signify, from the most malign to the most pleasing or healthy.[79] Jonathan Swift, well known for his scatological pre-occupations, and the physician Tobias Smollett, recommended stale urine left in the chamber pot as 'admirable against the vapours', and as useful a remedy as smelling salts.[80] But as the century progressed, scientific interest in odours became more intense, and a veritable taxonomy of smells was 'captured' and recorded by eighteenth-century chemists. As they did so, morbid anxieties crept in concerning the invisible dangers of infection, until Antoine Lavoisier brought a clearer understanding of the chemistry of air and respiration in the 1780s. New scientific knowledge gradually inculcated in the literate population a sense of the benefits of salubrious surroundings, of pure air and of personal hygiene. Increasingly it was the literate middle class who took control of their body odours as a form of individual expression, and who could afford the products to help them achieve this and gain pleasure from doing so, in spite of moral opinion. It was seen as a mark of distinction from the 'mechanic part of mankind', a means of distinction which, even if apocryphal, was to become a sharp signifier of class differences in the nineteenth century.[81]

Kitchen and table

In his survey on the *State of the Poor* Frederick Eden wrote, 'sitting together at a table is perhaps one of the strongest characteristics of civilisation and refinement'.[82] His comment belonged to an argument directed against the conditions in which the black African was forced to live on the West Indian plantations, where it was rarely possible for a family to sit at a table together to eat their 'morsal'. It was a comment which contained both a humanely meant criticism and at the same time a Eurocentric view as to what constituted 'civilisation and refinement'. Eden protested that in England 'not only the lowest peasant eats his meal at table, but also has his table covered with a table-cloth'. Questionable though this assumption may have been, the point lies in the significance Eden placed on the table as a focus for 'civilised' practices.

Direct physical contact at the table, the sharing of food and drink from one vessel, the taking of food with the fingers from a shared dish, was eliminated among the European social elites over several centuries. It took a very long time for an implement like the fork to be accepted even amongst the aristocracy, but in the sixteenth century it was established as a means of picking up solid foods from the dish, particularly sweetmeats and fruit. An apparently straight-

forward development, the introduction of the fork, in fact indicated a fundamental change in social relations.[83] Its introduction alongside the later additions of an individual glass, plate, napkin and cutlery set suggests a greater desire for the containment of the self, but also a need for self-control in order not to offend or revolt others at table. Seventeenth- and eighteenth-century treatises on table manners conjoined directions for civil behaviour with preventative measures against cross-contamination by hand or mouth. It is impossible to separate one from the other; and while hygiene was a concern, it was directly bound up with 'civility', the manifestation of concern for others before yourself, while at the same time protecting yourself from those around you. For example, in one of the most widely read treatises on conduct, the *Rules of Civility* by Antoine de Courtin first published in the seventeenth century and then translated from the French in the eighteenth, the following directions were given: 'Having serv'd yourself with your Spoon, you must remember to wipe it, and indeed as oft as you use it; for some are so nice, they will not eat Pottage, or any thing of that nature, in which you have put your Spoon unwip'd, after you have put it into your own mouth'.[84]

Courtin's *Rules* were written for those members of the gentry and middle class who were socially ambitious and had no opportunity to learn 'civility' at court, the training ground for the high degree of personal refinement required by the social elite. In addition to monitoring the person, it was necessary to know how to manage the implements and tablewares indispensable to polite society. One of the most potent indicators of social status was the ability to discriminate in the appropriate uses of cutlery, glasses and tablewares during the course of a meal. In 'polite' society everyone in the company agreed to follow a set of rules, in the hope that the meal could be enjoyed, secure in the knowledge that nobody would do anything unexpected or transgressive. An eighteenth-century author sought a more precise target for his 'Plain and Familiar Rules for a Modest and Genteel Behaviour' in order to equip the 'Man of Manners' with the social skills necessary to avoid exposure to 'Contempt and Ridicule'.

> It is observable in Families of Tradesmen, of great Worth and Account, who make very considerable Figures in their Coffee-Houses and Warehouses, that few of them know how to enter a Room with decency, and shew little or no regard to the seating themselves at Table, but all run promiscuously into the Dining-room, as into the Pit at the Playhouse.[85]

Cooking and eating in most early modern European households took place in close proximity to the hearth, and before the eight-

eenth century not many dwellings had a kitchen dedicated solely
to the preparation of food. Ownership of a gridiron, spits and jacks,
stew pans, skillets, ladles and skimmers, and more than one copper
or bell-metal pot indicated a household in which a variety of cook-
ing techniques were employed – grilling, roasting, stewing and
frying, with the preparation of sauces and vegetables to accom-
pany boiled, roasted and stewed meats. From an inventory it is
possible to get some idea of the nature of the household, how stable
and substantial an organisation it was, how much its members
valued food and drink as a means to reinforce family and social
bonds within the home.[86] But it is necessary to be cautious in
assuming that a well-furnished kitchen indicated a high social
rank. The inventory of a Bristol 'gentleman' may contain sparse
evidence of sophistication in the kitchen, whereas an inventory
taken after the death of the head of a family in trade or artisanal
work of a relatively humble nature may indicate food and drink
were afforded considerable importance. For example, Henry Hoare,
a Bristol tobacco pipemaker, had a fairly well equipped kitchen
with roasting andirons, a gridiron, a crane and a jack wheel chain,
iron, brass and copper cooking pots. The kitchen also contained
one square and one small oval table, an old settle, five chairs and
two joint stools, plus a looking glass, a glass case, three pictures and
eight books. Contents of this kind suggest the room was plain but
probably formed the focal point of home life, especially as no
parlour is accounted for and the inventory indicates that Hoare's
workshop was on the same site as his dwelling. The contents of the
house and workshop were valued at £19 15s after Hoare's death in
1728. In 1740 the goods belonging to Charles Stokes, gentleman,
were valued at £19 11s, and in the kitchen there was pewter to the
value of £1 6s, some earthenware valued at 2s 6d, a gridiron, pots,
saucepans and a teapot. A small 'parcel' of china kept in the 'fore
street rooms' was valued at 10s, and in the summer house there
were 'some ordinary prints' valued at 2s 6d. The kitchen was cer-
tainly no better equipped than Henry Hoare's, and evidence from
other inventories taken in a 'gentleman's' household suggest
greater value was attached to display through fine clothes, or
ownership of plate, pictures and furniture; for example the 'wear-
ing apparel' of John Shelbery, 'Gent', whose inventory is dated 1721,
was valued at £5 15s 6d, and included his two periwigs, dimity
waistcoat, velvet cap and scarlet mantle among other items. If
widowed or a bachelor, a 'Gent' may well have taken lodgings and
dined away from home, or had food prepared outside on orders
carried by a servant.[87]

Inventories taken of poor households list a frying pan as
the main or only cooking implement. There were also quite high

numbers of single people who were not always poor, but whose
ownership of goods was limited, and like the 'gent' just described
did not have the inclination to cook for themselves perhaps, or
did not inhabit premises suitable for food storage and preparation.
In urban areas it was common for people to eat away from lodg-
ings, or to bring foods prepared in cookhouses and bakeries into
the home. There were numerous street hawkers selling foodstuffs
and drinks, especially coffee and chocolate, so that in busy com-
mercial centres like Bristol, London, Leipzig and Paris people from
the middle and labouring classes ate for convenience and accord-
ing to their purse, often in the taverns. Not surprisingly the more
unstable population of the young and the single, those establishing
themselves in a trade or profession, and the many trying to survive
as best they could, were unlikely to enjoy a substantial material
existence. However, as the century advanced and more cheap
manufactured goods appeared on the market, the older habits of
living with a few highly durable artefacts began to be superseded
by the possession of more numerous, cheap and novel items like
the bright and decorative ceramic wares.[88]

Robert Bayley, a moderately wealthy Bristol merchant who died
in 1686 worth just over £223, owned an unusual variety of vessels
which represented old traditions and new practices. Listed were '2
wooden dishes & 1 doz trenchers' valued at 1s 7d. In pewter he
owned eleven dishes and one dozen plates to the value of £3 5s 4d.
Four china plates and an apple roaster were valued together at 1s
10d, which suggests the 'china' was probably blue and white tin-
glaze ware, perhaps dessert plates made in one of the Bristol
potteries. Five coffee dishes worth 1s 6d were itemised, as well as
an interesting object in the form of 'a great earthen dish' valued at
4s.[89] Nearly one hundred years later, John Saunders, a victualler
worth £96 11s 0d at his death in 1783, was materially better
equipped in ceramic wares than Robert Bayley, although some of
these wares were probably used in furnishing his trade. He owned
three china bowls worth 16s, and at this value they were porcelain
bowls which can be compared to the value of eighteen 'delft plates
& 3 dishes' valued at 2s. Half a dozen coffee cups and tea equipment
were itemised, the '6 china tea cups, 5 saucers, a teapot & basin'
valued at 6s. The pewter items listed were drinking vessels to the
capacity of quarts and pints, and were used in the selling of ales.
For dining, '28 pieces of Queens Ware' appear to have been used in
preference to pewter.[90] Inventories reveal the total value in wordly
goods and chattels, and a much more precise analysis would be
required to assess the relative value of their goods over this period
in time; John Saunders was clearly no wealthier than Robert Bayley
yet owned a greater quantity and variety of 'china' wares. How-

ever, even in late eighteenth-century Britain it would not be difficult to find examples of households in which china and creamware were given no house room at all, at least as far as can be ascertained from an inventory, and particularly in rural areas. Nevertheless, the collected evidence is now strong in support of a general shift from metals to ceramics in the material culture of the table.[91]

In 1766, during his first of two visits to Bath in search of a cure for gout, John Penrose, his wife and daughter Fanny travelled to Bristol where they visited an acquaintance, a Mr Loscombe, who evidently gave them a warm welcome in his very fine property. John Penrose described the dinner at Mr Loscombe's in some detail to his daughter Margaret at home in Cornwall: 'At the higher end of the Table two boil'd Chicken, at the lower end a Fore-quarter of Lamb, in the middle Sallad, on one side Asparagus and Gooseberries sugar'd, on the other Bacon with Cabbage, and a Gosse-berry Tart. All served in China, with surprising Elegance.'[92] It was during this visit that Penrose also remarked on the breakfast china at Spring Gardens, and it suggests the family may not have been accustomed to using fine ceramic vessels at home (see p. 129).

Creamware manufacturers like Josiah Wedgwood, Hartley & Greens of Leeds and the Coles of Swansea supplied the market for understated quality in household objects, elegant enough to uphold a sense of propriety without the ostentation of porcelains; affordable among the professional and entrepreneurial middle

35] Swansea creamware supper set, brown enamel painted motif, 1795–1805.

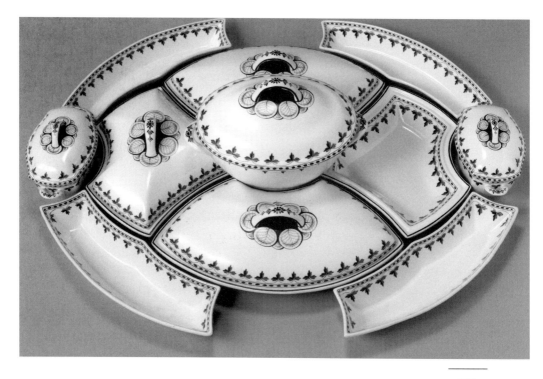

classes, but also acceptable to the upper classes for everyday use (Fig. 35). On the opposite side of country to John Penrose, the diary of Parson James Woodforde recorded the following on 17 April 1777:

> Sent my servants Will: and Ben with a cart this morn' to Norwich after some Wine from Mr. Priest and some dishes and plates etc. from Mr. Beloe's - China Merchant ... They did not return till 7 in the evening. They might have come home much sooner I think. The things came home very safe however as well as wine. I have now a compleat Table service of the cream coloured ware, with some other useful things ... My servants were both rather full in liquor, and as for Will, he behaved very surly and went to bed before I supped ...[93]

There were varying degrees of latitude in keeping a good table. Refinement was a relative concept, and often only perfunctorily considered. J. T. Smith described the sorry state of the Queen's ware at the dinner parties given in the chaotic Mortimer Street home of the sculptor Joseph Nollekens in the late eighteenth century:

> Two tables were joined: but as the legs of one were considerably shorter than those of the other, four blocks of wood had been prepared to receive them. The damask tablecloth was of a coffee-colour, similar to that formerly preferred by washers of Court-ruffles. I recollect that the knives and forks matched pretty well; but the plates of Queen's ware had not only been ill-used by being put upon the hob, by which they had lost some of their gadrooned-edges, but were of an unequal size, and the dishes were flat and therefore held little gravy. The dinner consisted of a roasted leg of pork ... a salad with four heads of celery standing pyramidically; mashed turnips neatly spooned over a large flat plate to the height of a quarter of an inch; ... The side-dishes were a chicken and a rein-deer's tongue, with parsley and butter, but the boat was without a ladle, and the plate hardly large enough for it to stand in. Close to Mrs. Nollekens's left elbow, stood a dumb-waiter with cheese, a slice of butter, a few watercresses, and a change of plates, knives and forks.[94]

Smith, who modelled for Nollekens and was preparing himself for admission to the Royal Academy, was struck by the scanty provisions for a company of twelve people, but in this case the company rather than the food was probably the most enjoyable and important focus for a gathering. There was at least a change of plates ready on the dumb waiter; the practice of providing clean tableware for each course, or at least some of the courses, could only be realistic when cheap and acceptable ceramic wares were available, with a reliable source of replacements should breakages occur.

Derisory though the Nollekens' attention to their table may have been, there is evidence that the presentation of food could be imaginative and decorative in the homes of the gentry and

middle classes. Some contemporary recipe books give an indication of the creativity that went into the appearance of food and the uses of tablewares in its preparation and presentation. For example, to make a decorative 'Harts-horne Jelly', Rebecca Price, who managed a country house in the late seventeenth and early eighteenth century, suggested ways of colouring the dessert with 'clovegilly-flower' for red, 'sirrup of violets' for blue, 'saffron' for yellow. The jelly might then be poured into 'Lemon pills [peels] cutt in halves', and when cool the lemon peel and jelly could be cut into quarters and laid on a 'silver server, and the severall coullers mingled one among the others will look very finely in ye lemon pills'.[95]

In the absence of mechanical devices a rich chocolate cream needed to be poured ten or twelve times from one bowl to another to whip it into a froth:

> when so don poure it leasurely into your cheny bason holding it as high from ye bason as you can so it may lye with a great froath all over it, let it stand till it get cold before you eat it and just before you send it to table, whip up a little raw creame with some chocolate in it and ye white of an egg; you may also put a little sugar to it, and as you whip it take of ye froath to lay upon your creame just as you send it to table.[96]

In the middle of the century a number of cookery books were published for a middle-class readership, many of them adapted from the elite cuisine of the French court. In the latter half of the 1700s one of the most important among these publications was Elizabeth Raffald's *The Experienced English Housekeeper*. The range of culinary skills covered is impressive, and Raffald included instructions on how to make decorative dishes for a festive occasion, which were lavish and obviously demanded considerable time and skill. In her 'Directions for a Grand Table' she claimed to have 'made it her study to set out the dinner in as elegant a manner as lies in my power, and in the modern taste', which followed the French pattern of a first 'remove' of savoury dishes replaced by a table which offered both sweet and savoury, incorporating decorative displays which were not intended to be consumed (Fig. 36). A third course, or a 'cold collation', was omitted 'for that generally consists of things extravagant'. Raffald advised the 'industrious house-keeper' to 'lay up in summer at a small expense' a range of sweetmeats prepared from the fruits then in season. Before the cloth was removed for the second course she instructed that fruit and sweetmeats should be already 'dished up in china dishes or fruit baskets; and as many dishes as you have in one course, so many baskets or plates your dessert must have'.[97] The copper plates or 'cuts' included in her book illustrate the table settings, and clearly reveal just how much plate or china would be required to

36] Elizabeth Raffald, 2nd Course Table Setting, *The Experienced English Housekeeper*, engraving, 179

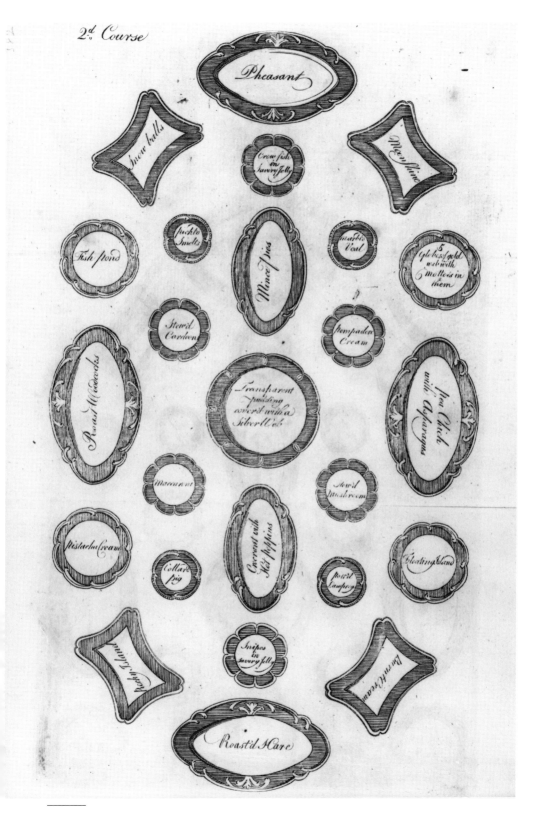

serve a festive meal. All the dishes were different and many required extensive and careful preparation; presenting a dinner of this scale was only possible in a skilled and well-organised household. The spinning of gold and silver sugar webs described by Raffald as a decoration for the dessert was a long and tricky process; refined cookery was - and still is - arduous and required stamina. The table setting illustrated has eight desserts for a festive meal in January, most of which required painstaking preparation. To make a Rocky Island:

> Make a little stiff flummery, and put it into five fish moulds ... when it is stiff, turn it out, and gild them with gold leaf, then take a deep China dish, fill it near full of clear calf's-foot jelly, and let it stand till it is set, then lay on your fishes, and a few slices of red currant jelly, cut very thin round them, then rasp a small French roll, and rub it over with white of an egg, and strew all over it silver bran and glitter mixed together, stick a sprig of myrtle in it, and put it into the middle of your dish, beat the white of an egg into a very high froth, then hang it on your sprig of myrtle like snow, and fill your dish to the brim with clear jelly; when you send it to the table, put lambs and ducks upon your jelly, with either green leaves or moss under them, with their heads toward the myrtle.[98]

On a non-festive occasion a table could still impress an observer like John Penrose. On his second visit to Bath in 1767 he wrote home to his daughter Fanny with a description of a 'Dinner at Mr Brinsden's' in which the first course offered a 'Pair of large Soals', one fried and one boiled, which cost 5s. In the same course there was a rump of beef at the lower end of the table and 'a Sallet in the middle'. Crab-sauce and melted butter were also available with side dishes of cucumbers and young onions. The second course contained '6 pigeons roasted' at the higher end of the table and a large dish of Asparagus at the lower end; on one side a gooseberry tart and on the other 'an hundred large Prawns, the least as large as the largest at Penryn ... price of them 3 shillings'. The two main courses were followed by 'Cheese sound and rotten ... Pats of butter, Radishes', after which the 'napkin', or tablecloth, was removed and sweetmeats were served consisting of '2 preserved Pine-apples, in a high Glass, which stood in a salver of preserved peaches, preserved in Brandy'. The food, which was presented in a china service, was accompanied by three different wines as well as beer and cyder. Penrose described in detail the equipage from which tea and coffee were offered after the dinner: 'Coffee out of very large white china cups, Tea out of very large Dishes, next kin to Basons of a Rummer fashion', which indicates a size similar to a roemer wine glass. By this time the English had established their preference for generous measures of tea and coffee in vessels much larger

than the Chinese tea bowl, and the special strengths and blends suited to English tastes were also well developed. Penrose described the coffee jug as plain and the tea urn likewise apart from a 'Chinese Border round the Bottom'. Evidently the tea urn, which stood on a mahogany table, was in silver and priced at 30 guineas. Valued at 7s 8d per ounce, the silver 'Waiter' on which the china tea and coffee cups stood cost £44 19s.[99] Clearly Penrose had dined with a man of substance who was not reticent about informing his guests of the value of their dinner and its 'equipage'. Dinners at which invited guests were present continued to be served in the manner Penrose described until the middle of the nineteenth century, when service à la Russe was adopted, in which the meal was eaten in a succession of separate courses brought to the table.

In the latter half of the eighteenth century the Sheffield and Birmingham metalware industries were transformed by the industrial technique of plating sheet metal with silver. It was possible to mass-produce wares of this kind only under steam-power, and this technological innovation enabled the well-to-do middle-class consumer to purchase a less expensive form of plate on which to serve elaborate dinners in the manner Raffald described. In these circumstances the creamwares and the porcelains were used to serve the desserts, and very often provided the dinner and dessert plates for the individual guests. Pewter was therefore further ousted from the affluent middle-class dining-room, continuing in use only in the kitchen among the servants, the less well-off stratas of the middle class, and in rural communities where change took place more slowly. Creamware services which closely followed metal prototypes in form were purchased for everyday use, or by sections of the middle class who desired a refined table but could not afford silver plate (Figs 35 and 37). The creamware cheese cradle in Figure 37 followed metal and wooden prototypes. Possibly people chose the attractive creamwares in preference to metalwares, but this is difficult to verify due to lack of clear documentary evidence. However, by the end of the century production techniques in ceramic manufactures had so improved as to make a supper service like the Swansea example in Figure 35 highly acceptable.

It was the aim of many middle-class households to separate food preparation from consumption as far as possible, and the dining room became a significant space in achieving this greater degree of refinement. Cooking was bound to be a messy affair with fish, fowl, game and slaughtered meats arriving in a state which required further work on the carcasses in or near the kitchen. As the cookery books of the period indicate, the aim among those who desired greater refinement was to present food in such a way as to

37] Swansea creamware cheese cradle, *c.* 1800.

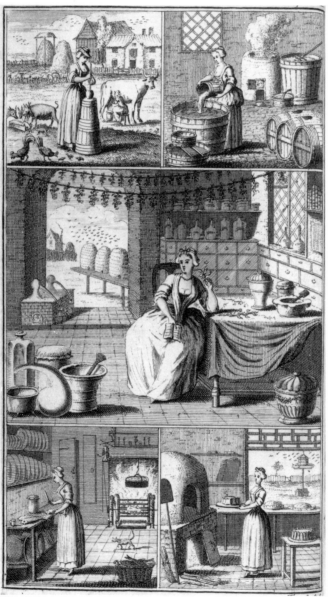

38] Toms, frontispiece for Nicholas Bailey, *Dictionarium Domesticum*, engraving, 1736.

distance it from the violence of its butchery, and to 'dress' the dishes and table for pleasurable display and consumption. The art of cookery established in the courts was slowly and imaginatively transformed by women like Elizabeth Raffald; she appropriated the skills of the male-dominated *haute cuisine*, adapted them and taught them to middle-class women. Such transformation was possible only when a middle-class woman's role within the home was redefined, to become one in which she supervised or specialised in specific responsibilities like cooking. Less and less was a middle-class woman likely to be active in the range of tasks indicated in Nicholas Bailey''s frontispiece for his 1737 *Dictionarium Domesticum* (Fig. 38), tasks which were bound up in the economic survival of the family dependent on land and husbandry. In the eighteenth century the publication of domestic economies like Bailey's *Dictionarium Domesticum* was increasingly superseded by the conduct book, and the cultivation of a modest, self-effacing domestic virtue, a model for the ideal feminine character which strove to distance the middle-class woman on the one hand from the ideals earlier aspired to and represented in the courtly aristocratic woman, and on the other hand from the 'coarse' labour of an agrarian or craft nature illustrated in Bailey's frontispiece. The culmination of this redefinition of a middle-class woman's role was her largely decorative and symbolic presence in the affluent nineteenth-century bourgeois home, although in reality such women were far from numerous and existed principally in the male imagination.[100]

Toxic vessels

One of the most important functions domestic artefacts fulfil in human life is to protect against pain and discomfort, and in this central function 'material culture incorporates into itself the frailties of sentience'.[101] When tea and coffee reached Europe in the seventeenth century it was quickly appreciated that ceramic vessels provided better protection against conducted heat than pewter or silver wares However, the material culture we make for ourselves can be dangerous, and there were invisible hazards present in the metals used in the production of domestic vessels: the lead contained in all but the salt and hard-paste porcelain glazes, the lead in pewter, copper and bell-metal pots, and the verdigris which formed on oxidised copper. During the course of the eighteenth century, as the observations and experiments conducted by chemists and physicians became better informed, suspicions increased that harm was being inflicted on consumers, let alone those who worked with the raw materials in the production of

these vessels. It was understood that lead poisoning 'sometimes …
attacks the human frame by open assault, but more frequently it
makes inroads into the constitution as an unsuspected enemy'.[102]
Lead released under attack from acid constituents in food and
drink was the cause of painful and debilitating conditions in con-
sumers, and of prolonged sickness and early death for those mining
and processing raw lead, as well as those handling the raw material
in manufactures. Nevertheless, while lead poisoning may well
have caused malaise, and sometimes acute illness, eighteenth-
century middle-class consumers were more likely to be carried off
by devastating infectious diseases, or the consequences of other
bodily malfunctions and their treatment.

For centuries litharge, or lead monoxide, was used to sweeten
acid wines and ciders, and the material was known as 'sugar of lead'.
A link between red wines and gout was suspected by the Greeks,
and the sixteenth-century physician and alchemist Paracelsus sus-
pected the 'tartarous' residue in wines were the cause of gout,
allthough he could not identify lead as the specific toxin.[103] Gout
sufferers were the target of satire during the eighteenth century,
usually represented by the aged and peevish sufferings of a life of
over-indulgence in the English 'gentleman' (Fig. 39). Anecdotal
accounts of the pain of a gouty knee or foot in memoirs and diaries
of the middle and upper classes are legion. At a time when patho-
logy was reliant on experience and 'educated guesswork', it is
impossible to be certain of the causes of so prevalent a complaint,
which were probably manifold.[104] The human body was in battle
with metal poisons on several fronts at once: from lead-glazed,
pewter and copper vessels; from lead pipes and water cisterns; from

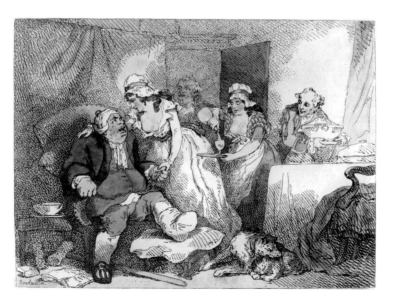

39] Thomas Rowlandson,
Comfort in the Gout, etch-
ing, engraving and ink
wash, *c.* 1790.

medicines in which metals were commonly used in treatment. Because of their uses in medicine, there was confusion about the harmful effects of metals. This led to even less concern about the ill effects of lead in manufacturing contexts, even though it was obvious that workers were falling sick. Although Josiah Wedgwood implemented straightforward measures to minimise the harm to his workers, many other manufacturers did not, and continued not to do so in the next century.

In 1754 James Lind speculated that the abdominal complaints supposedly caused by lemons were more likely due to lead leached from the glaze of ceramic vessels.[105] Fothergill identified vinegar, pickles and acid fruits as hazardous: 'These act powerfully upon lead and its preparation, and, it is to be feared, often acquire an unsuspected impregnation of that metal in various culinary processes'.[106] Elizabeth Raffald, author of *The Experienced English Housekeeper*, was aware of the dangers of pickling vegetables, particularly cucumbers, in brass or copper vessels; housewives were inclined to rely on verdigris to make their pickles a brighter green. She was insistent that the vessels used be well tinned, and that it was possible to green the pickles 'only by pouring your vinegar hot upon them'. Aware of the risk of verdigris poisoning, Mrs Raffald's confident recipe for baking sprats gives no indication of her concern for the hazards of preparing a dish which included acidic liquids in a lead-glazed vessel:

> Rub your Sprats with salt and pepper, and to every two pints of vinegar put one pint of red wine, dissolve a penny-worth of cochineal, lay your sprats in a deep earthen dish, pour in as much red wine, vinegar, and cochineal as will cover them, tie a paper over them, set them in an oven all night. – They will eat well, and keep for some time.[107]

If baked and stored in a salt-glazed stoneware or hard-paste porcelain vessel, the dish would have been harmless. Generally, recipe books gave very little advice on the safe preparation and storage of food in earthen and metal containers. In his *Cautions to the Heads of Families* Fothergill noted that many 'frugal' cooks preferred to bake their fruit pies in lead-glazed dishes because the litharge added sweetness to the acid fruit, and this meant less need for sugar, which was still an expensive item. He was concerned that women should be informed of the hidden dangers in their culinary habits, 'for certainly these good ladies would not designedly sweeten our viands with sugar of lead!'.[108] In the eighth edition of Mrs Charlotte Mason's *Lady's Assistant*, published in 1801, an appendix was added which gave better-informed directions for the avoidance of lead and verdigris contamination. Lead-glazed vessels are described and stated to be 'improper, though too often used, for preserving sour

fruits or pickles', and cooks are instructed that 'a sure way of judging whether the vinegar, or other acids, have dissolved part of the glazing, is, by their becoming vapid, or losing their sharpness, and acquiring a sweetish taste by standing in them for some time', in which case the contents of lead-glazed vessels should be 'thrown away as pernicious'.[109]

Fothergill identified a hazard in tea drinking due to the East India Company practice of lining tea chests with lead. The weak acids contained in tea all too often combined with moisture during the long sea voyages and this caused fermentation of the product: 'How far the tremors, depression of spirits, and other nervous symptoms, generally ascribed to this vegetable, or the hot water in which it is infused, may not, in such instances, with equal probability be attributed to the lead in which it is enclosed, is left for future observation'.[110] Tremor in the limbs and lethargy are symptoms of lead poisoning, and it is conceivable that Fothergill may have had a point. But the tea could only add to damage from other sources, and as with gout these symptoms had many uncertain causes.

Chemists and medical practitioners were well aware that the consequences of lead and copper poisoning from domestic vessels affected people from all social classes: 'no person of whatever rank or station, from the prince to the peasant, can, at all times, pronounce himself perfectly secure against its silent depredations'.[111] The more vicious poisoning associated with verdigris, the result of oxidation in copper vessels, could be fatal to those already frail, and copper coffee pots were a particular hazard if the liquid was allowed to cool and stand in the pot long enough for oxidation to take place. Often, because coffee was an expensive item for many people, the contaminated liquid was reheated and consumed.

In 1760 the problem of lead in tin-glazed delftwares was raised at a meeting of the Society for the Encouragement of Arts, Manufactures and Commerce by a Birmingham man. He claimed to have travelled the length and breadth of Britain 'in search of Mineral Productions', on which he had experimented in order to 'diversify and extend the Practice of Enamelling and improve the figuline Art; which last is, as yet, far from being in any Degree of Perfection in this Part of the World'.

> For the Delftware is clumsy and rotten, and its Glaze dangerous to Health, on account of the Quantity of calcin'd Lead and Tin employed in it. Matters that, even after Vitrification, submit to the milder Acids. The same bad Consequences attend the other Common Potteries that are glaz'd with Lead; and those glaz'd by the Fumes of Salt, though much less pernicious, are yet destitute of Beauty and Durability.[112]

When Fothergill wrote his *Cautions to the Heads of Families* it was

well known that safe ceramic vessels were available in the form of
stonewares, although his assessment of 'china' was questionable:
'The glazing of *stone* ware and china being a vitrification of the
clay, is indissoluble in acids, and therefore such vessels are perfectly
safe; while the glazing of ordinary *earthen*-ware, consisting of a
calx of lead, is easily acted upon by acids, and yields a noxious
quality'.[113]

Many of the soft-paste porcelains, fired at biscuit and glaze tem-
peratures lower than hard-paste, were in fact lead-glazed, and when
too long in contact with acidic contents presented similar hazards
to the consumer. *The Lady's Assistant* warns that 'some species of
the European manufactory are certainly glazed with a fine glass of
lead' and advises that the only safe porcelain for the containing of
acidic foods was that made in China.[114] In the middle of the century
attempts were made to devise adequate alkaline glazes and enamel-
ling techniques to render domestic vessels safe from oxidation and
attack from acidic food and drink. However, the softer soda-based
glazes do not have the durability of those containing lead as a
principal ingredient. Apart from the lead content in on-glaze
enamels, hard-paste porcelain offered a realistic solution to the
problem of lead contamination. These porcelains, glazed with a
harmless feldspathic flux rather than lead, had the potential to
provide safe eating and drinking vessels for all, but not until the
nineteenth century did they become a viable economic alternative
for consumers in the lower income groups. The exclusivity of hard-
paste porcelain, which was to a great extent maintained by
hand-painted enamel work, kept prices high.

Any assumptions that the creamwares were hazard-free also
required caution. They were lead-glazed and although 'fritting' pro-
cesses started to improve, it inevitably meant higher costs in
processing and in labour. Fritting consumed fuel and kiln space, as
well as requiring labour-intensive processes in the subsequent
preparation of the material. To frit lead it had to be melted down
in crucibles, after which it cooled to a solid glassy mass. This had
to be ground down to a fine powder for use as a glaze ingredient,
a hazardous process in itself because of the fine metallic and silica-
laden dust raised in mills and on grinding wheels which was
inhaled by the workers, especially in manufactories where water
supplies were limited in their capacity to wet or damp the raw
materials sufficiently when ground, and where any movement of
the dry ingedients raised fine particles of material.

In his *Observations and Experiments on the Poison of Lead*, Thomas
Percival MD reported a trial on the 'Burslem pottery, commonly
called the Queen's Ware'. This he undertook in the early 1770s,
when Wedgwood creamwares had been in production for about

ten years. Percival suspected that because of the 'very beautiful polish' of the wares lead must have entered into the 'composition of its glazing'. He tested the glaze by pouring about an ounce and a half of vinegar onto a Queensware plate and left it for twenty-four hours, during which time 'the vinegar had acquired a deeper colour, and assumed a dusky hue when two drops of the volatile tincture of sulphur were added to it'. When added to a separate batch of fresh vinegar in the same proportion a light cloudiness was observed, which was followed by a white sediment – the action of sulphur 'precipitated by the combination of the acid and alkali'. Percival's conclusion after repeating the trial several times was 'that lead is an ingredient in the glazing of the Queen's Ware; but the proportion in which it is used, or at least the quantity dissolved by the vegetable acid, appears to be very inconsiderable'. He recommended that there could be no objection 'to the common use of this beautiful pottery; but it shews that vessels of it are improper for the preserving of acid fruits and pickles'.[115]

In the *Galante und in der Oekonomie geübte Frauenzimmer* (The Polite and Economically Experienced Woman), published by Samuel Riedel in 1797, cautions against lead poisoning were not limited to cooking vessels. Among the educated European middle classes a shift of emphasis towards the importance of skilled parenting, and much more direct involvement of the natural parents rather than surrogates, led to further exhortations on the safety and value of play and the suitability of toys: 'All toys made of plaster, clay, glass and porcelain are particularly injurious to small children'. The danger of allowing children to play with earthenware lead-glazed vessels was emphasised by Riedel: 'Children prepare dishes of all kinds for themselves, including acidic ingredients using earthenware bowls and containers. There they allow them to remain for many days, forgetting to clean them. The lead particles of the glaze are released and absorbed by the foodstuffs …'.[116]

Riedel warned that remains left from inadequate cleaning could be highly toxic and often these incidents were not noticed by adults. It was recommended that tin, lead-plated and brass articles should also be avoided, especially lead soldiers. Examples such as this indicate that awareness of the effect of material substances on the human body was sharp, but there was a weight of inertia on the part of producers against taking positive action which would at least reduce the risk to both producers and consumers. This was partly due to lack of knowledge, but fundamentally the causes were economic. Precautions against contamination from toxic materials reduced profit margins. It was left to the medical men to communicate the dangers to the population, but, as might be expected, it was the more affluent and educated who benefited from

this knowledge and not the poor, who had to buy the cheapest and least safe vessels in which to prepare and store food. A much more serious threat to children's health lay in the introduction of a new design in creamware feeding bottles for infants, which were boat-shaped rather than cylindrical or bucket-shaped 'cups'. The boat-shaped vessels had a small opening in the middle into which the milk was poured and the child sucked from an outlet at one end of the bottle. It was therefore not easy to clean the vessel or even to see if there were residues of milk left inside. In addition nurses were in the habit of holding a baby's bottle under their armpit in order to keep the milk warm, but also at a perfect temperature for bacteria to multiply. Like the popular 'creamers' made in the form of a dairy cow, these vessels were potential hosts to tuberculosis, salmonella and other bacteria liable to cause serious illness.[117]

Chemists and medical practitioners criticised the luxury porcelain manufacturers for their secrecy and high prices which maintained their position as producers of an elite product. Developments in science and technology alerted many specialists in chemistry and medicine to the known damage inflicted on the population through the use of toxic materials in a domestic context. By the end of the century it was no longer simply a suspicion or a hunch that metals in everday use caused illness; proof was indisputable, although some reactions may have been too alarmist. A critic from within porcelain manufacture was Franz Joseph Weber, at one time technical inspector at the Höchst Porcelain Manufactory, and who subsequently held the post of director at Ilmenau in the Duchy of Saxe-Weimar. He was aware of the service hard-paste porcelains could provide in offering a totally safe alternative to lead-glazed vessels and metal domestic wares. Salt-glaze wares answered this requirement to a certain extent when used for the storage of food and drink, but were too coarse for social use among the affluent and refined middle and upper classes. If porcelains had not been so costly, Weber believed, the dangers of lead poisoning would have receded in a much larger section of the population. Porcelain had the potential to become a socially useful product, but mystification and high prices, due in large part to the maintenance of skilled hand painters, rendered much of the output fit only for the purpose of ornament, rather than use in the storage and consumption of food and drink. Weber's position as director of the Ilmenau Manufactory may well have heightened his awareness of porcelain's useful applications. Ilmenau was one of the Thuringian enterprises established by private entrepreneurs which manufactured a humbler product based on Meissen models, but specifically directed towards middle-class consumers. The

Höchst Manufactory closed in 1796, and Weber's strong words would suggest that he held the arcanists to blame for the demise of this and many other porcelain manufactories in the late eighteenth century. He wrote of one man 'who as a result of his insufferable Stupidity, would at every Opportunity loudly claim with his hand on his Heart, that he knew everything about Porcelain Manufacture, and when questioned consequently believed that nobody could possibly make the slightest Improvement in his speciality'.[118]

Slowly, advantaged and educated people were gaining awareness, and were determined themselves to do as much as they could to prevent illness. In Goethe's *Elective Affinities*, Charlotte, wishing to engage the Captain's attention, thinks up all sorts of questions to ask him:

> She liked being alive and so she sought to do away with anything that might be harmful or deadly: the lead-glazing on the earthenware crockery and the verdigris that formed on copper pots had worried her for a long time and she had him instruct her about this and the instruction had naturally to begin with the fundamental principles of physics and chemistry.[119]

While Charlotte may have had other motives for detaining the Captain, one fundamental principle had become clearer to physicians: 'It is always much easier to prevent diseases than to cure them'.[120]

Notes

1 See C. Campbell, 'Understanding Traditional and Modern Patterns of Consumption in Eighteenth-Century England: a Character-Action Approach', in J. Brewer and R. Porter (eds), *Consumption and the World of Goods* (London, Routledge, 1993).

2 A. Allardyce, *Scotland and Scotsmen in the Eighteenth Century: From the MSS of John Ramsey Esq. of Ochtertyre*, Vol. II (Edinburgh and London, Blackwood & Sons, 1888), pp. 71-2.

3 *Ibid.*, p. 72.

4 *Ibid.*, note 1, p. 72.

5 J. G. Fyfe, *Scottish Diaries and Memoirs 1746-1843* (Stirling, Eneas Mackay, 1942), pp. 162-3.

6 Allardyce, *Scotland and Scotsmen in the Eighteenth Century*, p. 72.

7 For a useful discussion of this transformation in Scotland see the Introduction to J. Dwyer, *Virtuous Discourse: Sensibility and Community in Late Eighteenth-Century Scotland* (Edinburgh, John Donald, 1987)

8 *Journal of Bishop Robert Forbes: Episcopal Journey and Visitation of the Diocese of Ross and Caithness 1762* (London, 1886), p. 187.

9 B. Mitchell and H. Penrose, *Letters from Bath 1766-1767 by the Reverend John Penrose* (Gloucester, Alan Sutton, 1983), p. 96.

10 *Ibid.*, p. 96.

11 J. Woodforde *The Diary of a Country Parson 1758-1802* ed. B. Beresford (Oxford, Oxford University Press, 1935), p. 216.

12 *Ibid.,* p. 131.

13 F. M. Eden, *The State of the Poor*, Vol. 2 (London, 1797), p. 449. The price of grain was high when Eden's survey was undertaken.

14 In rural mid-Wales an 'aceramic tradition' appears to have been continuous from the Bronze Age until the seventeenth and eighteenth centuries when wares were imported from Cheshire and south Lancashire, Liverpool, Buckley, and finally from the Staffordshire potteries. See E. Campbell, 'Post-Medieval Pottery in Wales: an Archaeological Survey', *Post-Medieval Archaeology*, 27 (1993), pp. 1-13.

15 H. Ramage, *Portraits of an Island: Eighteenth-Century Anglesey* (Anglesey Antiquarian Society and Field Club, 1987), p. 146.

16 *Ibid.,* p. 148.

17 C. Hutton, *Reminiscences of a Gentlewoman of the Last Century: Letters of Catherine Hutton*, ed. C. Hutton Beale (Birmingham, Cornish Brothers, 1891), p. 48.

18 P. Jenkins, *The Making of a Ruling Class: The Glamorgan Gentry 1640-1790* (Cambridge, Cambridge University Press, 1983), p. 252.

19 G. Wiegelmann, 'Der Wandel von Speisen- und Tischkultur im 18 Jahrhundert', in H. J. Teuteberg and G. Wiegelmann (eds), *Unsere Tägliche Kost: Geschichte und regionale Prägung* (Münster, F. Coppenrath Verlag, 1986), pp. 344, 337.

20 H. J. Teuteberg, 'Die Eingleiderung des Kaffees in dem täglichen Getränke-konsum', in *Unsere Täglichen Kost*, p. 192.

21 O. Fairclough, 'Porcelain and Silver: Sir Watkin Williams-Wynn's Table during the 1770s', paper given at Morley College in October 1995. National Library of Wales, Wynns/MS Box 115/3, Stewards Account Book for 1771. For the Wedgwood connection see H. Young (ed.), *The Genius of Wedgwood* (London, Victoria and Albert Museum, 1995), pp. 59, 62.

22 Woodforde, *The Diary of a Country Parson*, p. 65.

23 E. Burke, *A Philosophical Enquiry into the Origin of our Ideas of the Sublime and the Beautiful*, ed. A. Phillips (Oxford, Oxford University Press, 1990), p. 101.

24 See M. Wollstonecraft, *A Vindication of the Rights of Men, in a Letter to the Right Honourable Edmund Burke* (London, 1790), pp. 105-8.

25 *Pope's Bath Chronicle*, 24 October 1765 (Bath Central Library).

26 For a history of the coffee-house see A. Ellis, *The Penny Universities* (London, Secker and Warburg, 1956), and B. Lillywhite, *London Coffee Houses* (London, George Allen & Unwin, 1963). For a discussion of the significance of civility in the coffee-house see L. Klein, 'Coffeehouse Civility 1660-1714', *Huntington Library Quarterly*, 59, 1 (1997), pp. 31-51. For a brief but interesting account of coffee establishing a place in seventeenth-century Parisian life see J. Leclant, 'Coffee and Cafés in Paris, 1644-1693', in R. Forster, and O. Ranum (eds), *Food and Drink in History* (Baltimore, Johns Hopkins University Press, 1979), pp. 86-97.

27 Bristol Record Office, Diocese of Bristol Probate Inventory, John Kimber, coffee-seller, 1681.

28 Bristol Reference Library, Volume of MS Concerning Coffee-Houses, No. 34520, record of the 'Elephant Coffee-house' 1677.

29 Bristol Record Office, Richard Champion Letterbooks 1760-75, MS 38083. Henry Dawes to Richard Champion, 24 June 1763, fo. 53. The 'Wilkes' referred to here is of course the radical politician John Wilkes, and Dawes was referring to the rumpus caused by the publication on 23 April 1763 of the article in Number 45 of Wilkes's paper, the *North Briton*, which was critical of King George III.

30 R. Sennett, *The Fall of Public Man* (London, Faber & Faber, [1977] 1993), pp. 56-7.

———

See also J. Habermas, *The Structural Transformation of the Public Sphere: An Inquiry into a Category of Bourgeois Society* trans. T. Burger (Cambridge, Polity Press, 1989), pp. 32–3.

31 *Ibid.*, p. 63.

32 *Low-Life: or One Half of the World knows not how the Other Half Live* (London, 1764) p. 10. 'French mechanics' were skilled artisans from France working in London trades.

33 D. H. Solkin, *Painting for Money: The Visual Arts and the Public Sphere in Eighteenth-Century England* (New Haven and London, Yale University Press, 1992), pp. 28–9.

34 J. Macky, *A Journey Through England*, Vol. 1 (London, 1714), p. 108.

35 *Ibid.*, Vol. 2, p. 133.

36 For discussions of the bourgeois city elites see N. Rogers, 'Money, Land and Lineage: The Big Bourgeoisie of Hanoverian London', *Social History*, 4 (1979), pp. 437–54, and H. Horwitz, ' "The Mess of the Middle Class" Revisited: The Case of the "big bourgeoisie" of Augustan London', in *Continuity and Change*, 2, 2 (1987), pp. 263–96.

37 *Angenehmer Zeitvertreib* (Leipzig, 1755).

38 For excellent contributions on the eighteenth-century town and urban development see P. Borsay (ed.), *The Eighteenth-Century Town: A Reader in English Urban History 1688-1820* (London and New York, Longman, 1990).

39 S. Markham (ed.), *John Loveday of Caversham 1711-1789: The Life and Tours of an Eighteenth-Century Onlooker* (Salisbury, 1984), p. 58.

40 Macky, *A Journey Through England*, Vol. 2, p. 41.

41 C. Lennox, *The Female Quixote* (Oxford, Oxford University Press, World Classics Series, [1752] 1989), p. 279.

42 P. Meyer Spack, *Boredom: The Literary History of a State of Mind* (Chicago, University of Chicago Press, 1995), p. 32.

43 Campbell, 'Understanding Traditional and Modern Patterns of Consumption', p. 52. For a characterisation of affected boredom in London society a good example is Mr Meadows, in Fanny Burney's *Cecilia, or Memoirs of an Heiress* (1782).

44 Solkin, *Painting for Money*, see Chapter 4 for an excellent account of Vauxhall Gardens and the Hayman supper-box paintings.

45 P. Burke, *The Art of Conversation* (Cambridge, Polity Press, 1993), p. 117.

46 See M. Cohen, *Fashioning Masculinity: National Identity and Language in the Eighteenth Century* (London and New York, Routledge, 1996), for an interesting investigation of the construction of the gentleman and the English national male character through spoken language.

47 Langford, *A Polite and Commercial People*, pp. 463–5. See also J. Raven, H. Small and N. Tadmor (eds), *The Practice and Representation of Reading in England* (Cambridge, Cambridge University Press, 1996). There are many examples in letters, diaries and memoirs which indicate a diverse and complex picture of the social relations between men and women. Some of the best-known collections which throw light on the intellectual lives of women, the 'Blue Stockings', include M. Pennington (ed.), *Letters from Mrs Elizabeth Carter, to Mrs Montagu, Between the Years 1755 and 1800*, 3 vols (London, 1817); the *Letters of Anna Seward*, which were revised by Anna Seward herself, 6 vols (Edinburgh, 1811).

48 The British Library, Add. MS. 42672, Brockman Papers, fo. 251.

49 Bristol Record Office, Diocese of Bristol Probate Inventories. The author's survey of 2,252 inventories, which date from 1680 to 1749, clearly confirms that the

ownership of fine ceramics, which included items like punch-bowls, was on the increase at this time.

50 S. Nenadic, 'Middle-Rank Consumers and Domestic Culture in Edinburgh and Glasgow 1720–1840', *Past and Present*, 145 (1995), pp. 141-50.

51 *Das Jetzt Lebende und Florirende Leipzig* (Leipzig, 1736).

52 J. S. Bach, BWV 515, 'Erbauliche Gedanken eines Tabakrauchers' from the *Zweiten Notenbuch der Anna Magdalena Bach*, 1725. It has been suggested that the verses were written by Bach's son, Gottfried Heinrich, and in performances today the song is often interpreted 'tongue in cheek'.

53 'On a Pipe of Tobacco', in *The Gentleman's Magazine*, Vol. V, November 1735, p. 677.

54 F. M. Turner (ed.), *The Diary of Thomas Turner of East Hoathly (1754-1765)* (London, Bodley Head, 1925), pp. 85-6.

55 *Ibid.*, p. 87.

56 L. Weatherill, *Consumer Behaviour and Material Culture in Britain 1660-1760* (London, Routledge, 1988), p. 94. The notion of 'family' in a pre-industrial economy could include the apprentices and journeymen living in a master artisan's or shopkeeper's house, the domestic servants and those working in husbandry, but living within their employer's household. Such arrangements by no means indicated a high level of affluence, and even taking these additional members into account Lorna Weatherill argues that on average a middle-class family unit in England and Scotland was comprised of four to seven people. She also emphasises the point that a household was a 'dynamic entity' subject to cyclical and unexpected change. See also L. Davidoff and C. Hall, *Family Fortunes: Men and Women of the English Middle Class 1780-1850* (London, Routledge, [1987] 1992), p. 31.

57 *Pope's Bath Chronicle*, 27 January 1763 (Bath Central Library).

58 H. Chapone, *Mrs Chapone's Letter to a New-Married Lady* (London, 1777), p. 22.

59 H. Chapone, *Letters on the Improvement of the Mind Addressed to a Young Lady*, Vol. 1 (London, 4th edition, 1774), p. 8.

60 For wry comment on the relationship between employers and servants see the popular satire by Francis Coventry, *The History of Pompey the Little; or the Life and Adventures of a LAP-DOG* (London 1799), p. 47. For characteristic and crustier comments see J. Swift, *Directions to Servants in General* (London, 1745). See also P. Earle, *The Making of the English Middle Class: Business, Society and Family Life in London 1660-1730* (London, Methuen, 1989) p. 223.

61 Bristol Record Office, Episcopal Consistory Court of Bristol, *Easterbrook* v. *Easterbrook* 1796-98, Divorce 08025 (61).

62 On divorce see L. Stone, *Broken Lives: Separation and Divorce in England 1660-1857* (Oxford, Oxford University Press, 1993).

63 *Ibid.*, pp. 209-10, and for a detailed case study of *Middleton* v. *Middleton*.

64 Bristol Record Office, Diocese of Bristol Probate inventories, samples taken from Cause Papers after 1749. For a study of furniture of the period see C. D. Edwards, *Eighteenth-Century Furniture* (Manchester and New York, Manchester University Press, 1996).

65 Although aimed at affluent consumers, the Leeds Pottery pattern book of 1794 and 1814 gives a good indication of the range of vessels in creamware production during the last quarter of the eighteenth century. For sanitary wares see numbers 188-200.

66 S. Rolleston, *Dialogue Concerning Decency* (London, 1751), p. 46.

67 *Ibid.*, p. 46.

68 W. Bohun, *Privilegia Londini: or, the Rights, Liberties, Privileges, Laws and Customs, of the City of London* (London, 1723), p. 111.

69 Earle, *The Making of the English Middle Class*, p. 223.

70 A. Corbin, *The Foul and the Fragrant: Odour and the Social Imagination* (London, Picador, [1982] 1994), p. 25.

71 Woodforde, *The Diary of a Country Parson*, pp. 160–1.

72 See Langford, *A Polite and Commercial People*, pp. 429–30, and Borsay, 'The English Urban Renaissance: The Development of Provincial Urban Culture c. 1680–1760', in *The Eighteenth-Century Town*, pp. 168–9.

73 G. Vigarello, *Wasser und Siefe, Puder und Parfüm: Geschichte der Körperhygiene seit dem Mittelalter*, trans. L. Gränz from the French *Le Propre at le Sale* (1985) (Frankfurt am Main, Reihe Campus, 1992), p. 123.

74 R. Chartier, *A History of Private Life: Vol. III The Passions of the Renaissance* (Cambridge, Mass., Harvard University Press, 1986), p. 189.

75 For example see A. F. M. Willich MD, physician to the Saxon Embassy in London, *Lectures on Diet and Regimen: Being a Systematic Enquiry into the most Rational Means of Preserving Health and Prolonging Life* (1799).

76 Vigarello, *Wasser und Seife, Puder und Parfüm*, cited from a contemporary treatise on bodily hygiene, p. 131.

77 *Low-Life, or One Half of the World Knows not how the Other Half Lives* (London, 1764), p. 27.

78 See T. Sheraton, *Cabinet-Maker and Upholsterer's Drawing-Book* (1793), which had enormous influence in continental Europe and America as well as in Britain. See Edwards, *Eighteenth-Century Furniture*, especially on 'metamorphic' furniture pp. 176–81, and on bedrooms, dressing-rooms and closets pp. 187–90.

79 Corbin, *The Foul and the Fragrant*, pp. 40–1.

80 Swift, *Directions to Servants in General*, p. 88. T. Smollett, *Humphrey Clinker* (London, 1785), p. 27.

81 Corbin, *The Foul and the Fragrant*, p. 14 (Lavoisier), p. 143 on the need for the nineteenth-century bourgois individual 'to distinguish himself from the putrid masses'.

82 Sir F. M. Eden, *The State of the Poor* (London, 1797), p. 524.

83 N. Elias, *The Civilising Process: The History of Manners*, Part II, trans. E. Jephcott (Oxford, Blackwell, 1978), p. 69.

84 A. de Courtin, *The Rules of Civility, or the Maxims of Genteel Behaviour* (London, [1672] 1703), p. 92. La Salle's *Rules – Les Règles de la bienséance et de la civilité chrétienne* – was similarly translated and revised over a considerable length of time. Like de Courtin's work, La Salle's was intended to instruct a middle-class readership in courtly manners at table and in bodily hygiene. See also Elias, *The Civilising Process*, p. 93.

85 *The Man of Manners or, the Plebeian Polish'd* (London, 1737), p. 7.

86 See R. P. Garrard, 'English Probate Inventories and Their Use in Studying the Significance of the Domestic Interior, 1570–1700', in A. van der Woude and A. Schuurman (eds), *Probate Inventories: A New Source for the Historical Study of Wealth, Material Culture and Agricultural Development* (Wageningen, Afdeling Agrarische Geschiedenis Landbouwhogeschool-Wageningen, 1980).

87 Bristol Record Office, Diocese of Bristol Probate Inventories, Henry Hoare, Tobacco-pipe maker, 1728; Charles Stokes, Gent, 1740; John Shelbery, Gent, 1721.

88 D. Roche, *The People of Paris* (New York, Munich and London, Berg Publishing Ltd, [1981] 1987), pp. 140–5.

89 Bristol Record Office, Dioceses of Bristol Probate Inventory, Robert Bayley, Merchant, 1686.

90 Bristol Record Office, Diocese of Bristol Probate Inventory, John Saunders, Victualler (Cause Papers) 1783.

91 For evidence of these general conclusions drawn from probate inventories see Roche, *The People of Paris*; Weatherill, *Consumer Behaviour and Material Culture in Britain*; C. Shammas, *The Pre-Industrial Consumer in England and America* (Oxford, Clarendon Press, 1990).

92 B. Mitchell and H. Penrose, *Letters from Bath 1766-1767 by the Reverend John Penrose* (Gloucester, Alan Sutton, 1983), p. 129. The Mr Loscombe whom Penrose visited was probably Joseph Loscombe, a wealthy merchant who lived in a large house in Wilder Street, Bristol. See W. Ison, *The Georgian Buildings of Bristol* (Bath, Kingswood Press, 1978), p. 205.

93 Woodforde *The Diary of a Country Parson*, p. 131.

94 J. T. Smith, *Nollekens and his Times* (London, Pimlico [1828] 1986), p. 60. 'Court-ruffles' were plaited linen decorations used on the table.

95 M. Masson, *The Compleat Cook: or the Secrets of a Seventeenth-Century Housewife* (London, Routledge & Kegan Paul, 1974), p. 171.

96 *Ibid.*, p. 172.

97 E. Raffald, *The Experienced English Housekeeper* (London, 1782), p. 384.

98 *Ibid.*, pp. 201-2. Flummery was made from wheatmeal or oatmeal, soaked, sieved and boiled until it started to form a blancmange. With sugar, flavourings and sometimes brandy or madeira added it was palatable. For decorative purposes it was often coloured, as in Elizabeth Raffald's directions for making a 'Solomon's Temple in Flummery', p. 204. Flummery has another meaning apart from the culinary, i.e. empty compliments; trifles; nonsense (*OED*). In his *Dictionary*, Dr Johnson included John Locke's meaning of 'flattery'.

99 Mitchell and Penrose, *Letters from Bath*, p. 177.

100 For a detailed discussion of the conduct book and the redefinition of the middle-class woman's role in the domestic sphere see N. Armstrong, 'The Rise of the Domestic Woman', in N. Armstrong and L. Tennenhouse (eds), *The Ideology of Conduct* (London, Methuen, 1987), especially p. 105. Kathryn Shevelow's *Women and Print Culture: The Construction of Femininity in the Early Periodical* (New York, Routledge, 1989), is also an important contribution to the subject. An excellent study of the changes in the structure of middle-class life and its implications for men and women during the industrial revolution is L. Davidoff and C. Hall, *Family Fortunes: Men and Women of the English Middle Class 1780-1850* (London, Routledge, 1987). There are too many eighteenth-century conduct books to account for here, but some typical examples which ran into more than one edition include Thomas Gisborne's *An Enquiry into the Duties of the Female Sex* (1794), which was translated into German in 1800. Gisborne also published a similar title for the male sex of the 'higher and middle classes of Society in Great Britain'. For the education of the middle-class woman in matters of taste see Cosmetti's *The Polite Arts, dedicated to the Ladies* (1767), and James Usher's *Clio, or a Discourse on Taste* (1769, first published in 1767). For an eighteenth-century text of enormous influence among the educated European middle classes which expounded 'modern' ideas on the 'education' of the female child and her future adult role, see J. J. Rousseau's *Émile*, first published in 1762. It would be a mistake to assume the middle-class female constructed in the conduct book was formed entirely by men. Hester Chapone's publications are prescriptive in very similar terms but with an emphasis on the importance of educating young women, although it has to be said this was to a limited degree only. It would also be misleading to assume that all middle-class women conformed to these ideas. See

Vickery, *The Gentleman's Daughter: Women's Lives in Georgian England* (London and New Haven, Yale University Press, 1998).

101 E. Scarry, *The Body in Pain: The Making and Unmaking of the World* (Oxford, Oxford University Press, 1987), p. 244. This is a deeply thoughtful and fascinating investigation into the body, its experience of pain, and its encounter with the material world expressed through language and the making of things.

102 A. Fothergill, *Cautions to the Heads of Families, in Three Essays: 1. On Cyder-Wine. 2. On the Poison of Lead. 3. On the Poison of Copper* (Bath, 1790), p. 31.

103 R. Weedon, *Poison in the Pot: The Legacy of Lead* (Carbondale and Edwardsville, Southern Illinois University Press, 1984), pp. 76, 79., and the whole of Chapter 2, 'Punch Cures the Gout', for a lively and detailed account of gout, its likely causes and cures. Gout is now understood to be a metabolic disorder of uric acid which causes an arthritic condition in the small bones of the feet.

104 *Ibid.*, p. 77.

105 *Ibid.*, p. 66.

106 Fothergill, *Cautions to the Heads of Families*, p. 48.

107 Raffald, *The Experienced English Housekeeper*, pp. 342, 34.

108 Fothergill, *Cautions to the Heads of Families*, p. 49.

109 C. Mason, *The Lady's Assistant for Regulating and Supplying the Table* (8th edition, 1801, first published, London, 1773), p. 415.

110 Fothergill, *Cautions to the Heads of Families*, p. 51.

111 *Ibid.*, p. 31.

112 Royal Society of Arts, Archive of the Society for the Encouragement of Arts and Manufactures, Guard Books, Vol. 2, No. 32. Figuline = Figulate; in Samuel Johnson's Dictionary from the latin figulus, made of potter's clay.

113 Fothergill, *Cautions to the Heads of Families*, p. 49.

114 Mason, *The Lady's Assistant*, p. 415.

115 T. Percival, *Observations and Experiments on the Poison of Lead* (London, 1774), p. 62.

116 S. Riedel, *Das Galante und in der Oekonomie geübte Frauenzimmer*, Vol. 1 (Schweinfurt 1797), p. 578. Fothergill also pointed out to 'unsuspecting parents' the dangers of allowing their 'smiling innocents' to suck those 'pernicious toys' painted with red and white lead. *Cautions to the Heads of Families*, p. 53.

117 See J. Crellin, 'Medical Ceramics', *English Ceramic Circle Transactions*, 7, 3 (1970), p. 198.

118 F. J. Weber, *Die Kunst das ächte Porzellain zu Verfertigen* (Leipzig, 1798), p. 9.

119 J. W. von Goethe, *Elective Affinities*, trans. R. J. Hollingdale (London, Penguin Classics, [1809] 1978), p. 48.

120 Fothergill, *Cautions to the Heads of Families*, p. 30.

5 The transmission of styles

It was through the visual appearance of fine ceramics, textiles, prints, furniture and metalware products that consumers derived some sense of a shared material culture. By the end of the eighteenth century many manufactured artefacts were not expensive, and could be purchased by wage earners in the new industrial towns. Blue and white or floral painted 'china', hot water urns, tea trays and caddies, floral printed cottons and topical prints all contributed to a sense that some values, aspirations and social practices were broadly held in common across the middle classes. It was of course the style of these goods to which people responded, even if they had only a vague notion of the cultural origins of these styles and their transformations. It was through the ownership of goods in a particular style that people identified their tastes in common with, or in aspiration to, a social milieu to which they felt they belonged, or would wish to belong.

Images from the East

> As we passed along the coast of China, I thought it the finest prospect I had ever seen. When I saw their lofty pagodoes or steeples, fortifications, houses, and burying places, everything green, and carrying the appearance of plenty; it confirmed the ideas I had formed of them when in Europe, from Chinese paintings.[1]

On the last stage of his voyage to Canton in the late 1740s, an East India Company officer compared his first impression of China with those he had earlier received from paintings imported to the West. In his position (a privileged one as an officer in one of the most powerful institutions in Europe), he had access to rich sources of visual evidence before he sailed to the East Indies. He assessed his European impressions of China mediated through paintings against the reality unfolding before his eyes. Very few Europeans had access to experiences of this kind, and although there is little evidence to tell us what people's thoughts were in response to the exotic East India goods seen in the West, it is a question worth considering. What, for example, did provincial English men and women make of the images they saw painted on the Chinese

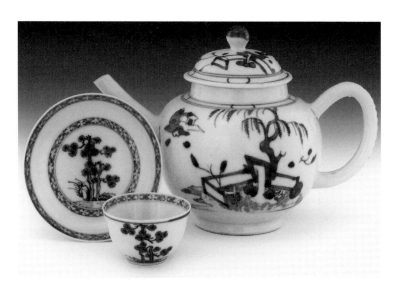

40] Chinese blue and
white imported porcelains.

porcelains? (Fig. 40). We know of the censorious sermons and lectures of men like Samuel Fawconer, who condemned 'Modern Luxury', and of John Brown, who regarded the 'publick Eye' in matters of 'Taste' to be 'generally depraved':

> Neither the comic Pencil, nor the serious Pen of our ingenious Countryman, have been able to keep alive the Taste of Nature, or of Beauty. The fantastic and grotesque have banished *both*. Every House of Fashion is now crowded with Porcelain Trees and Birds, Porcelain Men and Beasts, crosslegged Mandarins and Bramins, perpendicular Lines and stiff right Angles: Every gaudy *Chinese* Crudity, either in Colour, Form, Attitude, or Grouping, is adopted into fashionable Use, and become the Standard of Taste and Elegance.[2]

Consumer demand for East India merchandise and the European manufactured imitations of these goods confirms the strong attraction of the porcelains, wallpapers, furniture and fabrics, but there is little evidence of broad public opinion about them. In the commentaries which do exist, the frequent use of adjectives like 'fantastic', 'curious', 'grotesque' gives some indication of how people described these products both approvingly and pejoratively. However, it is not always possible to know whether or not an author is describing original Chinese or Japanese artefacts, or objects and interiors formed in the European chinoiserie styles, or a mixture of both. European chinoiseries were much more elaborate and crowded designs than the original Chinese, and bear little relationship to genuine Chinese artefacts. It was to rococo chinoiserie that John Brown referred when it was at the height of popularity in fashionable English homes.[3] Where chinoiserie can be clearly distinguished from original Chinese artefacts and export wares, adjectives like 'whimsical', 'capricious' and 'droll' often

appear, and (from the pens of satirists) 'mishapen', 'monstrous' and 'perverse'. Chinoiserie was enjoyed and then discarded when people became bored with it. It was an invented European genre which emerged as the West observed the East from a distance, understanding China as very different but not necessarily threatening, aggravating in its insularity but all the more exotic for its mysteries.[4]

Since the sixteenth century publications of West European voyages to the East had been in circulation; there was a considerable body of knowledge about China, which inspired respect for the people's astonishingly high craft skills and the sophisticated structure of Chinese government and its institutions. Images reached a limited European readership through publications like that of the Jesuit Athanasius Kircher (Fig. 41), and rare ambassadorial visits to the Imperial court like that of Jan Nieuhof (Fig. 42).[5] But there was little scholarly literature available to inform Western collectors, let alone a lay public who sought to purchase a few tea bowls, of the meaning of the emblematic images applied to the East India porcelains. It was extremely difficult for a searching cultural exchange to take place between China and the West. Foreigners were not permitted to move beyond Canton and relations between the Chinese authorities and Western merchants were heavily circumscribed by protocol and language barriers.[6] Not until the mid to late eighteenth century, and into the nineteenth century, did scholars undertake systematic studies of oriental cultures, and it became possible to interpret more accurately the images on porcelains, lacquer wares, furniture and silks.[7] The eight Buddhist and Taoist symbols, the Taoist Immortals, the Eight Precious Things, the Twelve Ornaments, the myths and tales from popular literature, the floral and animal emblems: all but a few of these meanings were inaccessible to most European consumers during the eighteenth century. The consequence in the West was an attempt to construct and manufacture an approximation of this little understood but fascinating culture which filled the domestic spaces of affluent consumers. Undistorted information about China was lacking, and in the absence of knowledge the chinoiserie style was a hybrid of first the baroque and then the rococo with an imagined Cathay. Chinoiserie became a domestic style, and one that was associated with the feminine. Publications like Jean Pillement's *A New Book of Chinese Ornaments* (1755), Darly's and Edwards's *A New Book of Chinese Designs* (1754) and Robert Sayer's *The Ladies Amusement, or the Whole Art of Japanning Made Easy* (1754) were the sources used by amateur japanners, but also liberally by skilled artisans and manufacturers for the production of furniture, ceramics, lacquerware, printed linens, cottons and wallpapers.

41] 'Chinese Woman with Bird', in Athanasius Kircher, *Antiquities of China*, etching and engraving, 1669.

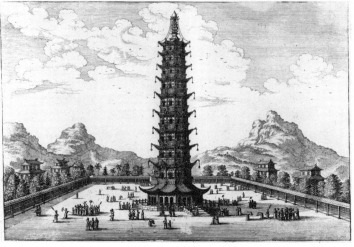

42] 'The Purceline Tower, Temple of Paolinx, Nanking', in Jan Nieuhof, *An Embassy of the East India Company*, engraving, 1669.

While cultural exchange between the East and the West was
very limited, and some might wish to argue that it was superficial
in its confinement to the so-called 'decorative arts', it was not
without significant consequences. The relationship was not trans-
formative, in the sense that the West or the East undertook major
revisions of their state institutions and social structures in the light
of new knowledge about each other. The respect in which China
was held by the European eighteenth-century intellectual elites
was later weakened by the West's fascination with its own achieve-
ments in science and engineering directed towards military and
industrial development.[8] However, at least some of the West's
social practices and cultural concepts, by which it formed an
understanding of what it meant to be 'civilised', were derived from
trade with the East. It amounted to more than simply adopting the
social practices of tea and coffee drinking. The entire fragile struc-
ture on which the East India trade was based relied on the tricky
diplomacy of West European agents engaging with another com-
plex, sophisticated and civilised culture.[9] Trade with the East from
the sixteenth to the eighteenth century was, if not transformative,
still a deeply significant experience, through which Europeans
learned about their position in the world and redefined their social
and cultural values.[10]

The influence of the East on European material culture is the
physical manifestation of this process. The artefacts imported from
India, China and Japan, and the European imitations of these
goods, were not simply tacked on to an existing framework of
indigenous products and enjoyed for their novelty and visual ap-
peal. They were successful and they were imitated successfully
because they had an integral role to play in the redefinition of
European social and cultural values. Once these goods entered
European material culture they had the effect of giving a physical
form to these values in conjunction with polite social practices like
drinking tea in the home and coffee in the coffee-house, where
much of the business of commerce was conducted. These material
artefacts transformed people's behaviour in ways which impinged
on their physical as well as their imaginative lives.[11] Because
encounters with these goods tended to be pleasurable, they also
had the effect of making it worthwhile to adopt and practice
values which greatly contributed to a sense of social cohesion. As
a twentieth-century social theorist has put it: 'Taste is what brings
together things and people that go together'.[12]

Imitation in one material of other artefacts of its kind, or of those
made in a different material, was not disparaged in the eighteenth
century. Artifice in achieving an acceptable or indistinguishable
equivalent, usually to objects or materials held in high value, was

perceived as admirable and desirable, although there is an important distinction to be made between imitation in the 'liberal' arts of painting and poetry and in the 'mechanic' arts of pottery or metalworking, for example. In the former, imitation was the subject of debate as an intellectual problem, in the latter it was only considered in terms of the techniques required to imitate successfully another artefact or a material quality.[13] However, imitation in the 'mechanic' arts was a complex cultural process; by imitating Chinese porcelains, the Dutch Delftware potters were introducing novel artefacts to a much wider community through a European earthenware technology.[14] The Dutch Delftwares in imitation of Jingdezhen porcelains were in turn imitated by tin-glaze potters across north-west Europe. According to an announcement in the Liverpool *Post Boy* of 23 May 1710:

> The Corporation of LIVERPOOL in Lancashire have encouraged there a manufactory of all sorts of fine, white and painted pots and other vessels and Tiles in imitation of China, both for inland and outland trade, which will be speedily ready and sold at reasonable rates.[15]

This was the Lord Street Pottery established by Richard Holt from London, and the mention of 'Tiles' indicates the confusion as to what was being imitated and the loose application of the term 'China'. The reference to tiles, which were not produced by the Chinese for export to the West, suggests that Holt's influence came from London delftware production, which had developed from the Dutch Delftwares rather than from the Jingdezhen porcelains. Liverpool delftwares were also modelled on those of Bristol, where production had begun in the latter half of the seventeenth century. In the process of imitating, very different and distant cultural forms were introduced to the West, but at the same time transformed. By the time 'Willow' pattern was established in the nineteenth century it was felt to be very English in a Chinese sort of way. Not only that: the conventions of owning and displaying blue and white pottery reached deep into European ceramic custom in the nineteenth century.

Taxonomies

The wider development of fine ceramic production in eighteenth-century Europe occurred, as we have seen, in response to consumer demand for the imported East India porcelains. Long-distance trade brought much more to the West than East India commodities. It opened up new land masses for exploration, encouraging development of a systematic method of recording and classifying the peoples, animals, plants and minerals to which European travellers

were exposed, and which they sought to expose further through expeditions of discovery.

The desire to classify was applied not only in these distant new worlds but in much more localised European contexts. It was a practice in some of the European courts to make images and arte-facts which represented the occupations and social positions of the subject peoples of a state. The Saxon Elector August II, and his son August III, who succeeded his father in 1733, supported the long-established tradition of ivory carving in the Dresden court workshops. The skills of the ivory figure sculptors were applied to form a collection which was a visual record of the peoples of Saxony. In the 1730s, when the Dresden court sculptors had got to grips with the technical difficulties of firing porcelain figures, part of their work included the production of small-scale sculptures depicting the labouring poor, the artisans and professionals of the Saxon state.[16] These porcelain figures replaced sugar sculpture on the tables at court festivities, but their purpose was not simply ornamental. In a society where people were acutely conscious of their social position, and where the hierarchy was rigid in com-parison to Britain, these depictions personified the subject peoples of the state and reinforced social distinctions. Figures of the des-titute were included in this scheme of things, very often modelled on engravings which circulated in European court culture during the seventeenth and eighteenth centuries (Figs 43 and 44). One of

43] Figure of a beggar, after Jacques Callot (Paul Heerman?), Dresden, c. 1725; ivory, silver gilt, diamonds, rubies and emeralds, 14 cm high.

44] Johann Gottlieb Kirchner, *Beggar Woman Carrying a Child, and Man Begging for Alms*, 1733, 12.4 cm and 13.5 cm high.

the main sources from which many of these figures were derived were the *Hauptstände*, books which explained the social structure of the state, and the responsibilities of the ruling elite, and tabulated with the support of engraved plates the professions and artisanal trades of the people.[17] The ivory and porcelain figures also gratified the princely passion for collecting, but a form of collecting in which information about the world outside the court was gathered and represented through the making of images. However, in the context of the court this function was not always distinguishable from spectacle.

The Saxon court menagerie illustrates vividly the conflation of spectacle with the passion for collecting. In 1734 the court raconteur Charles Louis Baron von Pöllnitz visited Dresden and judged the city among the most beautiful in the world. He was greatly impressed by the porcelain collections in what was then known as the Palais des Indes or the Hollande, later named the Japanese Palace, in which 'All the rooms of this Palace, which is of three floors, are so many Japanese and Chinese Porcelain Cabinets. I do not think that together all the shops of Amsterdam could supply so many Porcelains of such rarity and age.'[18] On stepping into the gardens of the palace he found himself surrounded by marble statues purchased from the collections of the Cardinals Annibal and Alexandre Albani in Rome. But in this well-built, paved and well-lit city, and not far from the palace, Pöllnitz came across another reminder of Rome. Built in wood against the Jagdschloß, or Hunting Lodge, was the amphitheatre or arena in which battles among 'savage beasts' were fought out, 'of which there were a very great number. One sees Lions, Tigers, Bears, in a word, all the ferocious animals from the four Corners of the World are to be found here.'[19] The Dresden court employed and patronised some of the most advanced scientific minds in Europe, and some of the most skilled and imaginative transformers of raw materials into art objects, yet there was a strong whiff of barbarity, and a tension between the refined and the raw was present in many of the the eighteenth-century court spectacles.

The wild creatures kept in the menagerie were the subjects of an ambitious project begun in the late 1720s, in which the Meissen modellers produced porcelain sculptures of the animals intended for display in the Japanese Palace (see Fig. 1). Where the material would tolerate it, some of these animal 'portraits' were life-size, others had to be considerably reduced; and in the absence of a rhinoceros, for example, engravings were all that could be relied upon. Work of this nature was not taxonomy in practice, but it bore some relationship to that purpose as well as contributing to spectacle. It was yet another extension of the princely passion for

collecting, annotating and recording in 'petrified' form what was in the Electoral possessions.[20]

These creatures were of course caught in the wild and shipped to Europe as part of a growing trade in exotic species. What Meissen began in the production of animal figures became a particular feature of luxury porcelain production, especially in the marketing of brilliantly coloured versions of exotic birds and anthropomorphised simians. It was these species of tropical birds and monkeys which in the seventeenth century had become the exotic pets of the European *haute monde*. The monkey was especially exotic, and erotic:

> Kiss mee, thou curious Miniature Man;
> How odde thou art? How pritty? How Japan?[21]

In the eighteenth century the elephant, the rhinoceros and the giraffe attracted large numbers of spectators in the increasing number of commercial shows which based their success on curiosity value, but which often inadvertently brought people into contact with natural history. These animals were traded principally from Africa, a continent most difficult to grasp comfortably in the European imagination (Fig. 45). In Jan van Kessel's representation of 'Africa', one of four painted panels of the world's continents, many of the artefacts depicted originated elsewhere. Van Kessel's compositions of the continents bear a strong relationship to the 'cabinets of curiosities', but they also represent the patterns of world trade in the mid-seventeenth century. In his representation of 'Africa' the porcelains had their origins in China; the glassware probably in Venice; the baskets in the left-hand side of the painting came from Japan; the tobacco and opium pipes probably from England and North America; the nautilus shell on the right-hand side of the painting behind 'Cleopatra' may have been fished out of the Indian Ocean, but here it has been transformed by European goldsmiths; the rug the goblet stands on is of Asian origin. The inaccuracies of this work are not important here; the value of van Kessel's vision of Africa lies in what it can tell us about the nature of trade and the lack of knowledge about Africa. Surrounding this central panel are sixteen smaller paintings representing the animals of Africa in their imagined habitat; most of the regions represented refer to the dimly perceived interior and the coastal ports, out of which these exotic animals were traded after their capture by Africans themselves (Fig. 46). The artefacts represented in the centre panel, especially the tobacco pipes, shells and coral, were commonly included in the cargoes of English ships which traded these commodities for human slaves and animals.

In 1738, when Captain Henry Flower returned from Angola in

45] Jan van Kessel, *Afrika*, centrepiece of *Le Temple des Idoles*, oil on copper, 1666.

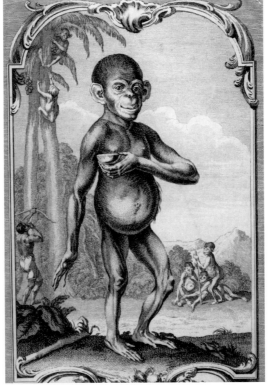

46] After Hubert François (Bourguignon) Gravelot, *Chimpanzee holding a Tea Bowl*, engraving, 1738.

the ship *Speaker*, he brought with him the chimpanzee 'of the Female Kind' illustrated in Figure 46. Not surprisingly she died in the year following her arrival in London, but attracted considerable curiosity while she survived London life. After her death someone wrote a satirical piece, an *Essay Towards the Character of the Late Chimpanzee*, in which the animal presented an opportunity to dissect and deplore the 'feminine' characteristics of the time: 'Though as may be suppos'd, she drank a considerable Quantity of Tea in a Week, she was never heard to utter one Word of Slander; – she never invented a Lie, or improv'd one. – To all Stories of that kind, she was ever deaf; nor once express'd a Desire to be acquainted with other People's Affairs.'[22]

Her liking for tea was a feature of considerable curiosity, to which the engraving testifies. Not until looking at the events depicted in the background of the image does the violence of her capture become clear. An exotic creature out of Africa with unavoidably 'human' characteristics, enjoying the polite social practice of tea drinking, represented an extraordinary collision between two worlds. The anonymous author of the *Essay* assumes her to be of human origin, 'of a Gentleman's Family', and extols her 'civilised' characteristics and virtues. In doing so he or she uses this collision in order to attack the values and practices of a 'polite' society – a society which could afford the luxury of being 'polite' only on the back of a commercial trade which had much brutality about it, and which was soon to cause the modern thinkers of the late eighteenth-century culture of sensibility to protest against the slave trade. However, there are other conclusions to be drawn from an image and a text of this kind which bear relation to the wider intellectual enquiry into natural history and human nature. It was increasingly believed that to compare humans with animals, and especially creatures which bore unmistakable resemblances to humans, was to gain knowledge and understanding about humankind itself. Where did a chimpanzee stand relative to the human species? These were the sorts of questions that naturalists were asking. In the mid-eighteenth century Georges-Louis Leclerc was concerned with inherited characteristics and sought possible links between environmental conditions and the *de*generation of a species. It was his belief that dark-skinned peoples long exposed to the ravages of hot climates had become degenerate from the 'European type' which, in Leclerc's view, represented a perfect specimen of humankind.[23] In the *Essay* the chimpanzee receives a fictional offer of marriage from a 'money-grabbing Jew', through which the author refers to contemporary notions of who or what represented degeneracy in mid-eighteenth-century London. A different perspective in intellectual

debates, however, was represented through a growing interest in the positive aspects of the 'savage state' of man, and a sense that 'civilising' influences were inclined to corrupt the instinctive nature of the human species, and instinct was one faculty that humans shared with the animals.[24] The *Essay on the Character of the Late Chimpanzee* may be considered trivial, but in fact it discloses a great deal about mid-eighteenth-century social and cultural attitudes. The *Essay* plays with what were believed to be the essential differences between humans and animals: the ability of humankind to reason, to exercise a moral sense, and to derive pleasure from the imagination, from intellectual curiosity and aesthetic experience, in other words a cultured society. The author suggests that even these elevated human faculties had been debased or distorted in the pursuit of 'civilised' living where social ambition and material wealth took precedence.

The expansion of overseas trade and the impetus this gave to scientific exploration encouraged the production of illustrated books and print portfolios which represented both the new discoveries of flora and fauna on other continents, and the systematic recording of native European species (Fig. 47). Botanical illustrations, especially the more decorative florilegia, were the sources used for the reproduction of floral imagery on porcelains, faience and creamwares throughout the century, and in fact encouraged the extension of painting skills which had to be worked up to meet the demand for products enhanced by colour and image. In fine ceramic production hand-painted floral motifs tapped into fields of knowledge and taxonomic practices currently developing through the exploration and observation of the botanist. Enamel flower painting on porcelain and on the finer faience wares was also related to the still admired seventeenth-century Dutch flower paintings; they represent a further development in the commodification of the natural world which began with the floral subjects painted in the Netherlands. Hand skills of a high order were required to 'remake' the living specimen.[25] In 1730–32 Robert Furber published the first seed catalogue in England called *The Twelve Months of Flowers*. It contained twelve hand-coloured engravings after the Flemish painter Peter Casteels, who specialised in flower subjects (Fig. 48). The first edition was of very fine quality and the list of subscribers included many members of the nobility. Subsequent editions titled *The Flower Garden Displayed* were less sumptuous, crudely hand-coloured or left entirely uncoloured, but thereby reaching a wider public. In these cheaper editions the prints were recommended for their uses beyond those of horticulture for 'Painters, Carvers, Japaners, etc., also for the Ladies, as Patterns for working, and Painting in Water-Colours; or Furniture

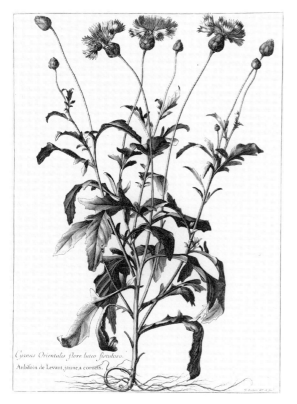

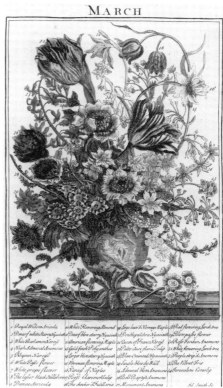

47] Nicolas Robert, 'Cyanus Orientalis', *Recueil des Plantes*, Vol. 1, engraving, 1700.

48] R. Furber, *Twelve Months of Flowers*, 'March', hand-coloured engraving, 1730.

for the Closet'.[26] People absorbed images of flowers which were not yet widely available; exotic plants in particular were expensive, difficult to cultivate, and not in bloom for long. Flora were valued and admired because in the eighteenth century the natural world was still in the process of being opened up to the European imagination, and to people's visual and olfactory sensibilities on a scale hitherto unknown to all but the social elites. It was possible not only to admire the beauty of hand-painted flowers on the surface of a plate, but often the wings of a butterfly or the intricacies of a beetle – creatures which were not easy to observe unless one could command the time and equipment required for such interests. Fine white vessels were one of the many surfaces on which these images could be made accessible and marketable; although producing an elite product, the court porcelain manufactories sought wider markets than their own social level and influenced the production of cheaper versions. The incorporation of these images onto ceramic vessels, wallpaper, printed textiles and embroidery formed a 'domestic' tributary in the processes of classification associated with the production of 'scientific knowledge'.[27]

The influence of oriental floral designs on European culture was of long standing, but generally confined to the material culture of

the social elites. In the late seventeenth and early eighteenth cen-
turies this situation started to change. In spite of protectionist
legislation intended to prevent Indian imported cottons from da-
maging the home textile industry, consumers were not to be put
off, and manufacturers set about imitating the rich visual sources
from the East for a greatly enlarged market.[28] The printed linens
and cottons developed from the painted and embroidered textiles
imported from India and China made a considerable impact on
the upholstered comfort of middle-class households, and through
a well-established trade in second-hand clothing on people's 'wear-
ing apparel' across the classes.[29] Although very expensive in their
imported painted form, wallpapers also became accessible later in
the century through a similar route, in which Western print tech-
nology made the product cheap enough for middle-class
consumers.

Later in the eighteenth century the still popular oriental motifs
were joined by designs which incorporated flora indigenous to
Europe. The Meissen Manufactory produced two lines in floral
motifs, the 'Indianische Blumen', or 'Indian Flowers' in imitation
of the Asian imported porcelains, and the 'Deutsche Blumen',
which represented the flora of the German regions (Fig. 49). The
latter, especially when produced by the Thuringian manufactories
for a middle-class market, were atttractive because they referred to
people's sense of locality and German identity. A similar pattern
occurred in printed textile production where fabrics printed with
designs based on botanic prints of native flowers appealed to con-
sumers for their natural and informal qualities (Fig. 50).

Amateur interest in botany was encouraged and sanctioned by
the Swedish naturalist Carl Linnaeus. He published botanical hand-
books which he believed were accessible to any member of the
literate population, 'even for Women themselves'.[30] In the second
half of the century numerous publications became available in the
form of botanic dictionaries as well as gardening books, some with
hand-coloured engraved plates, which were influenced by the work
of Linnaeus. The interest in botany and its increasing accessibility
as a subject of study coincided with the late eighteenth-century
'cultivation' of sensibility. Flowers were endowed with emblematic
meanings expressive of the heightened preoccupation with feelings
and the ability to empathise with the emotional condition of
others; a 'language of flowers' emerged which became a popular
form of sentimental communication in the nineteenth century.
Although in his publications Linnaeus wrote his botanical system
with the clear intention of avoiding any kind of overblown or
emotional use of language, other writers did not always follow his
example. In volume two of his *The Botanic Garden*, Erasmus Darwin

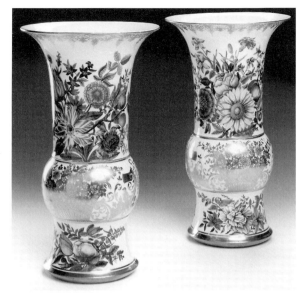

49] Meissen, *Two vases
with German flowers*,
enamel painted and
gilded, c. 1740–45.

50] Printed, lightly
glazed cotton, eighteenth
century.

explains the Linnaean system for a lay readership before launching
into the suggestive verse 'The Loves of the Plants':

> ... where Derwent rolls his dusky floods
> Through vaulted mountains, and a night of woods,
> The Nymph *Gossypia*, treads the velvet sod,
> And warms with rosy smiles the watery God.

And where the goddess at the shrine of Hygeia:

> Piles the dry cedar round her silver urn ...
> ... Culls the green herb of China's envy'd bowers,
> In gaudy cups the steamy treasure pours;
> And, sweetly-smiling, on her bended knee
> Presents the fragrant quintessence of Tea.[31]

Although this hyperbole was expressly what Linnaeus sought to
avoid, Darwin wrote *The Botanic Garden* at a time when England
was experiencing industrial revolution, and when among a
minority of educated men sexuality was openly discussed and
liberal ideas put into practice.[32] Whereas Silas Neville observed the
evidence of industry's encroachment on the countryside with dis-
taste, Darwin sincerely, if somewhat weightily, celebrated
modernity. In describing the achievements of technology he at-
tempted to draw parallels with the attributes of the sublime in the
Vale of Derwent, and with classical antiquity in a sacrificial brew
of tea. Consumers demanded that their upholstered interiors and
clothed bodies be covered with floral designs, and increasingly
towards the end of the century with a material culture which
referred backwards in time to the ancient world. While accepting

the benefits of modernity in material culture, the educated middle classes were signalling their desire to obscure its effects in their imaginations.[33]

Fascination with the natural world was chiefly sought through the study of botany and zoology because they were more accessible. Minerology presented more of a challenge as an amateur pursuit. It required sophisticated equipment for laboratory analysis, travel to remote geological sites where interesting mineral deposits were exposed and where the strata could be observed, but it was above all a complex and confusing subject to grasp. Although not as advanced and institutionalised a discipline as in the German States, France and Sweden, lithology was gaining in importance as a specialist field of study in Britain, and one of considerable importance because it contributed to the understanding of the earth's history.[34] In the late eighteenth century increasing numbers of enthusiasts collected mineral specimens for their curiosity value, rarity or aesthetic appeal.[35] With the development of tourist travel, geological marvels like the basalt columns of the Giant's Causeway and their counterparts on Staffa further encouraged the association of mineral matter with awesome natural events. At the same time the great projects for the building of canals and improvement of the roads, for the development of coal mining and quarrying, required men with sound knowledge of geology.[36] In 1778 William Pryce's *Minerologia Cornubiensis* was published, which was a sort of dictionary or compendium of the minerals and metals found in Cornwall, one of the oldest and most diverse mining regions in Britain. Such knowledge, generally accessible to an educated reader with a professional, speculative or amateur interest in mining and metallurgy, was also reaching publications like *The Gentleman's Magazine*. Fossils and petrifactions, shells, organic and inorganic matter enlarged under the microscope or magnifying glass, were all subjects of interest and were engraved and illustrated for publication.[37] If there was not opportunity to collect the real thing, then prints could provide an acceptable substitute.

One aim the minerologists shared with the botanists and zoologists was a taxonomic one, to classify and describe minerals according to their 'species'. It was clear that broad distinctions could be drawn between the sedimentary formations and the crystalline rocks, between rocks containing fossils and those without.[38] But if this was to be taken further, samples of these rocks had to be broken apart and their interior structures analysed. From this the 'species' of rock could be established, and, even more finely, its type within a group sharing similar characteristics could be determined.[39] A small salt-glazed teapot of the 1760s was painted in

51] White salt-glazed stoneware teapot, enamel painted in imitation of 'encrinile' limestone, Staffordshire, c. 1760, 9.2 cm high.

enamels to imitate a fossil-bearing limestone (Fig. 51). This type of 'encrinitic' limestone was found in Derbyshire and when carved and polished was used for ornamental purposes.[40] The design painted on the teapot was probably derived from such an ornament or from a sample of the stone cut and polished to reveal its interior structure. Examples of this kind are not common, but entrepreneurs in the pottery industry, and in other manufactures dependent on the availability of minerals, were prospecting for deposits in Staffordshire and the nearby limestone county of Derbyshire; they were aware of the properties of minerals and were open to exploiting the aesthetic quality of natural materials for commercial purposes. Manufacturers also produced wares in which the crystalline quality of granite was imitated, using tiny fragments of coloured clays to resemble quite closely the rock surface. The basalt ware carried resonances of volcanic origins, although in fact it was one of the cheaper and more stable of these dry-bodied wares to produce. With Vesuvius in active mode during the latter half of the eighteenth century, interest in vulcanology could be combined with that of antiquarianism on the sites of Herculaneum and Pompeii.[41] For the many who could not travel such distances there were prints to buy and basalt wares were produced in several manufactories. Interests could be pursued and imaginations stretched vicariously.

Natural history, unlike other branches of scientific enquiry, was accessible to people who did not possess specialist knowledge. It excited immense curiosity and its various branches could attract people principally for aesthetic reasons rather than for serious purposes of study. This was especially the case with subjects like botany or conchology, and the late eighteenth century was the beginning of what became a nineteenth-century middle-class

passion for collecting and making things out of the fruits of country walks, travels to the coast and to inland beauty spots, all so much more accessible as the railway network expanded.[42] It was in the last years of the eighteenth century that the beginnings of natural history as an amateur pursuit for 'ladies' got under way, and ceramic manufacturers produced blank white wares especially suited for the enamel painting of floral motifs. Natural history could be commodified in ways that the other sciences could not.

Emblems

There were many prints and pattern books in publication during the eighteenth century which contained designs for the specific and general use of furniture makers, goldsmiths, silversmiths, and for interior ornament required by architects, painters and stucco workers. For the manufacturers of fine ceramics these designs were of limited use, because when transposed into three-dimensional form they did not provide suitable models for ceramic production. A notable exception to this occurred late in the century when Josiah Wedgwood based many of his vases on the designs, for example, of Stefano della Bella and Jaques Stella. Designs from pattern books could be reproduced relatively faithfully in the production of two-dimensional motifs on textiles and wallpapers, and for ornamental purposes on ceramics, but they were essentially useful in stimulating imaginative possibilities in the making of three-dimensional things. They were starting points from which artists and artisans worked, and not infrequently the designs presented them with considerable challenges.[43] In the manufacture of fine ceramics ideas were most probably derived, and techniques developed, from direct observation of ceramic or metal models, and subsequent trial and error in the actual making and modifying of a piece.[44] It is known that Sir Charles Hanbury-Williams permitted the Chelsea Manufactory to copy from Meissen pieces in his collection. It simply was not possible to obtain sufficient information, about the production of a complex figure group for example, from a subject depicted in a two-dimensional drawing or engraving.[45]

The ancient stock of emblematic motifs had long been incorporated into many ceramic artefacts, especially the Spanish, Italian and French maiolica wares of the medieval and Renaissance periods, but also the English seventeenth-century slipwares, the German stonewares, and many other traditional pottery forms which did not necessarily serve an elite community. As a visual device emblems formed a source of ornamentation common to the applied arts which were reproduced in artisan and court

workshops through traditional practices, and often derived from pattern books. Emblems were useful as visual signifiers of meaning. Frequently they identified the attributes and functions of an institution like a guild, or a business, or reinforced allegiances to a community which could be generally, or sometimes only secretly, understood. Emblematic sources differed from those pattern books designed to extend the imaginative skills of an artisan or artist, and to encourage a break with tradition by stretching technique and formal expression to its limits. The emblem was an ancient form of signification and often the mark of conservative forces which sought to foster solidarity within secular and religious contexts, especially where the meaning of an emblem could be understood by the illiterate.

However, the emblem was subject to transformation in the Renaissance, a transformation which departed from what was generally understood to be the visual vocabulary of ornament used in the production of handmade artefacts and buildings. In the sixteenth century the new branch of arcane emblematics attributed to the Italian lawyer Andrea Alciato was at first a written form of textual communication to which images were later added. Until vernacular translations became available in the seventeenth century the emblem book required knowledge of Greek and Latin, and was therefore an elite product. Even in the vernacular an emblem book was expensive and accessible only to the literate. The function of the emblematic image was to make a concept visible; they were devices for assisting moral or divine contemplation and understanding.[46]

In the late seventeenth and eighteenth centuries the emblem book was especially subject to criticism in England for its association with an old order redolent of an oppressive elite culture, of Catholic mysticism, and of obscure attachments to outmoded alchemical and astrological practices and beliefs.[47] It did not appeal to the new cultural elite of English polite society which preferred at least to aim for an open and transparent intellectual exchange.[48] The emblematic device stubbornly refused to disappear completely however. Emblems had long circulated at a level of popular and folk signification and they continued to reach a very wide public through the chapbooks, almanacs and broadsheets, especially as a visual aid to fables and moral tales; for example woodcuts depicting the 'World Turned Upside Down' feature characteristics in their composition similar to the elite emblem form, but adapted and reproduced in the popular chapbooks.[49] While the cryptic and enigmatic forms of visual and literary engagement in the elite emblem book receded, the emblematic device became an extremely effective weapon in another sphere, that of political

satire.[50] The emblem was not displaced, but its form was re-appropriated and the arcane associations of the Renaissance gave way to the clear reason and merciless satiric insight of the Enlightenment.[51]

The uses of the emblem in European culture were complex, but through various routes these initially recondite images were transformed into desirable commodities. Originating in the elite form of the emblem book, an example of the type of transformation which occurred can be found in Otto van Veen's *Emblemes of Love*, published in Antwerp in 1608 with verses in Latin, English and Italian. Many of these secular, rather than divine, emblems were absorbed into proverbs and mottoes; a bear 'licking into shape' the formless body of her new born cub for example. Some were applied in porcelain figure subjects, and particularly the much-imitated *Devisenkinder*, or 'Motto Children', modelled by Michel Victor Acier at the Meissen Manufactory between 1775 and 1778. Otto van Veen's emblem, 'Union is Love's Wish', was one example among several figure subjects which were later reinterpreted by the Meissen Manufactory under the motto, *Ich vereinige sie*, 'I unite you' (Fig. 52).[52] The ancient lineage of the secular *Amor* can be verified through Alciato's derivation of the emblematic activities of Cupid from *The Greek Anthology*, and this classical pedigree was used to confer a degree of respectablility on these and other salacious subjects.[53] The allegory, which in many personifications was a close relative of the emblem, became a much used source for subjects reinterpreted in fine ceramics, because it was easier to commodify; for example typical subjects included the Four

52] Otto van Veen, 'Union is Love's Wish', *Amorum Emblemata*, engraving, 1608.

 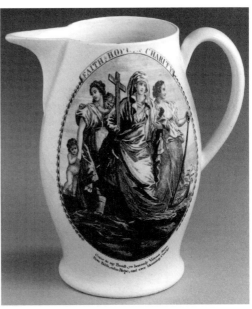

53, 54] Creamware jug, *Religion*, black transfer print, and the reverse, *Faith, Hope and Charity*, Liverpool, late eighteenth or early nineteenth century.

Elements, the Four Seasons, the Five Senses. In the late eighteenth century, when in England polite society placed high value on the cultivation of sensibility, these allegorical forms were rejected as no longer in the best 'Taste'. But the emblematic personification found further applications as the production of transfer-printed ceramics increased; these wares found favour with the middle-class consumers of urban manufacturing and rural farming communities, less well educated and less affluent than the professional middle class, and essentially not concerned with the finer principles of good taste. The popular subjects from the print shops were applied to thousand of mugs, jugs, teapots and bowls, reinforcing contemporary moral and pious religious concerns through emblematic personifications. In many respects this was a return to the earlier conservative function of the emblem, and the number of examples which remain of this type of product indicate that consumer demand was substantial (Figs 53 and 54). At the same time there was a vigorous branch of delftware and creamware production on which contemporary satirical prints were reproduced, either in painted or transfer-printed form. These products appealed particularly to a male fraternity of consumers who had reason to view the patriciate with a critical eye, and who sought to free themselves as far as possible from dependence on the ruling class for their livelihood. Emblematic devices were picked up by pottery manufacturers in response to the demand for commemorative wares, most noticeably in the production of items for fraternities like Freemasonry, but also for the growing number of clubs and societies through which the middle-class businessman,

artisan and tradesman, as well as the disaffected squires and Whig opponents among the landowning classes, sought solidarity and support.[54]

Emblems are constantly re-formed and new ones made. The novel commodities which entered people's lives from the East in the seventeenth century were rapidly formed into emblematic signifiers, and the 'china jar' is one example. In the moral imagination the 'china jar' was conflated with luxury in its most negative form, and in the imagination of the playwright William Wycherley and the poet John Gay with male and female desire. One of the most vivid and complex critiques of the new world of exotic and luxury goods came from Alexander Pope. In *The Rape of the Lock* the brittleness of 'China Vessels' formed a metaphor for ravaged virtue at the moment when Belinda's lock of hair is cut by her suitor:

> Then flash'd the living Lightning from her Eyes,
> And Screams of Horror rend th' affrighted Skies.
> Not louder Shrieks to pitying Heav'n are cast,
> When Husbands or when Lap-Dogs breathe their last,
> Or when rich *China* Vessels, fal'n from high,
> In glittring Dust and painted Fragments lie![55]

The trivial and the momentous, implied in Pope's title for the poem, are in constant tension. The five cantos trawl through a catalogue of commodities which at times, like John Gay's verse *To a Lady on her Passion for Old China*, become indistinguishable from the human subjects of this mock-heroic epic. In the 'gloomy Cave of *Spleen*' where Belinda retires to sulk at the loss of her lock:

> Unumbered Throngs on ev'ry side are seen
> Of Bodies chang'd to various Forms by *Spleen*.
> Here living *Teapots* stand, one Arm held out,
> One bent; the Handle this, and that the Spout:
> A Pipkin there like *Homer's Tripod* walks;
> Here sighs a Jar, and there a Goose-pye talks;[56]

Pope's creative imagination caught hold of the dilemma commerce brought to early eighteenth-century England: the problem of reconciling imperialist expansion with the commodification of English culture it brought in its wake, a *materialistic* culture which threatened to spoil and falsify the Augustan ideal. Pope was acutely aware of the contradictions in early eighteenth-century English society, but at the same time he admired and wished to support the interests of the aristocracy and landowning class. Although his family were in trade, like so many of his contemporaries of the 'middle Station', his inclination was to support an ideological framework in which the elites jealously guarded their privileges.

In *The Rape of the Lock* there is also an implicit recognition that privilege and wealth were founded and maintained through the violence of imperialist expansion, a fact which is also clearly, if not intentionally, represented in the engraving of the chimpanzee holding a tea bowl (see Fig. 46).[57]

If the shattered china vessels represented Belinda's ravaged virtue in *The Rape of the Lock*, the common emblem of the broken vase or cracked mirror symbolised, in middle-class genre paintings and prints, the consequences of loss of virginity before marriage, or worse, a pregnancy out of wedlock. In the popular culture of the people, the broken jug represented these social calamities, but usually with greater humour. Quite unlike the supple verse of Alexander Pope, a typical piece of doggerel accompanied a print entitled 'Mis Conduct', depicting a dejected beauty contemplating the shattered classical vase at her feet:

> Hapless Celia, witless Maid,
> By Fond credulity betray'd,
> Behold thy favorite Vase in pieces,
> Its size diminish'd, thine increases.[58]

Personifications

Edmund Burke believed 'the mind of man possesses a sort of creative power of its own', and this power was imagination.[59] Many theoretical treatises on Taste considered the imagination to be an essential faculty in the development of a refined and delicate sensibility capable of exercising sound judgement over things. Those writers who sought to defend luxury consumption argued that the proliferation of goods which were capable of carrying visual stimuli were valuable simply for the richer and very different world they presented to the imagination. Experiencing difference can be a cause of fear; the imagination can certainly conjure up pain as well as pleasure when working with material that may disturb certainties and familiarities. In the eighteenth century European peoples were not strangers to difference, but their changing economic and social lives made them more sharply aware of differences between themselves, and of the fact that in remote places there were others very different. Many of the luxury products and forms of entertainment popular in the eighteenth century reveal the mechanisms by which people sought to explore and reconcile differences, and suggest that they did so in ways which caused them pleasure rather than pain.[60]

Personifications derived from the emblem books, and from publications like Cesare Ripa's *Iconologia*, of which an English translation appeared in 1709, were exploited in the masquerade.

Derived from the court masque, it became an extremely successful commercial entertainment during the eighteenth century. In London the masquerade was organised by entrepreneurs like Count Heidegger in the Haymarket during the 1720s and 1730s, and later by Mrs Cornelys at Carlisle House.[61] Tickets had to be purchased, and attempts were made to keep the lower orders outside these events. At Vauxhall Gardens Jonathan Tyers attempted to keep 'the "inferior" sort' out of a public space intended for 'Persons of Quality, Ladies, Gentlemen, and others, who should honour him with their Company'.[62] Masquerades also became a popular if expensive form of entertainment in private company. To host a masquerade became *de rigueur* in fashionable society. In Fanny Burney's novel *Cecilia*, published in 1782, a guest personifying Hope at a private masquerade becomes the subject of discussion:

> 'Pray look, said the white domino, as they entered another apartment, 'at that figure of Hope; is there any in the room half so expressive of despondency?'
> 'The reason, however,' answered the school-master, 'is obvious; that light and beautiful silver anchor upon which she reclines, presents an occasion irresistible for an attitude of elegant dejection ...'
> 'But why,' said Cecilia, 'should she assume the character of *Hope*? Could she not have been equally dejected, and equally elegant as Niobe, or some tragedy Queen?'[63]

Cecilia's quick intelligence makes her critical of the paucity of imaginative masques in evidence. As the novelty wore thin late in the century there was an increasing predictability in these events. However, in the masquerades pleasure was derived from visual teasing and display of the self in relative anonymity. Within the 'luxurious proliferation of its forms' the masquerade held 'intense symbolic meaning' for eighteenth-century society.[64] Personification could allow for behavioural transgressions; disguise could offer exceptional freedoms at least for a few hours, and especially for women. The personifications commonly seen at a masquerade were reproduced in figure groups and painted subjects, chiefly in porcelain production, but also occasionally in cheaper earthenware versions by some of the Staffordshire enterprises like those of the Wood family. Subjects like the Virtues, Faith, Hope and Charity, Time clipping Cupid's wing, Prudence and Discretion, were produced in figure groups by the Chelsea and Derby manufactories. Popular subjects which were frequently found in the masquerade and in ceramic figure groups included personifications from Ovid's *Metamorphoses*, most of which referred to erotic encounters, for the masquerade was above all an erotically and exotically charged event. People took on the personification of the exotic 'other': the Chinese, the Persian, the Moor, the American

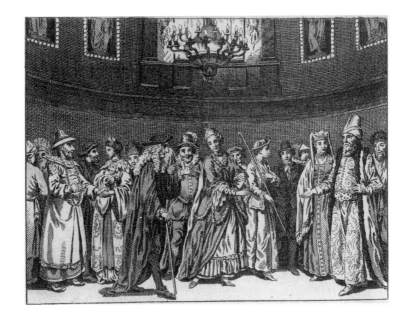

55] Grignon after Wale, *A Masquerade at the Pantheon*, etching, 1772.

Indian were popular disguises, many of which were derived from the new publications illustrating the peoples of the world, another form of taxonomic engagement which unfolded with the exploration of the continents (Fig. 55) The erotic and the exotic in the masquerade were a constant source of fascination or horror, depending on a person's point of view, and it was the target of much bitter moral invective. An attack on the masquerade was taken up in the *Essay Towards the Character of the Late Chimpanzee*. 'Masquerades she abominated: She could not think it consistent with the Dignity of an Human Creature to act under a Mask: she was so averse to such Behaviour, and had so little to be asham'd of, that it is well known she behav'd with all the Openness and Frankness imaginable, and was an utter Stranger to Concealments of any kind'.[65]

Masquerades were predominantly urban events, and the popularity of the rural idyll personified in the shepherds and shepherdesses was derived from the older form of court masque. Among the aristocracy and the educated elites of the late sixteenth century, particularly in France, was the desire to reproduce this imagined idyllic life of the rural peasantry. It was a theme which reached a long way back to the classical mythologies of the ancient world, and it lasted well into the eighteenth century, most notoriously as a form of court entertainment. Nevertheless, there are complex issues behind this social and cultural preoccupation which belie the cliché of the 'Dresden Shepherdess' and aristocratic pretences at dairying. Court life could be oppressive for those compelled to spend most of their time in this intricate and ponderous

web of ritual. For most of the time the court operated in an urban context, and it was a competitive society in which people constantly had to watch themselves and others. It was necessary to suppress the self in order to synchronise with the shifts in precedence and mark the important differences in court hierarchies: 'One *must* wear certain materials and certain shoes. One *must* move in certain ways characteristic of people belonging to court society. Even smiling is shaped by custom.'[66]

Traditionally, the nobility of the sixteenth and seventeenth centuries who were in attendance at court had been brought up on country estates. Confined in adulthood to this rigorous urban routine, from which there was no escape if a person wanted to hold on to privileges and a position of power in the upper levels of society, the 'nostalgia for a lost rural and "natural" homeland, the antithesis of urban court life', became a compelling fantasy.[67] The pastoral also formed a prototype for the urban middle-class construction of the rural idyll, hence the enduring appeal of the 'Dresden Shepherdess' and her rustic companions.[68]

The court pastoral was a romantic form and the characters in Honore d'Urfé's seventeenth-century novel *L'Astrée*, reputedly based on members of the French court, continued well into the eighteenth century as subjects suitable for depiction in the elite

56] The shepherd Céladon, believing his love is unrequited, throws himself into the floods of the river Lignon, from Honoré d' Urfé's *L'Astrée*, Nevers, cobalt blue pigment on tin-glaze, seventeenth century.

porcelain manufactories. Initially it was the faience potteries of
Nevers, not far from the alleged location of the action of the novel,
where the first illustrated scenes from the narrative were depicted
on ceramics (Fig. 56). The hero, the shepherd Celadon, was de-
scribed by d'Urfé as dressed entirely in green, and this colour
became synonymous with the personification of the shepherds
and shepherdesses at the masquerades. The contradictory nature
of this pastoral fantasy is evident in the 1751 English translation of
Toussaint's treatise on *Manners*. The notion of what constitutes
'good company' is defined by what it is not: 'Exclude, first, the
rustic and unpolished, all such as have neither manners, delicacy
nor taste'.[69] The people, the 'lower orders', were 'strange animals' at
whom it was pleasurable to laugh from the distance of privi-
lege.[70] In the context of the court, and in the eighteenth-century
masquerade, the purpose and the pleasures of the pastoral were
really to be found in the tensions of unfulfilled sexual desire, or in
the anticipation of its fulfilment.

> Last Masquerade was Sylvia nymph-like seen,
> Her hand a crook sustain'd, her dress was green;
> An amorous shepherd led her through the crowd,
> The nymph was innocent, the shepherds vow'd;
> But nymphs their innocence with shepherds trust;
> So both withdrew, as nymph and shepherd must.[71]

Seldom did the producers of fine ceramics engage with dark or
challenging subjects. Although the masquerades drew heavy moral
criticism, the same personifcations reinterpretated in ceramic
figures were made sweet and charming. In the porcelain figure
group one of the most popular subjects derived from contempor-
ary prints was 'The Flute Lesson', in which a young shepherd and
shepherdess engage in intimate instruction. Most of the major
manufactories produced versions of this theme, some of which
were elevated to a higher social class to become 'The Music Lesson'.
Subjects of this type were a direct reinterpretation of popular genre
themes found in the printshops, and very often these were en-
graved reproductions of contemporary paintings. In both
porcelain and earthenware figures, hand-painted and transfer-
printed vessels, this bucolic subject matter extended into
representations of farming peoples, gardeners and vintners, conti-
nuing to be produced and reinterpreted during the nineteenth
century. Another significant branch of subjects which represented
rural life was the hunting scenes, which, like the prints increasingly
purchased for dining-room walls, retained popularity into the next
century. Generally, fine ceramic production was circumscribed in
its subject matter not *simply* because of the domestic context of

consumption and the social nature of its uses; there was no inevitability about the appearance and function of these products. In the eighteenth century people were forming particular ideas about the function of the family and the values which should be represented in the home; this had a profound effect on the nature of the material culture produced. The transmission and adaptation of styles in fine ceramics were socially and culturally determined in such a way as to reinforce these values.

A taste for the antique

Antiquity was a vivid presence in the minds of well-educated and well-travelled men, and some women, of the eighteenth century. A humanist education was rooted in the classical languages, literatures and histories of ancient Greece and Rome. At the beginning of the early modern period the Italians had understood that, paradoxically, a reverence for antiquity was 'an essential element of modernity'.[72] The perception of, and relationship to, antiquity underwent further transformation in the late eighteenth century, marking the point at which our late modern period arguably began. Yet this intense cultural involvement with the antique, romanticised and inflected with contemporary ideological concerns, also marked the point when knowledge started to become detached from the ancient world and find new nourishment in 'progress'. Moreover, in the context of the exchange of goods, of production and consumption, antiquity was successfully commodified.

The appreciation of classical sculpture and the ability to articulate one's thoughts about it were skills owned by the social and economic elites, and it was they who early in the century had access to the collections of antiquities, and to Rome, an indispensable objective on the Grand Tour. One mechanism for maintaining the antique as exclusive territory for the 'men of taste', and by inference for the community of men who had control of the institutions of power, was to align appreciation for the beauty of antique works with erudition, or connoisseurship.[73] But even as a taste for consumer goods which made reference to the antique became more widespread outside elite circles - and in the case of ceramics very much in the wake of Josiah Wedgwood - a late eighteenth-century 'advertisement' of a Meissen product emphasised its erudite associations. A pair of candleholders in blue and white biscuit porcelain in imitation of a known antique sculpture appeared in the January 1794 edition of the *Journal für Fabrik, Manufaktur und Handlung*, a Leipzig periodical predominantly concerned with trade and manufacturing, but which gave a high

57] Plate III, A Pair of
Candleholders, Meissen
biscuit porcelain, *Journal für
Fabrik, Manufaktur und
Handlung*, January 1794,
hand-coloured engraving.

profile to luxury manufactures and to the current debates on taste
and luxury consumption (Fig. 57).

> Plate III. A pair of candleholders – 12 zoll high – in blue and white biscuit
> porcelain from the Electoral Porcelain Factory at Meissen. One repre-
> sents Ganymede, whom the eagle is about to abduct. The other
> represents Hebe, with the eagle reaching for her bowl. The idea for
> Ganymede is almost certainly from a candelabra five palms high and
> executed in marble, found in the vicinity of Rome. Perhaps this itself is
> an imitation of a bronze masterpiece by Leocras, mentioned by Pliny.
> Perhaps also, refined after the painting of a great Greek artist; who
> knows? Sufficient that it is work in a good style, the history of which
> has been completed anew by Vincenzo Pacetti in Rome, and it would
> prove to be an advantage for the Meissen Factory to observe this. In any
> case, the excellence of their biscuit figure groups is already well recog-
> nised by the connoisseurs and collectors of genuine porcelains. The same
> candleholders are also available in white paste only.[74]

Discussion of the iconographic pedigree of the candleholders
was more important than their suitability as ornamental or func-
tional objects; candle grease and biscuit porcelain were not very
compatible materials in fact. The luxury product was required to
carry more than its worth in materials. The consumer invested in
its ability to work upon the mind and the emotions. A knowledge
of the classical sources is assumed, and if not known would provide
a valuable opportunity for instruction and contemplation.

Imitations of classical figures were slow to emerge from the
manufactories of fine ceramics, although John Dwight certainly

indicated the potential long before the biscuit porcelains and Wedgwood dry bodies were developed (Fig. 58). There were two main reasons for this which were linked to the availability of skill and the nature of materials. A high level of academic skill was required to achieve a convincing rendition of sculptures, the principles of which provided artists, theorists and connoisseurs with criteria on which to base an assessment of true taste and quality. Modelling a figure after an antique original, or more usually a Roman copy of a Greek original, required more than average ability. Early porcelain figure sculpture was expressive, often interpreting mythological themes of the ancient world, but in a very different mode from that of the exacting imitation of classical sculpture. Even when classical subjects did appear after the development of biscuit porcelains in the latter half of the century, Meissen produced only a few examples; they were executed by modellers like Christian Gottfried Jüchtzer, who had access to the Dresden antique collection and who had received academic training at the Dresden Academy. Wedgwood was largely dependent on academically trained artists and highly skilled copyists in order to produce convincing versions of classical subjects, either in three-dimensional form or in relief, and he took the step of establishing a modelling studio in Rome to ensure a supply of high quality models.[75]

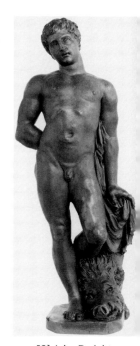

58] John Dwight, *Statuette of Meleager with Boar's Head*, red stoneware imitating bronze, Fulham, 1673–75, 30.5 cm high.

After the Seven Years War, which ended in 1763, confidence in the solvency and stability of absolutist regimes was severely damaged, and not least that of the Saxon House of Wettin. The promotion of the 'antique taste' was used by antiquarians like Pierre d'Hancarville, who collaborated with Sir William Hamilton in the publication of the *Collection of Etruscan, Greek and Roman Antiquities*, to downgrade the value of porcelains, then strongly associated with the absolutist court.[76] When Josiah Wedgwood developed his imitations of the antique style after the illustrations for Sir William Hamilton's folios, he did so in the knowledge that d'Hancarville was working hard to promote the ceramic artefacts of antiquity as valuable and technically difficult to produce. The ideological concerns of the antiquarians, including Winckelmann, led them to advocate the simplicity of Greek vessels to the detriment of the baroque and rococo porcelain wares. The economic interests of an 'entrepreneur' like d'Hancarville saw to it that the sums of money exchanged for antiquities remained high, and these factors rubbed off on Josiah Wedgwood very much to his advantage, an advantage of which he was keenly aware.[77]

The classical form which really gained a hold on the late eighteenth-century imagination was that of the vase. In the *Griechische Vasengemälde* of 1797, an analytical survey of the *Collection of*

Etruscan, Greek and Roman Antiquities published by Sir William
Hamilton and Pierre d'Hancarville between 1766 and 1776, the Ger-
man antiquarian Carl August Böttiger devoted a chapter to a
discussion of the arabesque decoration on Greek vases: 'Would that
our modern ornamentalists and arabesque painters had only some
of this sense of correctness! How many solecisms against good Taste
would then never have been encountered'.[78] Böttiger believed that
the production of luxury goods in the antique style could be better
achieved under the informed instruction of researchers in ancient
history, Winckelmann having established the ground rules. His
intense interest in the vase was founded on his conviction that it
represented an elevated vessel type suitable for contemplation and
designed to refine sensibilities of form, proportion and ultimately
'good taste'.

In a contribution to the June 1792 edition of the *Journal des
Luxus und der Moden*, Böttiger discussed the controversy concern-
ing the origin of the 'Etruscan' vases excavated in Italy, and
attention was drawn to the excellent use that Josiah Wedgwood
had made of Sir William Hamilton's *Collection of Etruscan, Greek
and Roman Antiquities*. The author described a friend's visit to the
Wedgwood showrooms in Soho:

> One believes that at the wave of a fairy's wand one has been transported
> to a room in ancient Herculaneum at Portici, or into the cabinet of the
> Cardinal Borgia at Veletri. Catching sight of the most recent vases,
> flower-pots, coloured bowls and tripods made by Wedgwood and his
> assistants after the genuine Hamilton antiques, one sees a perfect imita-
> tion not only in form and profile, but also in the intention to imitate
> the paintings through the re-invention of the Etrurian encaustic tech-
> nique, the latest masterstroke of his artistic talent.[79]

Böttiger hoped that the contents of the Wedgwood catalogues
would 'banish the tastelessly decorated forms and ornaments from
the chambers of the rich and noble, which are just as costly and
far more ephemeral ...'.[80] It was his belief that the classical vase
expressed the eternal verities in good taste. His report on the
showroom, admittedly second-hand and possibly an elaboration,
also suggests the importance Wedgwood attached to the selective
display of his classical imitations, and it would seem he did this
in a manner resembling an antiquarian collection, entirely to
Böttiger's taste. In fact Wedgwood's vase forms were based on a
relatively small selection of vessels in Sir William Hamilton's *Anti-
quities*. Many of his classical interpretations were closer to
Greek and Etruscan bronze prototypes, and even more to Manner-
ist and contemporary printed designs.[81] Nevertheless, the vases
based on Sir William Hamilton's collection and on contemporary

archaeological sources imitated the originals as closely as Etrurian skills and kiln technology made possible, and it was Wedgwood's concern to emphasise the significance of improved skill and innovations in technique, but to do so through objects which lifted ceramic manufactures from the mechanical to the level of a minor art in eighteenth-century terms.

Earlier in the century the 'china jar', the exotic oriental import, was invested with an emblematic role which referred to *vanitas*, the attributes of the feminine, the brittle and transitory condition of love and life, when 'The shivered China dropped upon the ground'.[82] The vases of antiquity, and particularly the funerary urn, were also absorbed into the lives of late eighteenth-century consumers on more than their material level. While the formal qualities of these ancient vessels were adapted for ornamental use in house and garden, their resonance in the emotional and imaginative life of the middle and upper classes was constantly reinforced in other cultural contexts, especially in poetry. The urn in particular nourished the preoccupation with death and suffering, and with notions of sacrifice to mark the indestructible bonds of friendship. In a poem dedicated to her close friend Henrietta O'Neill, who died at the age of thirty-six, the Sussex poet Charlotte Smith expressed her grief:

> O'er what, my angel friend, thou wert,
> Dejected Memory loves to mourn;
> Regretting still that tender heart,
> Now withering in a distant urn![83]

Ironically, at the point in time when the emblems of antiquity so preoccupied the imagination of the late Enlightenment, the tendency was to abandon the classical notions of poetic inspiration and to account for it in 'sensibility'. The use of the imagination to enter into a sympathetic relationship with a subject was a central concern in the latter half of the eighteenth century among the educated middle class. A concern for, and interest in, the welfare of others led to a heightened awareness of the value of friendship and the intensity of the passions (Fig. 59).[84] By the end of the century it was accepted that material goods also had their value in extending people's imaginative powers and providing a focus for 'those vague inconstant sentiments' which were the outcome of a heightened sensibility.[85] These were virtuous and noble sentiments of course, a long way from the hectic and dubious experiments at the masquerade. The development of Coade stone, which was a fabricated stoneware capable of withstanding frosts in British and even German winters, led to the production of fine architectural and garden ornament which predominantly featured

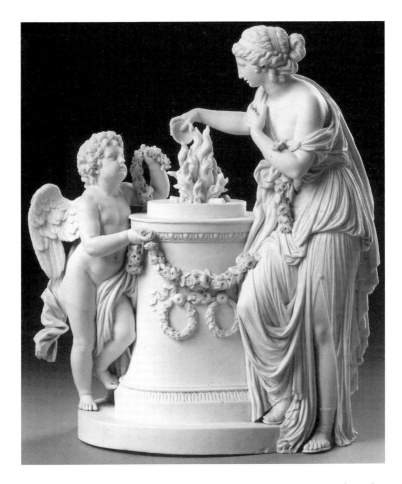

59] Christian Gottlieb Jüchtzer, *Sacrifice of Friendship*, Meissen, 1780, 36 cm high.

the classical and mannerist urn. It was in this context that the German *Magazin für Freunde des guten Geschmacks* recommended the memorial, which often incorporated the urn as a suitable object towards which the emotional issue of a heightened sensibility 'can flow with a resolute purpose'.[86] The sensitively constructed garden site, enhanced by a well-placed 'monument', was considered highly suitable in encouraging the development of imaginative powers and emotional sympathies.

The proportions of the classical urn became a central feature in the range of new forms produced in tablewares, coffee services and tea 'equipage'; it became thoroughly domesticated. A long way from the funerary associations of the antique cinerary urn, the tea urn was a metal vessel developed to provide sufficient hot water for prolonged and social tea drinking in polite society. It became an important feature in the tea-table equipage because of its imposing size and ability to carry references which alluded to the social standing of the family. In an image reminiscent of William Hogarth's 'The Breakfast' from *Marriage à la Mode*, John Collett's

The Honeymoon shows a young wife trying to coax her husband round from his weariness after their wedding night (Fig. 60). Around them are represented all the emblems of the affluent modern marriage and pretensions to gentrification, the pitfalls and mundane realities that await them as well as the pleasures. The engraving represents many of the fashionable imported and home manufactured commodities which marked the increased comfort of the domestic interior in 1765: the copper urn with silver finial, handles and tap; the teawares in the Chinese style, if not imported East India porcelains; the tripod tea-table and octagonal tray; the blue check calico upholstery on the settee; the richly coloured carpet; the exotic oriental jars, one of which contains an indoor plant; the fine quality clothes and linen of the young couple; even their domestic pets may be considered a requirement in the establishment of an affluent household.

The very nature of classical form and a public 'taste for the antique' made stringent demands on the producers of fine ceramics, but at a time when there were entrepreneurs who could meet the challenge. Yet even Josiah Wedgwood could find the difficulties irksome, and in a letter to Thomas Bentley he wrote

60] John Collett, *The Honeymoon*, coloured engraving, no. 3 of the series *Modern Love, c.* 1765.

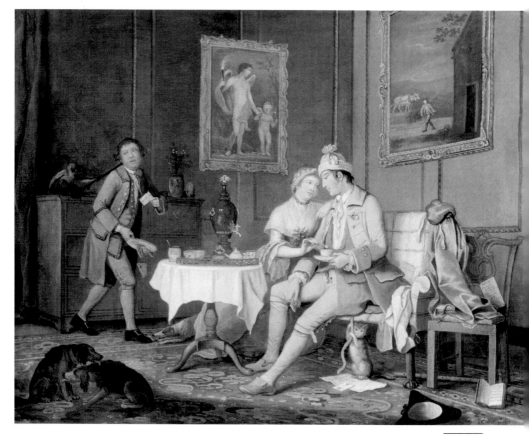

that he could 'almost envy many of my Bretheren for the sim-
plicity of their work, & the ease with which they can command
Plates, Dishes & Chamberpots to be made from one years end to
another'.[87] Not unlike Piccolpasso two centuries earlier, Josiah
Wedgwood wanted to advance the material and visual qualities of
ceramic products, and yet his modernity had to be disguised in the
forms of antiquity. In his poem *The Botanic Garden*, Erasmus Dar-
win expressed this duality with ponderous reverence to the
ancient Etruria which he believed vied with 'China itself in the
antiquity of its arts'. Beneath Etruria's 'magic hands':

> Glides the quick wheel, the plastic clay expands,
> Nerved with fine touch, thy fingers (as it turns)
> Mark the nice bounds of vases, ewers, and urns;
> Round each fair form in lines immortal trace
> Uncopied Beauty, and ideal Grace.[88]

In his admiration for Wedgwood's modernity Darwin sees:

> A new Etruria decks Britannia's isle.
> Charm'd by your touch, the flint liquescent pours
> Through finer sieves, and falls in whiter showers;
> The biscuit hardens, the enamel shines;
> Each nicer mould a softer feature drinks,
> The bold Cameo speaks, the soft intaglio thinks.[89]

Darwin held the conviction that these products formed by im-
proved techniques, and at the same time 'Rich with new taste', and
'with antient virtue bold', could with their presence influence and
improve people as well.[90] A debate, which would continue into the
nineteenth century, had already begun. It was led by the educated
elites who were critical of the standards of manufactured goods
produced and consumed, and who held the belief that a material
culture of 'good taste' appropriate to a person's position in life
would improve minds and morals.

Notes

1 *A Voyage to the East Indies in 1747 and 1748* (London, 1762), p. 117.

2 J. Brown, *An Estimate of the Manners and Principles of the Times* (London, 1757),
p. 47. In his reference to 'our ingenious Countryman' Brown meant William
Hogarth. Many of Brown's criticisms are rehearsed again in S. Fawconer's *An Essay
on Modern Luxury* (1765). Commentaries on taste and consumer goods are more
easily found in nineteenth-century archival sources, but eighteenth-century ma-
terial is not exhausted and further research can yield memoirs, diaries and
journals, letters, business and personal papers which may throw more light on
the reception of these products and the social behaviour associated withh them.
For an excellent example see A. Vickery, *The Gentleman's Daughter: Women's
Lives in Georgian England* (London and New Haven, Yale University Press, 1998).

3 H. Honour, *Chinoiserie: The Vision of Cathay* (London, John Murray, 1961), pp. 134–5.

4 G. S. Rousseau and R. Porter (eds), *Exoticism in the Enlightenment*, (Manchester, Manchester University Press, 1990), p. 17.

5 A. Kircher, *Antiquities of China* (1669), and J. Nieuhof, *An Embassy of the East India Company* (1669).

6 D. Lach, *Asia in the Making of Europe*, Vol. 1 (Chicago, University of Chicago Press, 1965), p. xii.

7 F. Mannsaker, 'Elegancy and Wildness: Reflections of the East in the Eighteenth-Century Imagination', in Rousseau and Porter (eds), *Exoticism in the Enlightenment*, p. 177, and with reference to Warren Hastings who encouraged scholarship in Indian culture and affairs, p. 176.

8 Lach, *Asia in the Making of Europe*, Vol. 1, pp. xii–xiii. For a very interesting argument about the appropriation of 'rationality' as a superior European faculty, the reasons why this perception arose, and why it should be rigorously questioned, see J. Goody, *The East in the West* (Cambridge, Cambridge University Press, 1996).

9 Lach, *Asia in the Making of Europe*, Vol. 1, p. xii. In many of the African and East Indian trading posts most Europeans penetrated no further than the ports, many of which were heavily fortified. Extensive British colonial expansion in India did not take place until after the Battle of Plassey in 1757, when Britain took control of Bengal, Bihar and Orissa, and in Africa not until the nineteenth century. China itself had control of a very large empire with administration extending into Outer Mongolia, Manchuria and Korea in the north, the 'tributary' states of Nepal and Burma to the south, and after 1724 as far as Kashgar in the West. Although virtually isolated, with very limited trade relations with the West, Japan's economic strength and prosperity grew fast during the eighteenth century, which placed it in an advantageous position in relation to Western expansion during the nineteenth century.

10 Rousseau and Porter (eds), *Exoticism in the Enlightenment*, p. ix.

11 C. Mukerji, *From Graven Images: Patterns of Modern Materialism* (New York, Columbia University Press, 1983), p. 15.

12 P. Bourdieu, *Distinction: A Social Critique of the Judgement of Taste*, trans. R. Nice (London, Routledge, [1979] 1984), p. 241. Bourdieu refers to the 'social sense' which is guided by the signs of the body, 'clothing, pronunciation, bearing, posture, manners', which are registered often unconsciously as 'antipathies' or 'sympathies'.

13 For an extended discussion of this issue see R. Benhamou, 'Imitation in the Decorative Arts in the Eighteenth Century', *Journal of Design History*, 4, 1 (1991), pp. 1-13. For the luxury market in France which focuses on the imitation of East India porcelains and lacquer wares see Chapter 4 of C. Sargentson's *Merchants and Luxury Markets: The Marchands Merciers of Eighteenth-Century Paris* (London, Victoria and Albert Museum, 1996).

14 Following the Italian maiolica potters and painters some of the earliest French imitations in earthenware of the Chinese imported porcelains were produced at the French pottery town of Nevers in the mid-seventeenth century. However, little Chinese porcelain was imported to France at this time and Nevers was still producing wares for an elite market. Its influence was therefore less widespread than the Dutch Delftwares. For a history of production at Nevers see M. Taburet, *La Faïence de Nevers et le miracle lyonnais au XVIe siècle* (Paris, Sous le Vent, 1981). A chinoiserie style can be seen in some of the details in Fig. 56, a tin-glaze plate produced in Nevers.

15 Liverpool Record Office, Liverpool Libraries and Information Services, Entwhistle Collection, 942 ENT/1, fo. 112.

16 In the early experimental years at Meissen sculptors like Balthasar Permoser and Paul Heerman, who were highly skilled in ivory figure carving and clay modelling, worked on prototypes for production in red stoneware and porcelain. The court sculptors did not find the transition from ivory to porcelain satisfactory. The new material presented them with considerable technical difficulties and the final result, when compared with ivory, was not as pleasing; the precision with which an image could be represented in ivory was not possible to achieve in porcelain, the materials required very different forms of expression. Furthermore, the objects made from stoneware and porcelain were reproducible, they were formed in moulds and in the process lost the individual mark of the artist who formed the original model. For further reading see S. Asche, 'Die Dresdner Bildhauer des fruhen achtzehnten Jahrhunderts als Meister der Böttgersteinzeugs und Böttger porzellans', *Keramos*, 49 (1970), pp. 33–91. M. Baker, 'The Ivory Multiplied: Small-scale Sculpture and its Reproductions in the Eighteenth Century', in A. Hughes and E. Ranfft (eds), *Sculpture and its Reproductions* (London, Reaktion Books, 1997).

17 The publisher Christoph Weigel produced the 'Ständebuch' which described and illustrated the professions and trades; for example the *Abbildung der gemein-nutzlichen Haupt-Stände von denen Regenten und ihren so in Friedens-als Kriegs-Zeiten zugeordneten Bedienten an/bis auf alle Künstler und Handwerker* (Regenspurg,1698). Weigel's publication on the Saxon mining industry, the *Abbildung und Beschreibung derer sämtlichen Berg-Wercks* of 1721, was the source used at Meissen for the later figure groups of Saxon miners.

18 C. L. Baron von Pöllnitz, *Memoires de Charles Louis Baron de Pöllnitz, contenant les Observations qu'il a faites dans ses Voyages, et le caractere des Personnes qui composent les principles Cours de l'Europe* (Liège, 1734), p. 139 (author's translation): 'Toutes les chambres de ce Palais, qui est de trois étages, sont autant de Cabinets de Porcelaines du Japon et de la Chine. Je ne crois pas que tous les Magasins ensemble d'Amsterdam puissent fournir autant de Porcelaines rares et anciennes …'.

19 *Ibid.*, p. 140 (author's translation): '... Bêtes sauvages, qui y sont en grand nombre. On y voit des Lions, des Tigres, des Ours, en un mot, de tout ce que les quatre Parties du Monde fournissent d'animaux les plus féroces'. See also L. Sponsel, *Der Zwinger, die Hoffeste und die Schlossbaupläne zu Dresden* (1924). This publication contains plans of the amphitheatre as well as many interesting reproductions of engravings and water-colours of the court festivals.

20 For a catalogue of the Meissen animal sculptures see C. Albiker, *Die Meißner Porzellantiere im 18 Jahrhundert* (Berlin, 1935).

21 Attributed to John Wilmot, Earl of Rochester, 'A Letter from Artemiza in the Town to Chloe in the Countrey', in K. Walker (ed.), *The Poems of John Wilmot Earl of Rochester* (Oxford, Basil Blackwell, 1984), p. 87. 'Japan' was a contemporary expression for 'exotic', p. 279.

22 *An Essay Towards the Character of the Late Chimpanzee* (London, 1739), p. 13.

23 On eighteenth-century debates concerning the understanding and management of the living world, with particular reference to the work of Georges-Louis Leclerc, later Comte de Buffon, see E. Spary, 'Political, Natural and Bodily Economies', in N. Jardine, J. A. Secord and E. C. Spary (eds) *Cultures of Natural History* (Cambridge, Cambridge University Press, 1996), especially p. 187.

24 With reference to the Scottish Enlightenment approach to natural history, including the work of Adam Ferguson, see P. B. Wood, 'The Science of Man', in Jardine, Secord and Spary (eds), *Cultures of Natural History*. See pp. 198-9 for a

discussion of the work of John Gregory, who strongly supported comparison between animals and humans, in order to better understand the human mind.

25 N. Bryson, *Looking at the Overlooked: Four Essays on Still Life Painting* (London, Reaktion Books, 1990), pp. 108-10. Many of the finely painted floral ceramic services were not used at the table, or only rarely used; they were purchased mainly for display, which is why there are numerous examples in museum collections still in fine condition.

26 R. Furber, *The Flower Garden Displayed* (London, 1730-32), frontispiece. See also G. Saunders, *Picturing Plants: An Analytical History of Botanical Illustration* (London, Zwemmer in association with the Victoria and Albert Museum, 1995), pp. 106, 111.

27 Bryson, *Looking at the Overlooked*, p. 106. T. Clayton, *The English Print 1688-1802* (New Haven and London, Yale University Press, 1997), pp. 98-101.

28 For an interesting point of view on the 'democratisation' of the flower in domestic culture, and on the uses and meanings of flowers in different world cultures see J. Goody, *The Culture of Flowers* (Cambridge, Cambridge University Press, 1993), p. 207. For the imitation of Indian textiles in English manufactures see B. Lemire, *Fashion's Favourite: The Cotton Trade and the Consumer in Britain 1660-1800* (Oxford, Oxford University Press, 1991), pp. 31-3. See also the rich work on ornament by Joan Evans, *Pattern: A Study of Ornament in Western Art 1180-1900*, Vol. II, 'The Return to Nature' (New York, Da Capo Press, 1976, reprint of the 1931 edition published by the Clarendon Press, Oxford, Vol. 2. Evans' work was first published in 1893.

29 Lemire, *Fashion's Favourite*, on the trade in second-hand clothes pp. 61-76.

30 Cited in L. Koerner, 'Carl Linnaeus in his time and place', in Jardine, Secord and Spary (eds), *Cultures of Natural History*, p. 148. Although a reluctant traveller himself, Linnaeus enlisted his students to travel and investigate the world along the old trade routes. He hoped they might bring back information about porcelain manufacture from China, and artefacts in his extraordinary home included china items on which were painted the 'Linnaea borealis', his heraldic flower. See L. Koerner, 'Carl Linnaeus', pp. 153-4.

31 E. Darwin, *The Botanic Garden*, Vol. II (London, 1791, 3rd edition), p. 87. Hygeia, the daughter of Asclepius, personifies health. The nymph Gossypia represents cotton, and Darwin had in mind Sir Richard Arkwright's 'magnificent machinery for spinning cotton' in a mill near Matlock in Derbyshire. See p. 60 for the verse and the note on p. 61 for Darwin's explanation of his botanic analogy to contemporary cotton manufactures.

32 Following Lisbet Koerner's essay on Linnaeus, see Londa Schiebinger 'Gender and Natural History', in Jardine, Secord and Spary (eds), *Cultures of Natural History*, and with specific reference to Erasmus Darwin pp. 174-5.

33 For a discussion of the sublime landscape and industrial development see D. E. Cosgrove, 'Sublime Nature: Landscape and Industrial Capitalism', in *Social Formation and Symbolic Landscape* (Sydney, Croom Helm Ltd, 1984.

34 For a discussion of eighteenth-century developments in geology in Britain see R. Porter, *The Making of Geology* (Cambridge, Cambridge University Press, 1977), pp. 170-6.

35 M. Rudwick, 'Minerals, Strata and Fossils', in Jardine, Decord and Spary (eds), *Cultures of Natural History*, pp. 266-7.

36 Porter, *The Making of Geology*, p. 136.

37 S. Lambert, *Pattern and Design: Designs for the Decorative Arts 1480-1980* (London, Victoria and Albert Museum, 1983), p. 34, with reference to the work of Matthew Darly.

38 Porter, *The Making of Geology*, p.122.

39 Rudwick, 'Minerals, Strata and Fossils', p.269.

40 H. B. Woodward, *The Geology of England and Wales* (London, George Phillip & Son, 1887), p.163. 'The Derbyshire marble is found very serviceable for chimney-pieces and other ornaments, and from its varied characters is known as Black, Rosewood, Shelley or Mussell, Bird's-eye, Dog's-tooth, Coralloid, Entrochal, or Encrinital limestone.'

41 Porter, *The Making of Geology*, p.123.

42 On the enthusiasm for natural history in the nineteenth century see D. Allen, 'Tastes and Crazes', in Jardine, Secord and Spary (eds), *Cultures of Natural History*, pp.394–407. See also Evans, *Pattern: A Study of Ornament in Western Art*, Vol. 2. For a discussion of how the lives of ordinary people were drawn into areas of new scientific knowledge, and especially that of natural history see J. H. Plumb, 'The Acceptance of Modernity', in N. McKendrick, J. Brewer and J. H. Plumb, *The Birth of a Consumer Society: The Commercialization of Eighteenth-Century England* (London, Europa Books, 1982).

43 The 'ambitious' designers of the seventeenth and eighteenth centuries included J. A. Meissonier, N. Pineau, G. M. Oppenord, and J. Linnell, but there were many others. It is impossible to list the extent of their works because their ornamental designs were copied by engravers and bound in different combinations or sold as individual prints. One of the best known of these engravers, responsible for the reproduction and distribution of a large body of designs, was Gabriel Huquier who worked in Paris. On the use of printed ornament see J. Styles, 'Goldsmiths and the London Luxury Trades 1550-1750', in *Goldsmiths, Siversmiths and Bankers: Innovation and the Transfer of Skill, 1550-1750* (London and Stroud, Centre for Metropolitan History and Alan Sutton Publishing, 1995), p.117.

44 Designs originally intended for production in metal usually had to be amended for manufacture in clay because the material would not tolerate the formal extremes possible in cast or turned metals, although eighteenth-century porcelain and creamware manufacturers tested their clays to extreme formal limits in following the neo-classical style.

45 Hanbury-Williams served as the British Envoy in Saxony and was presented with a gift of Meissen porcelain by Augustus III. See E. Adams, *Chelsea Porcelain* (London, Barrie & Jenkins, 1987), pp.63-4.

46 For a useful discussion of the function of emblems see W. Harms, 'The Authority of the Emblem', *Emblematica*, 5, 1 (1991). See also Evans, *Pattern: A Study of Ornament in Western Europe 1180-1900*, Vol. 1, pp.148-159.

47 Critical opposition to the emblem came principally from the work of Anthony Ashley Cooper, Earl of Shaftesbury, who in the early eighteenth century was one of the leading exponents of the new 'polite' culture; see his *Characteristics of Men, Manners, Opinions, Times* (1711). It was in his unfinished *Second Characters or the Language of Forms* (1713) that he criticised the emblem form for representing all that is 'magical, mystical, monkish and Gothic'. See R. Freeman, *English Emblem Books* (New York, Octagon Books, [1948] 1978), p.10. Rosemary Freeman points out that in the title of this work Shaftesbury uses the term 'Characters' to mean 'symbols' or 'signs'; footnote, p.9.

48 For a valuable discussion of the application of the emblematic form in satirical prints see D. Donald, Chapter 2 'Wit and Emblem: The Language of Political Prints', in her book *The Age of Caricature: Satirical Prints in the Reign of George III* (New Haven and London, Yale University Press, 1996).

49 See J. Ashton, *Chapbooks of the Eighteenth Century* (London, Skoob Books, no date but first published by Chatto & Windus in 1882), p.272. On emblematic devices

in English pottery see P. Brears, *The English Country Pottery: Its History and Techniques* (Newton Abbott, David and Charles, 1971).

50 Donald, *The Age of Caricature*, pp. 50-4, and on the process of 'cultural sinking' pp. 56-7.

51 M. Bath, *Speaking Pictures: English Emblem Books and Renaissance Culture* (London, Longman, 1994), p. 261.

52 W. Goder, 'Michel Victor Acier zum 250. Geburtstag', *Keramos: Zeitschrift der Gesellschaft der Keramikfreunde E. V. Düsseldorf*, 112 (April 1986), p. 32.

53 Bath, *Speaking Pictures*, pp. 30-1.

54 For an interesting study on the purposes of fraternal clubs and societies and the use of ceramics in reinforcing political allegiancies, especially during campaigns associated with John Wilkes, see J. Brewer 'Commercialization and Politics', in McKendrick, Brewer and Plumb, *The Birth of a Consumer Society*.

55 A. Pope, *The Rape of the Lock*, Canto V, in *The Poems of Alexander Pope*, ed. J. Butt (London, Routledge, reprinted 1992), p. 231.

56 *Ibid.*, p. 233.

57 For a detailed discussion of Pope's *The Rape of the Lock* see L. Brown, *Alexander Pope* (Oxford, Basil Blackwell, 1985), 'Imperialism and Poetic Form' and p. 19. See also C. E. Nicholson, 'A World of Artefacts: The Rape of the Lock in Social History', *Literature and History* (1979), pp. 183-93.

58 E. Fuchs, *Illustrierte Sittengeschichte: 3 Die Galante Zeit* (Frankfurt am Main, Fischer Verlag, [1910] 1985) p. 111. See the 1910 edition for both the print and the verse.

59 E. Burke, *A Philosophical Enquiry into the Origin of our Ideas of the Sublime and the Beautiful*, ed. A. Phillips (Oxford, Oxford University Press, World's Classics Series, [1759] 1990), p. 16, 'Introduction on Taste'.

60 On experiencing the Gothic fantasy 'without pain, discomfort and squalor' see P. Langford, *A Polite and Commercial People: England 1727-1783* (Oxford, Oxford University Press, [1989] 1992), p. 432.

61 For a rich and detailed study of the masquerade see T. Castle, *Masquerade and Civilisation: The Carnivalesque in Eighteenth-Century Culture and Fiction* (London, Methuen, 1986), p. 18. See also P. Stallybrass and A. White, *The Politics and Poetics of Transgression* (London, Methuen, 1986).

62 D. Solkin, *Painting for Money: The Visual Arts and the Public Sphere in Eighteenth-Century England* (New Haven and London, Yale University Press, 1992), pp. 110-11. The characters of the Italian Comedy were common subjects for porcelain figures, but they have been discussed in numerous publications. A good comprehensive survey of the subjects used by the porcelain manufactories can be found in H. Reber and W. Meister, *European Porcelain* (Oxford, Oxford/Phaidon, 1983). For a more extensive study of printed sources used by the manufactories see S. Ducret, *Keramik und Graphik des 18 Jahrhunderts: Vorlagen für Maler und Modelleure* (Braunschweig, Klinckhardt und Biermann, 1973).

63 F. Burney, *Cecilia, or the Memoirs of an Heiress* (Oxford, Oxford University Press, World Classics Series, [1782] 1992), pp. 120-1.

64 Castle, *Masquerade and Civilization*, p. 5.

65 *An Essay Towards the Character of the Late Chimpanzee* (London, 1739), p. 18.

66 For a detailed study of this subject see N. Elias, *The Court Society*, trans. E. Jephcott (Oxford, Basil Blackwell, 1983), especially Chapter 8, 'On the Sociogenesis of Aristocratic Romanticism', and pp. 231-2. Elias's work applies most specifically to the French court and should not be assumed as typical of all European courts.

67 *Ibid.*, p. 229

68 *Ibid.*, p. 226.

69 F. V. Toussaint, *Manners: Translated from the French: Wherein the Principles of Mor-ality or Social Duties ... are Described in all their Branches* (London, 1751), p. 83.

70 D. Roche, *The People of Paris* (New York, Munich and London, Berg Publishing Ltd, 1987), p. 44. Social distinctions were generally more rigidly observed on the Continent than in Britain during the eighteenth century, although the gulf between property owners and the labouring poor in Britain was unbridgeable.

71 J. Gay, 'The Tea-Table: A Town Eclogue', in *The Works of the English Poets*, Vol. 41 (London, 1779); Doris and Melanthe gossip about their acquaintance Sylvia's conduct at the masquerade.

72 F. Haskell and N. Penny, *Taste and the Antique: The Lure of Classical Sculpture 1500-1900* (New Haven and London, Yale University Press, 1982), p. 1.

73 *Ibid.*, p. 52.

74 *Journal für Fabrik, Manufaktur und Handlung* (Journal for Factory, Manufactory and Trade), (January 1794) (author's translation), p. 60: 'Ein paar Camin-Leuchter. 12 Zoll hoch. von blauem und weißen Biscuit der Churfürstl Porzellan-Fabrik zu Meissen. Der eine stellet den Ganymedes vor, den der Adler so eben entfuhren will: der andere als Gegenstück, die Hebe, welche dem Adler ihre Schale reicht. Die idee des Genymedes ist fast ganz einem vor kurzem unweit Rom gefunden, fünf Palmen hohen Candelaber von Marmor, ausgeführt. Vielleicht ist derselbe ein Nachtbild jenes Meisterstücks des Leocras von Bronze, dessen Plinius geden-ket. Vielleicht auch, nach dem Gemälde irgend eines großen griechlichen Künstlers gebildet; wer weis das. Genug, es ist eine Arbeit von gutem Styl, welche der geschichte Vicenzo Pacetti zu Rom, weider ergänzt hat; und deren Befolgung der Meissner Fabrik zum Vortheil gereichen mus. Ohne dies sind schon ihre Biscuit=Gruppen und Figuren, von Kunstkennern und Liebhabern ächten Pro-zellans, als die aller vorzüglichen annerkannt worden. Auch ganz aus Weisser Masse werden derglsichen Leuchter geliefert.'

75 R. Reilly, 'Josiah Wedgwood, a Lifetime of Achievement', in H. Young (ed.), *The Genius of Wedgwood* (London, Victoria and Albert Museum, 1995), p. 55.

76 M. Vickers, 'Value and Simplicity: Eighteenth-Century Taste and the Study of Greek Vases', *Past and Present*, 116 (August 1987), p. 132.

77 *Ibid.*, see the interesting argument on pp. 119-124.

78 C. A. Böttiger, *Griechische Vasengemälde* (Greek Vase Paintings) (Weimar, 1797) (author's translation), p. 91: 'Möchten doch unsere modernen Ornamentisken und Arabeskenmahler nur etwas von diesen Gefühle der Schicklichkeit gehabt haben! Wie viele Solöcismen gegen den guten Geschmack ürden dann nie be-gangen worden seyn!'

79 C. A. Böttiger, 'Ueber die Prachtgefässe der Alten', *Journal des Luxus und der Moden* (Journal of Luxury and Fashion) (June 1792) (author's translation), pp. 286-7: 'Man glaubt sich ... in ein Antikaglienzimmer der Herculanischen Alterthümer zu Portici, oder in das Cabinet des Cardinal Borgia zu Veletri durch den Zauber-stab einer Fee versetzt zu sehn, wenn man die neuesten Vasen, Pateren, Farbenschaalen und Tripoden erblickt, die Wedgwood und seine Gehülfen nach ächten, meist Hamiltonischen Antiken, nicht bloß in Form und Umriß, sondern nun auch durch das letzte Meisterstück seines Künstlertalents, die Wiedererfin-dung der Etrurischen Enkaustik in Absicht auf die Gemälde selbst, bis zur größten Vollkommenheit nachgemacht hat'.

80 *Ibid.* (author's translation), p. 287: '... hoffentlich aus den Zimmern der Reichen und Vornehmen immer mehr die geschmacklosen Formen in Decorationen und Aufsätzen verbannen, welche oft eben so kostbar, und weilt vergänglicher sind ...'

81 For example, Jacques Stella, Stefano della Bella, Edme Bouchardon and Friedrich Kirschner. For useful comparisons see H. Young, 'Catalogue E, "Vase Maker General"', in *The Genius of Wedgwood* pp. 102-117.

82 J. Gay, 'The Toilette: A Town Eclogue', in *The Works of the English Poets*, Vol. 41
 p. 226.

83 C. Smith, *Elegiac Sonnets* (London, 1789; 5th edition with additions 1797), p. 76.

84 J. Engell, *The Creative Imagination: Enlightenment to Romanticism* (Cambridge,
 Mass., Harvard University Press, 1981), pp. 150, 155.

85 F. A. Leo, 'Ueber die Denkmale im Garten', *Magazin für Freunde des guten Gesch-
 macks* (Magazine for Friends of Good Taste), Vol. 1 (Leipzig, 1976), no page
 numbers: '. . . und den unbestimmten, schwankenden Empfindungen. welche sie
 einflößen, Bestimmtheit und feste Richtung geben.'

86 *Ibid.*

87 Josiah Wedgwood to Thomas Bentley, WMSS. E. 18680-25, 5 July 1776, cited in
 N. Mckendrick, 'Josiah Wedgwood and Factory Discipline', *Historical Journal*, 4,
 1 (1961), p. 31.

88 E. Darwin, *The Botanic Garden*, Vol. 1 (London, 3rd edition, 1791), p. 85.

89 *Ibid.*, p. 87.

90 *Ibid.*, p. 87.

Conclusion

If production and consumption is a process of licking culture into shape as Mary Douglas and Baron Isherwood describe it, then it is a process which never ceases; culture is continually being made and remade, recycled and reinterpreted in part through the making and consuming of material goods. However, the rate at which these transformative processes take place is highly variable and complex. In his book about still life painting, *Looking at the Overlooked*, the art historian Norman Bryson expresses the view that still life painting 'is under-interpreted'.[1] The subjects of this genre are predominantly artefacts which belong to the domestic sphere, a space that is undervalued at the level of intellectual discourse. It has been the intention in this book to persuade the reader that a particular class of domestic artefact needs more and deeper interpretation than it has generally received in the past: the attempt here has been to write about fine ceramics in a different way. In addition it could be argued that our material culture is too important to be overlooked. The difficulty is that the artefacts of everyday life have an air of the commonplace about them, and yet the American anthropologist James Deetz wrote of how 'profoundly our world is the product of our thoughts', and though part of our 'physical environment', material culture is modified 'through culturally determined behaviour'.[2] In Deetz's terms, material culture includes artefacts within *and* without the domestic context. Ideas of this order raise many questions concerning the level of responsibility we should take for the material culture we make for our world.

Our cultural behaviour may in fact be formed by the interventions of material things not previously known to us, not 'thought' into a physical presence. One might ask why the eighteenth century should have any greater significance for an enquiry of this kind than any other historical period. Ceramic artefacts are particularly impervious to radical transformations: a bowl has fundamentally changed little in its form over thousands of years; the teapot has altered in style but not in its component parts since it was first manufactured in Europe. The reason why the eighteenth century repays closer scrutiny is because there was a shift in the formerly slow tempo of change in the material culture of the

domestic environment towards a relatively rapid absorption of new and diverse forms of consumer goods. While this process began in the seventeenth century with the expansion of overseas trade, it was in the eighteenth century that greater numbers of the European population began to feel the impact of the new consumer goods, augmented by the growth in European production of these desirable artefacts. Experience of new material things can transform ways of thinking and behaving, and eighteenth-century contemporaries certainly wrote about the impact of refined consumer goods in those terms.

The beautiful and exotic form of a nautilus shell, transformed into an object of curiosity for the collections of the sixteenth-century European elite, eventually reached wealthy Dutch merchant households as a commodity of the East India trade. But as one example of many exotic luxury artefacts, the market for goods of this splendour was bound to be limited; the social and economic elites could not sustain a sufficiently high level of demand for them, and neither could the luxury manufactories established under court patronage. A much greater demand was generated by the entrepreneurs and middle-class consumers outside these elite circles who were content to settle for goods of less brilliance, but of sufficient refinement for their consumers to define themselves as 'polite' or 'genteel', and at least to experience a marked improvement in the material and bodily comforts of living.[3]

Through the production and consumption of artefacts we change and remake ourselves, we are constantly licking ourselves into shape. In the context of eighteenth-century Britain it was the middle classes who engaged with a material culture that affirmed a sense of belonging to a civilised society; it was the middle-class entrepreneurs who made their products meet the contemporary tastes and requirements of this class, which in Britain had transformed itself by the end of the century. The drive to develop commerce was not, and is not, an entirely civilised process, at times far from it. The polite social practices and the artefacts manufactured to support them served to confirm at least the illusion that progress was achieved in a moral and civilised structure. To a considerable extent the new material culture helped to sustain the growth of commercial and industrial capitalism in the eighteenth century, and at the same time established the structures of civilised living still reproduced in the late twentieth century.

Notes

1 N. Bryson, *Looking at the Overlooked: Four Essays on Still Life Painting* (London, Reaktion Books, 1990), p. 10.

2 J. Deetz, *In Small Things Forgotten* (New York, Doubleday, 1977), p. 24. See also S. Lubar and W. D. Kingery, *History from Things: Essays on Material Culture* (Washington and London, Smithsonian Institution, 1993).

3 J. Goody, *The East in the West* (Cambridge, Cambridge University Press, 1996), p. 224.

Select bibliography

Adams, E., *Chelsea Porcelain*, London, Barrie and Jenkins, 1987.

Adams, E. and Redstone, D. *Bow Porcelain*, London, Faber & Faber, 1981.

Allardyce, A. (ed.), *Scotland and Scotsmen in the Eighteenth Century: From the MSS of John Ramsey Esq. of Ochtertyre*, Edinburgh and London, Blackwood and Sons, 1888.

Alpers, S., *The Art of Describing: Dutch Art in the Seventeenth Century*, London, Pelican Books, [1983] 1989.

Amico, L., *Bernard Palissy: In Search of Earthly Paradise*, Paris, Flammarion, 1996.

Appadurai, A., *The Social Life of Things: Commodities in Cultural Perspective*, Cambridge, Cambridge University Press, [1986] 1992.

Archer, M., *Delftware: The Tin-Glazed Earthenware of the British Isles*, London, Victoria and Albert Museum, 1997.

Armstrong, N. and Tennenhouse, L., *The Ideology of Conduct*, London, Methuen, 1987.

Asch, R. G. and Birke, A. M. (eds), *Princes, Patronage, and the Nobility: The Court at the Beginning of the Modern Age c. 1450-1650*, London and Oxford, The German Historical Institute/ Oxford University Press, 1991.

Astell, M., *An Essay in Defence of the Female Sex*, London, 1696.

Bakhtin, M., *Rabelais and His World*, Bloomington, Indiana University Press, [1965] 1984.

Barker, D., *William Greatbatch a Staffordshire Potter*, Jonathan Horne, 1991.

Barker-Benfield, G. J., *The Culture of Sensibility: Sex and Society in Eighteenth-Century Britain*, Chicago, University of Chicago Press, 1992.

Barry, J. and Brooks, C. (eds), *The Middling Sort of People: Culture, Society and Politics in England 1500-1800*, London, Macmillan, 1994.

Barton, M., *A History of the Cornish China-Clay Industry*, Truro, D. Bradford-Barton Ltd, 1966.

Bath, M., *Speaking Pictures: English Emblem Books and Renaissance Culture*, London, Longman, 1994.

Berg, M. *The Age of Manufactures 1700-1820*, London, Fontana Press, 1985.

Bermingham, A. and Brewer, J. (eds), *The Consumption of Culture, 1600-1800: Image, Object, Text*, Vol. 3 of Consumption and Culture in the Seventeenth and Eighteenth Century Series, London, Routledge, 1995.

Borsay, P. (ed.), *The Eighteenth-Century Town: A Reader in English Urban History 1688-1820*, London and New York, Longman, 1990.

Bourdieu, P., *Distinction: A Social Critique of the Judgement of Taste*, trans. R. Nice, London and New York, Routledge, [1979] 1984.

——, *Outline of a Theory of Practice,* Cambridge, Cambridge University Press, 1977.

Bremmer, J. and Roodenburg, H. (eds), *A Cultural History of Gesture*, Cambridge, Polity Press, 1991.

Brewer, J., 'Commercialization and Politics', in N. McKendrick, J. Brewer and J. H. Plumb, *The Birth of a Consumer Society: The Commercialization of Eighteenth-Century England*, London, Europa Books, 1982.

——, *The Pleasures of the Imagination: English Culture in the Eighyteenth Century*, London, Harper Collins, 1997.

Brewer, J. and Porter, R. (eds), *Consumption and the World of Goods*, Vol. 1 of Consumption and Culture in the Seventeenth and Eighteenth Century Series, London, Routledge, 1993.

Brown, J., *An Estimate of the Manners and Principles of the Times*, London, 1757.

Brown, P., *In Praise of Hot Liquors: The Study of Chocolate, Coffee and Tea-Drinking 1600–1850*, York, York Civic Trust, 1995.

Bryson, N., *Looking at the Overlooked: Four Essays on Still Life Painting*, London, Reaktion Books, 1990.

Burke, E., *A Philosophical Enquiry in to the Origin of our Ideas of the Sublime and the Beautiful*, ed. A. Phillips, Oxford, Oxford University Press, [1757] 1990.

Burke, P., *The Art of Conversation*, Cambridge, Polity Press, 1993.

Burney, F., *Cecilia, or the Memoirs of an Heiress,* Oxford, Oxford University Press, World's Classics Series, [1782] 1992.

Campbell, C., *The Romantic Ethic and the Spirit of Modern Consumerism,* Oxford, Basil Blackwell, 1987.

Campbell, R., *The London Tradesman*, London, 1747.

Castle, T., *Masquerade and Civilisation: The Carnivalesque in Eighteenth-Century Culture and Fiction*, London, Methuen, 1986.

Chapone, H. *Letters on the Improvement of the Mind Addressed to a Young Lady*, London, 4th edition, 1774.

——, *Mrs Chapone's Letter to a New-Married Lady*, London, 1777.

Chartier, R. (ed.), *A History of Private Life: Vol. III The Passions of the Renaissance*, Cambridge Mass., Harvard University Press, 1986.

Chaudhuri, K. N., *The Trading World of Asia and the English East India Company 1660–1760*, Cambridge, Cambridge University Press, 1978.

Clayton, T., *The English Print 1688–1802*, New Haven and London, Yale University Press, 1997.

Clunas, C., *Chinese Export Art and Design,* London, Victoria and Albert Museum, 1987.

Corbin, A., *The Foul and the Fragrant: Odour and the Social Imagination,* London, Picador, [1982] 1994.

Cosgrove, D. E., *Social Formation and Symbolic Landscape,* Sydney, Croom Helm, 1984.

de Courtin, A., *The Rules of Civility, or the Maxims of Genteel Behaviour*, London, 1672.

Cozens-Hardy, B., *The Diary of Silas Neville 1767-1788*, London, New York and Toronto, Oxford University Press, 1950.

Darwin, E., *The Botanic Garden*, London, 1791.

Daunton, M.J., *Progress and Poverty: An Economic and Social History of Britain 1700-1850*, Oxford, Oxford University Press, 1995.

Davenant, C., *Sir Charles Davenant: The Political and Commercial Works of that Celebrated Writer*, collected and revised by Sir Charles Whitworth, London, 1771.

Davidoff, L. and Hall, C., *Family Fortunes: Men and Women of the English Middle Class 1780-1850*, London, Routledge, [1987] 1992.

Deetz, J., *In Small Things Forgotten*, New York, Doubleday, 1977.

Donald, D., *The Age of Caricature: Satirical Prints in the Reign of George III*, New Haven and London, Yale University Press, 1996.

Douglas, M. and Isherwood, B., *The World of Goods: Towards an Anthropology of Consumption*, New York, Norton, 1978 / London, Penguin Books, 1980.

Ducret, S., *Keramik und Graphik des 18 Jahrhunderts: Vorlagen für Maler und Modelleure*, Braunschweig, Klinckhardt und Biermann, 1973.

Earle, P., *The Making of the English Middle Class: Business, Society and Family Life in London 1660-1730*, London, Methuen, 1989.

Eden, F.M., *The State of the Poor*, London, 1797.

Edwards, C., *Eighteenth-Century Furniture*, Manchester and New York, Manchester University Press, 1996.

Elias, N., *The Civilising Process: Vol. 1 The History of Manners*, trans. E. Jephcott, Oxford, Basil Blackwell, 1978.

——, *The Court Society*, trans. E. Jephcott, Oxford, Basil Blackwell, 1983.

Ellis, A., *The Penny Universities*, London, Secker and Warburg, 1956.

Evans, J., *A Study of Ornament in Western Art 1180-1900*, 2 vols, reprinted, New York, Da Capo Press, 1976.

Fairchild, T., *The City Gardener, containing the most Experienced Methods of Cultivating and Ordering such Evergreens, Fruit-Trees, flowering Shrubs, Flowers, Exotick Plants, &c as will be Ornamental, and thrive best in the London Gardens*, London, 1722.

Fawconer, S., *An Essay on Modern Luxury*, 1765.

Ferguson, A. *An Essay on the History of Civil Society*, ed. F. Oz-Salzberger, Cambridge, Cambridge University Press, 1995.

Forberger, R., *Die Manufaktur in Sachsen vom Ende 16 bis zum Anfang des 19 Jahrhunderts*, Berlin, Berlin Akademie Verlag, 1958.

Fothergill, A., *Cautions to the Heads of Families in Three Essays, 1. On Cyder-Wine 2. On the Poison of Lead 3. On the Poison of Copper*, Bath, 1790.

Foucault, M., *The Order of Things*, London, Routledge, [1966] 1992.

Fyfe, J.G., *Scottish Diaries and Memoires 1746-1843*, Stirling, Eneas Mackay, 1942.

Gaimster, D. and Redknap, M. (eds), *Everyday and Exotic Pottery from Europe c. 650-1900*, Oxford, Oxbow Books, 1992.

Gaimster, D., *German Stoneware 1200-1900*, London, British Museum Publications, 1997.

Gay, J., *The Works of the English Poets*, Vol. 41, London, 1779.

Gisborne, T., *An Enquiry into the Duties of the Men in the Higher and Middle Class Society in Great Britain*, London, 1794.

——, *An Enquiry into the Duties of the Female Sex*, London, 1797.

Goder, W. *et al.*, *Johann Friedrich Böttger: Die Erfindung des Europäischen Porzellans*, Leipzig, Edition Leipzig, 1982.

Goody, J., *The Culture of Flowers*, Cambridge, Cambridge University Press, 1993.

——, *The East in the West*, Cambridge, Cambridge University Press, 1996.

Grigsby, L. B., *English Pottery 1650-1800: The Henry H. Weldon Collection*, London, Sotheby's Publications, 1990.

Habermas, J., *The Structural Transformation of the Public Sphere: An Inquiry into a Category of Bourgeois Society*, trans. T. Burger, Cambridge, Polity Press, [1962] 1989.

Haskell, F. and Penny, N. *Taste and the Antique: The Lure of Classical Sculpture 1500-1900*, New Haven and London, Yale University Press, 1982.

Hatcher, J. and Barker, T. C., *A History of British Pewter*, London, Longman, 1974.

Haywood, E. *The Female Spectator*, London, 1745.

Hodder, I., *The Meaning of Things: Material Culture and Symbolic Expression*, London, Unwin Hyman, 1989.

Hogarth, W. *The Analysis of Beauty*, London, 1753.

Holgate, D., *New Hall*, London, Chapman and Hall, 1987.

Honour, H., *Chinoiserie: The Vision of Cathay*, London, John Murray, 1961.

Hook, D. R. and Gaimster, D. R. M., *Trade and Discovery: The Scientific Study of Artefacts from Post-Medieval Europe and Beyond*, British Museum Occasional Paper 109, London, British Museum, 1995.

Hoppit, J., *Risk and Failure in English Business 1700-1800*, Cambridge, Cambridge University Press, 1987.

Howard, D. and Ayers, J., *China for the West: Chinese Porcelain and other Decorative Arts for Export in the Mottahedeh Collection*, London and New York, Sotheby Parke Bernet, 1978.

Hudson, J., *The Florists Companion*, Newcastle, 1794.

Hume, D., *David Hume: Selected Essays*, ed. S. Copley and A. Edgar, Oxford, Oxford University Press, World's Classics Series, 1993.

Hunt, M., *The Middling Sort: Commerce, Gender, and the Family in England, 1680-1780*, Berkeley, Los Angeles and London, University of California Press, 1996.

Hutton, C., *Reminiscences of a Gentlewoman of the Last Century: Letters of Catherine Hutton*, ed. C. Hutton Beale, Birmingham, Cornish Brothers, 1891.

Impey, O. and Ayers, J., *Porcelain for Palaces: The Fashion for Japan in Europe 1650-1750*, London, Oriental Ceramic Society, 1990.

Impey, O. R. and Macgregor, A. G. (eds), *The Origins of Museums: The*

Cabinet of Curiosities in Sixteenth and Seventeenth-Century Europe, Oxford, Oxford University Press, 1985.

Ison, W., *The Georgian Buildings of Bristol*, Bath, Kingsmead Press, 1978.

Jardine, L., *Worldly Goods: A New History of the Renaissance*, London, Macmillan, 1996.

Jardine, N., Secord, J. A. and Spary, E. C. (eds), *Cultures of Natural History*, Cambridge, Cambridge University Press, 1996.

Jenkins, P., *The Making of a Ruling Class: The Glamorgan Gentry 1640-1790*, Cambridge, Cambridge University Press, 1983.

Johnson, S. *A Dictionary of the English Language*, London, 1756.

Kowaleski-Wallace, E., *Consuming Subjects: Women, Shopping, and Business in the Eighteenth Century*, New York, Columbia University Press, 1997.

Lach, D., *Asia in the Making of Europe*, 2 vols, Chicago, Chicago University Press, 1965.

Lambert, S., *Pattern and Design: Designs for the Decorative Arts 1480-1980*, London, Victoria and Albert Museum, 1983.

Landes, D., *The Unbound Prometheus: Technological Change and Industrial Development in Western Europe from 1750 to the Present*, Cambridge, Cambridge University Press, 1969.

Langford, P., *A Polite and Commercial People: England 1727-1783*, Oxford, Oxford University Press, [1989] 1992.

——, *Public Life and the Propertied Englishman 1689-1798*, Oxford, Clarendon Press, 1991.

Lemire, B., *Fashion's Favourite: The Cotton Trade and the Consumer in Britain 1660-1800*, Oxford, Oxford University Press, 1991.

Lennox, C., *The Female Quixote*, Oxford, Oxford University Press, World's Classics Series, [1752] 1989.

Lillywhite, B., *London Coffee Houses*, London, George Allen and Unwin, 1963.

Linebaugh, P., *The London Hanged: Crime and Civil Society in the Eighteenth Century*, London, Penguin Books, 1991.

Low-Life, or One Half of the World Knows not how the Other Half Lives, London, 1764.

Lubar, S. and Kingery, W.D., *History from Things: Essays on Material Culture*, Washington and London, Smithsonian Institute, 1993.

Macky, J. *A Journey Through England*, 2 vols, London, 1714.

Markham, S., *John Loveday of Caversham 1711-1789: The Life and Tours of an Eighteenth- Century Onlooker*, Salisbury, 1984.

Mason, C., *The Lady's Assistant for Regulating and Supplying the Table*, 8th edition, London, 1801.

Masson, M., *The Compleat Cook: or the Secrets of a Seventeenth-Century Housewife,* London, Routledge & Kegan Paul, 1974.

Mathias, P., *The Transformation of England: Essays in the Economic and Social History of England in the Eighteenth Century*, London, Methuen, 1979.

McKendrick, N., Brewer, J. and Plumb, J. H., *The Birth of a Consumer*

Society: The Commercialization of Eighteenth-Century England, London, Europa Books, 1982.

Meyer Spack, P., *Boredom: A Literary History of a State of Mind*, Chicago, University of Chicago Press, 1995.

Mitchell, B. and Penrose, H., *Letters from Bath 1766-1767 by the Reverend John Penrose*, Alan Sutton, Gloucester, 1983.

Montias, J., *Artists and Artisan in Delft: A Socio-Economic Study of the Seventeenth Century*, Princeton, Princeton University Press, 1982.

Mui, H. C. and Mui L. H., *Shops and Shopkeeping in Eighteenth-Century England*, Montreal, McGill-Queen's University Press / London, Routledge, 1989.

Mukerji, C., *From Graven Images: Patterns of Modern Materialism*, New York, Columbia University Press, 1983.

Nenadic, S., 'Middle-Rank Consumers and Domestic Culture in Edinburgh and Glasgow 1720-1840', *Past and Present*, 145 (1995), pp. 122-56.

Pallach, U., *Materielle Kultur und Mentalität im 18 Jahrhundert: Wirtschaftliche Entwicklung und politisch-sozialer Funktionswandel des Luxus in Frankreich und im Alten Reich am Ende des Ancien Régime*, Munich, Universitäts Verlag, 1987.

Parker, G., *A View of Society and Manners in High and Low Life*, London, 1781.

Pearce, S., *Museums Objects and Collections: A Cultural Study*, Leicester and London, Leicester University Press, 1992.

Piccolpasso, C., *Arte de Vasaio,* transcribed and translated by R. Lightbown and A. Caiger-Smith, 2 vols, Leicester, Scolar Press, 1980.

Plumb, J. H., 'The Acceptance of Modernity', in N. McKendrick, J. Brewer and J. H. Plumb, *The Birth of a Consumer Society: The Commercialization of Eighteenth-Century England*, London, Europa Books, 1982.

Pöllnitz, C. L. Baron von, *Memoires de Charles Louis Baron de Pöllnitz*, Liege, 1734.

Pope, A., *The Poems of Alexander Pope*, ed. J. Butt, London, Routledge, 1992.

Porter, R., *The Making of Geology*, Cambridge, Cambridge University Press, 1977.

Postlethwayt, M., *Brtitain's Commercial Interest Explained and Improved*, 2 vols, London, 1757.

Price, E. Stanley, *A Liverpool Pottery Printer*, privately printed, 1947.

Raffald, E. *The Experienced English Housekeeper*, London, 1782.

Raven, J., *Judging New Wealth: Popular Publishing and Responses to Commerce in England 1750-1800*, Oxford, Clarendon Press, 1992.

Reber, H. and Meister, W., *European Porcelain*, Oxford, Oxford/Phaidon, 1983.

Reilly, R., *Wedgwood*, 2 vols, London, Macmillan, 1989.

Roche, D., *The People of Paris*, New York, Oxford and Munich, Berg Publishing Ltd, 1987.

Rolleston, S., *Dialogue Concerning Decency,* London, 1751.

Rousseau, G.S. and Porter, R., *Exoticism in the Enlightenment,* Manchester, Manchester University Press, 1990.

Rückert, R., *Biographische Daten der Meißener Manufakturisten des 18 Jahrhunderts,* Munich, Bayerisches Nationalmuseum, 1990.

Sargentson, C., *Merchants and Luxury Markets: The Marchands Merciers of Eighteenth-Century Paris,* London, Victoria and Albert Museum, 1996.

Saunders, G., *Picturing Plants: An Analytical History of Botanical Illustration,* London, Zwemmer and the Victoria and Albert Museum, 1995.

Sayer, R., *The Ladies Amusement: or, Whole Art of Japanning Made Easy,* 1762.

Schama, S., *The Embarrassment of Riches: An Interpretation of Dutch Culture in the Golden Age,* London, Fontana Press, 1988.

Scherf, H., *Thüringer Porzellan unter besonderes Berücksichtigung der Erzeugnisse des 18 und frühen 19 Jahrhunderts,* Leipzig, Seeman, 1980.

Schlechte, M., 'SATURNALIA SAXONIAE – Das Saturnfest 1719 eine ikonographische Untersuchung', *Dresdner Hefte 21: Beiträge zur Kulturgeschichte,* 8, 1 (1990), pp. 39-52.

Sekora, J., *Luxury: The Concept in Western Thought from Eden to Smollett,* Baltimore, Johns Hopkins University Press, 1977.

Sennett, R., *The Fall of Public Man,* London, Faber & Faber, [1977] 1993.

Shammas, C. *The Pre-Industrial Consumer in England and America,* Oxford, Clarendon Press, 1990.

Sheaf, C. and Kilburn, R., *The Hatcher Porcelain Cargoes: The Complete Record,* Oxford, Phaidon/Christies, 1988.

Sieber, F., *Volk und Volkstümliche Motivik im Festwerk des Barocks,* Berlin, Berlin Akademie Verlag, 1960.

Smith, J.T., *Nollekens and His Times,* London, Pimlico, [1828] 1986.

Smith, P., *The Business of Alchemy: Science and Culture in the Holy Roman Empire,* Princeton, Princeton University Press, 1994.

Smollett, T., *The Expedition of Humphrey Clinker,* Oxford, Oxford University Press, World's Classics Series, [1771] 1985.

Solkin, D.H., *Painting for Money: The Visual Arts and the Public Sphere in Eighteenth-Century England,* New Haven and London, Yale University Press, 1992.

Stallybrass, P. and White, A., *The Politics and Poetics of Transgression,* London, Methuen, 1986.

Stone, L., *Broken Lives: Separation and Divorce in England 1660–1857,* Oxford, Oxford University Press, 1993.

Swift, J., *Directions to Servants in General,* London, 1745.

Taburet, M., *La Faïence de Nevers et le miracle lyonnais au XVIe siècle,* Paris, Sous le Vent, 1981.

Teuteberg, H.J. and Wiegelmann, G. (eds), *Unsere Tägliche Kost: Geschichte und regionale Prägung,* Münster, F. Coppenrath Verlag, 1986.

Thomas, K., *Man and the Natural World: Changing Attitudes in England 1500-1800,* London, Allen Lane, 1983.

Thornton, P. *Authentic Decor: The Domestic Interior 1620-1920*, London, Weidenfeld and Nicholson, 1993.

Toussaint, F. V., *Manners*, translated from the French, London, 1751.

Towney, D., *The Leeds Pottery*, London, Cory, Adams & Mackay, 1963.

Turner, F. M., *The Diary of Thomas Turner of East Hoathly (1754-1765)*, London, Bodley Head, 1925.

Vickers, M., 'Value and Simplicity: Eighteenth-Century Taste and the Study of Greek Vases', *Past and Present*, 116 (1987), pp. 98-137.

Vickery, A., *The Gentleman's Daughter: Women's Lives in Georgian England*, London and New Haven, Yale University Press, 1998.

Weatherill, L., *Consumer Behaviour and Material Culture in Britain 1660-1760*, London, Routledge, 1988.

——, *The Pottery Trade and North Staffordshire 1660-1760*, Manchester, Manchester University Press, 1971.

Weber, F. J., *Die Kunst das ächte Porzellain zu verfertigen*, Leipzig, 1798.

Weedon, R., *Poison in the Pot: The Legacy of Lead*, Carbondale and Edwardsville, Southern Illinois University Press, 1984.

Wheaton, B. K., *Savouring the Past: The French Kitchen and Table from 1300-1789*, University Park Pa., University of Pennsylvania Press, 1983.

Williams, R., *The Country and the City*, London, Hogarth Press, 1985.

Williams-Wood, C., *English Transfer-Printed Pottery Pottery and Porcelain: A History of Over-Glaze Printing*, London, Faber & Faber, 1981.

Wilson, T., *Ceramic Art of the Italian Renaissance*, London, British Museum Publications, 1987.

Woodforde, J., *The Diary of a Country Parson 1758-1802*, ed. B. Beresford, Oxford, Oxford University Press, 1935.

Wycherley, W., *The Works of the Ingenious Mr. William Wycherley*, London, 1713.

Young, H. (ed.), *The Genius of Wedgwood*, London, Victoria and Albert Museum, 1995.

Index

Notes: Literary works can be found under authors' names. Page numbers in *italic* refer to illustrations. 'n.' after a page number refers to a note on that page.

DATE DUE

GAYLORD			PRINTED IN U.S.A